CW01276893

Plaster Monuments

Plaster Monuments

Architecture and
the Power of Reproduction

Mari Lending

Princeton University Press
Princeton and Oxford

For Storm, as always.

Contents

Acknowledgments ix

Introduction: Monuments in Flux 1
 Plaster Perfection
 Exhibiting History
 Portable Monuments
 Antiquities as Novelties
 Reassessing a Space in Time

1. Travels in the Province of Reproductions 30
 Architecture Museums
 Rome—London—Paris—New York
 American Perfection
 An Epitome of Monuments in Central Park
 Traveling in the Province of Reproductions
 Temporal Cartographies
 Scaffolded Visibility

2. Trocadéro: Proust's Museum 70
 The Tyranny of the Particular
 Viollet-le-Duc's Museum
 Plaster Kiss
 Traversing Names and Landscapes
 Patina and the Work of Time
 Museophilia

3. The Poetics of Plaster 106
 Monuments in Time
 Monuments in Space and Scale
 Collapsing Taxonomies
 Architectural Promenades
 At Home in History: Traveling Portals
 Preserved in Plaster

4. Cablegrams and Monuments 145
 The Hall of Architecture, Pittsburgh
 A Readymade Monument
 Beaux-Arts Contemporaneity
 Move Every Stone!
 Cast in Situ, Lost at Sea
 Remounting Monuments

5. The Yale Battle of the Casts: Albers vs. Rudolph 183
 The Yale Cast Collection
 Historical or Contemporary
 Beaux-Arts Brutalism
 Cast Concrete and Plaster Casts
 Chance Encounters
 The Man, the Symptom
 Polychronic Wonders
 Fractured Temporalities (Learning from History)

Coda: Lost Continents, Fluctuating Objects 225
 Museum Vogues
 The Politics of Reproductions
 When the Cathedrals Were White

Notes 238
Bibliography 264
Index 275
Illustration Credits 282

Acknowledgments

In 2009 I was invited to give a talk to an exclusive little group of Norwegian architects, Gamle arkitekters gruppe (Old Architects' Group), the still-living masters of Norwegian modernism of Pritzker Prize laureate Sverre Fehn's generation. Honored, I proposed the title "Svart gips" ("Black Plaster") and was excited to present my early attempts to understand the scope of the casting of Norwegian stave church portals and their international dissemination in the last decades of the nineteenth century. During the presentation one of the architects expressed how shocked she was to learn that such a venerable institution as the V&A had generated the appalling idea of reproducing these beautiful wooden antiquities in plaster, before she literally collapsed and was carried out of the Norwegian Architectural Association's board room and set down to recover on a sofa in an adjacent room. A week later I received a ten-page handwritten letter from a distinguished architect, professor emeritus as well as a former dean of the school of architecture in Oslo. He confided that he had hardly slept since the talk, envisioning that I might present students with this material and the associated ideas on history. It all appeared as a mockery of everything his generation of architects had endorsed: honesty, truthfulness, originality, authenticity. I was both moved and puzzled by the letter, and urged that it be published in the journal *Arkitektur N*, as I felt that it addressed profound ideological issues of public interest. That unfortunately did not happen. This reaction made me no less curious about why these architectural plaster casts have borne such disrepute in their afterlife and, more importantly, what they meant at the time of their making. I must confess that I have shared much of this material with students over the years. The stave church seminar I ran with a wonderful little group of students in 2012 is still one of my most cherished moments as a teacher.

The Oslo School of Architecture and Design has been a luxurious milieu in which to contemplate the plaster monuments. Two dear

friends and colleagues have been key to the project. I had already begun to ponder an article on Proust and the Trocadéro (published first as "Spøkelsesmuseer"/"Ghost Museums"). I believe that the insight that this world of architectural reproductions might lead to something more can be dated to the time Mari Hvattum and I were drifting in Cervantes's birth town, Alcalá de Henares in Spain, in October 2008. I had recently returned from a year in New York as a visiting scholar at Columbia University, working on scale models while growing increasingly attracted to these models at full scale. During these years Victor Plahte Tschudi and I paid several visits to Rome, discovering the similarities between his work on seventeenth-century engravings of antiquity and my molds and casts, and all the twisted temporalities that are harbored in these two media of reproduction. Having Mari and Victor around for both the everyday and the extraordinary means everything to me.

This book has benefited greatly from the two international research projects *Place and Displacement: Exhibiting Architecture* and *The Printed and the Built: Architecture and Public Debate in Modern Europe* run out of OCCAS (the Oslo Centre for Critical Architectural Studies) and sponsored by the Norwegian Research Council, as well as the EU-funded project *Printing the Past (PriArc)*, part of the HERA program "Uses of the Past," graciously directed by Mari Hvattum. These initiatives have allowed us to bring favorite scholars to Oslo over and over, and have enabled me to present facets of the work, as it has developed over the years, to distinguished historians and exhibition scholars and specialists on nineteenth-century print culture. I have also benefited from lecturing on this material in Europe and the United States, making presentations at conferences on both sides of the Atlantic, as well as publishing bits and pieces along the way. Among those I am particularly indebted to, through discussions, commenting, reading, critique, encouragement, and exchange of material and ideas are: Tim Anstey, Thordis Arrhenius, Barry Bergdoll, Carson Chan, Beatriz Colomina, Adrian Forty, Karin Gundersen, Hilde Heinen, Lars Holen, Juliet Koss, Rolf Lending, Wallis Miller, Gro Bjørnerud Mo, Stanislaus von Moos, Sarah Mulrooney, Jorge Otero-Pailos, Eeva-Liisa Pelkonen, Timothy M. Rohan, Kari Rønneberg, Léa-Catherine Szacka, Erik Thorstensen, Panayotis Tournikiotis, and Peter Zumthor.

I have been assisted generously in archives as well as in storage spaces. A warm thanks to Ian Jenkins for an unforgettable tour of the British Museum's casts at Blythe House in 2014, and to Niall Hobhouse for arranging that. Tracy Myers and Alyssum Skjeie have been incredibly helpful at the Carnegie Museum of Art, and a warm thanks to Franklin Toker as well. Barbara File helped me in the Metropolitan Museum of Art archives, and Élisabeth le Breton at the Louvre Museum has generously helped me with rare images from the Louvre collection. A special thanks to Christiane Pinatel for letting me use her splendid photograph on the book cover. The hospitality of Robert Stern and Richard DeFlumeri, when I was a visiting scholar at Yale School of Architecture in 2014 and beyond, has been invaluable, and no less important were my discussions with Brenda Danilowitz at the Josef and Anni Albers foundation. Thanks to Robert Shure, a living *formatore* and restorer who stands in an unbroken chain with the skilled artisans who crafted the nineteenth-century plaster monuments, whom I can also thank for the company of Ashurnasirpal II, hunting a lion from

his chariot, in my Oslo apartment. At the Victoria and Albert Museum, Holly (Marjorie) Trusted helped me track down the origins of the circulating stave church portals, while Paul Williamson guided me through broken casts backstage at South Kensington. More stave church mysteries were solved with the kindest help of Jan Zahle and Henrik Holm at the Royal Cast Collection/National Gallery of Denmark in Copenhagen, and Sonja Innselset at the University Museum of Bergen. Our librarians at the school in Oslo are world-class. The anonymous readers for Princeton University Press gave invaluable suggestions to improve the manuscript, and I wish I could thank them in person. I appreciate the beautiful work of Luke Bulman and Camille Sacha Salvador, the book's designers, and of Steven Sears, who handled its production. I am forever grateful to my editor Michelle Komie for firmly believing in all this weirdness and to Lauren Lepow, who has been as much a soul mate as a copyeditor.

Introduction
Monuments in Flux

The absentminded visitor drifts by chance into the Hall of Architecture at the Carnegie Museum in Pittsburgh, where astonishment awaits. In part, the surprise is the sheer number of architectural fragments: Egyptian capitals, Assyrian pavements, Phoenician reliefs, Greek temple porches, Hellenistic columns, Etruscan urns, Roman entablatures, Gothic portals, Renaissance balconies, niches, and choir stalls; parapets and balustrades, sarcophagi, pulpits, and ornamental details. Center stage, a three-arched Romanesque church façade spans the entire width of the skylit gallery, colliding awkwardly into the surrounding peristyle. We find ourselves in a hypnotic space fabricated from reproduced building parts from widely various times and places. Cast from buildings still in use, from ruins, or from bits and pieces of architecture long since relocated to museums, the fragments present a condensed historical panorama. Decontextualized, dismembered, and with surfaces fashioned to imitate the patina of their referents, the casts convey a weird reality effect. Mute and ghostlike, they seem programmed to evoke the experience of the real thing. For me, the effect of this mimetic extravaganza only became more puzzling when I recognized—among chefs d'oeuvre such as a column from the Vesta temple at Tivoli, a portal from the cathedral in Bordeaux, and Lorenzo Ghiberti's golden Gates of Paradise from the baptistery in Florence—a twelfth-century Norwegian stave-church portal. Impeccably documenting the laboriously carved ornaments of the wooden church, it is mounted shoulder to shoulder with doorways from French and British medieval stone churches, the sequence materializing as three-dimensional wallpaper. Less famous perhaps than many of its fellow exhibits, the portal of the Sauland church sparked questions: How had it traveled all the way to Pennsylvania? Who had made it, why, and when? Above all, in what kind of world could this this patchwork architectural spectacle make sense?

If the immediate impression is shaped by the sheer size of the objects, a closer look conjures a strangely distorted experience of scale.

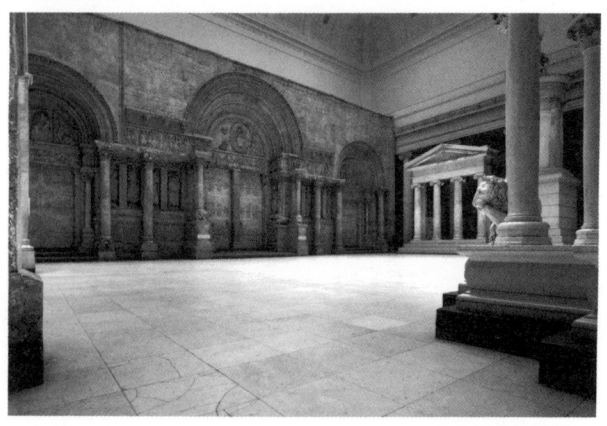

Figure 1.
Saint-Gilles façade and Nike Apteros temple front, Hall of Architecture, c. 1907. Carnegie Museum of Art, Pittsburgh.

At the Acropolis, the Temple of Nike Apteros appears tiny compared to the Parthenon, balancing on the verge of the rock. The Erechtheion temple, on the other hand, seems rather big, with its larger-than-life caryatides floating high above the ground. In the Carnegie Hall of Architecture they appear matched in size. The porches of both the Nike Apteros and the Erechtheion are dwarfed by the Choragic Monument of Lysicrates, which they flank—a structure that despite its massive base does not appear especially imposing scale-wise in its urban context in Athens. Similarly, both the Greek temple fronts look diminutive in comparison with the immense façade of the twelfth-century abbey church Saint-Gilles-du-Gard, the cornerstone of the Pittsburgh collection (figure 1).

If anything, this staged encounter of objects from faraway times and places prompts comparison. Yet comparing one exhibit with another, while bearing the real monuments in mind, is perplexing. Except for one scale model in the gallery—a reconstructed Parthenon with a label stating that it is executed at 1:20—most of the plaster monuments come without indication of scale or provenance. Despite their massive presence, they stand as transparent signifiers, devoid of the medium specificity that genre definitions such as "oil on canvas," "albumen print," or "bronze" routinely bring to museum pieces. Realizing that the little label by the stave-church portal dates the church to the wrong century and states that the original is "at its place of origin," while actually it was demolished in the mid-nineteenth century, the viewer confronts the limited value of the modest museum paratext.

The Hall of Architecture prompts more questions. For instance, why does the Nike Apteros pediment appear flawless in comparison to its Athenian referent (even in its most recent 2010 version, designed by the Acropolis Restoration Service, which after decades of vigorous building is still in the process of reshaping both the singular monuments and the full skyline of the Athenian Acropolis)? Lost in anachronistic deliberation, vaguely recollecting the little temple's complicated trajectory of falling in and out of existence across history, I could at least conclude that the ancient structure at no point could have looked exactly like this, and that this plaster monument must be depicting something other than a ruin in a particular state of ruination (figure 2).

The first impression of these casts teaches us a lesson, namely, that both monuments and their representations are in constant flux. Cross-historical referencing "does not happen in frictionless ways," as Alexander Nagel observes: "History is effective and real even as chronology is bent and folded. New configurations of problems and objects are taking shape before our eyes."[1] Strange constellations and bewildering juxtapositions cause time and space to bend and fold inside the four walls of the Hall of Architecture, walls that themselves testify to a startling inversion as the

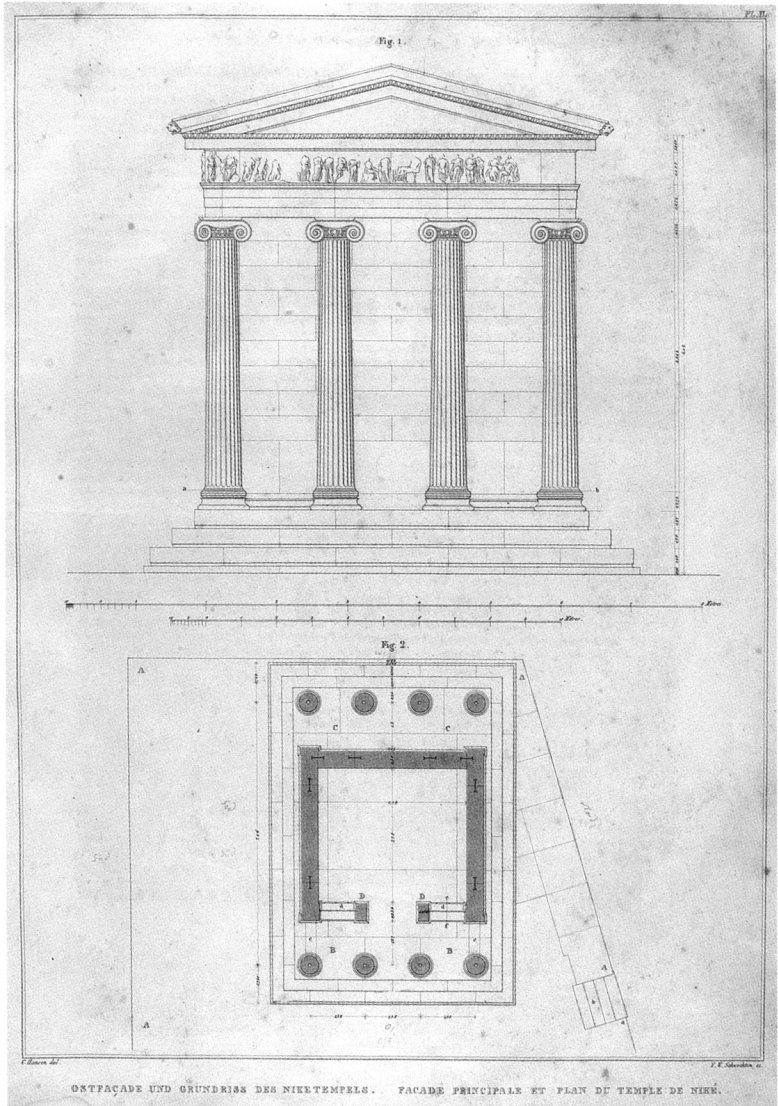

Figure 2.
Nike Apteros temple first restored on paper in 1834. From Ludwig Ross, Eduard Schaubert, and Christian Hansen, *Die Akropolis von Athen nach den Neuesten Ausbragungen. Erste Abtheilung der Temple der Nike Apteros* (Berlin, 1839).

architectural frame slowly reveals itself as an abstracted reconstruction of the imagined exterior of the Mausoleum of Halicarnassus, turned outside in. The odd effect of this representation of a memorial once counted among the Seven Wonders of the World is intensified when in a corner one spots a convincingly patinated replica of a column from the same structure, looking strikingly real in front of a Beaux-Arts interpretation of its own vanished totality.

Much of my astonishment that day in Pittsburgh was due to the epiphanic association evoked by this assembly of plaster monuments, namely, of a literary landscape structured precisely by epiphanies in the guise of *mémoires involontaires*. The room made me think of a dazzling scene in Marcel Proust's *In Search of Lost Time*. As a young boy, the main character, Marcel, visits the Trocadéro Museum in Paris, particularly admiring a plaster portal from the medieval church in the fictitious Norman town

Balbec, imbued, as I remembered it, with the alluring epithet "Persian." Marcel becomes increasingly impatient to experience the totality of the church firsthand. Yet when he at long last finds himself in front of the real building, it appears to represent nothing but an oppressive "tyrannie du particulier." The actual church seemed arbitrary, while its plaster version in Paris appeared perfect, universal, and timeless.

There is nothing timeless about the Hall of Architecture in Pittsburgh. Neither the individual casts nor the installation as a whole would be likely to stir ideas of perfection or universality. Even the accidental visitor—unaware of the fact that objects like these once furnished galleries from Moscow to San Francisco—will likely find the display old-fashioned, a relic of a bygone museum paradigm. The whole ensemble conveys a backstage ambience, appearing, in all its beauty, like a depository of artifacts of ambiguous provenance, lost in both time and space. The dizzying sensation of time travel was inescapable, but not to the monuments' original times or places. Evoking multiple times and numerous places, the reproductions hover somewhere between depiction and construction. A premodernist world unfolds before the present-day visitor, a time capsule containing the reminiscing present of a historicist culture, ordering, elaborating, and presenting the past. Virtually unchanged since its inauguration in 1907, the Hall of Architecture is a monument in its own right. It is a mausoleum-as-museum, an epitaph of a nineteenth-century mass medium. Up until the first decades of the twentieth century, when most cast collections were consigned to storage, destruction, and oblivion, these plaster monuments traveled the world at high speed, reifying architecture for wide audiences.

Plaster Perfection

My first encounter with the Hall of Architecture, in 2008, was purely serendipitous. I was making my way in a rented convertible to see Frank Lloyd Wright's Fallingwater, a popular pilgrimage site for architourists from all over the world. The Hall of Architecture, by contrast, is not considered a must-see even for architecture and exhibition historians, and it is only sporadically and peripherally commented on.

I was soon to become entangled in a nineteenth-century web of monument production, exchange, and curatorial efforts, and to undertake visits and revisits to extant cast galleries, as well as storage spaces, and archives in Europe and the United States. But first I returned to Proust before going back to the Carnegie archive, and was surprised to discover the institutional and biographical connections between the French novel and the Pittsburgh museum. Industrialist Andrew Carnegie had a world-class architecture collection installed in his hometown at the very moment when these displays were falling out of vogue. Most of the items were ordered from an extensive assortment of catalogues, issued by European museums, such as the Louvre and the British Museum, with unparalleled collections of antiquities, and from plaster cast companies from Cairo to Oslo. The French monuments in the Hall of Architecture were produced in the workshop of the same museum in which the young Marcel, within the frame of a novel, was admiring the Balbec cast. Whereas most

of the casts that arrived in Pittsburgh were at the time staples in the plaster monument trade—a booming marketplace in the last decades of the nineteenth century—the façade of the pilgrimage church Saint-Gilles-du-Gard was a singular sensation. It was the result of what might euphemistically be termed a resolute diplomacy to get around French monument legislation, made possible by Andrew Carnegie's unparalleled wealth and power. One of its kind, it was manufactured for the Hall of Architecture by the Trocadéro's experienced molders. The same molders spent the summer of 1906 assembling the monument that had arrived in two hundred crates, shipped by four steamers across the Atlantic before traveling by train from New York to Pittsburgh.

More precisely, Proust's Trocadéro Museum is the Musée de sculpture comparée. Opened to the public in the Palais du Trocadéro in 1882, it was founded on the initiative of Eugène-Emmanuel Viollet-le-Duc, and many of its major pieces were made during his restorations of French medieval monuments. Heralded as a "complete series," the casts merged to produce an unprecedented panorama of a national architecture as an evolutionary continuum, and were intended to show a totality inaccessible in the fragmented reality of the quotidian world.[2] However, as museums on both sides of the Atlantic purchased these serialized national monuments, the casts were transplanted into new agendas and curatorial programs. Accordingly, their meaning and function changed.

Proust praised the timeless perfection of a plaster cast while deeming the real church "reduced to nothing but its own shape in stone."[3] This inversion of modern hierarchies of originals and copies is indeed immanent in Proust's aesthetics. Still, read historically, the novel's portrayal of the perfect copy and its ambiguous original goes to the core of architectural cast culture, at the moment of its demise. Just as Proust's novel was published, many museums were deaccessioning their casts. The reasons for dismantling these collections were, as we will see, various and local. Yet overall, such displays became an intellectual and artistic embarrassment in modernist culture, and were over a few decades subjected to neglect, denial, and violent destruction. A late occurrence is the assault on the exhibits in the Cour vitrée at the École des Beaux-Arts in Paris in May 1968. Among the monuments salvaged from the turmoil was the colossal ruin of the Temple of Castor and Pollux from the Roman Forum (see figure 29). Rebuilt in Versailles in 1976, a century after its first erection in Paris, it testifies to the history of construction, destruction, and reconstruction at work in the world of plaster architecture.

Prior to this twentieth-century iconoclasm, plaster monuments had been advocated by scholarly elites as a medium par excellence for teaching and disseminating historical architecture. Conceived as providing ideal exhibits rather than second-class substitutes, the cast business was orchestrated by prominent museum directors, archaeologists, architects, art and architecture historians, and antiquarians. While selecting architectural pieces for the Metropolitan Museum of Art in New York, architect Pierre Le Brun in 1885 confirmed a particular nineteenth-century topos when he claimed that cast collections represented "a completeness and unity not found possible in museums of originals."[4] One might be forgiven for assuming that this was a particularly American sentiment. After all, US museums in the late nineteenth century hardly had sufficient

Figure 3.
The porch of the Siphnian Treasury and Nike of Samothrace in the Daru stairwell, Louvre, Paris, c. 1901.

antiquities to match their rising aspirations, and American participation in archaeological digs was rare. But the sentiment was by no means exclusively American. When Charles Callahan Perkins—theorizing the foundations for future American museums in 1870—explained that sound collections could be built only through the inclusion of "plaster casts, which in most respects supply the place of the originals, and cannot be dispensed with even in the presence of originals," he was quoting "the eminent German professor of archæology" Heinrich Brunn, director of the Munich Glyptothek.[5] The embrace of the full scale reproductions was nurtured by the ambition both to fill gaps in museum collections and to curate the past in accordance with contemporary art-historical obsessions—most importantly, chronology, comparison, and evolution. After having toured museums on the Continent in 1851, Charles Newton of the British Museum lamented the randomness governing most collections—dismissing, for instance, the Vatican, infamous for its chaotic display and poor light conditions, as a "wilderness."[6] A decade before excavating the Mausoleum of Halicarnassus, an event soon followed by

the introduction of the Amazonomachy frieze on the international cast market, while the marble fragments were installed in London, Newton concluded that the "great principle of chronological arrangement" was achievable only through a "well-selected *Museum of casts.*" Claiming that only reproductions could depict the history of monuments "in one synoptical and simultaneous view," he launched an ideal of perfect historical sequences to be admired by large audiences.[7]

The impressionable material of plaster proved capable of presenting flawless editions of individual works; as we will see, the opinion that a good cast, "identical with the original," afforded "the same satisfaction to the cultivated eye" was commonsensical.[8] Indeed, a perfect cast was considered more valuable than an inferior original. "I should presume that casts are preferable to originals, because they cast a purer and more direct shadow, whereas in a fragment of ancient sculpture you can hardly distinguish the dirt, as it were, from the shadow," opined W. R. Hamilton at the British Museum in 1853.[9] While a cast could reveal qualities that were lost in deteriorating marbles, the relation between the original and the reproduction could also become more complex. In fact, some instantly canonical works existed in plaster perfection only. After the French excavations at Delphi in the 1890s, the unearthed artifacts remained in Greece. The Louvre's *atelier de moulage* (plaster-cast workshop) boldly translated the debris from the porch of the Treasury of the Siphnians into a Greek monument that premiered at the 1900 Exposition universelle in Paris. Until the modernist refurbishment of the Daru stairway in 1934, it proudly marked the entrance to the Louvre alongside the Nike of Samothrace. This modern French invention—initially a copy without an original—soon traveled to museums around the world, serving to showcase developments in early Greek architecture by denoting a nonexistent structure in Greece (figure 3).

Plaster Monuments: Architecture and the Power of Reproduction looks into the ways in which monuments were shaped and enhanced off-site, how major architectural works were presented, invented, documented, preserved, circulated, traded, and exhibited in the ephemeral material of plaster, and how the casts shaped notions of origins, originality, and authenticity in the life of monuments.

Exhibiting History

Often pictured as stable structures that give voice to the past across history, monuments are always in flux—styled and reframed in accordance with the taste and interests of shifting present moments. As Thordis Arrhenius has shown, the invention of the modern cult of monuments dovetailed with discourses of conservation: "Exposed and vulnerable, always in need of reinforced protection," they are both "lost and found."[10] With exceptions such as the Choragic Monument of Lysicrates and Trajan's Column—erected for commemorative purposes—the monuments that appear in this book belong to the class labeled "unintentional." In his influential monument taxonomy, Alois Riegl defined this category in terms of historical value, encompassing architecture that "constitutes an irreplaceable and irremovable link in a chain of development."[11] Most of

Figure 4.
Building the East Gateway, Great Stupa at Sanchi. Eastern Cast Court photographed by Isabel Agnes Cowper, c. 1872. Albumen photograph. The cast was destroyed in the 1950s. Victoria and Albert Museum, London.

the plaster casts we are considering reproduce major ruins of antiquity, as well as buildings that were designated historical monuments by the bodies for the preservation of national heritage that emerged across Europe during the nineteenth century.[12] In curated arrangements, recently unearthed ruins, reevaluated national buildings, and architecture from far-flung regions displayed timeliness and change. When the ancient gateway from the Great Stupa at Sanchi, cast on-site in India in the 1860s, landed at the South Kensington Museum, the canon was expanded in time and space (figure 4). The aggregate of casts from Indochina that first appeared in Paris in 1867 canonized Angkor Wat as an "eternal ruin," while its restored plaster perfection off-site enabled its "inclusion in the colonizer's own canon of cultural heritage," Michael Falser argues.[13] This book shows how architecture takes on major public importance "when uncoupled from its traditional grounding in real space," as Richard Wittman puts it.[14] It was through full-scale, three-dimensional fragments that an emerging global history of monuments could be experienced spatially, synoptically, and simultaneously. As we shall see, the entrepreneurs who orchestrated their exchange and exhibition referred to both the originals and the reproductions as monuments. This does not signify a lack of media sensitivity. Rather it testifies to the acknowledgment that monuments were no less curated in situ than in galleries. Monuments travel across media and materials, in space and in time, producing complex entanglements of copies and originals.

Plaster casts are not, of course, a nineteenth-century invention. Egyptian tombs and Persian palaces were clad with plaster, often in lavish ornamentation. In the first century BCE, Pliny the Elder accredited the fourth-century BCE Greek sculptor Lysistratus of Sicyon with the invention of taking casts from sculptures.[15] In Greek and Roman antiquity, bronze and marble statues were imitated and disseminated in plaster, keeping lost originals alive.[16] Since François I in the 1540s obtained permission to cast statuary in the Vatican and reproduce bronzes for his new palace at Fontainebleau, reproductions of classical sculpture proliferated in princely collections, glyptotheques, and academies, within a paradigm where copies and works presumed original coexisted harmoniously.[17] The Art Academy in Berlin acquired plaster casts from the late seventeenth century, amassing an enormous collection that was augmented further when transferred to Friedrich August Stüler's Neues Museum in 1855, where the grand stairway was crowned by the Erechtheion porch (figure 5). In 1755, before embarking for Rome, Johann Joachim Winckelmann published "Thoughts on the Imitation of Greek Works in Painting and Sculpture," based on casts in Dresden.[18] Goethe and Schiller studied antiquity in the form of reproductions in the Antikensaal in Mannheim, and, as Suzanne Marchand notes, not even academic classicists considered material authenticity essential. Appreciation of the artworks of antiquity depended on "their aesthetic value rather than their historicity."[19] Increasingly canonical and proliferating versions of statues such as the Laocoön, the Farnese Hercules, the Venus de Milo, the Dancing Faun, the Dying Gladiator, the Apollo Belvedere, and the Nike of Samothrace designated a subject matter for European art history.

While reproductions were crucial to the modern reception of the classical tradition, the casting of architecture is a historicist rather

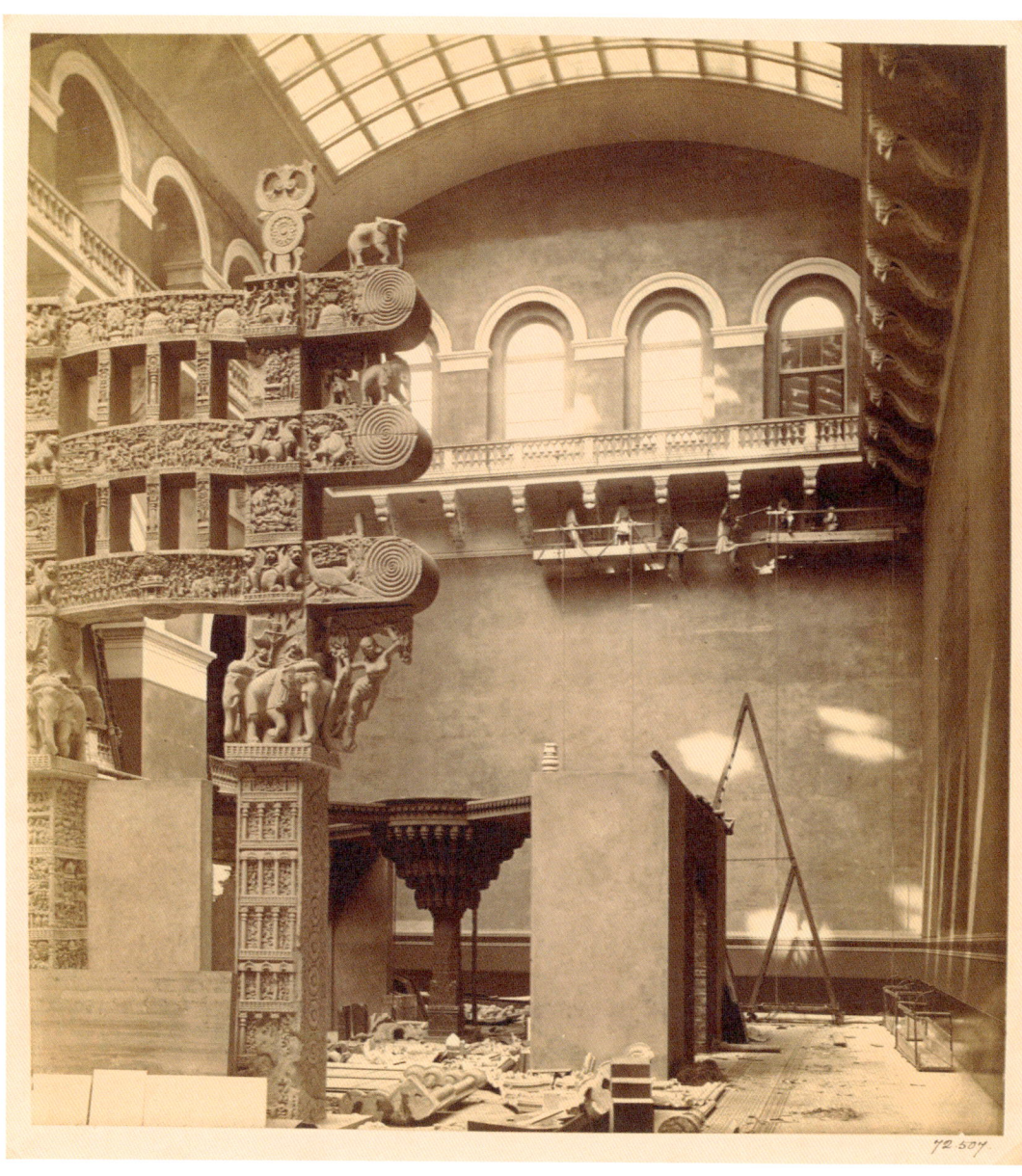

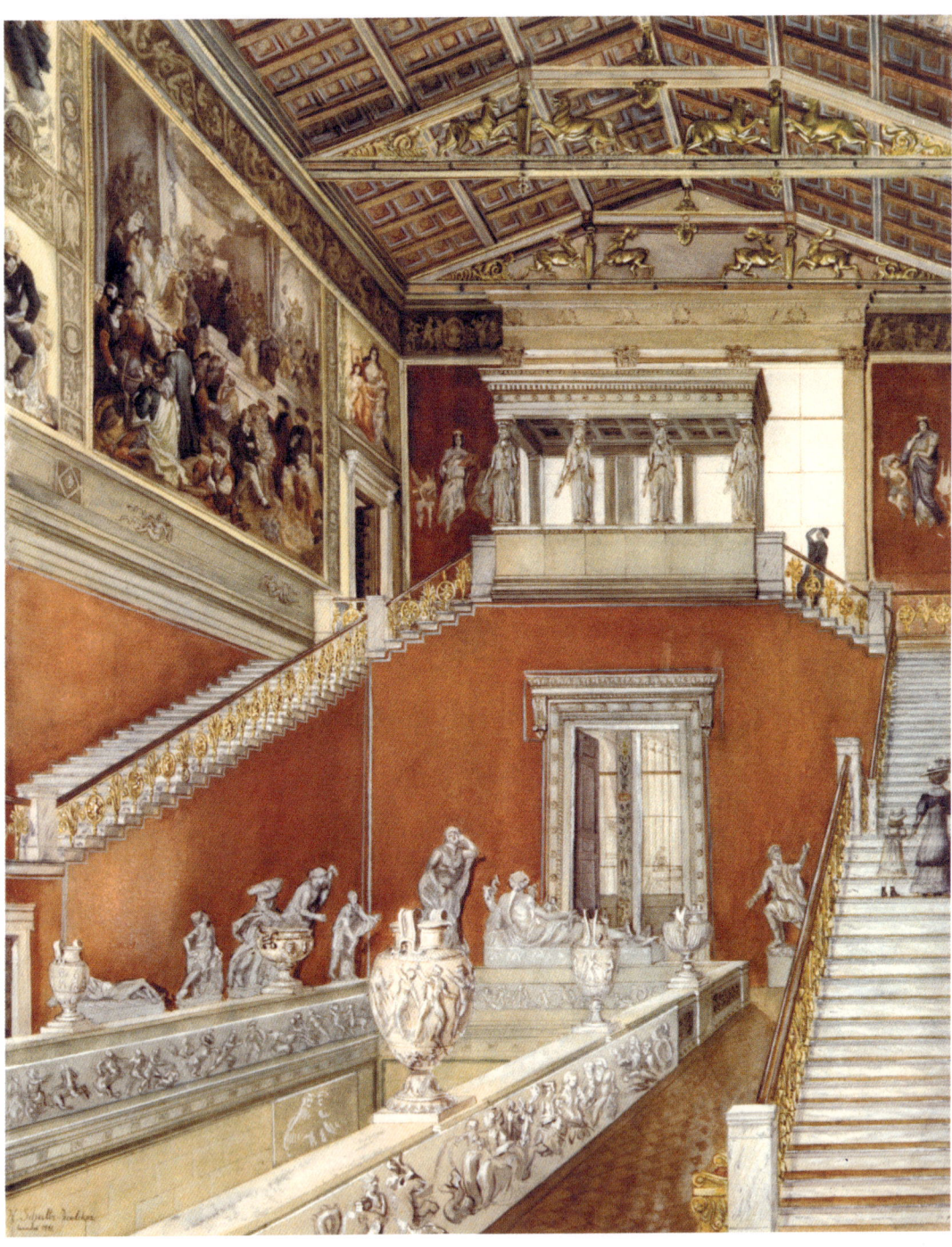

than classicist phenomenon. The Berlin academy collection served as an "umbilical cord, connecting Berlin to Rome and the present to the past."[20] Very differently, the diffusion of huge building fragments, made possible by new casting techniques invented in the mid-nineteenth century, was about connecting the past to the present.[21] Different from the architectural ornaments and details that were part of academy and school collections, these bigger reproductions were about change and history, rather than serving as models for emulation and architectural solutions. An expression of what Stephen Bann has termed the "historical-mindedness" of the nineteenth century, the architectural casts had little to do with notions of timeless beauty or universal standards.[22] The tradition of casting classical sculpture is centuries older than that of casting architecture, it survived longer, and it has been subject to much more scholarship. This book addresses the circulation of architecture specifically. It queries the way reproductions of building fragments resonate with nineteenth-century historical imaginations, within an intellectual horizon where full-scale architectural replicas were considered a powerful way of exhibiting architecture as a fundamental historical phenomenon.

Considering the scope of late nineteenth-century casting of architecture and the key role these objects played in shaping the architecture museum, surprisingly little is written on architectural cast culture. Placed within the emerging scholarly field of architecture exhibitions, *Plaster Monuments* draws on archival material, cast catalogues, and contemporary debates on these objects in the making, as well as contributions on individual monuments and specific collections. *Plaster Casts: Making, Collecting and Displaying from Classical Antiquity to the Present*, a 2010 volume edited by Rune Fredriksen and Eckart Marchand, an important milestone in the current reassessment of cast culture, includes a section on architecture. Recent decades have seen an uptick in the number of studies by curators and scholars—particularly those close to the Paris and London collections—among them Ian Jenkins, Christiane Pinatel, and Isabelle Flour. Contributions to the understanding of the architectural casts also appear in scholarship with different agendas, such as Michael Falser's work on the French mediation of monuments in Indochina, Can Bilsel's discussions of authenticity in regard to the Pergamon Altar, Jill Pearlman's work on the American Bauhaus legacy and Timothy M. Rohan's on Paul Rudolph, as well as Anne Middleton Wagner's observations on the Cour vitrée at the École des Beaux-Arts in a monograph on a French nineteenth-century sculptor. To date, scholarship focused specifically on architectural casts has appeared primarily in articles. Further, this book aligns itself with recent studies on the architectural object as historical artifact, reflecting complex temporalities. The plaster monuments sprang from a worldview based on the presumption that history could be conceived of as a "systematic whole, constituted by distinct and homogeneous epochs, each with a particular character and a distinct style," as Mari Hvattum aptly defines historicism.[23] Anne Bordeleau notes how, in the nineteenth century, architecture was "conceived against the temporal ground of a flowing history."[24] Such insights define a frame for the way these casts reflected changing ideas of the past, the present, and the future. This study of the power of reproductions shows how the increasing assortment of portable

Figure 5. Treppenhalle, Neues Museum, Berlin.

Figure 6.
Juxtaposing casts in London with deteriorating marbles in Athens. Photographs taken from scaffolding by the photographer Walter Hege, working for the German Archaeological Institute at Athens. "The Parthenon Frieze: Effects of a Century of Decay," *Illustrated London News*, May 18, 1926.

monuments formed tangible iterations of historical awareness—exposing architecture as epoch-bound and site-specific, relative to time and place.

The plaster monuments belonged to what Malcolm Baker has labeled a nineteenth-century "reproductional continuum."[25] Developing in parallel, architectural casting and photography met in complex interactions. The three-dimensional reproductions were photogenic and capable of taking the place of extant or extinct originals in surprising ways. When the British Egyptologist Flinders Petrie in the late 1880s published *Racial Photographs from the Egyptian Monuments*, he propelled 190 sepia photographs of stone carvings, mostly from the Theban Necropolis into circulation more than a decade before important casts from Luxor appeared in museums. However, the objects depicted in the photographs were actually casts, "therefore far clearer than if [taken] directly from stone."[26] What this suggests is that material authenticity might not be the best means to grasp the epistemology of monuments as cultural and historical artifacts. Further, it hints at the interrelationship of casting and photography at work in many of the collections discussed in this book. Seen as "complementary," casts could represent at full scale and in three dimensions what the scale-less medium of photography could only capture in two, and became "indispensable to the complete comprehension of an art fundamentally one of the sense of touch."[27]

The emphasis on sensation made the finishing of the casts critical. As we will see, the question of patina bristled with profound theoretical concerns insofar as the surface not only anchored the monument in time, but also prompted questions regarding the temporality of the plaster monument itself. Painted surfaces realized the assumed color schemes of ancient architecture and brought scholarly debates on polychromy to the attention of popular audiences. Another take on presumed original states resulted in assemblies of pristine white casts, heralding perfection as a property of the reproduction, while a third strategy was to imitate the current state of the weathered originals. The passion for truthful presentation was at the core of all these different takes on patina and surface, authenticity and history. Across collections, the casts' styles spanned a range from ahistorical abstraction to empirical documentation, bespeaking both idealized origins and deteriorating presences.

In this way, the casts showcased the intricate relations between ever-changing originals and their serialized reproductions. When in 1929 the *Illustrated London News* published "The Parthenon Frieze: Effects of a Century of Decay," new shots of the frieze in Athens were juxtaposed with the British Museum's casts made in 1802 (figure 6). The photographs documented drastic corrosion and revealed "how much the sculptures have suffered in the intervening period."[28] The casts had been made for Lord Elgin, the British ambassador to Constantinople, while he was assembling what was to become the eponymous collection of Parthenon marbles that the British Parliament secured for the British Museum in 1816. The readers in 1929, exposed to the frieze shot from a scaffold raised for the Greek archaeologist Nikolaos Balanos's restoration work, could hardly miss the point. The casts in London were clearly closer to the original than the eroded marbles in Athens. Yet if this piece of illustrated journalism rehearsed the moral justification of confiscation as conservation—an argument that has followed the Elgin Marbles through two

THE PARTHENON FRIEZE:
EFFECTS OF A CENTURY OF DECAY.

1. AS IT WAS IN 1801: A PLASTER CAST OF A FIGURE OF A WARRIOR LACING HIS SANDALS—A BAS-RELIEF IN THE FRIEZE OF THE PARTHENON. (DETAIL FROM NO. 11 ON PAGE 841.)

2. AS IT IS TO-DAY, BADLY DECAYED: A RECENT PHOTOGRAPH OF THE ORIGINAL BAS-RELIEF ON THE PARTHENON FROM WHICH THE CAST (IN NO. 1) WAS TAKEN. (DETAIL FROM NO. 12 ON PAGE 841.)

3. AS IT WAS IN 1801: ONE OF THE PLASTER CASTS MADE FOR LORD ELGIN FROM PART OF THE FRIEZE OF THE PARTHENON LEFT IN POSITION ON THE TEMPLE. (DETAIL FROM NO. 11 ON PAGE 841.)

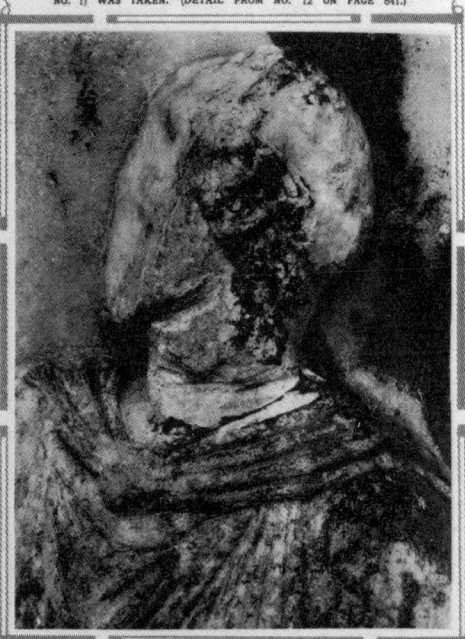

4. AS IT IS TO-DAY: THE ORIGINAL HEAD (FROM WHICH THE PLASTER CAST SEEN IN NO. 3 WAS MADE) RUINED BY EXPOSURE TO THE WEATHER. (DETAIL FROM NO. 12 ON PAGE 841.)

The illustrations on pages 840 and 841 show how those parts of the Parthenon frieze still left *in situ* on the temple have decayed during the last 128 years. The effects are made clear by the juxtaposition of plaster casts (now in the British Museum) made for Lord Elgin in 1801, and recent photographs of the original bas-reliefs from which the casts were taken. The above illustrations, which reveal the damage in greater detail, are enlarged sections of Nos. 11 and 12 on the double page. No. 1 above shows the head of the left-hand figure in the plaster cast seen in No. 11; while No. 2 above shows the head of the same figure in the original sculpture seen in No. 12. Similarly, Nos. 3 and 4 above bear the same relation to the central figure in Nos. 11 and 12. It may be recalled that in 1801 Lord Elgin, the British Ambassador to Turkey, obtained permission from the Sultan to remove some of the Parthenon sculptures, and took most of the metopes, the pediments, and the frieze. Their conveyance to England cost about £36,000. In 1816 they were bought by the British Government, and are in the British Museum. Lord Elgin thus saved most of the precious sculptures from the decay which, as our illustrations show, has since overtaken the remainder.

Figure 7.
Archibald Archer, *The Temporary Elgin Room*, the British Museum, 1819. Oil on canvas.

Figure 8.
Lawrence Alma-Tadema, *Phidias Showing the Frieze of the Parthenon to His Friends*, 1868. Oil on canvas.

centuries—the marbles were also imperiled within the presumed protective space of the museum at a time when most museums were heated by coal. No less controversial than Balanos's interventions on-site is the infamous event in conservation history that simultaneously took place at the British Museum. The art dealer Joseph Duveen wanted the Elgin Marbles' surfaces "restored" to a classicist white when installed in the new Duveen Gallery, leading to a cleansing process in 1937–38 that forever changed their patina.[29] A laboratory for understanding the fragments' lost totality and original architectural setting, the Parthenon galleries at the British Museum "remained a repository of casts," until a new "minimalist approach to museum display" demanded their removal.[30]

In fact, the monument that perhaps best captures the issues at play in the cast courts is the Parthenon, an edifice fluctuating on-site as well as in reproduction. Rarely has the evocative power of the architectural fragment been more lucidly encapsulated than by Antoine-Chrysôstome Quatremère de Quincy, reporting from the Temporary Elgin Room in 1818 (figure 7). In the 1790s, Quatremère had critiqued Napoleon's despoliation of masterpieces in conquered countries and portrayed the decontextualized artworks in Parisian museums as lifeless and imprisoned. It is surprising, then, that he should be the source of one of the most noteworthy reasons presented for the superiority of experiencing architecture in the museum. The Elgin Marbles were, by any measure, the result of profound disintegration—parts of the structural ornaments had even been cropped to facilitate transport to London. Quatremère, a specialist on Greek antiquity, had never been to Greece. Exposed to this apotheosis of Greek antiquity, he concluded that fragments assembled in a gallery offer a more genuine understanding than the building itself. "In a finished building, each sculptural object, seen in its place, loses some of its grandeur; considered together with everything that accompanies it, it can be examined only from one side and in one respect."[31] Whereas individual features drowned in the completed structure, the fragment in the museum drew the admiring eye to the painstaking execution of architectural details. By the power of the imagination, the relocated fragment could evoke otherwise ungraspable totalities.

These fragments-as-exhibits, then, provoked a temporal displacement, an imaginary time travel that propelled the observer back to their moment of creation and to the ateliers of the makers of the Parthenon. The resemblance between ruins and construction sites has fascinated architects throughout modernity. The twin nature of the ruin, says Stanislaus von Moos, implies "the past *as well* as the future, in short its contradictory relation to the course of time."[32] In the history of architecture, the occurrence of scaffolding marks newness and decline: ruination, restoration, and building. In the history of monuments, scaffolding offers privileged moments of close-up inspection, as captured in Lawrence Alma-Tadema's painting of Phidias showing Pericles, Socrates, and Alcibiades the fresh Parthenon frieze before the scaffolding was dismantled and the frieze would forever rest in shadow twelve meters above ground (figure 8). Reporting from a provisionary gallery at the construction site of the British Museum in Bloomsbury, Quatremère, among the Parthenon ruins, found himself "on the building site or even in the studio itself; you have your hands on the objects, they appear before you in their real dimensions,

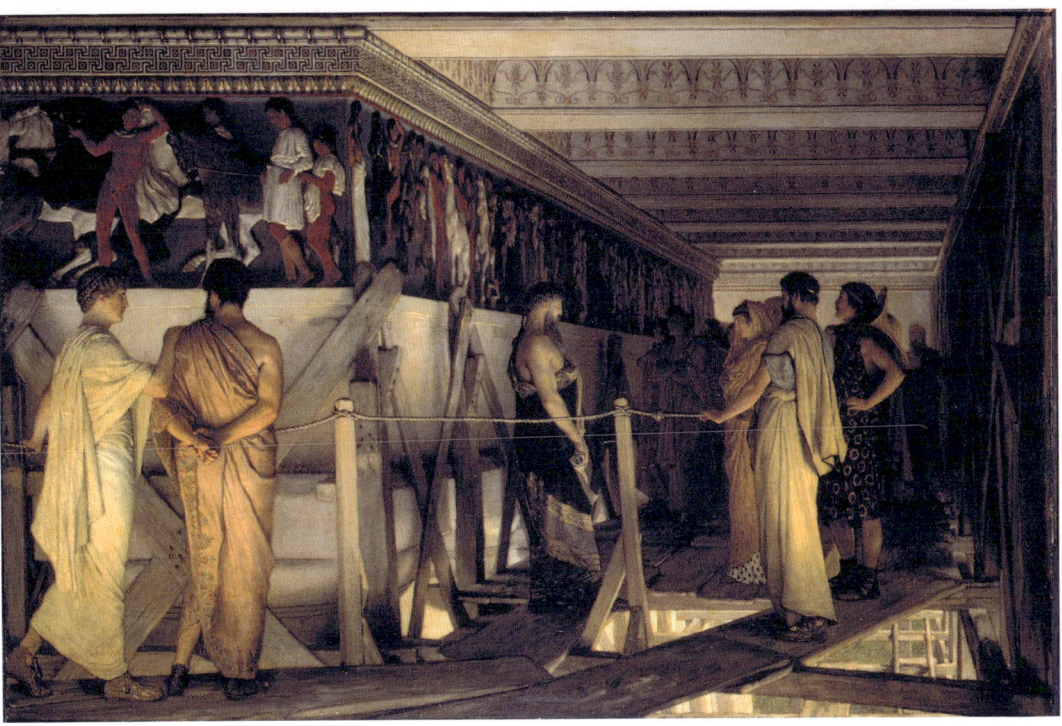

Figure 9.
The northwest corner of the Parthenon under construction in the Cour vitrée at the École des Beaux-Arts, Paris, mid-1860s.

you move around each of them."[33] Here, the imaginary ancient workshop and the modern museum fuse, presenting to the visitor an ancient, hyper-famous novelty. For the first time since the fifth century BCE, the fragments of the Parthenon were reclaimed for aesthetic appreciation, with the pediment sculptures placed on plinths and the frieze and metopes mounted at eye level.

Quatremère was talking about originals. More important than the distinction between copy and original, however, is the strikingly historicist perspective that emerges through the figure of the *pars pro toto*, a trope that became instrumental for the curating of history in plaster. The museum setting dissociated the fragments from an unachievable totality, revealing instead a work in the making (figure 9). Rather than displaying the remains of a timeless monument, the plaster Parthenon traveled

the world loaded with historical aspirations. Fragments evoked the lost building; their arrangement vivified the history of architecture. The casts created order from disorder by presenting coherent sequences of buildings "inevitably separated in reality," as the curator of the biggest Belgian collection of architectural reproductions put it in 1902. They served as "milestones" on the itinerary through history, during which the visitor would "unite in the mind" the totalities conjured by the fragments.[34]

Portable Monuments

"There are cathedrals one would like to place in museums," exclaimed Napoleon, according to Victor Hugo, when visiting the cathedral at Auch.[35] Still, architecture, owing to its physicality, site-specificity, and seemingly immovable presence appears inherently resistant to both displacement and display. "There are numerous antique monuments which cannot be dragged into museums—great architectural works whose meaning is so profoundly interwoven with the place where they were erected that removing them will cause serious loss," stated the founders of the Society for the Preservation of Norwegian Ancient Monuments in 1845.[36] The difficulties of curating architecture have been persistently rehearsed, not least by the pioneers in the field: "Buildings are made to remain fixed on the spot where they are originally erected, and are of such a scale that they cannot be collected together in any gallery, however large," according to James Fergusson, who compared the display of capitals, cornices, and architectural details to "a collection of fingers or toes of sculpture, or eyes or ears out of paintings."[37] Harald Hals, head of the planning department in Oslo and the curator of numerous architecture exhibitions, echoed this sentiment in his unrealized proposal for a Norwegian architecture museum in 1934: "A building is unsuitable as a museum exhibit. It cannot be moved around and be 'placed' like a piece of furniture, a painting, or a sculpture, and it is unreasonably space consuming. If several buildings were to form a collection, it would soon expand beyond every thinkable border."[38]

Yet architecture travels, and not only through mediations. Marcel Breuer's House in the Garden at the Museum of Modern Art in 1949 is described by Barry Bergdoll as "one of the most influential of all exhibitions mounted by the Museum in its more than seventy-five years of exhibiting architecture."[39] In the 1960s, Cold War geopolitics and the construction of the Aswan High Dam turned a number of so-called surplus temples into portable exhibits: at the Metropolitan, the Roman era Nubian Temple of Dendur was in 1978 euphemistically labeled "a gift from Egypt" and encased in a mammoth glass vitrine to be admired also from Central Park.[40] Since 2000, two prototypes of Jean Prouvé's Maisons Tropicales, lifted from Brazzaville, Congo, and Niamey, Niger, have been circulating through auction houses, museums, and cities on two continents.[41] Inclined toward the singular rather than the typical, these examples share with the open-air museum's assemblies of vernacular buildings the desire to stage authenticity despite decontextualization in time, place, and function.

The plaster monuments posed different claims to authenticity. They were conceived within a paradigm that believed in the value of reproductions and assumed that "*true* copies" would bring masterworks "fully within the reach of all as printing does good books."[42] They were authorized and authored by *formatori*, skilled artisans who would ideally make the molds from the original as part of the authentication process of the plaster monument. Ghiberti's doors should be purchased from Florence, the Pergamon slabs from Berlin. Otherwise, authenticity was rarely a problem. The subsequent displays of the Pergamon Altar in Berlin, combining marbles and plaster casts, "demonstrated that authenticity could lie in the architectural experiences (however theatrical) newly constructed inside the museum rather than in concrete referents outside of it," as Wallis Miller asserts.[43] At the relocated Crystal Palace at Sydenham, the ten architecture courts inaugurated in 1854 made the earliest and most ambitious attempt to display a progressive history of architecture in plaster monuments, recording "the rise, progress, and fall of mighty kingdoms, whose monuments are reproduced within its walls."[44] Here, concerns about "the inauthenticity of plaster" were addressed only in terms of its "supposedly inauthentic new audience," as Kate Nichols has shown.[45] Also in the case of reproductions of monuments where the manipulation of the subject matter was substantial, authenticity was part of the effect of the displayed objects. For the French casts from Angkor Wat, the "so-called authenticity of these often deceptive reconstructions" was supported by "the faithfulness usually granted to the plaster cast medium," according to Isabelle Flour.[46]

"Buildings could not travel, so people had to," writes Mario Carpo when discussing how the invention of print allowed for "a new availability of trustworthy, portable, and inexpensive printed images of architecture."[47] In many respects, the traveling monuments belong to this tradition. As full-size image-objects they acted as space-time complexes, replacing the grand tour for those who could not trek through Europe and experience the monuments firsthand. "The few who travel much fail to remember that the masses of the people travel but little," Andrew Carnegie mused at the 1893 World's Columbian Exposition where casts from the Trocadéro were exhibited.[48] "If they cannot go to the objects which allure people abroad, we shall do the best to bring the rarest of those objects to them at home," he pledged, assuring his fellow Pittsburghers that they could safely pursue their workaday lives while enjoying "some of the pleasures and benefits of travel abroad."[49]

Yet the idea of the cast courts as a surrogate for the grand tour sprang from the very core of elitist grand tour culture. While creating his home museum, John Soane was in 1812 fantasizing about what posterity would make of his plaster heaven at Lincoln's Inn Fields: "It is difficult to determine for what purposes such a strange and mixed assemblage of ancient works or rather copies of [cast from] them, for many are not of stone or marble, have been brought together—some have suggested that it might have been to the advancement of Architectural knowledge by making the young Students in that noble & useful Art who had no means of visiting Greece and Italy some better ideas of ancient Works than would be conveyed thro: the medium of drawings or prints."[50] Similarly, the Architectural Museum in London was established to give "art-workmen

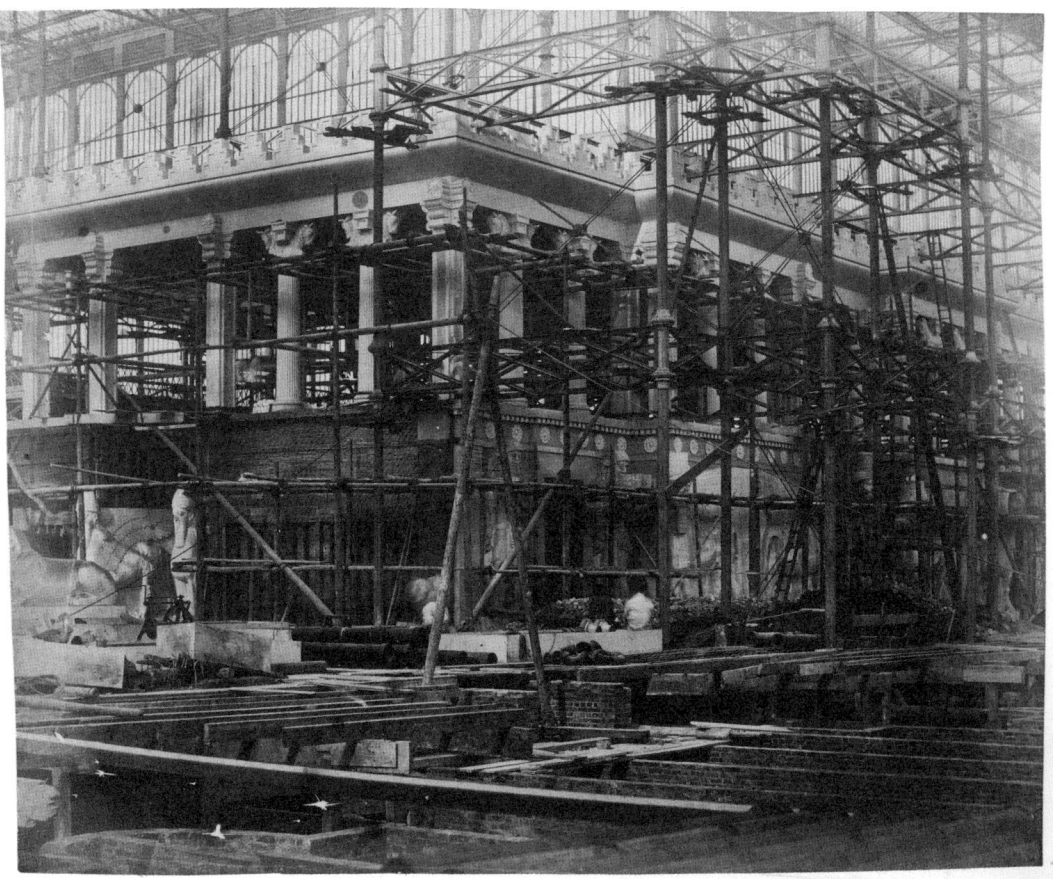

an opportunity of studying reproductions of works, the originals of which neither their time nor means would allow them to visit."⁵¹ Metaphors of traveling also pertained to the portable monuments at Sydenham, offering a virtual grand tour into what had hitherto been "unattainable, except by laborious foreign travel," and an architectural experience in which tourists could effortlessly inspect the most celebrated buildings in the world.⁵²

Figure 10.
Assyria under construction. From Philip H. Delamotte, *Photographic Views of the Progress of the Crystal Palace, Sydenham. Taken during the progress of the works, by desire of the directors* (London, 1855).

Antiquities as Novelties

During the summer of 1847, while preparing for his return to England, Austen Henry Layard mused melancholically that the "ruins of Nimroud had been again covered up, and its palaces were once more hidden from the eye." Looking back at years of excavations, he could at least feel some satisfaction: "Scarcely a year before, with the exception of the ruins of Khorsabad, not one Assyrian monument had been known."⁵³ After having been "buried for nearly twenty-five centuries beneath a vast accumulation of earth and rubbish," the unearthed bits of the temple-palaces became contemporary sensations.⁵⁴ In 1852, the Nineveh gallery opened at the British Museum, and two years later the Assyrian court premiered at Sydenham (figure 10).⁵⁵ This plaster assembly turned an archaeological

Figure 11.
Pergamon casts offered from the firm Gebrüder Micheli, Berlin. From *LVI. Ausstellung der Königlichen Akademie der Künste zu Berlin*, 1883.

contemporaneity into an imaginary architectural totality: "The court is not a complete restauration of any particular Assyrian building. It has been the endeavor to convey to the spectator as exact an idea as possible of Assyrian architecture," Nineveh's excavator explained in the handbook to the Assyrian court.[56] The Crystal Palace popularized archaeology and antiquity, presenting history in the making. Up to two million visitors yearly promenaded through space and time, immersed in environments that oscillated between archaeological accuracy and atmospheric imagination.

The German excavations at Pergamon provide another illustration of the proximity between archaeology and casting. According to Alina Payne, the find sent "the whole archeology and art history world into shock," by turning "the received aesthetic of the Greek Winckelmannian ideal" upside down.[57] One person affected by this shock was the American critic Charles Callahan Perkins, who in 1881 reported on the first public display at Schinkel's Altes Museum of the fragments that had arrived in Berlin two years earlier, and that were later constructed and exhibited as the Pergamon Altar. His article was generously illustrated with plans, reconstructions, and details.[58] Yet, realizing that the Pergamon marbles relied on spatial effects inevitably lost in two-dimensional representation, he announced his urgent longing "for the day when we shall see casts from them added to the collections of Art Museums in America."[59] His wish was soon fulfilled, and the Pergamon casts made their triumphant way even to smaller American towns. In 1899, for instance, the popular panel showing the goddess Athena fighting a giant was in place at the Horace Smith Collection in Springfield, Massachusetts, where it is today accompanied by a rare wall label verifying its origin: "Plaster cast by the Formerei der Kgl. Museen, Berlin, Germany"[60] (figure 11). Both the British excavations in Halicarnassus in the 1860s and the German archaeological mission at Pergamon resulted in the appearance of long-lost, brand-new Hellenistic monuments. Slabs from the Amazonomachy frieze from Halicarnassus and the Gigantomachy frieze from Pergamon could elucidate the transition between Greek and Roman antiquity in galleries across the Western world. Just as the Parthenon and the Mausoleum of Halicarnassus were catapulted out of London and into an international orbit of exhibition, the circulating Pergamon casts originated in Berlin.

A key initiative in this distribution of monuments was the Convention for promoting universally Reproductions of Works of Art for the benefit of Museums of all Countries. During the 1867 Exposition universelle in Paris, Henry Cole, director at the South Kensington Museum, had fifteen European princes confirm "their desire to promote" the production and exchange of national monuments. Practical and procedural, global in scope, brief in phrasing, and aiming at immediate action, this visionary document theorized plaster monuments as an architectural mass medium, as rapidly developing reproductive technologies allowed for the dissemination of architecture on an unprecedented scale (figure 12).

In encouraging the serialization of monuments, the Convention looked to the future as well as to the past. The envisioned flow of reproductions would not only present the progress of art; it would constitute a source for future artistic production. As importantly, the Convention consolidated national pasts by recommending that each country select

CONVENTION

FOR PROMOTING UNIVERSALLY REPRODUCTIONS OF WORKS OF ART FOR THE BENEFIT OF MUSEUMS OF ALL COUNTRIES.

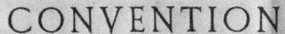

Throughout the world every country possesses fine Historical Monuments of Art of its own, which can easily be reproduced by Casts, Electrotypes, Photographs, and other processes, without the slightest damage to the originals.

(*a*) The knowledge of such monuments is necessary to the progress of Art, and the reproductions of them would be of a high value to all Museums for public instruction.

(*b*) The commencement of a system of reproducing Works of Art has been made by the South Kensington Museum, and illustrations of it are now exhibited in the British Section of the Paris Exhibition, where may be seen specimens of French, Indian, Spanish, Portuguese, German, Swiss, Russian, Hindoo, Celtic, and English art.

(*c*) The following outline of operations is suggested:

I. Each country to form its own Commission according to its own views for obtaining such reproductions as it may desire for its own Museums.

II. The Commissions of each Country to correspond with one another and send information of what reproductions each causes to be made, so that every Country, if disposed, may take advantage of the labours of other Countries at a moderate cost.

III. Each Country to arrange for making exchanges of objects which it desires.

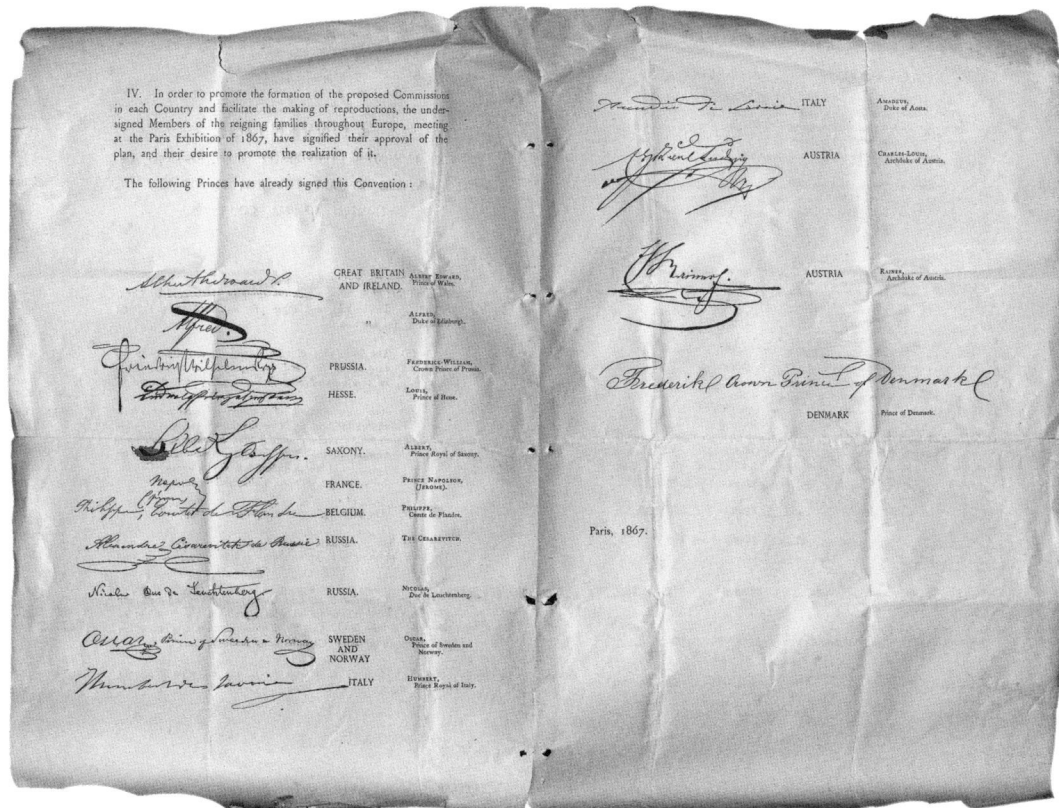

Figure 12.
Convention for promoting universally Reproductions of Works of Art for the benefit of Museums of all Countries, 1867. Norwegian original copy.

its most venerable "historical monuments" to be duplicated. This idea of codifying historical monuments with an eye to potential reproductions highlights the reciprocity between canonization and mediation. When nations catalogued their heritage, canonization became both invention and reinvention. Detached from their place of origin, important buildings were made movable representatives of a national past. Recommendations were given for the formation of national commissions to establish procedures for the exchange of desired objects between museums, and members were advised to correspond closely to "take the advantage of the labours of other Countries at a moderate cost."

A version of such an imaginary museum was demonstrated at the British section in the 1867 Paris Exposition universelle, showing "specimens of French, Italian, Spanish, Portuguese, German, Swiss, Russian, Hindoo, Celtic, and English Art." Massively augmented, this collection was in 1873 installed in the two new Architectural Courts at the South Kensington Museum—in 1899 renamed the Victoria and Albert Museum. The courts' dimensions were determined by the width of the three-arched Portico de la Gloria, cast on-site in the mid-1860s at the cathedral at Santiago de Compostela, and the half-height of Trajan's Column—cast in its totality from a mold commissioned by Napoleon III and made in Rome in 1864—installed in two pieces to fit under the skylight.[61] In all their variety, the eclectic collection at South Kensington and the display of French monuments at the Trocadéro remained the primary references for most cast courts planned over the next decades.

Cole's will-to-circulation sparked a proliferation of new plaster monuments. Yet his optimistic belief that casting would not cause damage to the originals was soon disputed. Acknowledging how molding injured the colors and patina of artifacts, many museums banned the making of new casts from their treasures. By the 1890s, the Assyrian casts formerly sold out of the British Museum had become rare and were much in demand. Today the extant plaster monuments cast in nineteenth-century molds have become irreproducible originals in their own right.

Reassessing a Space in Time

Plaster might, as Goethe claimed, lack the magic of marble and appear "chalky and dead." But Goethe could also appreciate the particular magic of a fresh cast. "What a joy it is to enter a caster's workshop and watch the exquisite limbs of the statues coming out of the molds one after the other," he enthused while roaming the workshops of Roman *formatori* in the 1780s.[62] Over time, connotations of dust and death have outlived dreams of freshness and birth. "Plaster casts. The words carry an apologetic sibilance, and the associations are terrible: cheap reproductions, broken legs," wrote art critic Calvin Tomkins in a 1986 piece entitled "Gods and Heroes," portraying the Laocoön as tennis player John McEnroe's classical alter ego.[63] The parallel between the desperately struggling Trojan priest and the notoriously ill-tempered athlete had a local and clearly metonymical purpose. In 1986 the US Open took place in Queens, New York, not far from the Queens Museum where the Laocoön and other casts from the Metropolitan's storerooms were reintroduced

into public space. While the show *The Heroic Spirit: Classical Sculpture from Ancient Greece to Michelangelo* marked an early reappreciation of the remnants of nineteenth-century cast culture, Tomkins's article also afforded an interesting glimpse behind the scenes, revealing the Metropolitan's storage spaces that pitilessly reflected the sudden undesirability of these former objects of desire. More recently, French casts made from temples in Indochina from the 1860s onward were found "covered in poisonous mushrooms and dissolving back into powder," and were painstakingly restored before being exhibited in Paris in 2013.[64]

Slowly recirculating, and even traded, these discarded objects draw us back to a time when casts merited scholarship, money, and pride. In 1822, a set of the Parthenon casts made in Athens in 1802 was offered to "the lovers of Antique, Architects, and Others" at Christie's in London.[65] The auction announcement spurred debate among a civic-spirited London elite of "patrons and professors of architecture," and it was suggested that the British Museum should aquire them and make them "a nucleus for one of the most splendid architectural museums of which the world can boast."[66] In 2006, panels from Ghiberti's doors and reliefs from the Pergamon Altar were among the works offered at Sotheby's in New York (figure 13). Appearing at Christie's in London in 2012, they were identified by provenance as well as authorship. Credited "Historic plaster cast from the Metropolitan Museum of Art, New York," lot 136, "Twelve sections from the Parthenon Frieze after the antique attributed to D. Brucciani & Co., probably late 19th early 20th century," fetched £67,250. Domenico Brucciani—whose business was renamed D. Brucciani & Co. after he passed away in 1880—was the master plaster caster for both the British Museum and the South Kensington Museum, selling casts from a gallery in Covent Garden and from constantly updated sales catalogues. In 2014, other Brucciani Parthenon casts changed hands at the "Forever Chic" auction at Christie's in New York, yet another event symptomatic of the current reevaluation of nineteenth-century casts.

"As the trend away from theory's abstraction has moved the tectonic plates of research more and more towards materiality, so has its manifestation in 'things' attracted greater interest," states Alina Payne.[67] Yet the theoretical backdrop that enables the current reassessment of objects, buildings, and spaces is also a more particular one. The destabilization of the original/copy dichotomy has meandered from the realm of texts to a wide territory of objects. In lieu of ideas of permanence, origins, and authenticity, we are witnessing a new sensitivity concerning how objects behave, change, move, work, and fluctuate in time and space. The plaster monuments hint at a substitutional paradigm, resembling early modern practices explored by Christopher S. Wood, when "copying was the normal way to make new things," and when the meaning of an artifact was found and preserved "across a chain of mutually substitutable artifacts," rather than by the authority of historical origins and first versions.[68]

Reproductions are not only part of the works from which they are derived, but artifacts that in their own right warrant inclusion in the history of art and architecture. "No copies, no originals," write Bruno Latour and Adam Lowe when proposing how a work's aura might migrate from a corrupted original to contemporary high-end facsimiles. "To stamp a piece with the mark of originality requires the huge pressure that only

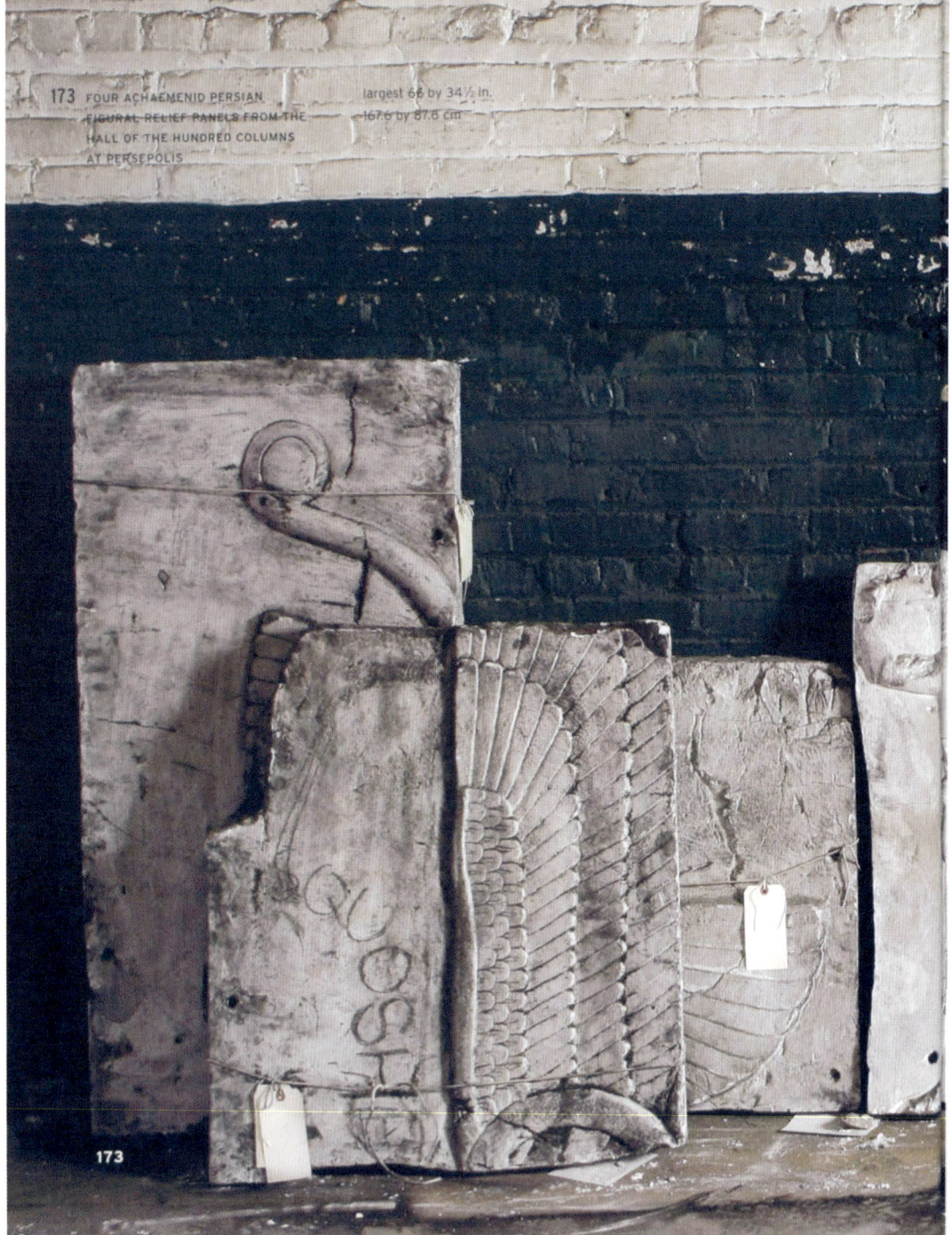

173 FOUR ACHAEMENID PERSIAN FIGURAL RELIEF PANELS FROM THE HALL OF THE HUNDRED COLUMNS AT PERSEPOLIS

largest 66 by 34½ in.
167.6 by 87.6 cm

a great number of reproductions can provide."⁶⁹ This book aims at showing how the architectural casts belonged to value systems that were obscured when the casts were deemed obsolete, and how they kept historical structures alive for new audiences, while defining their original monuments as, precisely, originals.

From the extant cast collections, and in the traces of the lost ones, emerges a "history of things," George Kubler's 1960s coinage. Kubler was interested in reuniting "ideas and objects under the rubric of visual form." Products of scientific aspiration, historical imagination, and aesthetic appreciation, the architectural casts reflected empirical preconditions and theoretical speculation. This history of things included "both artifacts and works of art, both replicas and unique examples, both tools and expressions," and, as Kubler beautifully put it, "From all these things a shape in time emerges." The monuments and documents surviving from nineteenth-century cast culture testify to the intellectual culture that formed their transient habitats, appearing as a Kublerian shape in time of their own, as conflations of ideas and objects expressed in visual form. The replicated monuments appearing in this account are of a far more concrete kind than the ones that Kubler saw flowing through a global history in formal sequences. The time span in question—a few decades at the turn of the twentieth century—is but a brief moment compared to Kubler's vast durations, and while he found that "the notion of style has no more mesh than wrapping paper and storage boxes," style formed a solid subject matter in nineteenth-century cast culture. Still, the complex handing down of "things of great generative powers, in the category of the Parthenon, or of the portal statues at Reims," informed the desires and dreams of the architectural cast industry before it faded into obscurity. In retrospect, the exploration of history through plaster monuments emerges exactly as a cultural "self-image reflected in things"—a portrait given to posterity.⁷⁰

Plaster Monuments anatomizes various monuments, documents, collections, and episodes in the history of architectural casts, objects produced and distributed within a historicist worldview preoccupied with totalities, invention, and perfection. Its main aim is to illuminate the ways the plaster monuments worked, or were meant to work. It draws on archives in London, New York, Pittsburgh, New Haven, Oslo, and Bergen; on extant or reinstalled collections in London, Paris, Pittsburgh, Rome, Copenhagen, Basel, New Haven, and Norwich, Connecticut, as well as casts in storage at the Victoria and Albert Museum, the British Museum, the Royal Museum of Fine Arts in Brussels, and the Museum of Cultural History in Oslo.

The first chapter anchors the itinerant monument within the context of the architecture museum, spanning a range of curatorial ideals from the atmospheric and picturesque to the scientific. It begins with the Temple of Castor and Pollux, a monument quintessential to European grand tour culture, serving various purposes in its travels across media, scale, and temporalities—from ruined fragments to reimagined perfection. But if monuments traveled, visionary plaster curators also did. The itinerary of the grand tour into the "province of reproductions" that the archaeologist Edward Robinson embarked on in the summer of 1891 provides a unique overview of European cast culture, its main institutions and protagonists.

Figure 13. Achaemenid Persian relief panels from the Hall of a Hundred Columns at Persepolis in storage. From Sotheby's catalogue *Historic Plaster Casts from the Metropolitan Museum of Art, New York*. Auction, February 28, 2006.

Commissioned to make the collection at the Metropolitan Museum of Art number one in the world, he aimed at compiling an assortment of monuments that would draw European scholars "to New York as they now go to Rome, Athens, or the other great centers of the study of art."[71]

Marcel Proust did not share his contemporaries' increasing distaste for plaster. Taking *In Search of Lost Time* as a point of departure, chapter 2 shows that the monument's irreducible particular does not reside in its material authenticity. Rehearsing the supposition that architecture is best appreciated in the museum, Proust's portrayal of the relation of a deteriorating original outside curatorial control and a perfect reproduction mirrors the early historical, scientific, and aesthetic objectives of the Musée de sculpture comparée. Further, Proust's thinking on reproduction challenges the notions of aura developed by his German translator Walter Benjamin, inspired by the theories of origins and patina that were realized in displays at the Trocadéro.

Chapter 3 considers the ordering of history that the plaster monuments promised. To be sure, the efforts to create a continuous historical space were constantly undermined by the sheer size and immovability of the objects when they were installed in the galleries—frustrating curators and confusing the audience. The only place where order could be attained was in the catalogue, which in many cases became the collection's ideal paper version. This chapter explores a world where galleries were edited and catalogues curated in an attempt to fix in place the monuments that soon proved just as unruly as architecture outside the museum. Still, if the shaping of perfect chronological trajectories proved utopian, their plaster counterparts enhanced the monuments in situ. The Norwegian stave churches provide one example of architectural structures that were designated as monuments—serialized on paper and in plaster—at the very moment that their originals were being destroyed.

Even before the museum had opened, a critic warned that the hasty assembly of architectural casts at the Carnegie Museum might result in "the most conventional of ready-made collections."[72] In hindsight, it is precisely this ready-made quality that makes the Hall of Architecture so captivating, reflecting the decreasing supply of casts at the time of its making, when molds were worn out, staples were out of stock, and new legislation prevented the making of additional molds. Chapter 4 takes the Carnegie collection as a prism to refract the mundane factors involved in the making of a collection of plaster monuments, including the effort to ship these enormous fragments across half the world.

The final chapter analyzes the cast collection established at the Yale School of Fine Arts in the 1860s. The Yale collection offers an extraordinary case study of how historicism rubs against modernism, and of the rupture of Beaux-Arts and Bauhaus teaching. The surprise here is not so much that it was Bauhaus instructor Josef Albers who destroyed Yale's collection. Rather, what is startling is that Paul Rudolph, who came across the survivors of Albers's exorcism while designing the Art and Architecture Building in the early 1960s, mounted these objets trouvés throughout the school, repurposing them as projective instruments—pointing to the future. Promoting the unfulfilled potentials of the Beaux-Arts, Rudolph deprived the casts of their chronological and pedagogical intentions, awakening polychronic effects in a brutalist structure while

echoing picturesque displays and prechronological interests in the plaster monuments.

Finally, the coda elaborates on the dismantling of the cast collections and discusses their present-day, budding reevaluation—not only as rare objects but as entanglements of theory, materiality, and history. As such, it suggests continuities between nineteenth-century cast culture and contemporary reproductions in new media that give voice to artifacts of the past, for the future.

The contemporary observer's response to a plaster monument differs from, say, that of Proust's Marcel at the turn of the twentieth century. When looking at different editions of casts, we see neither a perfect reproduction salvaged from the destructive work of time, nor a replica documenting a monument at a particular moment, but irreproducible historical objects, impregnated with age value. The remnants of nineteenth-century cast culture interrogate concepts of originality, authenticity, and authorship, forcing a reconsideration of received ideas of monuments and permanence. The idea of the precious original, the tenacious cult of authenticity, the obsession with indigenous materiality, the modernist ideology of honesty, and essentialist conceptions of site-specificity are all challenged by the historical patina of the traveling monument. The material banality of the plaster monument presents to us the enormous effort involved in their production as well as their profound historicity.

Chapter 1

Travels in the Province of Reproductions

Figure 14.
Henry Parke, *Student Surveying the Temple of Jupiter Stator at Rome*, 1801, watercolor. Sir John Soane's Museum, London.

A watercolor from the early nineteenth century depicts a British gentleman impeccably dressed in a gray frock coat, beige breeches, white stockings, delicate black shoes, and a top hat. Holding a rod, he is balancing high up on a simple ladder leaning against an enormous architectural structure. The image portrays a sumptuous capital of the Corinthian order, parts of a lavish entablature, and the upper portion of a fluted column. No indication is given as to the length of the ladder, but the ground, unseen, lies far below. The endeavor was certainly a thrill at a time when ascending monuments was considered a dangerous enterprise. In 1770 a student was reported to have died after falling from a ladder while measuring another monument at the Roman Forum.[1] The grand tourist architect, completely dwarfed by the capital he is about to measure, puts his life at risk to get the perfect close-up of the monument (figure 14).

This watercolor, *Student Surveying the Temple of Jupiter Stator at Rome*, may be autobiographical. Professor John Soane commissioned his student Henry Parke to create the work, which Soane used in the series of six annual lectures he gave at the Royal Academy in London between 1810 and 1820. Very much like the flood of digitalized images presented to students in architecture schools today, the lectures' illustrative materials included more than a thousand images altogether, hundreds of them made by Soane himself. Among those who assisted in presenting the drawings to the students during class were Soane's friend and colleague at the Royal Academy, the painter Joseph Mallord William Turner.[2]

Parke's watercolor, which portrayed the Temple of Castor and Pollux in the Roman Forum, belonged to the second lecture, devoted to the classical orders of architecture. While noting that many were "lost in silent admiration of its uncommon beauties," Soane himself was unusually stirred when discussing the temple ruin. It is "most sublime and awfully grand

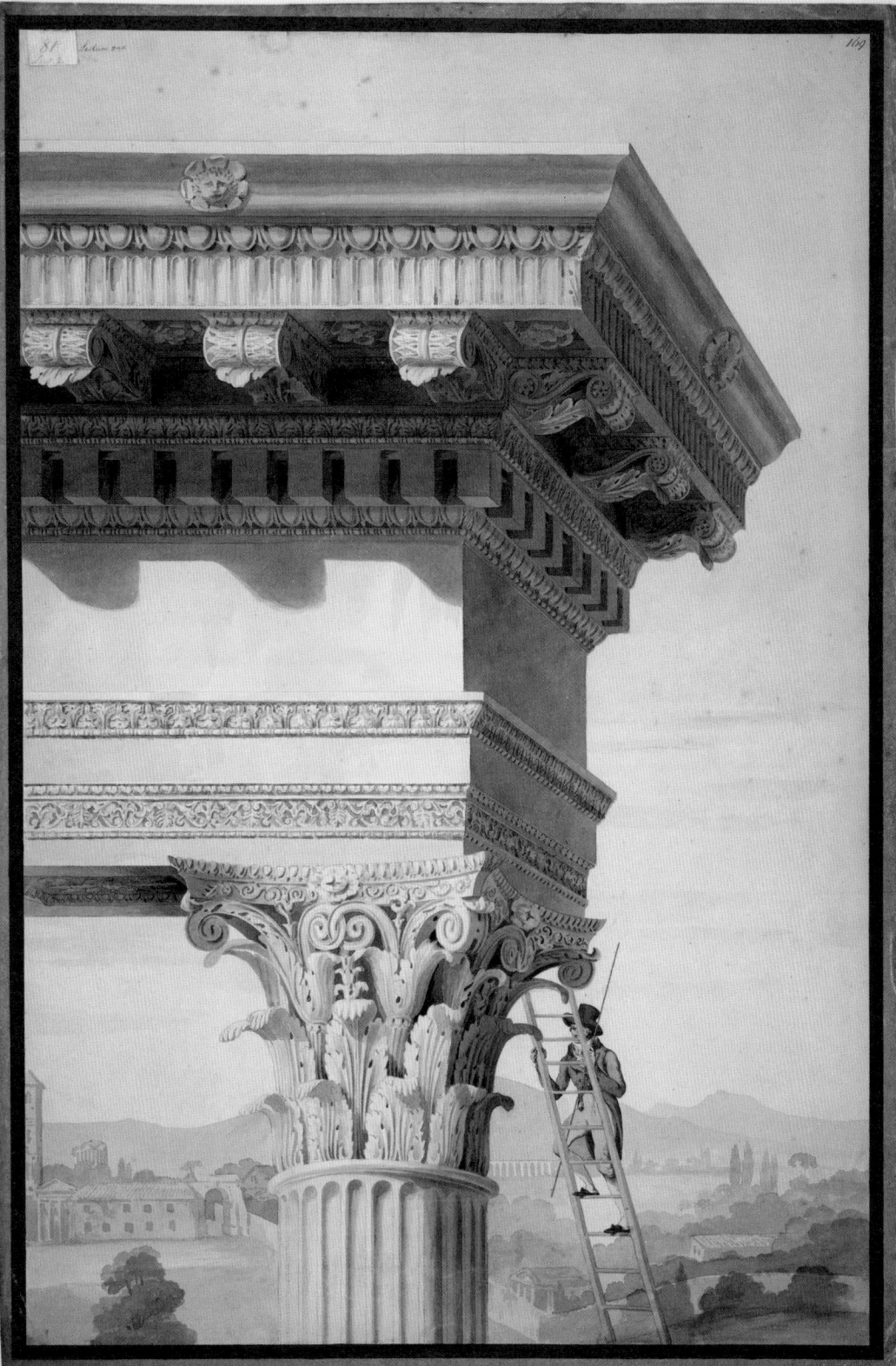

Figure 15.
Giovanni Battista Piranesi, *Veduta di Campo Vaccino*, 1775. Etching.

and impressive," he rhapsodized, "whether we consider the excellence of the execution, the largeness of its general parts, the uncommon taste and elegance in the various enrichments," or its extraordinary effect of light and shadow.[3] Excellence, magnitude, enrichment of detail, and the play of light and shadow are qualities highlighted in Parke's illustration. Soane, who had made several sketches and drawings of the temple on his grand tour in 1778–80, described the effect of its details as "uncommonly beautiful." It "cannot be sufficiently admired," the professor told the audience of up to six hundred students and other visitors. "All lovers of art must regret its buried and dilapidated state," lamented the otherwise passionate ruin aficionado. Parke's drawing reconstructed for Soane's students a portion of the structure resurrected to an imagined pristine state. Fresh, direct from Rome, the reconstruction idealized the ruin's physiognomy and fictionalized the environment in which it sits. Towering over a park-like landscape with a few scattered vernacular buildings and an aqueduct at the foot of distant, soft hills, the temple portrayed in the image gives no hint of the busy excavations of the Roman Forum that had intensified since the 1770s.[4] At the time Parke made this drawing, excavations of the foundations of the largest temple columns at the Forum were beginning to reveal the full extent of the remnants of the fifty-foot-tall structure in Carrara marble.

Not even a dedicated lecture could do justice to the noble beauty of the entire composition, said Soane, and the students were encouraged to study the monument in depth and in various media at his home at Lincoln's Inn Fields, before and after the lecture. In fact, his collection included more plaster casts of this temple than of any other building, from the first three casts he had purchased at an auction at Christie's in London in 1801 to the last five, which he acquired in 1834 at the age of eighty. Altogether, twenty-one casts of the Temple of Castor and Pollux were dispersed throughout his house.[5] Drawings, paintings, and engravings, depicting both the casts as mounted in the house and the ruin in Rome, in different states and temporalities, were part of his collection as well. Before enrolling at the Royal Academy in the early 1770s, the young Soane, an intern at architect George Dance's office, was familiar with the full-scale cast of the entablature that Dance had bought in Rome in the 1760s, during his grand tour, when the monument was covered in scaffolding owing to restoration work. This was an attractive state in which to find a monument, enabling close-up study and providing rare opportunities to measure, draw, or have molds made of antique ruins, without resort to precarious ladders. Giovanni Battista Piranesi was among those who climbed the monument in 1760, and several of his versions of the temple were part of Soane's collection of engravings (figure 15). The two large casts of the capital and cornice form central components in Joseph Michael Gandy's watercolors of Soane's interiors (figure 16).[6] Soane also possessed two scale models of the ruin, one in cork and one in plaster. The porous medium of the first realistically captured the crumbling quality of the ancient marble monument (figure 17). Cased in glass and mounted on a wooden base with a plaque identifying it as "Model of three columns of the Temple of Castor in the Forum—Rome," the latter was placed on the mantel over the fireplace in Soane's library, where it is still one of the first objects to meet the visitor's eye (figure 18).[7] Serving as a *mise en abyme*

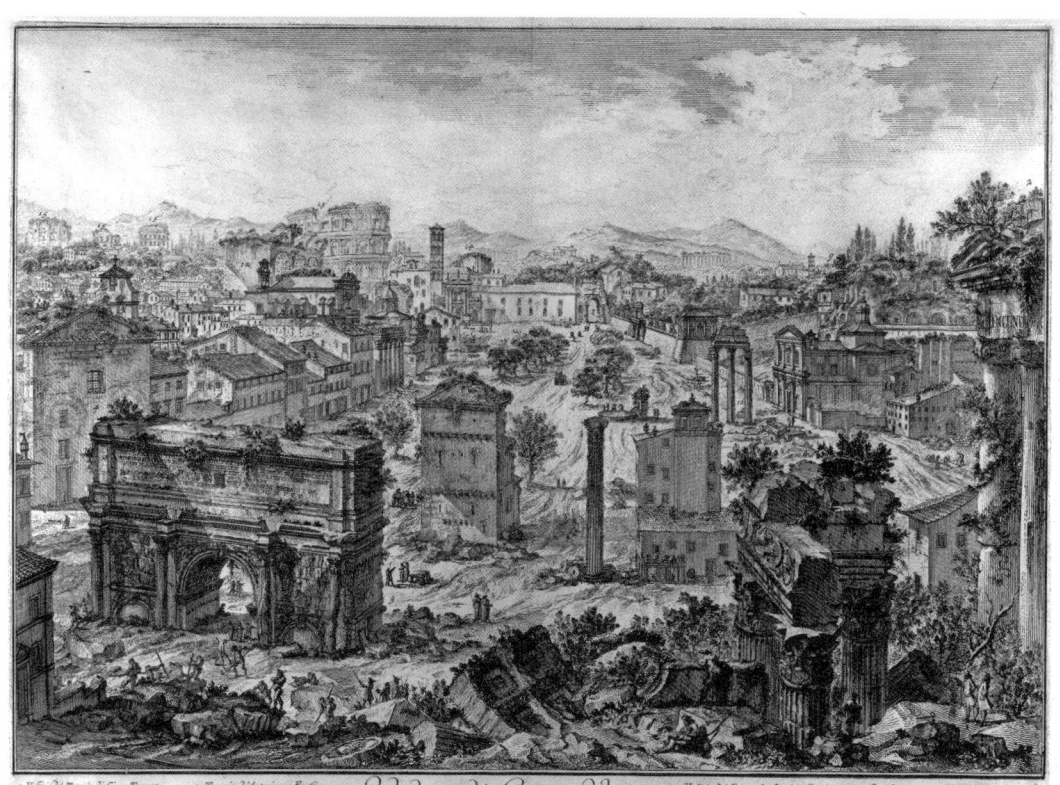

this reconstructed plaster miniature introduces the Temple of Castor and Pollux fluctuating in media and materiality, scale and temporality, to be encountered repeatedly in the labyrinthine milieu of the house, which became a national museum in 1837 by Sir John Soane's bequest. On a grander scale it points toward the trajectory of this multimedia traveling monument. Together, this scale model, the many casts, and Henry Parke's watercolor anticipate the phantasmagorical perfection of the enormous plaster monument that was built in the Cour vitrée at the École des Beaux-Arts in Paris in the mid-1870s. Further, they point toward a substantial chapter in the history of museums of architecture that aimed at presenting architectural monuments with as much fidelity as possible to the real thing, according to different ideals of history and by means of reproductions. In the pages that follow, I show how monuments traveled in space, time, and media, and how visionary curators traveled to collect the matter that could show architecture as history, in the gallery.

Figure 16, opposite left. Joseph Michael Gandy, *View of the Dome Area Looking East*, 1811. Watercolor. Sir John Soane's Museum, London.

Figure 17, opposite right. Castor and Pollux colonnade, cork model. Sir John Soane's Museum, London.

Figure 18, above. Scale model in plaster on mantel over the fireplace in the dining room and library. Sir John Soane's Museum, London.

Architecture Museums

In its breathtaking idiosyncrasy Sir John Soane's Museum remains a singular case. It is a world of its own—an irreproducible, baffling commingling of originals and reproductions. Soane preferred to think of his house as a "union of the arts."[8] Nonetheless, together with two other enterprises formed by the visions of one man, it belongs to the history of the architecture museum. All articulated the past in immersive experiences according to distinct aesthetic and curatorial strategies, and form particular modern vantage points from which to apprehend architecture as a profoundly historical phenomenon.

The Museum of French Monuments displayed architectural objects salvaged from the vandalism of the French Revolution in the abandoned early seventeenth-century Petits-Augustins convent. It opened for public view in 1795 and was dissolved by the Bourbon Restoration two decades later.[9] Alexandre Lenoir, an antiquarian, arranged the first museum "historique and chronologique," in which the visitor would traverse the sequence of centuries (figure 19).[10] An Enlightenment project, the itinerary through time and space began with somber and gloomy early medieval displays, and continued with the galleries becoming brighter and the objects better illuminated in the approach to the eighteenth century. Lenoir's abstracted equation of time and space "would prove enormously significant for the collecting of architecture, for it provided a straightforward equation between the most insignificant material fragments and the grandest conceptual schemes."[11] Within this grand conceptual scheme—laid out as

Figure 19.
Napoleon and Joséphine visiting the Museum of French Monuments with Alexandre Lenoir, Gothic gallery.

total environments that heightened the theatrical experience of authenticity and time travel—the core matter was French, but the historical and geographical scope wider, including Egyptian, Greek, and Roman works. Lenoir's museum was critiqued for its anachronisms. "It has to be conceded that the imagination of this celebrated conservator played a more active role in his efforts than did any real knowledge or any real spirit on his part," Viollet-le-Duc commented during his 1860s campaign to establish a Parisian museum with systematically displayed full-scale plaster monuments.[12] Still its chronological spatiality makes it an important forebear of later displays of architecture, including the one that eventually opened on the Trocadéro hill in 1882.

In the 1820s the collector Alexandre Du Sommerard began installing French medieval and Renaissance artifacts in his home in the Hôtel de Cluny, the former residence of the abbots of Cluny that had been nationalized by the Revolution. A "striking spectacle," this methodical collection laid out in thematic rooms facilitated a new experience of the past.[13] Du Sommerard opened his home to visitors during the 1830s, and upon his death in 1843 the French state purchased what then became the Musée de Cluny, a third formative institution in the history of architecture museums. Although these museums were not exclusively devoted to architecture, their architectural frames and fragments presented architecture as history: Soane by picturesque means, Lenoir by the promenade through time, while Du Sommerard installed prototypes of the modern period room. All these traits were debated in the displays over full-scale plaster monuments in the latter part of the century. "Revolving around the idea of meaning in history," Soane's and Lenoir's projects shared many

similarities, as Alexandra Stara argues, by displaying "the role of fragments in this process."[14]

Architectural museums have appeared in many guises throughout European history. The Roman emperor Hadrian's collection of architectural reproductions and relocated fragments at his villa at Tivoli formed an early version, according to Françoise Choay.[15] Drawing collections established in the late seventeenth century represent predecessors to the modern architecture museum, as John Harris has shown.[16] Deposits of architectural knowledge in print, such paper museums also anticipate the regime of comparison that later unfolded in the compositions of full-scale reproductions. The government should encourage architects as it does painters and sculptors, according to Étienne-Louis Boullée. "With time, one would have a *museum of architecture* that would include everything one could hope from the art by means of the efforts of those who cultivate it." Claude-Nicolas Ledoux—assembling engravings of his work for publication at the turn of the eighteenth century—referred to the collection as an "Encyclopedia or Architectural Museum."[17] However, these "architectural 'museums', visual counterparts of the Encyclopedic discourse," were conceived systematically rather than historically, notes Anthony Vidler. "Examples might be drawn from history, but, once selected, they merged into a timeless canon."[18] Whereas these printed museums were preoccupied with Enlightenment ideas of types, theoretical origins, first principles, and immutable laws, the museums of Lenoir, Soane, and Du Sommerard presented architecture as relative to time and place. This burgeoning will to historicize architecture by means of exhibition could also be detected in collections of scale models. In 1806, the well-traveled architect and painter Louis-François Cassas opened a gallery in Paris, where models of monuments in different states and from different periods appeared together. The assembly showcased both development and the work of time, as restoration architect Jacques-Guillaume Legrand asserted in the catalogue, enabling architects and amateurs alike to traverse millennia and simultaneously grasp buildings in their actual and original state.[19]

All earlier attempts to establish architecture museums were dismissed when James Fergusson, on the occasion of the incorporation of the Architectural Museum into the new South Kensington Museum in 1857, proposed a concept for an ideal, scientific architecture museum, laid out "on a proper scale" and "carried out with a proper cosmopolitan liberality of feeling."[20] Anything but polite or congratulatory, Fergusson's most brutal criticism was leveled at the subject of his talk, the Architectural

Figure 20.
The cluttered interior of the Architectural Museum at Cannon Row, London, c. 1855.

Museum established in 1851 when Sir Gilbert Scott purchased at auction a huge collection of casts from the late Gothic revivalist Lewis Nockalls Cottingham. Aiming at counterbalancing the classical impetus of the British Museum, the new museum involved a number of central players in British architectural culture, among them Charles Cockerell, Charles Barry, Owen Jones, John Ruskin, and George Godwin, editor of *The Builder*.[21] When merged into the conglomerate of museums, collections, scholarly societies, and professional schools in the new South Kensington Museum, the collection, so its founders hoped, would get more attention than it had in its former "confined and dirty rooms in Cannon-row," to better propagate medieval revival for new museum audiences (figure 20).[22] "Gothic is not an art for knights and nobles; it is an art for the people; it is not an art for churches or sanctuaries, it is an art for houses and homes; it is not an art for England only, but an art for the world: above all, it is not an art of form or tradition only, but an art of vital practice and perpetual renewal," Ruskin declared in 1858, in the dedication speech for the collection that also included his own Venetian casts.[23] Yet the merger became a disappointment, as Henry Cole wanted to exhibit only a small selection of the Gothic elements. After an uneasy decade at South Kensington the museum added the epithet "Royal" to its name and moved on to new premises: "Those who would study the stones of Venice should come here to examine their casts," in the enticing words of the 1880s guide.[24]

James Fergusson deemed the museum that "arose out of the debris of Mr. Cottingham's collection" to be myopically Gothic and "too exclusively mediæval to perform."[25] Praising Soane's house as the earliest attempt at an architecture museum in England with its "extensive collection of casts and illustrations," he did, however, find it "somewhat marred by the quirks and quiddities which [Soane] indulged in."[26] He also grasped the opportunity to critique the institution he was himself directing, the Crystal Palace at Sydenham with its ten architecture courts inaugurated only three years earlier. Spanning from Assyria and ancient Egypt through the Renaissance, the courts' monumental spectacle displayed a progressive history of architecture at full scale in a London suburb. Acknowledging it as "by far the most complete and perfect that has ever been attempted," he nevertheless aligned himself with the critics who found the courts populist: "There are some minds which can only be approached by having their wholesome food so clogged with sweetness or so savored with spices as almost to destroy its nutritious qualities."[27] It was not the plaster casts per se that troubled the director. On the contrary. For all his self-doubt, the one solution he could envision for a modern architecture museum was a scientifically arranged collection of plaster casts: "I need hardly add that they must be arranged chronologically." In his talk Fergusson launched the program for the cast collections that would soon proliferate all over Europe and the United States, catering to both generalist and specialist audiences. Plans, sections, drawings, and diagrams might be "the delight of the professional architect; but not one unprofessional person in a hundred can comprehend what it is all about." A good cast's "beauties and defects all could appreciate."[28] He highlighted a certain Roman monument that everyone deserved to experience firsthand, in a museum: a thousand years and "the thoughts of hundreds, perhaps thousands of

minds ... at last produced the capital known as that of the Temple of Jupiter Stator."²⁹

Fergusson also invoked the topos of the plaster monuments as a substitute for travel. While the grand tour was for the happy few, well-arranged museums could be appreciated by the many: "architecture has become the privilege and the exclusive property of a small and limited class of persons, and has consequently been narrowed into the reproduction of some technical or archæological form of art."³⁰ Less than twenty years after the introduction of the photographic process, Fergusson underlined the importance of contextualizing the full-scale fragments with other media, such as models and drawings, but especially photographs: "From its accuracy and truthfulness the latter forms a most invaluable adjunct to such a museum."³¹ The main attraction, the full-scale casts that would unfold the development of monuments through time, should be treated to mirror the monuments in situ in their current state, not restored to an imagined former glory.

The scientific clarity that Fergusson desired made him nostalgic for the moment when the casts had arrived at Sydenham, before they were integrated into fanciful confections: "The process followed in the Crystal Palace is something like transposing the problems of Euclid into lyric verse, or teaching theology by means of the religious novel."³² There was beauty and usefulness in the brand-new, unvarnished casts, "arranged and labeled on the shelves of the workshops—the capitals in one place, the pinnacles, the mouldings, the foliage, the canopies, &c., each in its own class and according to its date." Essentially, Fergusson recommended a warehouse aesthetics for the display of architecture, with truth "presented in its simplest and purest form."³³ Thus it comes as no surprise that he considered Du Sommerard's medieval atmospheres and Soane's picturesque arrangements to be more akin to religious novels than to his vision of a future scientific architecture museum, chronologically ordered and instructive and factual as a manual.

Still, the organization of Soane's house points to some very specific features, debates, and challenges pertaining to the architecture museum in general and the cast museum in particular. Anticipated in the relatively small home museum, these were reflected in more spacious public museums decades later. Soane's juxtaposition of full-scale casts and scale models, so carefully curated in this London domesticity, highlights the importance of size within this museological paradigm. While the casts at full scale were supposed to immerse the visitor in a simulated experience of the real thing, the scale models contextualized the monuments from which the full-scale fragments were drawn. In virtually no other extant space is this effect more palpable than in Lincoln's Inn Fields. Seeing the little plaster model of the Temple of Castor and Pollux on the mantelpiece before moving on through the narrow passage, making a right turn toward the picture room, and coming upon the enormous casts of the entablature and a capital in a narrow alcove—these are among the unforgettable impressions left on the visitor. Soane's constellation of artifacts draws on the mathematical sublime, by exposing the strikingly big fragments of the enormous temple in such a miniature space. Compared to the halls that were later designed for the plaster monuments, this eccentric arrangement in a domestic interior both bewilders

and clarifies. For more than two centuries visitors have experienced the same reconstructed vantage point in the narrow corridor that the grand tourist enjoys in Henry Parke's watercolor, and the same close-up view of the details that George Dance and Piranesi saw in the 1760s, a bodily experience, without needing either ladder or scaffold. Yet Soane's picturesque play with scale—producing unexpected views and surprising adjacencies—was exactly what later cast museums wanted to get away from. Chronology became a main curatorial device, establishing spaces for sequences of the monuments of the world on what Fergusson called "proper scale."

Rome—London—Paris—New York

Henry Parke's restoration on paper of a fantasy original state of the largest temple columns at the Roman Forum might appear paradoxical. Begun under Emperor Augustus, the Temple of Castor and Pollux had been almost entirely destroyed in the fifteenth century. What remained was a fraction of a colonnade of a lost building. However perfect the structure looks in Parke's version, the image is still showing a ruin and not the entire structure, something contemporary audiences would be well aware of. The watercolor testifies to a monument in flux within a world of competing mediations, and opens up questions of what this version was meant to signify within these fluctuating representations. The three- and two-dimensional interpretations—full-scale casts, scale models, and the versions on paper and canvas—oscillated between documentary depictions and idealized conceptions. This practice of reconstructing ruins on paper was central to the French Beaux-Arts tradition. The Grand Prix recipients at the school in Paris spent four or five years in Rome as *pensionnaires* at the Villa Medici, assigned to make two sets of drawings, or *envois*, of the ancient monuments: one *état actuel* and one *état restauré*.[34] These exercises became part of a broader visual culture. In scaled versions the actual and restored states were reflected in the travel-friendly cork models that proliferated from the late eighteenth century, capturing in their porous material expression the ruinous state of ancient monuments, and in reconstructed models depicting presumed pristine states. The full-scale architectural casts amplified the inventive dimension at work when realizing the imagined perfection of antique monuments. Among the most flamboyant examples was the version of the Temple of Castor and Pollux ruin that was built at the École des Beaux-Arts in Paris in the 1870s.

After the closure of the Museum of French Monuments in 1816 most of the exhibits were dispersed. Concurrent with the repatriation of artworks Napoleon had brought to the Louvre, the exhibits at the Petits-Augustins were lifted from their atmospheric chronologies and returned to their "places naturelles," or moved to the Louvre or other museums.[35] Soon a number of schools and ateliers in the Louvre crossed the Seine and took over the premises, and became the reformed École des Beaux-Arts. A new building program was initiated to meet the needs of the school. The conversion of the existing buildings was begun by François Debret and continued by Félix Duban in 1832. Duban used the façade portion from the Château d'Anet (which functioned as a stone quarry during the

Revolution), the Arc de Gaillon, and some Gothic building fragments collected by Lenoir to stage an outdoor "museum of French national architecture."[36] As such, ruins of the ruins from the short-lived Museum of French Monuments remained characteristic features of the school.[37] This urban open-air museum composed of leftovers from Lenoir's collection of national monuments caused controversy: "One should avoid, in the museum of the École des Beaux-Arts, placing too prominently works of art whose composition and taste are not entirely in harmony with the principles of ancient architecture."[38] Less controversial and more of a sensation were the plaster monuments erected in the courtyard of the Palais des Études, which Duban covered with an iron and glass roof. Flooded by natural light, the Cour vitrée would house "the most beautiful works of architecture," from Greece and Italy, according to the architect.[39] Ernest-Georges Coquart, who continued Duban's work after 1870, created a polychrome *Néo-Grec* environment when painting the ironwork blue and the walls Pompeian red.[40]

For the inauguration in December 1876, two imposing casts were in place. The school already had a number of pieces from both the Parthenon and the Temple of Castor and Pollux. The latter was an obligatory object of study, and the oldest casts of this monument had been collected by architect Léon Dufourny in Rome between 1782 and 1794 and donated to the state, deposited at the Louvre, and in 1803 passed on to the school.[41] Yet the school deemed it important for all students to be acquainted with the *dimensions réelles* of the two most remarkable monuments of ancient Greece and Rome—respectively, more than sixteen and eighteen meters tall.[42] The most canonical specimens of the Doric and Corinthian orders faced each other from the north and south sides of the court, with sculpture from antiquity to the Renaissance balancing on pedestals and in the two-story arches in the walls—together symbolizing the school's curriculum (figures 21 and 22).

The three-columned northwest corner of the Parthenon had been commissioned by the Commission des Monuments historiques (Historic Monuments Commission) in Athens in 1844, during an archaeological expedition.[43] The reconstitution of the Temple of Castor and Pollux was an entirely in-house affair. It materialized through the combined efforts of three Prix de Rome recipients and skilled molders at the school in Paris. In 1870, Charles-Louis-Ferdinand Dutert—the future architect of another iconic *modern* monument, the Palais des machines at the 1889 Exposition universelle in Paris—arrived in Rome for a four-year stay and found the ruin scaffolded. He started restoring the entablature in drawings praised for their archaeological accuracy: "This work was nearly completed when I learned that Mr. Coquart was raising in the Cour vitrée two of these three columns and that he proposed to restore them."[44] Planned for the south side of the court by Duban and based on Dutert's drawings, the Castor and Pollux monument was erected by Ernest Coquart between 1872 and 1874.[45] The whole operation was made possible by the improved casting techniques developed by Alexandre de Sachy, the school's chief molder from 1848 through 1886. With armatures of iron, early casts were heavy, and it was impossible to construct whole portions of buildings. De Sachy's invention allowed for unprecedented lighter and bigger casts, strengthened from behind with wooden frames and canvas.

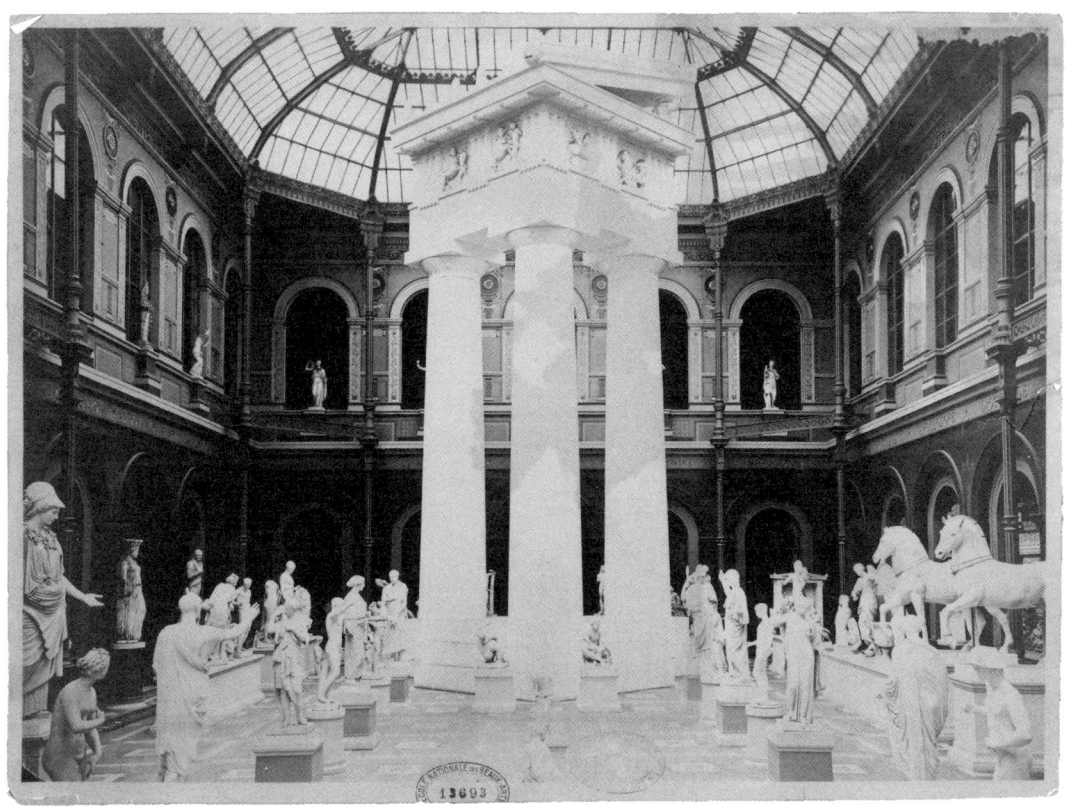

Figure 21, opposite.
Maison Giradou, La Cour vitrée dans le Palais des études, École des Beaux-Arts, Paris, 1929.

Figure 22, above.
"La cour vitrée du Palais des études, avant 1884." École des Beaux-Arts, Paris.

Under Coquart's direction de Sachy reproduced and restored the great monuments of Periclean Athens and Augustan Rome at full scale in Paris.

Photographs show that the casts almost hit the glass roof that spans the space. The Roman monument is seemingly rising from a square pit in the floor, curbed by a small barrier. It is tempting to think that this installation—a pragmatic solution—makes a topographical reference to the original's rapidly changing archaeological condition. The excavations at the Roman Forum and the unearthing of the ground levels of antiquity stirred great interest beyond the circles of archaeologists and architects. What is most striking, however, is that the reconstitution contains only two columns, while the ruin's celebrity was inseparable from its iconic three columns. Over more than a hundred years this monument had circulated in a variety of media, depicting fluctuating states of ruination and restoration. This full-scale Parisian version added a new conception of the ruin, omitting the characteristic oblique sides in favor of a highly stylized entablature resting on two flawless capitals. This innovation had a strange effect on the whole. The specificity that informed the object as a ruin was wiped away. Rather than communicating a dilapidated remnant of antiquity, the fragment rerepresented in plaster conforms to conventions of reproducing a detail from an imaginable, continually existing, ideal whole. The cast takes on an exemplary status as part of a perfect, vanished, totality. This plaster perfection does not convey decay. Eliding the material historicity of the monument, it presents a spotless, gloriously fictional ruined masterpiece of the Corinthian order. The cast was designed to display the perfection of antiquity, not the passing of time. The two columns, the perfectly cropped entablature, and the lowering into the floor bespoke flexibility, versatility, pragmatics and plasticity, and fantasies about perfect ruins projected onto the past in plaster. Less archaeologically accurate but deliberately enhanced, the plaster monument presented a legible antiquity as part of the student's everyday environment.

The epicenter of classical teaching constituted by the École also became the center for an international trade in casts from the classical tradition. A 1881 sales catalogue authored by Alexandre de Sachy offered numerous casts of the Castor and Pollux monument made at the school's plaster workshop, in various scales, states, and versions. Some of the entries are marked "Restauration ancienne" or "Restauration nouvelle," referring not to the actual monument's trajectory of restoration, but to the assortment of the authored work of Coquart, Dutert, Dufourny, and Duban.[46] Casting was a method of renewal, and "restoration" a matter of representation and mediation, belonging to complexes of reproductions depicting fragments from a ruin through both fictitious and factual states and times.

Not many museums tried to install the entire Castor and Pollux monument; however, restored and unrestored bits and pieces became part of a busy transatlantic trade. The first parts that arrived at the Metropolitan Museum of Art, for instance, were the "Base, Capital and Entablature, Temple of Jupiter Stator, ¼ full size," bought for 350 francs, restored and scaled by Ferdinand Dutert.[47] Only one American museum attempted to purchase the whole thing. Interestingly, at the Carnegie Institute in Pittsburgh the monument would not have been deployed as part of a picturesque vision of the past or to corroborate the prominence of the classical tradition, nor would it have presented a French nineteenth-century

Figure 23.
Curating monuments in the gallery. Undated drawing. Carnegie Museum of Art, Pittsburgh.

fantasy of an ancient monument conceived within a particular pedagogy. The director simply wanted "a fine specimen of Roman architecture, to correspond in some ways with the Nike of Apteros," for an empty plot between the Romanesque church Saint-Gilles and the Erechtheion porch (figure 23).[48] Camille Enlart, the director at the Musée de sculpture comparée and an important adviser for the selection of monuments in the Hall of Architecture, confirmed to the Carnegie director John W. Beatty that the Temple of Castor and Pollux was "an excellent choice," and "the only Roman order, of which a complete proof can be made in Paris." He referred Beatty to the École des Beaux-Arts, where casts of the monument were still for sale in 1906, and added, surprisingly—given the immense size of the object—that the columns "adapt themselves very well to be placed in a museum."[49] The school's chief molder had confirmed that he still had "the molds of the capitals and the entablature of the colonnade which interests you, and of which he will execute a proof for you, similar to the one exposed in the Glass Court of the École des Beaux-Arts, that there gives such a fine effect."[50]

The sales catalogues of casts at the École came without illustrations. The only image left to attest to the attempt to purchase this monument is a sketch on tracing paper produced in Pittsburgh, which much more closely resembles the ruin in Rome than the hyper-stylized French version

Travels in the Province of Reproductions

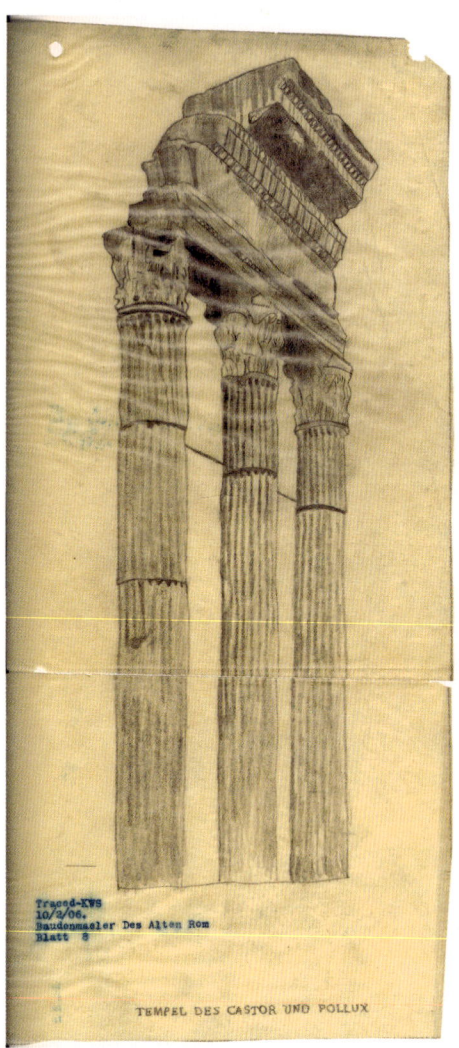

Figure 24.
Tracing of the ruin of the Temple of Castor and Pollux. Undated. Carnegie Museum of Art, Pittsburgh.

(figure 24). When he eventually realized that the nearly nineteen-meter-tall object could not possibly fit in the Hall of Architecture, Beatty inventively proposed having the monument amputated from below. "I will reply with all frankness," Enlart responded, mildly shocked by the adventurous American, "that this solution would seem to me a bad one."[51] Accordingly he advised on how to deal with the problem by showing fragments to "preserve the full value" of the monument, but suggested that he should perhaps consider swapping the Roman monument for "an angle of the Parthenon."[52] In the end, the Carnegie Institute settled for another "talismanic" Roman favorite of John Soane's, one that left its mark across media in Lincoln's Inn Fields and found its way into many of his building designs, and that became a staple in many cast collections.[53] A column with a capital and a piece of the entablature from the Vesta temple at Tivoli were also in stock at the École, and soon in place in Pittsburgh.

American Perfection

"The idea of endowing a city like New York with a collection of original sculptures or paintings by old masters" was unrealistic, according to the French archaeologist Salomon Reinach: "not having known the drawbacks of monarchism, it must be content not to know its advantages either."[54] Reinach, a curator at the Musée des antiquités nationales, praised the initiatives at the Metropolitan Museum of Art that promised to make it "the richest museum of casts in the world."[55] American museum history offers a fascinating illustration of the maxim of "the advantages of backwardness," coined by the Russian-American economist Alexander Gerchenkron in the 1950s. Many museum schemes had been suspended because of the Civil War; when they regained momentum in the late 1860s, spirits were high and ambitions grand. There were, however, not many art collections of importance in the United States, and the former British colony had, for obvious geopolitical reasons, not been part of the race for antiquities in the Mediterranean and the Middle East. American archaeology was not yet of any consequence, and the prospect of acquiring antiquities for museums did not look encouraging. Every day it is "harder and harder to get hold of the *chef d'oeuvres* of antiquity," said Richard Morris Hunt, the first American architect trained at the École in Paris, in an 1869 summit to discuss the foundations for what was incorporated the following year as the Metropolitan Art-Museum.[56] This problem was reframed as a great opportunity. America should not aim for "ideal and impossible museums, filled with masterpieces of original art, but museums mainly composed of reproductions," Charles Callahan Perkins, a trustee at Boston's Museum of Fine Arts declared in 1870: "These will answer our purpose, as we aim

at collecting material for the education of a nation in art, not at making collections of objects of art."[57]

Plaster casts were nothing new in America. From the 1770s the Farnese Hercules, the Venus de Milo, and other famous statues embellished Thomas Jefferson's Monticello. The Boston Athenaeum, founded in 1805, acquired its first casts in the early 1820s, and its sculpture gallery opened on Beacon Street in 1839. In 1876, the same year the Corcoran Gallery in Washington, DC, started collecting casts, the Museum of Fine Arts in Boston opened in Copley Square. Together with casts from the Athenaeum, it showed new reproductions imported from England, as well as thirty casts from the Alhambra presented in Spain's section at the 1876 Centennial Exhibition in Philadelphia.[58] By 1890 the museum owned nearly eight hundred plaster reproductions. Perkins envisioned a museum similar to the South Kensington with its more than seven thousand casts, only better: "If museums are to be made invalid hospitals for poor pictures and many other sorts of rubbish bestowed upon them by persons of doubtful judgment, their action will be highly deleterious; but if, on the contrary, they are what they ought to be and can be made by the exercise of judgment, firmness, and common sense, they cannot but be in the highest degree beneficial in their effects upon all classes of the community."[59]

This reads as a motto for American collecting during the next decades. Judgment, firmness, and common sense meant ideal collections of perfect casts. In this process, the Metropolitan Museum of Art serves as an interesting but typical example. In November 1869 a group of public-spirited New Yorkers—industrialists, politicians, artists, architects, and scholars—gathered at the Union League Club in Manhattan to plan the establishment of a "permanent national gallery of art and museum of historical relics, in which works of high character of painting and sculpture and valuable historical memorials might be collected."[60] New York was about to become a leading metropolis. "What is there remaining to be done in the simple interest of industrial and commercial enterprise," asked a reverend Dr. Thompson: the time had come to manifest "our higher culture."[61] One address in particular from this summit of a New York elite deserves to be quoted at some length as it is so symptomatic of the mind-set of a nation prospering in wealth and initiative, and for whom the disproportion of the depositories of art in the Old and New Worlds seemed a kind of systemic mishap. The following is a portrayal of Europe seen from Midtown Manhattan in 1869. "Beyond the sea," claimed William Cullen Bryant, the poet and editor of the *New York Evening Post*:

> there is a little kingdom of Saxony, which, with an area less than that of Massachusetts, and a population but little larger, possesses a Museum of Fine Arts, marvelously rich, which no man who visits the continent of Europe is willing to own that he has not seen. There is Spain, a third-rate power of Europe and poor besides, with a Museum of Fine Arts at her capital, the opulence and extent of which absolutely bewilder the visitor. I will not speak of France and England, conquering nations, which have gathered their treasures of art in part from regions overrun by their armies; nor yet of Italy, the fortunate inheritor of so many glorious productions of her own artists. But there are Holland and Belgium,

kingdoms almost too small to be heeded by the greater powers of Europe in the consultations which decide the destinies of nations, and these little kingdoms have their public collections of art, the resort of admiring visitors from all parts of the civilized world.[62]

Professor George F. Comfort, who the following year published *Art Museums in America*, continued by elegantly turning an obvious shortcoming into an advantage with a surprising premise: "we ought to be farther advanced in aesthetic culture than other nations whose origin was many centuries earlier."[63] Old and small signified the opposite of prosperous and visionary in this discourse of tabula rasa. Already this evening at the Union League Club, and in innumerable deliberations and documents in the coming decades, reproductions were corroborated as a fully credible and attractive basis for a great museum in New York City. From the very beginning the South Kensington Museum, the Royal Museums in Berlin, and the Musée de sculpture comparée in Paris served as the models. Reproductions were proposed for paintings as well—they give "a reasonably fair idea of the originals"—still, most of those present at the club found reproductions more suitable for three-dimensional works. "It is possible to reproduce every work of sculpture in the world as perfect, in form, as the originals," Professor Comfort assured his interlocutors, repeating the well-established opinion that a plaster cast might even trump the original: "It may be made more perfect as a copy: its texture is superior, inasmuch as it has none of the bright reflections and semi-translucency of marble."[64]

Architecture was, as always, a curatorial challenge. The plaster monuments came to the rescue: "We cannot reproduce in full size the great temples of architecture, the great cathedrals of the middle ages, the temples of antiquity or any other great buildings; but they can be reproduced perfectly in form."[65] In 1880 the Metropolitan moved into its first purpose-built building on Fifth Avenue. Within a decade the polychrome, Gothic structure in the park, designed by Calvert Vaux and J. W. Mould with Frederick Law Olmsted, was filled with monuments from a vast range of places and times.[66]

An Epitome of Monuments in Central Park

Architecture was core to the Metropolitan Museum of Fine Arts from the beginning. Three collections formed its backbone. In 1874, and in competition with the Louvre and the Hermitage in St. Petersburg, the museum acquired a collection of Cypriot antiquities excavated by the Civil War hero general Luigi Palma di Cesnola, the US consul at Cyprus from 1865, who was appointed the Metropolitan's first director in 1879.[67] The same amount spent on the Cesnola collection was made available for the purchase of a collection of historical sculpture when trustee and banker Henry Gordon Marquand, the museum's second president, in 1886 donated $10,000 for the purpose. The architecture collection surpassed this value tenfold when the businessman Levi Hale Willard in 1883 bequeathed $100,000 for a permanent "Museum of Architecture" that would "cultivate and encourage a popular taste of this grandest of all the

arts."[68] The donation was widely reported in the press; headlines read, "An Architectural Museum for New York."[69]

The Willard bequest came with precise instructions. Following Willard's wish a commission chaired by Napoleon Le Brun, of the New York Chapter of the American Institute of Architects, appointed his son Pierre Le Brun as purchasing agent. Like the Architectural Museum at South Kensington, the Willard collection constituted a museum within a museum, and, as in London, it was orchestrated by influential players in the architecture world. James Fergusson had criticized the Architectural Museum for being glutted with redundant pieces—this American collection could be composed from scratch. On his first of three trips to Europe—from December 1884 through June 1885—Pierre Le Brun toured Great Britain, France, Italy, Germany, and Austria, meeting "with prominent museum authorities, archeologists, architects & others whose experience or opinion were valuable," identifying works presenting "all the distinctive styles in historical sequence . . . to show their inter-relationships and transitions."[70] The Crystal Palace was the most relevant model, although Le Brun commented that "no chronological arrangement showing transitions or growth of style is attempted," while the Musée de sculpture comparée was impressive, yet too national in scope. The classical collection at the École des Beaux-Arts offered "no novel or particular instruction in the classification of objects"; the Royal Museums in Berlin, the Architectural Courts at South Kensington, the Vienna museum, and museums and schools throughout Germany all manifested confusion in the "manner in which detail of different periods & schools has been crowded and mingled together." Italy had no cast collections of importance, Pierre Le Brun reported, while the beautifully displayed collections at Cambridge, Dresden, and Munich hardly included architecture. "All that I saw of Museums offered convincing proof of the supreme importance & value of a well laid plan in the selection & arrangement of objects," he informed the committee when he returned home. "Starting on a perfectly clear basis," the Metropolitan would "profit by the successes, the mistakes & the initiatives of similar undertakings abroad."

Referring to the system of exchange between museums spurred by Henry Cole's 1867 Convention promoting reproductions, Le Brun lamented the poor quality of scale models in European cast courts. Overall they were too small, imperfect, and "not accurately detailed," he explained in his 1885 report: "To execute a model with architectural exactitude a complete set of working drawings is required." "Every part, plain & ornamental, must be drawn to the full scale of the model," he said, highlighting the "drawings and careful restorations of ancient monuments" made by French Prix de Rome winners and in the school's possession. While in Europe, he commissioned a number of models at scales of 1:20, 1:10, and "¼ full."

Among the models made especially for the Metropolitan was the Parthenon built by Adolphe Jolly under the direction of architect and archaeologist Charles Chipiez, distinguished for his detailed drawings of ancient monuments. This model was already a celebrity when it arrived in New York. The French minister of fine arts had requested that it be shown first at the Exposition universelle in 1889, where it was presented as a loan from the Metropolitan.[71] Upon its arrival in New York, this new

Parthenon was to be immediately installed "at whatever cost of temporary inconvenience," and when completed it "excited great attention and admiration."[72] Chipiez's and Jolly's one-off model of Notre-Dame became another star attraction, and so did Chipiez's restored Pantheon, manufactured by Abel Poulin, both built at 1:20. The Choragic Monument of Lysicrates at Athens, at 1:10, was made from molds in Munich; the 1:20 Arch of Constantine was crafted by the sculptors Trabacchi and Cencetti in Rome; and the 1:10 "Restored Pediments, temple of Zeus," was made in Berlin. These "delicate and expensive models," gathered from specialists across Europe, became a source of pride, "a unique and characteristic feature of the collection," and much loved by museumgoers. When the Hypostyle Hall at Karnak, the Pantheon, and the Arch of Constantine landed in New York, the museum was confident that they would "rival in interest and surpass in size the model of the Parthenon erected a year ago."[73] At the time "the Cathedral of Notre Dame in Paris [was] progressing to completion," and the French sculptor Emile Cognaux, who traveled with the myriad pieces from Paris to New York, used six months to build the model on-site, in the gallery, in 1893.[74] In 1899, a request to copy the $18,000 Parthenon model was declined, as this was a Metropolitan original.[75]

About half of the casts, more than three hundred objects, were installed in the purpose-built glass- and iron-roofed Grand Hall for the opening on November 4, 1889. Serving as adviser to the Department of Sculpture and Casts, Pierre Le Brun had recommended chronology as the curatorial device.[76] Forty pedestals with wheels were constructed for the scale models so they could "easily be moved around" and placed next to the full-scale casts they contextualized. Over the next few years new monuments were mounted as they arrived from Europe, and were allotted more space in adjacent galleries. The ongoing installation of this architecture museum took place in a building that was constantly enlarged, morphing from its early Gothic revival appearance to the characteristic Beaux-Arts monumentality still facing Fifth Avenue.[77]

But the "full size models" were the most important "to illustrate the history of Architecture" in the galleries.[78] The portals from the cathedrals of Aix and Siena, and a window from the Certosa at Pavia, will be in place in some months, read the November 1891 report, and the busy period of installation was expected to come to a conclusion as soon as "three consignments, one from the Trocadéro, one from Berlin and one from Milan," reached New York.[79] Thus a substantial architecture collection was more or less in place when the Metropolitan decided to create "THE MOST IMPORTANT COLLECTION OF CASTS IN ANY PART OF THE WORLD," as spelled out in capital letters by the so-called Special Committee to Enlarge the Collection of Casts, a high-powered group of businessmen, architects, artists, designers, scholars, art dealers, and collectors.[80] The cover of the 1892 publication explaining the enterprise and aiming at attracting subscribers for the grand initiative of presenting a full trajectory of the plastic arts in perfect order—"however widely their originals may be separated"—depicted a gallery from the Trocadéro as one of the models that should be surpassed in New York (figure 25).[81] The subscription aspired to raise $100,000, and the press followed the operation with excitement: the Metropolitan's "plaster-cast collection, by virtue of a

sumptuous endowment, will soon be the largest in the world."[82]

To pursue this most ambitious collection of plaster monuments ever conceived, Edward Robinson was made purchasing agent. A Harvard-trained art historian and archaeologist—at the time the curator of classical antiquities at the Boston Museum of Fine Art and its director from 1902—Robinson was an internationally leading plaster cast expert. A visionary cast thinker, he was involved in the development of a number of American collections and was responsible for making Boston's collection world-class. He stepped down as its director in 1905 after the so-called battle of the casts when the assistant director successfully plotted with the art collector Isabella Stewart Gardner and other prominent Bostonians to get rid of the reproductions while Robinson was visiting museums in Italy, Germany, Switzerland, Holland, Belgium, and England, gathering ideas for a new museum building in Boston. He was immediately appointed curator of classical art at the Metropolitan before becoming the museum's director in 1910, the same year the last catalogue of the cast collection, authored by Robinson, was published.

With its "epitome of the history of art by monuments," the Metropolitan was to outshine all competition. Robinson reported to the committee on the depressing state of European museums with collections "which either illustrate the same point or have no bearing whatever upon the development of art," and on forlorn installations "confusing the popular mind."[83] Furthermore, he assessed in great detail the entire international cast market and discussed European debates on casts, as well as casting methods and policies, surface treatment, and incrustation techniques. The Metropolitan should display a scientific "organic whole—a unit," with every epoch represented within "the chronological system" that was about to replace the haphazard and obsolete classifications still governing most European museums. The audience's perception of the monuments was a critical concern. A sense of unity "is the secret of making a gallery of casts attractive to the public," he explained—what "leads them to look carefully from one object to another, and keeps their interest quickened as they pass from room to room."[84] Robinson championed the Musée de sculpture comparée's way of showing relations in style in works across epochs through carefully selected pieces: "The extent to which this purpose has been attained in French mediæval and renaissance art, during the brief period of nine

Figure 25. Photograph of gallery from the Musée de sculpture comparée on the cover of *Special Committee to Enlarge Collection of Casts, Report of Committee to Members and Subscribers, February 1, 1892*. The Metropolitan Museum of Art, New York.

years since the museum was opened, furnishes an admirable illustration of what can be accomplished in our own city with adequate means."[85] Yet, in contrast to the Trocadéro's national impetus and the global scope at South Kensington, the museum in Central Park should display an unprecedented universality curated in accordance with the latest achievements in the "science of art." Again, the characteristic American tabula rasa was at work. While European colleagues were "often embarrassed by casts which have been brought into their museums, in past times, without special scientific purpose," the Metropolitan was favorably "unencumbered by any useless accumulation inherited from former generations" and would install perfection in galleries "erected especially and exclusively for that purpose."[86]

Robinson's scheme was remarkable in the way it inverted one of the typical reasons given for collecting casts in the United States, namely, presenting the grand tour for those who could not travel through Europe to see the monuments firsthand. When claiming that the collection would have "European scholars come to New York as they now go to Rome, Athens, or the other great centers of the study of art, in order to see the perfect museum of reproductions," Robinson was—perhaps unconsciously—echoing another ambitious plaster entrepreneur.[87] The detachment of the traveling monuments from historical and geographical origins lent them new significance. Establishing perfection off-site, the reproductions were imagined to redirect the itineraries of contemporary grand tourists as well. While working on the reproduction of the Temple of Castor and Pollux, Ferdinand Dutert declared that eventually the marble fragments would be "scattered on the Forum, exposed to impious travelers' small hammers. But soon the École des Beaux-Arts will fully have recovered these columns. One will have to go to Paris to study one of the most beautiful ancient Corinthian Roman orders."[88] Another fascinating inversion might be identified in the grand tour Robinson himself undertook in the summer of 1891.

Traveling in the Province of Reproductions

On June 3, 1891, Edward Robinson embarked on a grand European journey. London, Berlin, Dresden, Florence, Milan, and Paris were among the cities he visited on a tour that took place, as he reported to the committee in September, in "the province of reproductions."[89] Prior to this inverted grand tour, Robinson had prepared a 130-page document entitled *Tentative Lists of Objects desirable for a Collection of Casts, Sculptural and Architectural, intended to illustrate the History of Plastic Art*. At first glance it looks like a typical museum catalogue: a carefully organized inventory naming and numbering a comprehensive aggregation of objects. Under the "Architectural Lists" were compiled more lists, periodically ordered and further subdivided in terms of national or regional styles, with separate lists for Egyptian, Assyrian, Phoenician, Persian, Cypriot, Greek, Etruscan, Roman, Byzantine, Romanesque, Gothic, Saracenic, and Renaissance (Italian, German and French) architecture.[90] Even though certain periods were not yet fully covered—such as Moorish Spain, Arabian Egypt, and India—the *Tentative Lists* had been drafted regardless

of "whether these objects had or had not been already cast."[91] As the preface rightly states, the "field in architecture is unlimited except by considerations of space."[92] The architectural lists simply stated what was already acquired, for Robinson to expand en route.

Among the plethora of catalogues of casts that flourished in the last decades of the nineteenth century, the *Tentative Lists* is a truly visionary document, provisionally compiled as preparation for a "final list" and "a step toward a complete catalogue." It is a vision of a utopian museum: "the ideal to which the Museum might ultimately hope to attain."[93] Every object desired for the future collection—idealistically conceived but pragmatic in its planned execution—was recorded under four categories: "Title of object," "Original in," "Buy cast from," and "Foreign price."

The index, with its chronologically arranged categories of monuments and the lists in concert designating a world-historical panorama of architecture, is itself captivating reading. Still, the document's most fascinating section and its true ambition are hidden in the dryness of the very first list, entitled "Explanation of Marks, Figures, and Abbreviations." A system of signs provided the key to the status of the desired objects. For example, the figure *X* signified that "as far as known, no mold of the object at present exists, though one could probably be made," while a question mark indicated "a doubt as to the maker of whom the cast should be ordered." Appended to the entries, and sometimes in combination, such coding makes the "Buy cast from" rubric a particular thriller. As long as the desired object existed in the market—if molds were made or casts were in stock—its maker or copyright holder would appear in the "Buy cast from" column, indicating institutions and individuals, namely, the main players and citizens in the "province of reproductions" that Robinson was preparing to visit. Entries in the list of abbreviations include *Akad.*, *Munich*, *Brucciani*, *Kreittmayr*, and *Louvre*, signifying, respectively, "G. Geiler, Formator an der Kgl. Akademie der Künste, Munich"; "D. Brucciani & Co., 40 Russell Street, Covent Garden, London"; "Joseph Kreittmayr (moulder for the Bavarian National Museum), Hildegardstrasse 12, Munich"; and "Eugène Arrondelle, Chef du Moulage, Musée du Louvre, Pavillion Daru, Paris." Altogether these notations served as a detailed address book, coinciding with Robinson's itinerary.

This apparently trivial list of abbreviated information distills nineteenth-century cast culture. By signaling the provenance of the objects, the lists quietly display a cartography of the finest cast makers across Europe, both the private *formatori* and the world-class museums manufacturing the monuments that rapidly traveled the world. As a guidebook to the province of reproductions, however, Robinson's compilation did more than merely mapping the territory. His initiative bears witness to a dream of infinite expansion by including a number of monuments never before cast, evoking Jorge Luis Borges's cartographer who attempts to make a 1:1 map of the world. If epithets such as "complete" and "perfect" sprinkled throughout the documents involved in this endeavor described ideals rather than realities, this first printed inventory of the imagined collection strove for uncompromising completeness and perfection without regard to the cumbersome constraints of reality. Intended for "private circulation," this proto-catalogue incorporated the most important addressees among its abbreviations: distinguished

European museum directors, curators, archaeologists, art historians, and *formatori*. They were sent the document in advance of Robinson's trip, and his report described how he met with them all to discuss, perfect, and finalize the selection and to place orders for a perfect museum that would bring the world to New York. Robinson wanted the best casts available on the market and put great effort into locating the most valuable editions. Among those who were particularly thanked for helping finalize the selection were Mr. Armstrong, director for art in the Science and Art Department, and Caspar Purdon Clarke of the Indian Department at the South Kensington Museum; Professor Ernst Curtius and Dr. Wilhelm von Bode of Berlin; Professor Georg Treu, director of the Albertinum at Dresden; Professor Heinrich Brunn of Munich; professor in classical archaeology Adolf Michaelis of Strasbourg; Professor Heinrich Brugsch Bey of the Cairo museum; and Salomon Reinach of the Musée de St. Germain.[94]

Museum officials have of course always traveled in curated territories. When Charles Newton in the troubled fall of 1848 toured European museums on behalf of the British Museum's Department of Antiquities, he journeyed in the province of originals, with the Elgin Marbles as "the touchstone of excellence," as Ian Jenkins puts it—the ultimate expression of perfection within a Winckelmannian scheme of rise and fall combined with a proto-Darwinist view of art developing along evolutionary lines.[95] Nonetheless, it was after this journey that Newton appealed for a museum arranged "in one great chronological series," achievable only through the establishment of a "well-selected *Museum of casts*."[96]

Another important trip took place the year after Newton's report was printed in the new journal *The Museum of Classical Antiquities: A Quarterly Journal of Architecture and the Sister Branches of Classic Art*. In the fall of 1852 the two directors of the Fine Art Department at Sydenham traveled for three months to commission the casts that in June 1854 were in place in the architecture courts at the Crystal Palace: "Shortly after the erection of the first column, Messrs. Owen Jones and Digby Wyatt were charged with a mission to the continent, in order to procure examples of the principle works of art in Europe."[97]

Armed with letters of introduction from Lord Malmesbury, the British secretary of state, the two architects boosted the cast production at a number of European institutions. At the Louvre they were welcome to "obtain casts of any objects, which could with safety be taken," and at Munich, assisted by the British ambassador and "the instrumentality and influence" of Leo von Klenze, the directorate "permitted casts of the most choice objects in the Glyptothek for the first time to be taken."[98] Their itinerary included Paris, Rome, Turin, Florence, Venice, Naples, Padua, Berlin, Vienna, Prague, Dresden, Munich, Stuttgart, and Brussels. They met with casters and sculptors, and massively increased the availability of architectural reproductions in the market. With a generous budget and a nearly boundless space to furnish, they were aiming at fulfilling the prospectus for the Crystal Palace: "architectural remains and casts of architectural monuments of past and present times will occupy every salient part of the building."[99]

In Paris they met at the École des Beaux-Arts with Alexandre de Sachy, who had a lot of new molds made from his casts, and with

Pierre-Laurent Micheli at the Louvre's *atelier de moulage*, where molds struck from statues such as the Laocoön and the Apollo Belvedere, before they were repatriated to the Vatican, were still in stock.[100] The 1854 *Guidebook to the Crystal Palace* also recounted the "chief exceptions to the general courtesy" shown to Owen Jones and Digby Wyatt, simultaneously giving the audience some interesting insight into the politics of casting. In Rome "every arrangement had been made for procuring casts of the great Obelisk of the Lateran, the celebrated antique equestrian statue of Marcus Aurelius on the capitol, the beautiful monuments by Andrea Sansovino in the church of S. M. del Popolo, the interesting bas-reliefs from the arch of Titus, and other works, when an order from the Papal Government forbade the copies to be taken; and, accordingly, for the present, our collection, as regards these valuable subjects, is incomplete."[101] Padua also proved disappointing, as the plan of acquiring a number of bronzes by Donatello fell through: "in spite of numerous appeals, aided by the influence of Cardinal Wiseman, the capitular authorities refused their consent."[102] In Vienna, the Austrian authorities violated permissions and agreements. "Although the influence of Lord Malmesbury and Lord Westmoreland (our ambassador at Vienna) was most actively exerted," the travelers failed to obtain the pulpit in the Church of St. Stephen. The guidebook reporting on these political and diplomatic difficulties ventilated the hope that the mere announcement of these deficiencies would change the attitudes of governments reluctant to participate in the casting industry to "advance human enjoyment."[103] Finally, the guidebook announced that despite the "protestations of the Archbishop of York, the Duke of Northumberland, Archdeacon Wilberforce, Sir Charles Barry," and others, the churchwardens of Beverly Minster, Yorkshire, refused to allow the Percy shrine to be cast. Testimonies such as these show the lofty apparatus governing international casting, involving actors spanning from the Holy See, national governments, and archbishops to ambassadors, grand dukes, and local churchwardens. Elsewhere the journey mostly went according to plan.[104] In addition to the works made and ordered across the Continent, objects were also purchased from the British Museum, among them the Rosetta Stone, the Elgin Marbles, and the Assyrian sculptures cast by Domenico Brucciani.

This was the province for which Edward Robinson embarked forty years later. His *Tentative Lists* documented the state of the art of the European cast industry and a market that had rapidly expanded over recent decades, and gave a full panorama of the makers of these monuments that traveled the world toward the end of the nineteenth century. The blend of *formatori*, institutions (often named by place), and museum officials as they appear in the inventory reads like a found poem, an ode to the plaster monument: Dresden, Brucciani, Louvre, Kreittmayr, E.B.A, Martinelli, Berlin, Boston, Lelli, Malpieri (L.), Gherardi, Mercatali, Paoli, Arch. Museum, Pierotti, Trocadéro, Massler, Kunsthardt, Darmstadt, Stoltzenburg, Steffensen, Guidotti, Mathivet, Bonï, Rothermundt, M.H.R. (L.), Boschen, Lisbon, Jeladon, Sabatino de Angelis of Naples. By exhibiting the updated productions of all these sources, "New-York was about to realize what has long been the dream of archæologists and artists in Europe," Robinson assured the trustees.[105]

Temporal Cartographies

Back in New York, Edward Robinson's collecting expedition was transformed into an immersive experience of time travel in the Hall of Casts, the Metropolitan's "very center."[106] The committee had proposed that the works be installed "in a building specially constructed to display them under the best conditions of light."[107] Grouped "in a highly impressive as well as artistic manner," the various galleries merged "into one complete display," wrote one reviewer after the opening of the augmented collection in November 1895: "It fills one with awe to go among these reproductions of the great masters of ages gone, nor is one even satiated, though a daily visitor to the halls."[108] At the time, the collection contained more than 2,000 casts, and the close to 2,700 entries in the 1910 catalogue are tagged with traces of Robinson's grand tour—both in the references to the European sales catalogues and in the bibliographical references to scholarship by the museum directors, curators, archaeologists, and art historians he had met with. If an "epitome of the history of art by monuments" in the end could never be fully rendered even in plaster, the proto-catalogue of 1891, in its quixotic ambition of casting and curating the world, became a paradigm in its own right—fulfilling mid-nineteenth-century fantasies of combined inventories of monuments designating a perfectly ordered history.

The Metropolitan collection presented a temporal cartography, of sorts, one that was designed to portray the historicity of architecture by means of reproductions. In contrast to the ahistorical edition of the Temple of Castor and Pollux in Paris, Edward Robinson aimed at showing how architecture changes through time. This was expressed in various ways, such as by styling a monument in double temporalities or by pointing to the contemporaneity of antiquities.

Already with the installation of the Willard collection, the Parthenon was well represented by the exclusive scale model and the full-scale frieze, metopes, and pediment sculptures, purchased from Brucciani & Co. in London. Robinson was ardent in his desire to procure an updated model of the Acropolis as well; in fact he saw this mission as "perhaps the most important of my whole trip."[109] In the *Tentative Lists* he had underscored "Have a new model of the Acropolis made, somewhat larger than that now in the market, about 5 ft. by 3 ft 6 in., which shall show clearly the results of all excavations up to date."[110] The Acropolis model that currently appeared in many collections he deemed "at best only a sketch." It "has been antiquated for some twenty years, by excavations and other alterations in the appearance of the surface."[111] In 1891 Robinson believed that the work at the Acropolis was basically concluded, and that the moment had come for "reproducing its modern appearance."[112] On that point history would prove him terribly wrong; however, Ernst Curtius in Berlin supported the idea of a new model of the contemporary Acropolis to give context to the full-scale reproductions. He introduced Robinson to the sculptor Heinrich Walger, who specialized in relief maps; the geographer J. A. Kaupert, "the first living authority on the geography of Athens"; and Dr. Dörpfeld, the head at the German institute in Athens. "The model," Robinson wrote, "therefore, when finished will represent the combined work of the four most eminent specialists of the present

day in the subject to be treated—Curtius on the history, Kaupert on the geography, Dörpfeld on the significance of local details, and Walger as the artist."[113] Together with the restored scale model and the full-scale Parthenon fragments, this topographical model presented the audience with the contemporary remains of antiquity, archaeology as an agent of historical change, and the ruinous reality of the restoration, as well as the temple sculptures as ever-changing historical documents. This Parthenon apparatus in different scales and temporalities authorized the museum as the one place to fully grasp a monument in time. The experience of time travel was implied in the juxtaposition of the same monuments in different states and times. The spatial organization caused anachronic effects and temporal differentiation, letting lecturers guide the audience through history, in the galleries. "We lift our eyes from the Acropolis in its ruin to the Parthenon in its glory."[114]

The Metropolitan's Choragic Monument of Lysicrates displayed another strategy to give the audience a close look at the work of time. In Paris the full-size Temple of Castor and Pollux stood as an idealized, ahistorical monument. In New York, accompanied by a scale model, the full-scale version of the Greek monument presented two temporal frames. One-half showed "its present condition, the other in what is believed by the best authorities to have been its original state," read a report from the Committee on Sculptures & Casts in 1891: "The two portions are easily distinguished, not only by the difference of the forms and surfaces but by a slight difference in color. All the details were imported either from Athens or from Paris and then copied and repeated in the Museum in sufficient quantity to reconstitute the entire monument."[115] The printed entry rephrased this temporal epistemology: "*Choragic Monument of Lysicrates*, Antique details from E. des B. A. Restored details from E. des B. A. and Met. Mus. Art. (Combined at Met. Mus. Art)."[116] Pointing to the original in "Athens," this inventive curating of the monument—offering the actual and the restored states—was thus an in-house operation made in New York of joint parts signed by the *formatore* Martinelli in Athens, while a section of the frieze was produced in Boston. This representation of two moments in the life of a monument demonstrated the versatility of a plaster monument in its assembly of pieces from different sources, made by casters in different cities, at different times, and depicting different states. Moreover, in contrast to the imagined perfection of the Parisian Castor and Pollux colonnade, this American Lysicrates monument evidenced an archaeological interest that allowed the visitor to move around the cylindrical object, exposed to its historical contingency by means of a temporally dynamic montage.[117]

The work of time was further exposed at the Metropolitan. Important additions among the objects Robinson purchased during his 1891 expedition were the pediment groups from the temple of Zeus at Olympia. They were suggested to him when he spent ten days in Dresden with Georg Treu, who was at the time preparing a publication on the sculptures that had been excavated at Olympia by the Germans from 1875 to 1881. Treu was investigating the pediment sculptures by combining the originals with reproductions of pieces residing elsewhere. He demarcated "the restorations by a pale clay-colored tint so that they may be easily recognized. The result, of course, is a great improvement in the effect of the

Figure 26.
East pediment Temple of Zeus at Olympia over Erechtheion porch. Hall of Casts, Architecture Hall, view facing east, 1909. The Metropolitan Museum of Art, New York.

two groups, which, as you know, were found in a badly broken condition," Robinson reported. Treu promised the Metropolitan reproductions of his restored fragments, to add to those they received from Berlin, where the casts—also from the originals in the museum at Olympia—were mainly produced.[118] In New York, the east and west pediments were hung high on the eastern and western walls of a gallery (figures 26 and 27). "Our casts show them as complete," wrote Robinson.[119] Accordingly, the combination of reproductions and originals in Dresden was translated into a plaster monument of restored and unrestored casts in New York, pointing to the material historicity of monuments and their traveling in time.

Size was also a critical issue in this ambitious architecture museum in New York. Even a few years before the colossal casts of the Parthenon and the Temple of Castor and Pollux were in place in Paris, Charles C. Perkins described the École des Beaux-Arts as an architecture museum, and one that surpassed its rivals with its glass-roofed exhibition hall, of "immense height and lighted from above." "The architectural casts of the same size as the originals produce an admirable effect," he observed.[120] Edward Robinson made some interesting deliberations on the question of "proper size" that might explain why he did not obtain the two gargantuan objects from Paris. Of course, both the Parthenon and the Temple of Castor and Pollux were already well represented by Pierre Le Brun's purchases. In addition to the "Base, Capital and Entablature, Temple of Jupiter Stator, ¼ full size," the Metropolitan held several other full-scale pieces from the temple ruin. During Christmas 1891, some "very important" items arrived, among them "a section of the full sized Entablature and half capital of the Temple of Jupiter Stator, Rome."[121] Further "Antefix, Temple of Jupiter Stator," "Frieze, Temple of Jupiter Stator," and the "Fragments from Entablature, Temple of Jupiter Stator, Reduplicated and combined at Met. Mus. of Art," were all bought from the École, respectively, for 3½, 12 and 833 francs.[122] That the last of these was "reduplicated" and combined in New York again testifies to the adaptability of the serialized reproductions, in their capacity not only to be mounted differently in different spaces but to be modified and styled in new contexts as well. Further, the replication established a topomimetic connection between Paris and New York in the positioning of the grandest monuments of the Doric and Corinthian orders, which faced each other across the Cour vitrée: "A portion of the entablature of the Parthenon at full size occupies the space on the east wall opposite the entablature of the so-called Temple of Jupiter Stator" (figure 28).[123]

Robinson particularly revealed his ideas on the proper size of monuments in the galleries in regard to the Assyrian temple-palaces. While in London he was eager to obtain what he referred to as chief objects, namely, the colossal winged lion and bull that marked the entrance of the Nineveh gallery at the British Museum. They were invaluable for the Metropolitan "both for decorative purposes—placed at either side of the entrance to an Assyrian Room," and, more importantly, "because there are no other pieces in any museum so well adapted for giving a conception of the colossal side of Assyrian art without being so large as to overpower everything else in their department."[124] This invocation of overpowering objects might be understood as a reference to the two mammoth casts at the École des Beaux-Arts as well as to the Trajan's Column in the Architectural Courts

HALL OF CASTS — LOOKING EAST THE METROPOLITAN MUSEUM OF ART

Figure 27.
West pediment Temple of Zeus at Olympia. Hall of Casts: Architecture Hall, view facing west, 1915. The Metropolitan Museum of Art, New York.

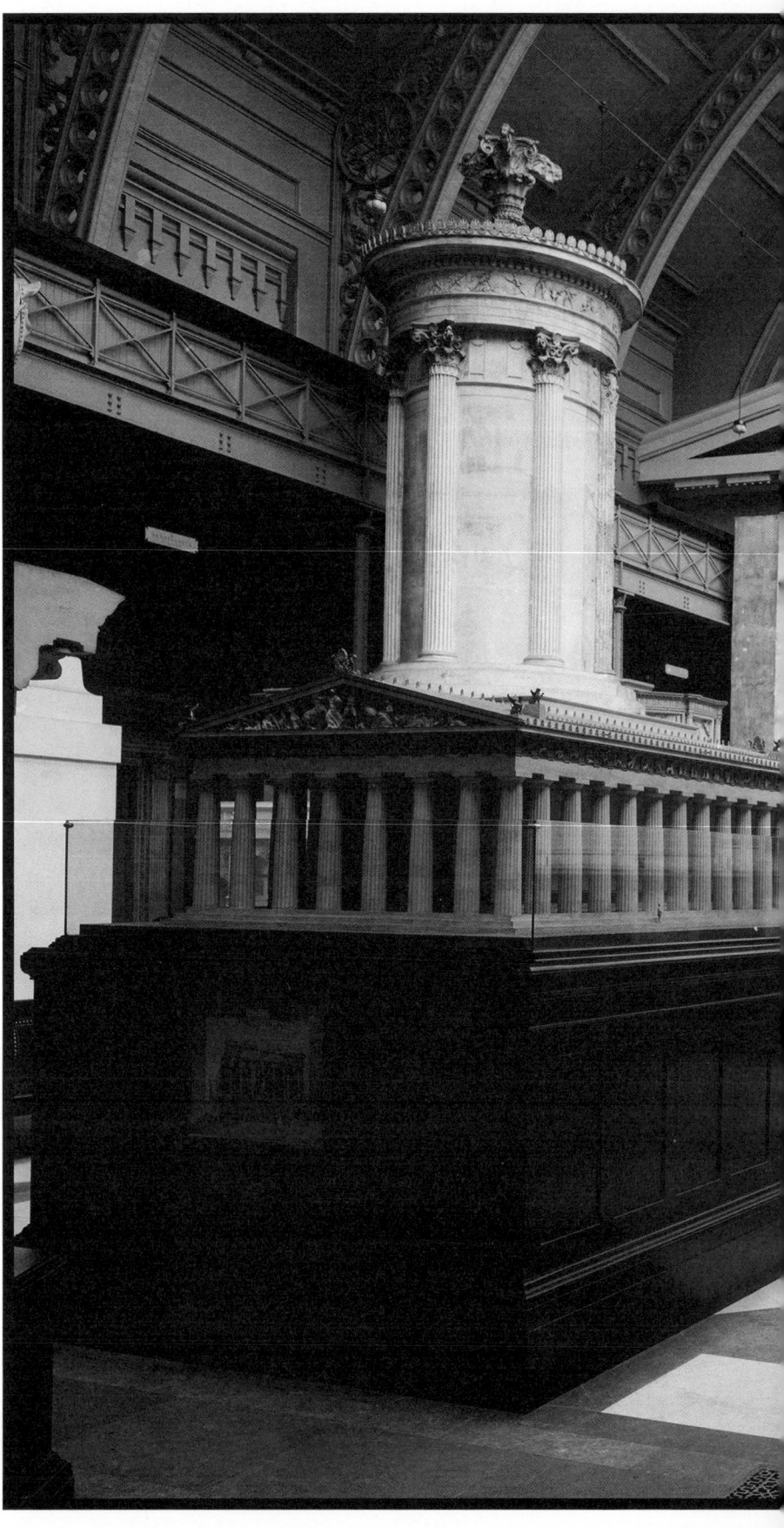

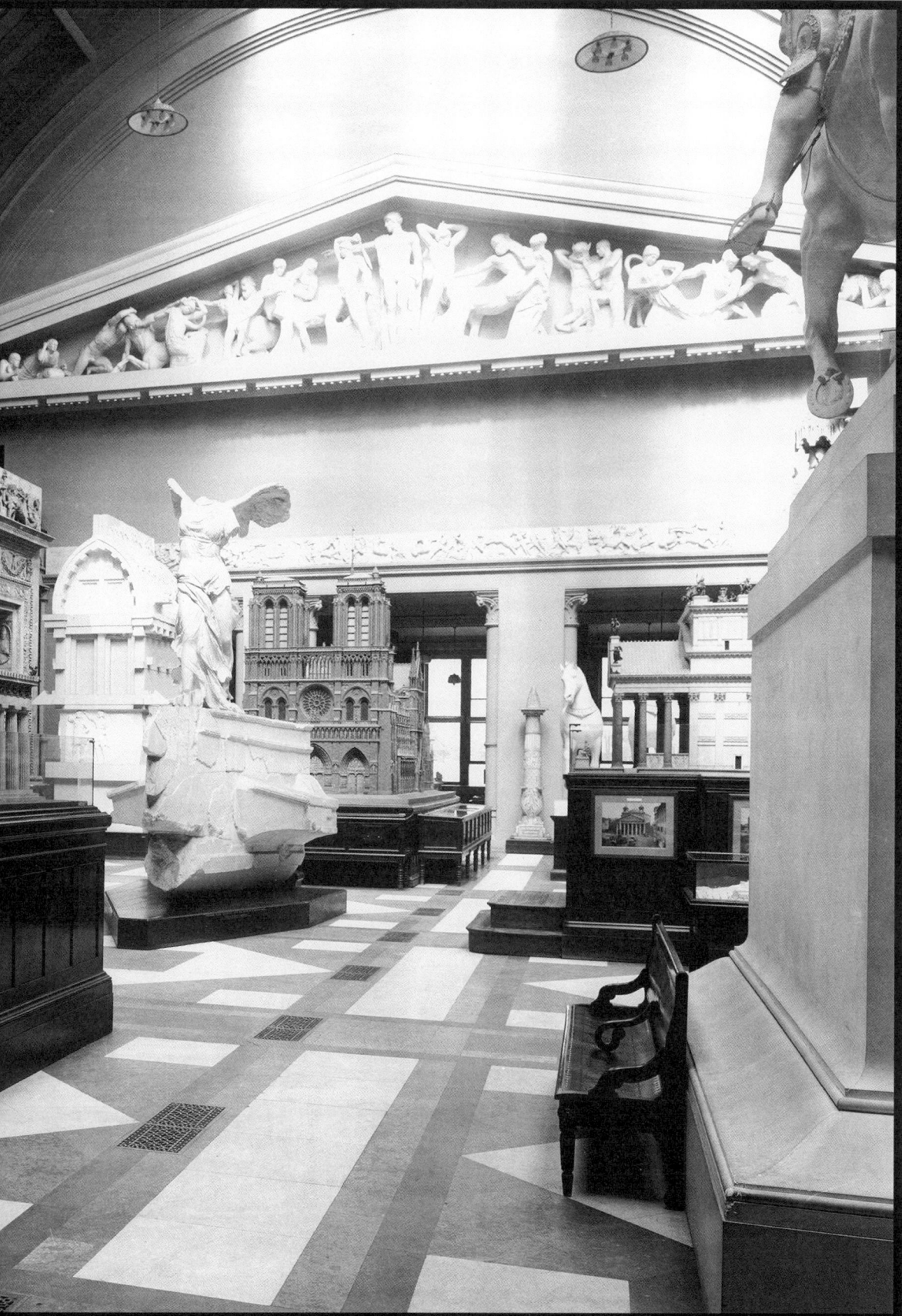

Figure 28.
Temple of Castor and Pollux, entablature and capital, gallery of casts (first floor, wing A, gallery 38), 1913. The Metropolitan Museum of Art, New York.

at the South Kensington—the latter never appeared in Robinson's monument deliberations. The architecture collection Robinson perfected for the Metropolitan Museum of Art came close to fulfilling the prospectus for an ideal architecture museum James Fergusson outlined in 1857. Fergusson envisioned a museum of monuments on a "proper scale," objects whose real dimensions would be emphasized in the constellation of full-scale casts, scale models, and photography. This was exactly what transpired in New York, in a collection that aimed at showing the work of time in the monuments of the past, without including objects that in their hugeness eclipsed their monumental environments.

Scaffolded Visibility

"I would particularly desire to direct the attention of amateur photographers to this task; earnestly requesting them to bear in mind that while a photograph of a landscape is merely an amusing toy, one of early architecture is a precious historical document," John Ruskin instructed the readers of *The Seven Lamps of Architecture*, a decade after the invention of the daguerreotype.[125] Shots of historical architecture, Ruskin stipulated, "should be taken, not merely when it presents itself under picturesque general forms, but stone by stone, and sculpture by sculpture." The advice given was both practical and risky, bearing in mind the weight and vulnerability of mid-nineteenth-century photographic equipment. To photograph "early architecture" stone by stone, sculpture by sculpture, required more than moving about on the ground. Accordingly, Ruskin encouraged the first generation of amateur photographers to look out for ancient buildings wrapped in scaffolding, "seizing every opportunity afforded by scaffolding to approach it closely," and to climb with the camera and shoot until all "details are completely obtained."

Photographic depiction changed the perception of architecture. So did the casting of the monuments of the past. Comparing photographs to casts, Ruskin saw both reproductive media as indispensable. Yet casts were more important for the preservation, reproduction, and dissemination of historical architecture: "It would be still more patriotic in lovers of architecture to obtain casts of the sculptures of the thirteenth century, wherever an opportunity occurs, and to place them where they would be easily accessible to the ordinary workman. The Architectural Museum at Westminster is one of the institutions which it appears to me most desirable to enrich in this manner."[126]

In 1760 George Dance and Piranesi climbed the scaffolded Castor and Pollux ruin at the Roman Forum, as did Ferdinand Dutert in 1870. Their close look at details resulted in two- and three-dimensional reproductions of the monument that traveled the world in various media, scales, and times. The two gentlemen in hard hats rebuilding the temple in the 1970s share the benefits of scaffolding with Dance, Piranesi, and Dutert. They have a palpable advantage over the grand tourist, in his top hat, climbing a flimsy ladder propped against the same monument in Henry Parke's watercolor (figure 29 and see figure 14). But what they are looking at in close-up is similar to what Soane had Parke depict. The two twentieth-century monument builders take their place in a proud lineage

Figure 29.
Rebuilding the Castor and Pollux colonnade, Versailles, 1975–76.

of monument climbing, with a view of the real thing, just as Ruskin had recommended, from a stable scaffold. Climbing monuments during restoration work is, however, as the grand tour once was, a joy and a thrill for the happy few. Cumbersome and even dangerous as such ascents can be, it is more convenient to see architecture in a museum, in tempered, curatorial environments.

If scaffolding creates a privileged state in which to find monuments, it also provides a privileged condition for domesticating architecture into museum exhibits, transitional moments at which to zoom in on lavish building parts. In France, the restoration of French medieval monuments under the auspices of the Commission des monuments historiques produced fragments of a national heritage, first displayed in Paris, before the serialized monuments began their journey through the province of

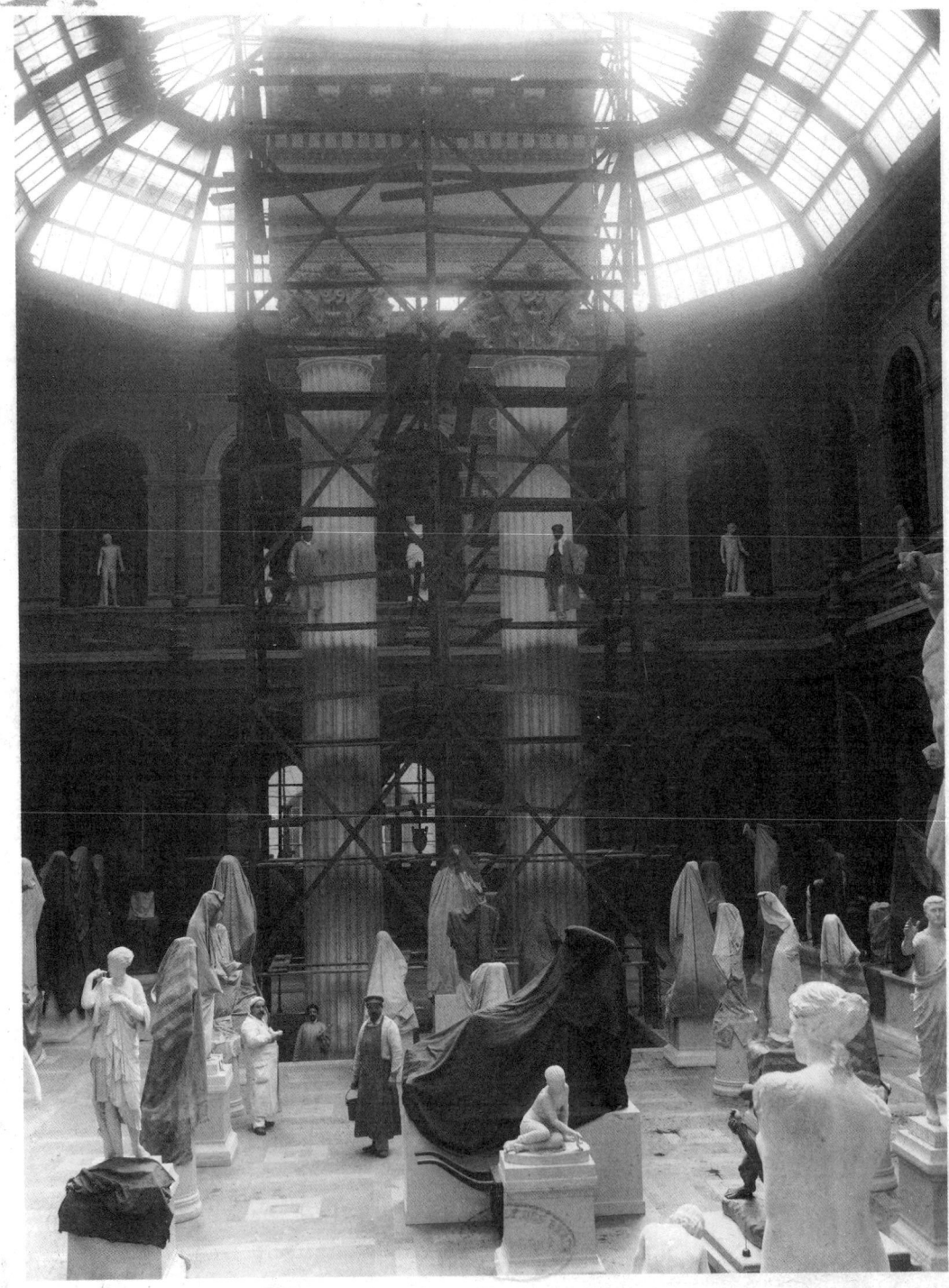

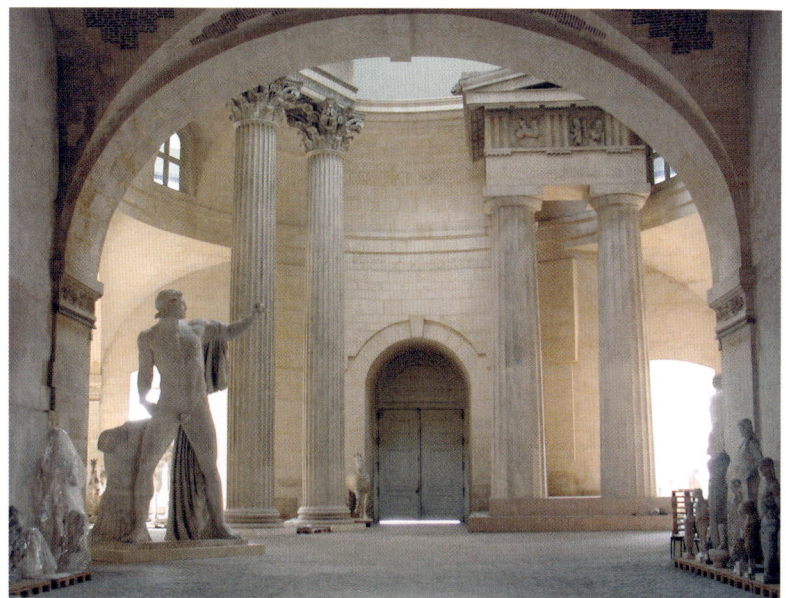

Figure 30, opposite.
"La Cour vitrée: installation des colonnes monumentales après 1870." École des Beaux-Arts, Paris.

Figure 31, left.
The Parthenon and the Castor and Pollux colonnade at Versailles, today.

reproductions. Monument restoration provided "opportunities for casting operations, without additional cost for erecting scaffoldings."[127]

The two workers in hard hats have an exclusive closeness to the enormous Corinthian plaster monument, one they share only with its original builders a century earlier. Reconstructed to a state outside historic time and place, it nonetheless has a very specific time and place. A nineteenth-century Beaux-Arts invention, devised in Rome and materialized in Paris, the last journey of this Roman ruin is quite a recent one. Conceived as a symbol of a repressive pedagogical regime, this imaginary though very real version of the Temple of Castor and Pollux was threatened with ruin during the political uprisings of 1968, yet another episode in the French tradition of monument vandalization.[128] After a century at its place of origin in Paris, it was dismantled for transportation and traveled, with the corner of the Parthenon as well as approximately fifteen hundred casts, to storage in Versailles. There it was resurrected in the mid-1970s in the cupula of the Petite Écurie that Jules Hardouin-Mansart designed for Louis XIV. It took Ernest Coquart, with world-class molders, almost three years to build it in the Cour vitrée in the 1870s, and two years to reerect it a century later (figure 30). Since Henry Parke had to go all the way to Rome to find the monument in its (fictitious) reality, the French monument has become portable. Today, in Versailles, the upper galleries allow for close-up study very different from what we see when admiring the ruin at the Roman Forum (figure 31).

Seeing the Parthenon fragments in London in 1818 made Quatremère de Quincy realize that architecture is best understood in the museum. The first installation of the Elgin Marbles enabled inspection of Illios, Helios, Dionysus, Iris, and the head of Selene's horse from all sides, for the first time, while the frieze and metopes, hung at eye level, gave visitors an intimate vantage to study the marbles in detail. Not only a ladder but a torch would have been required to see the Parthenon frieze at the Acropolis, placed twelve meters above the stylobate and always obscured

Travels in the Province of Reproductions

Figure 32.
The museum corridor with capital and other pieces from the Temple of Castor and Pollux. Sir John Soane's Museum, London.

by shadows, hidden behind the columns carrying the entablature with the architecturally integrated metopes, and only indirectly lit by reflected sunlight from the marble wall below. A close-up of what had survived of the pedimental sculptures would have demanded an even higher climb. "In architecture, a fragment of a cornice and an entablature is enough to re-establish the whole," stated Quatremère when contemplating the Parthenon indoors, in pieces.[129] The same is true for the experience of seeing the capital and entablature of the Temple of Castor and Pollux in the narrow corridor in Sir John Soane's Museum, compared to the effect those elements have on the visitor strolling through the Roman Forum (figure 32). The imagination fills in missing pieces, Quatremère observed, while the intact object in situ "offers the mind a determinate image: there is nothing further to see."[130] While pointing to the evocative power of the portable monument, Quatremère anticipated the program of the full-scale architectural collections in Europe and America later in the century.

Chapter 2

Trocadéro: Proust's Museum

Figure 33.
Twelfth-century gallery, Trocadéro. From Paul Frantz Julien Marcou, *Album du Musée de Sculpture Comparée*, vol. 1 (Paris, 1897).

Marcel Proust's *In Search of Lost Time* was written and published as the tide was turning against the plaster monuments.[1] Prominently placed in the novel's museum—abundantly furnished with factual and fictional works of art and architecture—resides a plaster portal cast from a medieval church in Normandy, which is only partly imaginary. The scene in question revolves around one of the first and most compelling objects of desire introduced in the novel and captures with emblematic power the disappointment that governs the logic of desire played out in Proust's aesthetics.

"The church at Balbec, built in the twelfth and thirteenth century, still half Romanesque, is perhaps the most curious example of our Norman Gothic, and so singular! It is almost Persian in style!"[2] This first mention of the church appears in the opening volume, *The Way by Swann's*, published in 1913. In addition to calling it "singular" and "most curious," the condensed characterization provides the little medieval structure with three stylistic epithets. The suggestive portrayal is articulated by the connoisseur and art collector Charles Swann—who studied architecture for ten years, specializing in the study of historical monuments and particularly French medieval architecture—a detail that has not received much attention in Proust scholarship.[3] For the young Marcel, Swann's alluring evocation spurs a wild desire to see this extraordinary architectural work, a longing cultivated for years before his grandmother finally takes him on his first of several trips to Balbec for a summer holiday. Preparing himself for the encounter with the real thing, Marcel studies the Balbec portal in what in the novel is referred to as the Trocadéro Museum (figure 33). Here, at the Musée de sculpture comparée, Marcel undergoes one of his formative aesthetic experiences, an experience that prepares the ground for one of the most profound disappointments in the novel's endless series of disappointments, caused by the collision of expectation and reality (figure 34).

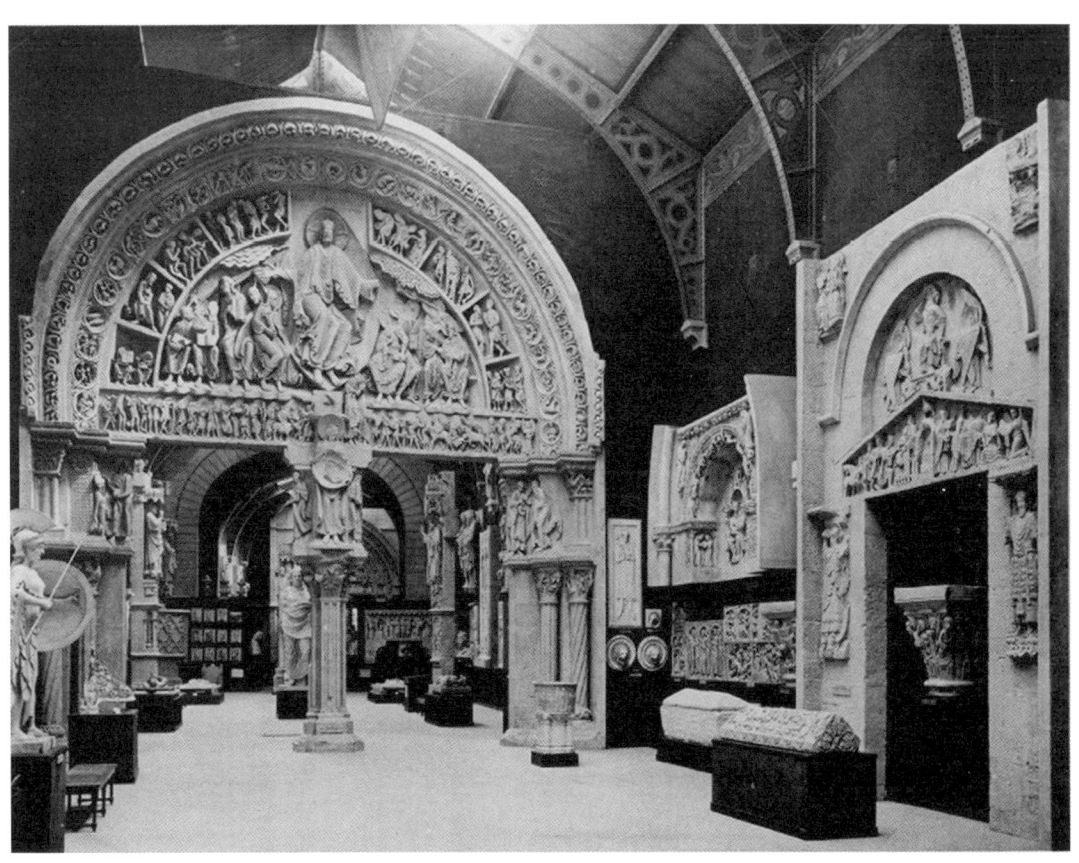

Figure 34.
Young boy, Marcel's age, admiring a plaster portal at the Trocadéro, Paris, 2007.

Figure 35.
Claude Monet, *The Saint-Lazare Station*, 1877. Oil on canvas.

Proust's placement of this museo-theoretical drama is noteworthy. It is played out in the two sections entitled "Place-Names: The Name" and "Place-Names: The Place." Within the novel's intricate structure, Proust separates the two "Place-Names" parts by hundreds of pages. The first serves as an appendix to *The Way by Swann's*, while the second is the title of the last of two parts that together form *In the Shadow of Young Girls in Flower*. Thus the anticipations, repetitions, variations, and reverberations at work in altogether fewer than thirty pages become tremendously effective. It is also worth noticing that the (imagined) plaster cast of a church (also imagined) is interwoven in a sumptuous web of real and fictional works of art and architecture. This department of Proust's *musée imaginaire* comprises movement, from the city to the coast, from the copy to the original—and back again.[4]

Already at Gare Saint-Lazare, where Marcel and his grandmother are waiting to depart on an epic journey toward Normandy, Claude Monet's recent series of paintings from the same Parisian train station springs to life in a striking ekphrasis (figure 35). Monet's thunder-gray, almost abstract vision of locomotives and steam under vast, glass-roofed ceilings leads the thoughts of the excited traveler in unexpected directions. The modern structure of steel and glass hidden behind a Parisian Beaux-Arts façade transcends both time and space. The "huge glass-roofed machine-shop" acts as a canvas on which were "spread out one of those vast bleak skies, dense with portents of pent-up tragedy, resembling certain skies of Mantegna's or Veronese's, fraught with their quasi-Parisian modernity, an apt backdrop to the most awesome or hideous of acts, such as the Crucifixion or a departure by train."[5]

En route toward the coast the train compartment turns into a hypersensitive optical apparatus. A scenic landscape of forests, meadows, and villages "smeared with the opal glow of darkness" appears under a sky tinted by clouds, with the sunrise projected as on screens onto the glass windows. The result is a depiction that oscillates between picturesque landscape painting and psychedelic-cinematic movement. Marcel keeps running back and forth, from side to side of the compartment, anxious to reassemble in one continuous image the "intermittent fragments of my lovely, changeable red morning," and to obtain a comprehensive view, a "single lasting picture."[6]

The seventeenth-century epistolary author Madame de Sévigné's memoirs are consulted when necessary—that is to say, constantly. Passages depicting the diva La Berma, modeled on Sarah Bernhardt, vivify the art of theater. As on many occasions, Françoise, the faithful, aging family maid, sparks associations with exquisite artworks. Dressed in a faded cerise-colored and fur-collared coat, she "would have delighted one in a portrait

by Chardin or Whistler."[7] The evocation of James McNeill Whistler prefigures the impressionist Elstir (a partial Whistler anagram) whom the young traveler shall soon befriend in Balbec. Appearing as an amalgam of Whistler, Monet, Turner, and Vermeer, Elstir's urban-maritime tableaus from the Norman seaside will become the basis for the theory of artistic creation, relying on metaphor and metamorphosis, that is core to Proust's aesthetics. Prior to the departure from Paris, Marcel's mother encourages him to take inspiration from "the delighted traveler that Mr. Ruskin writes about."[8] John Ruskin's name anticipates another fundamental yet constantly postponed journey, long before Venice rises through a flow of epiphanies from the cobblestones in the courtyard of a Parisian palace in the final volume. Open and discreet references invoke a future Venice as place and imagination, drawing on Ruskin, Turner, and Whistler, accompanied by Carpaccio, Titian, Veronese, Gentile and Giovanni Bellini—not to mention the avant-garde designs of Mariano Fortuny, whose lush textiles and couture are woven into Proust's palimpsest, and anticipate reverberations back and forth between Balbec and Venice. Indeed, an elaborate aesthetic fabric forms the backdrop for Proust's museum philosophy, in which a cast from the Trocadéro in Paris is placed center stage.

The Tyranny of the Particular

Heading toward Balbec, Marcel, tormented by the departure from home, becomes hysterically expectant at the promise of encountering the totality from which the plaster fragment in Paris is derived. To relax him, the family doctor has recommended "beer or brandy" for the young boy in order to calm his nerves and enable him to arrive "in the state he called 'euphoria', in which the nervous system is briefly less susceptible."[9] But not even a generous dose of brandy can set a hypersensitive mind at rest, and euphoria certainly cannot mitigate the brutal clash of imagination and reality. For, finally in front of the church, in this long-awaited moment, Marcel unexpectedly finds himself desperately yearning for the museum in Paris. He immediately realizes that the original does not measure up to the copy. Not only is the church trivialized by its surroundings, by prosaic elements such as a square, a café, a billiard saloon, a bank, a bus station, streetlights, and trams. Marcel is also discouraged to discover that it is located in Balbec-en-Terre and not, as he believed, in Balbec-Plage, "soaked by the spindrift blown from the tumultuous deep," inseparable from the steep Norman topography and built of stone quarried from "wave-washed cliffs."[10] Marcel expected the real church—"the church itself, the statue in person, the real things!"—to be more imposing than the plaster monument in Paris. It turns out to be "much less."[11] Most aggravating of all, the original, as Proust puts it, is reduced to "nothing but its own shape in stone."[12] The church has absolutely nothing of the aura that is normally ascribed to the unique, the particular, the original. While the plaster portal in Paris appeared universal and immortal, endowed "with a general existence and an inaccessible beauty," the real building with its meticulously sculptured doorway appears to Marcel as "a little old woman in stone, whose height I could measure and whose wrinkles I could count."[13] Whereas the cast is perfect

and unalterable, the stone version is the victim of time and reality. It is caught in "the tyranny of the Particular."[14] While the gallery offered the perfect curatorial setting for the plaster portal, the deteriorating church is lost in context and smothered by its milieu—contaminated by smell ("from the pastrycook's kitchen"), by natural, uncontrolled light ("the rays of the setting sun"), by dirt ("stained by the same soot as the neighbouring houses"), and also by its tangibility. Marcel even fantasizes about tagging his name on the stone.[15]

At more or less the same time, in the nonfictional world, while campaigning to get rid of the plaster casts at the Museum of Fine Arts in Boston, assistant director Matthew Prichard underscored the discrepancies between a reproduction and its original. Insofar as casts were still to be tolerated in the galleries, he recommended that they be accompanied by labels firmly warning the audiences: "So true is this that the one thing possible to predicate of every cast, which might indeed be inscribed under each in a museum, is THE ORIGINAL DOES NOT LOOK LIKE THIS."[16] Marcel Proust would have subscribed to Prichard's warning, spelling out in capital letters the epistemological differences between the original work and the reproduction. However, the fact that the cast looked nothing like the original led Proust to the opposite conclusion with regard to value. To Proust, the reproduction looked much better than the original church. Fragmented, decontextualized, and translated—in time, place, discourse, and materiality—the cast testified to a more truthful version of the original than the original itself could ever present.

In the late 1970s, Arthur Drexler, the architecture curator at the Museum of Modern Art in New York, discussed scale models in three distinct modes. Models, he claimed, either described "a building as it actually will be; as it will be perceived; or as it ought to be perceived." Mounting, at the peak of postmodernism, a seminal show on Beaux-Arts architecture in an American epicenter of modernist art, he was rehearsing the differences between Beaux-Arts and modernist representational conventions. Drexler concluded that the "fundamental preoccupation of our time" is with the building as it ought to be conceived, "telling us what to look for and how to see it." As such, he suggested that the model's power to govern the perception of the viewer underpinned the rupture between the model as a projected image and its promised future building, and hinted at the autonomy of any architectural model. More importantly, when discussing models by Mies van der Rohe and Le Corbusier, Drexler claimed that modern architecture had striven to dismiss actualities of perception such as "physiological limitations of sight, the fortuitous associations individual participants carry in their heads, and such arbitrary but predictable interventions as moonlight and fog"—all such trappings of "sentimental concern of literary culture."[17] Proust, an exponent of modernist literary culture, had arrived at a similar conclusion from a different direction. Physiological and psychological preconditions, private, accidental associations, anything that could be captured in a poetics of "moonlight and fog" (history and time certainly belong to this category) are in Proust properties of the real building, always already caught in a web of uncontrollable circumstances subjected to the "tyranny of the particular." As a full-scale model the cast could leave all that behind. In the novel the plaster reproduction presents the true essence of the building,

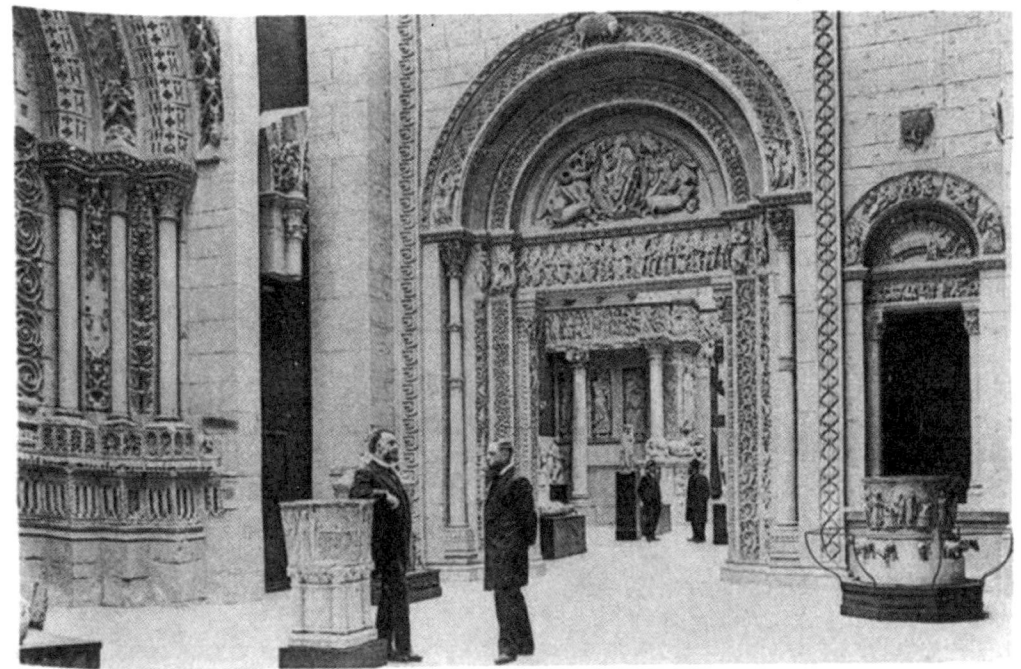

Figure 36. Twelfth- and thirteenth-century galleries, Trocadéro. From Camille Enlart and Jules Roussel, *Catalogue Général du Musée de sculpture comparée au Palais du Trocadéro (moulages)* (Paris, 1910).

in a controlled curatorial environment, as the ideal way and place to see architecture as it ought to be perceived, without poetical idiosyncrasies interfering in its perception.

Read as fiction, the stylistic consideration of the Balbec portal's sculptural program conjures a twofold ekphrasis—effectively bringing the perfect reproduction as well as the dilapidated, disappointing medieval church to life for the reader. Yet read historically and institutionally, the cast reveals itself as not only an object lifted from the Parisian collection. The remediation at work turns out to be more intricate than a straightforward translation from a (fictional) stone building to an (imagined) plaster cast. The perception of both the cast and its referent is in alignment with the intellectual culture governing the Trocadéro Museum. As Marcel would acknowledge in Balbec, a cast displayed under ideal conditions allowed for in-depth analysis and the appreciation of details undisturbed by the trivialities of the real world. That is why the encounter with the real thing became so traumatic. Corrupted in both time and place, the "original" was nothing but a reduction in stone compared to the flawless plaster version with which he had fallen in love. If the brutal collision of the real and the imagined is typical for Proust, the conflict between a deteriorating original outside curatorial control and a perfectly mounted reproduction mirrors in detail the historical, scientific, and aesthetic objectives of the Musée de sculpture comparée. Proust's receptivity to the reproduction would certainly have pleased the founders, architects, restorers, artists, molders, directors, curators, archivists, and photographers involved in what became one of the most influential collections of plaster monuments, and in which exquisite reproductions of portals from French medieval churches formed the core (figure 36).

Viollet-le-Duc's Museum

From its conception, the museum at the Trocadéro promoted the benefits of plaster far beyond the often-stated opinion that a good reproduction is more valuable than a poor original. The museum posed a number of interesting questions regarding the possibilities of displaying architecture in the museum, involving theories of history, historicity, origins, authenticity, and temporalities. There is no reason to distinguish between the work itself and its reproduction, stated the 1892 *Catalogue raisonné*, maintaining that a cast has "the complete scientific value of the original and thus deserves to be examined with the same interest."[18] Scholarship on French architecture through the centuries might in fact be better done in the galleries, as the fragments seen together revealed affinities, relations, and influences undetectable in the fragmented reality of the real world.[19] Camille Enlart, director of the museum from 1903 through 1927—trained at the École des Beaux-Arts before specializing in Romanesque and Gothic architecture—stated that a good cast was preferable to any original. Summing up the first three decades of the institution, he reiterated the museum's raison d'être: a perfect cast is not only "plus exact que l'original," but is in its plaster perfection closer to the monument's moment of origin, and thus in a sense closer to the original than the original itself.[20]

By the time the museum was finally incorporated in 1879, Eugène-Emmanuel Viollet-le-Duc had for decades—together with a group of molders, architects, restorers, and artists—been involved in various initiatives for establishing a national museum of French monuments. In 1848 they presented a petition to the General Assembly, proposing a museum of reproductions made during restorations of medieval monuments, and in 1855 the idea of a museum of casts of the most beautiful French monuments of the twelfth and thirteenth centuries was relaunched. Despite its slow realization, the enterprise never left Viollet-le-Duc's mind, and in the 180-page entry "Sculpture" from 1866 in his *Dictionnaire raisonné de l'architecture* the idea was further developed. He recommended special galleries for casts of antique and medieval sculpture to show how art in all epochs developed according to certain identical principles, and the comparative scheme was fully worked out. For instance, he suggested that works from Periclean Athens shown in parallel with French Gothic architecture would reveal striking analogies "not only in form but in execution," as "numerous points of contact unite those two arts," despite their differences in expression (figure 37).[21] He added that in the 1850s, French Gothic statuary had been sent to England, and that the same casts had been unsuccessfully offered gratis to establish a museum for comparative sculpture in Paris.[22] The entry on sculpture—which reads like a blueprint for the museum's many catalogues—repeatedly promotes medieval art and architecture as a harmonious whole, with the portals of the Chartres Cathedral serving as a principal example of the inseparable alliance of the two arts.[23] Unlike the best Greek works, including those by Phidias, French masterpieces provide no clues as to where the sculptor's work ends and the architect's starts: "the result is like a fabric made by the same hand."[24] He insisted that works of the twelfth and thirteenth centuries rivaled those of Greek antiquity, and, importantly, that the development in French architecture, from the earliest periods to the Renaissance,

followed the phases that Winckelmann had identified in Greek art: childhood, adolescence, maturity, and decline.[25]

With the French tradition at its core, the museum's outlook was global and moored in an overarching theory of cultural, political, and aesthetic development based on influence and affinities across time and place. The audacious temporal displacement of Greek architectural development to French soil involved a broad historical panorama, drawing on theories of race and migration, allowing, for instance, speculations on resemblances between Hindu and Scandinavian ornaments of a certain "origine nord-orientale."[26] If the outlook was grand, it was also in-depth and detailed, with careful explanations of profound variations in French regions and schools, the result of different sources of inspiration and pollination. Overall, however, an "entirely French" force was defined: the architects of the Middle Ages made themselves "neither Greek, Roman, Byzantine, nor German," resulting in a quality deserving "a high rank in the history of art."[27] A full, physical demonstration of this original French contribution to the history of art and architecture and its particular evolutionary schemes could clearly be displayed only in the form of reproductions.

During the decades prior to the establishment of the Musée de sculpture comparée, unsuccessful efforts had also been made to have a number of plaster monuments—cast during restorations authorized by the Historic Monuments Commission—included in the major cast collection in Paris, at the École des Beaux-Arts. Unsurprisingly, the epicenter of Beaux-Arts training persistently refused to include medieval casts in its collection of Greek, Roman, and Renaissance works, or to historicize the canon with works from periods seen as transitional. Moreover, French vernacular structures had no place amid the masterpieces of the classical canon.

The entry for "Sculpture" from the *Dictionnaire* is saturated with critique of the École. Viollet-le-Duc noted that neither Greek antiquity nor the French Middle Ages needed academies, museums, or committees giving awards and medals. Art was a need of life and flourished everywhere.[28] The entry for "Restoration" embodies an even more explicit critique of the "veritable fanatics" who had monopolized the past by excising "entire chapters," and declaring "that humanity only produced works worth preserving in certain historical periods."[29] Here, Viollet-le-Duc quotes extensively from a report the first inspector-general of historical monuments, Ludovic Vitet, had submitted in 1831 to the minister of the interior, defying "experts'" claims that there was hardly any art of notable value in France before François I. Central to the rediscovery, recovery, and reappropriation of medieval monuments as French heritage, Vitet's argument serves as a textbook example of the phenomenon of inventing tradition as a modern, national project: "we have to recognize that at the end of barbarism there did arise in the Middle Ages a great and beautiful school of sculpture which was heir to the methods and even to the style of ancient art. Even so, this medieval school was also already a modern school, modern in both its spirit and in the effects it produced."[30] The "Restoration" entry from the *Dictionnaire* is a meditation on history, aligned with new historical disciplines such as comparative anatomy, historical geology, anthropology, ethnography, archaeology, and philology: "Our age has wished to analyze the past, classify it, compare it, and write

Figure 37.
The Erechtheion caryatid purchased from the British Museum displayed in the twelfth-century gallery, adjacent to the smiling angel from Reims Cathedral. From P. F. J. Marcou, *Album du Musée de Sculpture Comparée*, vol. 2 (Paris, 1897).

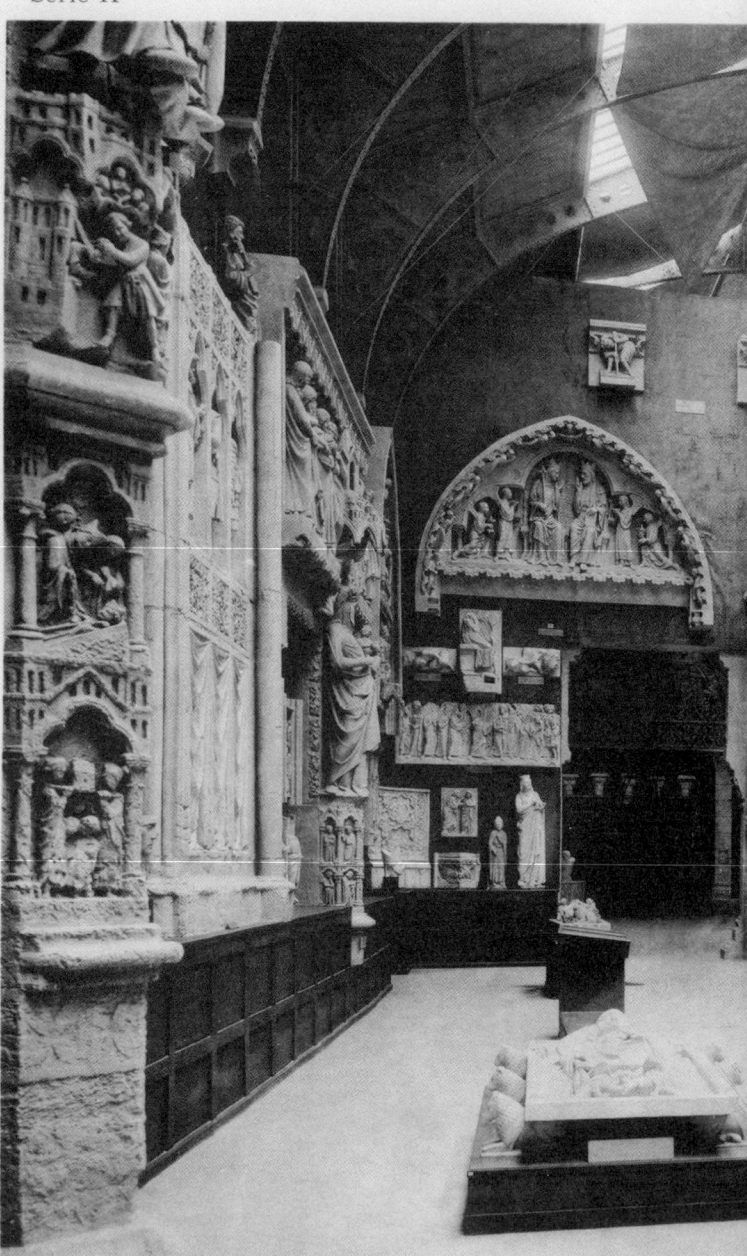

XIIIᵉ Siècle

Pl. 81

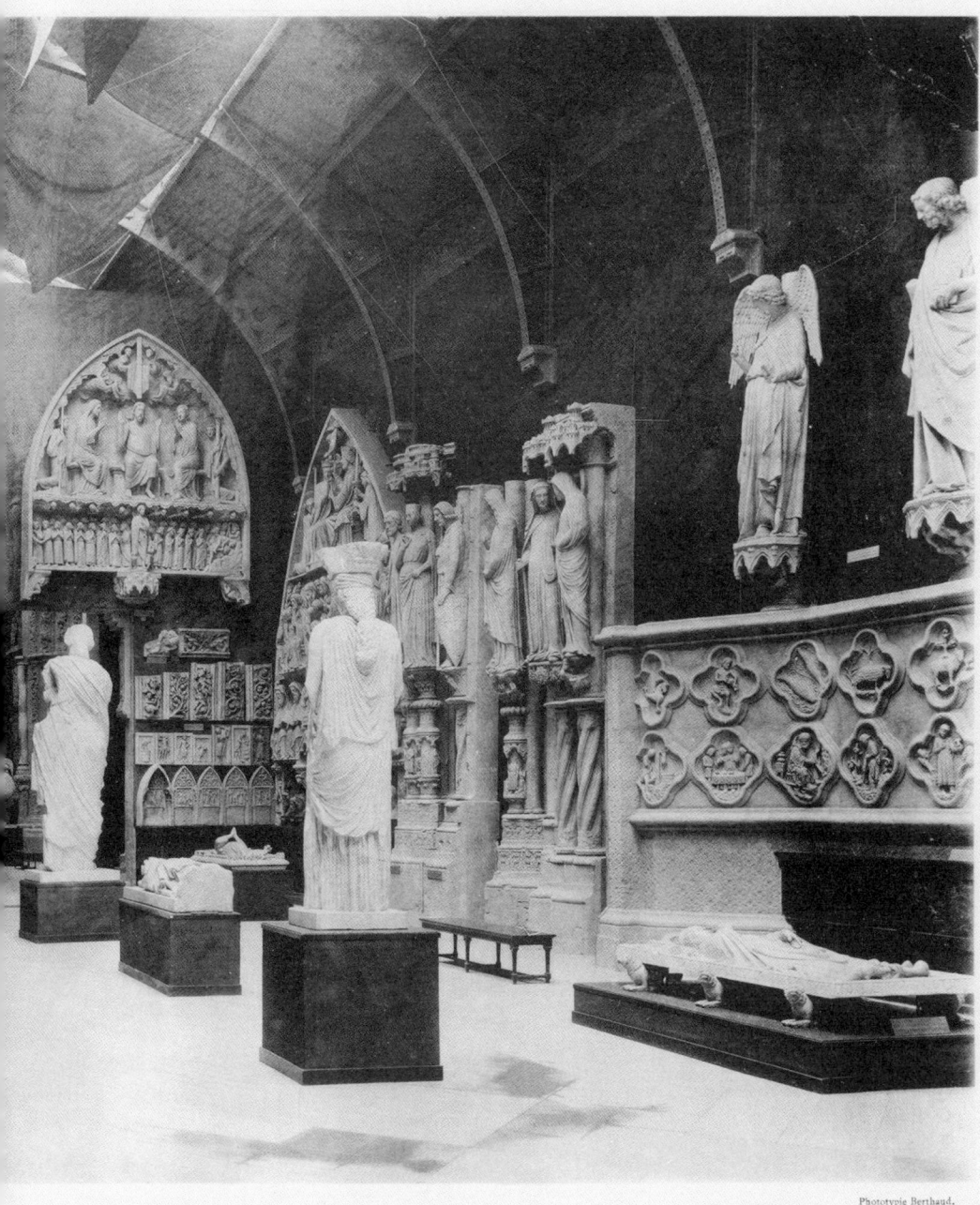

Phototypie Berthaud.

E DE SCULPTURE COMPARÉE

its complete history, following step-by-step the procession, the progress, and the various transformations of humanity."[31] Again, the display of architecture as a continuous progress could be realized only in plaster, in well-ordered collections of prominent editions: "Europeans of our age have arrived at a stage in the development of human intelligence where, as they accelerate their forward pace, and perhaps precisely because they are already advancing so rapidly, they also feel a deep need to re-create the entire human past, almost as one might collect an extensive library."[32]

The animosity between Viollet-le-Duc, championing French patrimony, and the École des Beaux-Arts is well known. When the architect-restorer was appointed professor at the École in 1864 and arrived to deliver his inaugural lecture accompanied by his friend Prosper Mérimée (the inspector-general of historical monuments from 1834), he was met by students and faculty throwing eggs and apples, bellowing "cock crows, elephant trumpets, lion roars, hen clucks, donkey brays."[33] The result of this antagonism between the two principal hegemonies in French nineteenth-century historicism—the national, regional, and local camp of medievalists and restorers versus the neoclassical bastion at the École—was that Paris got two distinct, paradigmatic collections of plaster casts. Both became tremendously influential, not least by providing the international market with casts manufactured in their workshops. The Trocadéro Museum, in particular, offered casts not available anywhere else.

The Palais du Trocadéro, designed by Gabriel Davioud and Jules Bourdais for the 1878 Paris Exposition universelle was left empty after the exhibition closed down. The following summer Viollet-le-Duc wrote two reports outlining the foundations of a "Musée de sculpture comparée" that in "un ordre méthodique" would display the evolution of art of different civilizations and rehabilitate medieval architecture by showing the most indigenous French works.[34] In November 1879 Jules Ferry and Antoine Proust, ministers of interior and education and the fine arts, respectively, acquiesced, and casts made during restoration works in recent decades under the auspices of the Historic Monuments Commission were installed in the high-ceilinged galleries in the eastern wing. In May 1882 three galleries were inaugurated. The museum's "véritable père" did not live to see the audiences admiring the result of his grand plaster vision—his successors compared him to Moses, who did not live to see the Promised Land—but his influence in the galleries and in the catalogues remained palpable.[35] The following year two more galleries were furnished, and in 1886 the seventeenth- and eighteenth-century galleries opened. It was thus a new and fashionable Paris museum that the young Marcel, within the framework of Proust's novel, recurrently visited during the 1890s. Furthermore, it was a museum that addressed experts and popular audiences on the same level. From its first catalogue, published in 1883, the museum's publications persistently aimed at guiding visitors through the history of French monuments as well as through the galleries.

New casts kept arriving in great numbers, and the galleries were soon filled to the brim. When it was decided that the museum should be part of the 1889 Exposition universelle, the western, so-called Passy Wing was also allotted for the collection. More monuments were installed, and even more for the *Exposition retrospective de l'art français*, organized by the commission in 1889, including a number of scale models made by Anatole

de Baudot, who taught restoration at the museum. The museum faced increasing difficulties in finding room—and the *right sort* of room—for a constantly expanding French canon. In 1900 the exterior galleries toward the Champ de Mars were glassed in and used as exhibition spaces.

The Musée de sculpture comparée was conceived for exhibiting series of masterpieces, facilitating a comparison and a comprehensiveness of French monuments impossible in the real world. The only museum run under the patronage of the Historic Monuments Commission, it was an act of preservation in its own right. Documenting the works of the past for the future, the commission also amassed stocks of building parts that could be incorporated into more perfect wholes. In regard to the portal of the church of Moissac, additional fragments were cast later on, "to reconstruct the portal as a whole in the museum."[36] As a preservation initiative, the museum echoed the new historical sensibility captured in the young Victor Hugo's war on the demolition of the ancient monuments of France from 1825, and in Baron Taylor's *Voyages pittoresques et romantiques dans l'ancienne France*, published in twenty-four volumes from 1820 through 1878.[37] The Trocadéro displayed well-known monuments as well as less familiar buildings dispersed throughout the provinces and exposed to negligence and destruction.[38] Preserved in plaster, the chronologically mounted monuments exposed evolution in form and style, in the grand periods but, as importantly, in transitional works, so perfectly captured in the portrayal of the Balbec church in Proust.

Plaster Kiss

Most late nineteenth-century cast courts aimed at showing the development of art and architecture according to distinctive ideas about history. The collections were updated in accordance with archaeological excavations, explorations, restoration, the canonization of new national monuments, and the availability of casts in the market.

The Trocadéro collection is special for a number of reasons. Despite its national scope, it was founded, as the catalogues persistently emphasized, on a rigorous Winckelmannian scheme.[39] In establishing ancient and medieval works in parallel series, Viollet-le-Duc wanted to abolish "the idea that one was inferior to the other," and demonstrate on a grand scale that architecture developed from hieratic archaism to naturalism, and from deliberate simplicity to exaggeration.[40] The theory that art evolves from childhood and adolescence toward mature perfection before decline, was, however, doubly transplanted when it materialized in late nineteenth-century Paris. In this francophone version—adjusted in both time and space and displayed by reproductions—the structure nevertheless remained intact. The Musée de sculpture comparée has been considered a national endeavor compared to the classical scope of the École des Beaux-Arts and the postclassical, eclectic collection at the South Kensington Museum. The comparison at work at the Trocadéro, however, was not restricted to the French tradition. The galleries contextualized the advancement in French architectural sculpture with Egyptian, Assyrian, Greek, and Roman work, as well as with "sculptures étrangères" from the seventh through the eighteenth century. Two factors might have

contributed to leaving the museum's adoption of Winckelmannian aesthetics and radical installation partly in the blind spot of posterity. First, the non-French casts were omitted when, for the 1937 Exposition internationale des Arts et des Techniques appliqués à la Vie moderne, the institution changed its name to Musée des monuments français.[41] More importantly, the museum provided minimal documentation for the foreign specimens, although the photographic documentation organized by the Trocadéro is unparalleled in the history of architectural casts. When an archivist at the commission in 1897 published a five-volume photographic album of the collection, he left out the non-French casts, as these were considered commonplaces; "généralement trop connues," as he phrased it.[42] The museum's original contribution was the invention of an unbroken French tradition.

This translation of the fundamentals of classical art into a national and modern architectural trajectory—taking timeless universalism hostage for a national historicist endeavor—implied a veritable relativization of the classical absolute. Classical antiquity served both as a historical backdrop and as an aesthetic trajectory enforcing the national genealogy in which architecture was seen as a product of time and place, expressed as evolution in style. Through comparison of minor and subtle changes within one school or region, and comparison on a grander scale between different epochs and places, as well as the "points of comparison" made to foreign works, the canon was reevaluated and expanded.[43] In a curving succession of galleries one could simultaneously catch glimpses of Egyptian, Assyrian, Greek, Roman, and "foreign" masterpieces while wandering through the history of French architecture; even the nonspecialist visitor could immediately recognize that the progressive scheme of childhood, adolescence, and mature perfection manifested itself in the French context.

Several British forerunners served as inspiration for the Trocadéro endeavor, including the British Museum, the Architectural Museum, the Crystal Palace at Sydenham, and the Architectural Courts at South Kensington, yet they were all "plus pittoresque que critique," as Enlart stated, repeating Viollet-le-Duc's critique of the British lack of system.[44] It was nevertheless an Englishman, Charles Newton of the British Museum, who spelled out the ideals of comparison that were explicit in the name of the French cast museum. "The great task of Archæology—comparison—though much promoted by the facilities of modern travelling, is still greatly hindered by the inability of memory to transport from place to place, and to recall at intervals of time, those finer distinctions and resemblances on which classification mainly depends, and which no drawing or engraving of the copyist can adequately convey," Newton wrote in 1851, when proposing to establish an ideal museum of casts in London to assemble the fragments of antiquity that were scattered all over Europe.[45] Plaster casts could "supply this deficiency in the natural powers of the mind," as the only medium in which the history of art and architecture could be fully grasped, and "not disposed, as is too often the case, merely to please the eye, but so as to develop, by a series of transition specimens, the chief features of successive styles."[46] Viollet-le-Duc's museum was not first and foremost conceived to please the eye, but rather, in a scientific and critical way, to show the minutiae of stylistic development, "those

Figure 38.
French medieval portal depicted in a landscape. Lithography from *Voyages pittoresques et romantiques dans l'ancienne France*, vol. 2, *Ancienne Normandie* (Paris, 1824).

finer distinctions and resemblances." It was peerless in its fulfillment of Newton's ambition, with the difference that it did not spring from excavation but from restoration, and that it depicted portions of buildings still in use rather than ruins.

While the fragments Newton wished to gather were scattered throughout European museums, the fragments at the Trocadéro were scattered throughout France. The galleries at the Trocadéro accomplished the one "synoptical view" that Newton imagined in the form of a three-dimensional panorama of French medieval architecture. We can now see that Marcel's train journey from Paris to the Norman coast repeats both the *Voyages pittoresques*, in which Gothic architecture was represented as indigenously French, and the sequences of galleries within which the Balbec portal had found its proper place in the history of architecture (figure 38). Traveling by train through the very landscape that had been designated as indigenous France, the young voyager "sensed neither inertia nor fancy, but necessity and life," when aiming at reassembling intermittent fragments in one continuous image, one comprehensive view. As Marcel heads toward the Balbec church, electrified by its perfect reproduction in Paris, his "single lasting picture" reads as a doubling of the museum galleries, where curated fragments presented the French past as a solid tradition of stylistic development.

Camille Enlart introduced a captivating metaphor to explain the awakening of a forgotten tradition. Through the course of the past three decades, he wrote, the museum's display of Gothic architecture had been a revelation to the public; they were thrilled by these wonders that had been eclipsed by the classical tradition's disinterest in France's medieval past. Like Sleeping Beauty awakened by Prince Charming's kiss, the dormant architecture of the Middle Ages had been awaiting a kiss to be brought back to life.[47] This resurrection could take place only in plaster, whose abstract materiality could elevate the French vernacular into

the ranks of first-class art.⁴⁸ "Vernacular" is a badly chosen descriptor for the monuments at the Trocadéro, however. One important purpose was exactly to rescue the medieval structures from vernacular anonymity and romantic conceptions of collectivity. Just as the masterpieces of antiquity had been handed down as the work of individual geniuses, the Trocadéro embraced the critical mission of providing its monuments with the signatures of architects and artists. Again, placed side by side, to be studied both synoptically and in depth, the faithful reproductions had the full scientific value of the originals and could help attribute authorship to the monuments, as well as revealing affinities and influences in a way the scattered originals could not. The catalogues serving as guides to the galleries became sites for scholarship on the monuments and the biographies of their makers.

The plaster kiss—the intimate touch between plaster and stone—resurrecting a latent French patrimony in full scale and in three dimensions: not only did it produce tantalizing museum objects. It also changed the monuments in situ, with respect to value as well as appearance. One of the first portals installed at the Trocadéro was from the abbey church Madeleine de Vézelay, Viollet-le-Duc's first major restoration project, begun in 1840, when he was twenty-six years old. This Romanesque-Gothic church built for a small Burgundy congregation had—owing to its association with Bernard of Clairvaux—enjoyed fame as a pilgrimage site, but it had long since fallen into obscurity. In its restored state, its status changed. Relaunched as a treasure of the French patrimony with a significantly altered historic fabric, the church was transformed from a local religious building to a secularized historic monument, Kevin D. Murphy observes, "compatible with modern spatial sensibilities," and "of interest to a pan-European public."⁴⁹ The cast portal came from a church that had been restored in accordance with a modern sensibility; Viollet-le-Duc had "produced a space that simultaneously represented the medieval past and the nineteenth century."⁵⁰ In Paris, the Vézelay portal was presented to entirely different audiences of tourists and museum crowds, transplanted from local to global patrimony (figure 39).

In the Convention for promoting universally Reproductions of Works of Art for the benefit of Museums of all Countries, the agreement that Henry Cole had fifteen European princes sign in Paris 1867, Prince Napoleon, first cousin of Napoleon III, signed on behalf of France. The main purpose of the Convention was to facilitate an international flow of national monuments, designated and produced partly in response to international demand, selected by national committees that should also procure examples for their own museums and local audiences. The French Historic Monuments Commission, founded in 1837, might have served as a model, and the Trocadéro Museum became an ideal facilitator for the circulation of monuments. At the turn of the century it became "the core of a restricted scheme of diffusion decided by the government, which would then send a standard set of twelve selected casts to any recognized school of art."⁵¹ The museum gathered monuments from the provinces, then "returned" French patrimony to the peripheries in curated form. Yet the main site for an unbroken national tradition was the Trocadéro. The French tradition, then, ingathered to the museum, subsequently radiated outward, injecting its national treasures into an international, global

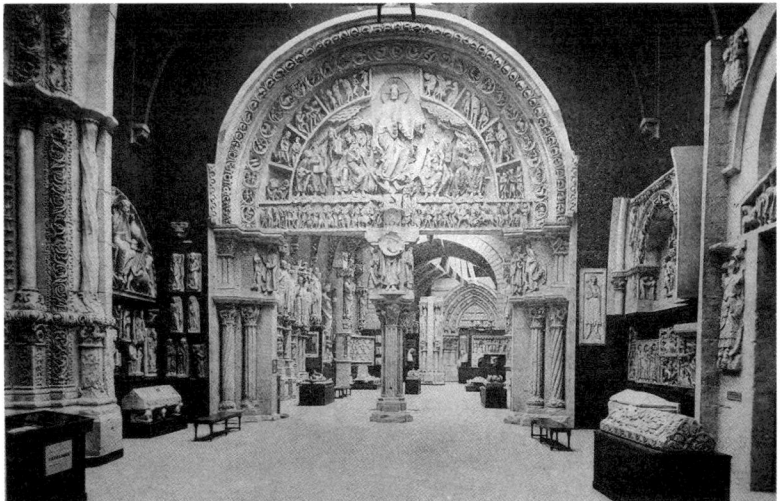

Figure 39.
Portal, the abbey church Madeleine de Vézelay. From Enlart and Roussel, *Catalogue Général du Musée de sculpture comparée au Palais du Trocadéro* (Paris, 1910).

history in the form of indispensable, individual monuments in museums on both sides of the Atlantic.

The curatorial apparatus in Paris was much praised and served as a touchstone for other collections. Returning to New York from his travels in the "province of reproductions" in 1891, Edward Robinson found that only the Albertinum in Dresden could compete with the Trocadéro as "the best-arranged" and most beautiful cast collection, with each cast's artistic value "so insisted upon by the careful attention given to the study of lighting it, and by the sumptuousness of its setting."[52] It was in this sumptuous, carefully lit, and richly mounted collection that the young Marcel fell in love with the universal, immortal beauty of the portal of the Balbec church.

Traversing Names and Landscapes

Proust's naming and placing of the fictitious church and town Balbec in Normandy effectively set two different but intimately entangled historical discourses into play: nineteenth-century archaeology and the concurrent reevaluation of medieval architecture. The religious monuments carried both political and cultural implications. Employing recently invented stylistic adjectives, Proust captures some fine nuances in medieval architecture. Yet he also anchored the Balbec church in something older, something almost timelessly ancient, by referring to geological features, the bedrock and the soil, in a way that resembles what the French historian Fernand Braudel would term "geographical time." In reality, it was geological time, the time of the landscape, a *longue durée* of almost imperceptible movement, "a history in slow motion from which permanent values can be detected."[53] "By naming his Norman town Balbec, a place of pleasure and thereby of longing and loss," Michael Roth argues, Proust "evokes the memory of the ancient city of Baalbek, in present-day Lebanon, a place of the framing and recycling of ruins, of conflicting cultures and desires."[54] Echoing Baalbek, the ancient Heliopolis, excavated at the turn of the twentieth century, Proust's Balbec evoked ruins and fragmented pasts for

his contemporary readership. The Norman landscape in which this evocation of Middle Eastern antiquity sits is anything but accidental. The name Balbec enabled Proust to evoke a double historicity; it pointed to an emerging global history of monuments in which antiquities appeared as novelties, lost and recovered, as well as to a particularly national history, eclipsed and refound, and its position in time and space within an all-encompassing history of monuments. Consequently, there are three temporalities at stake in the framing of the church at Balbec: its material dependence on geology and the ahistorical bedrock; the contemporaneity of archaeology; and the invention of a particular national past, encapsulated in the Frenchness of the medieval monuments.

In Proust, the historicist cast museum is filtered through a modernist sensibility, attuned to expose these temporal complexities. The doorway at the Trocadéro and the promise of the real church are core to the medievalism that saturates *In Search of Lost Time*. Proust hardly ever invokes the classical tradition, let alone classical antiquity in any art form. As a thought experiment, one could wonder what would have happened if the young Marcel had been exposed to the full-scale northeast corner of the Parthenon or the stylized version of the Castor and Pollux portico in the Cour vitrée at the École. Would this have made him long as desperately to go to Athens or Rome to see the originals? If perhaps nonsensical, such a scenario is also unthinkable. The Trocadéro Museum posed a challenge to the classical tradition—a challenge that resonates intimately with Proust's medievalism. Placing the church in a part of France of great importance to the appropriation of French medievalism, Proust is tying it to the invention of a national tradition that was displayed in Paris in the form of plaster monuments.

The church at Balbec is first mentioned by the architect and connoisseur Swann. Yet Balbec as a place and as a name appears earlier, in part 1, "Combray," one summer evening on the banks of the river Vivonne in the village of Combray. Here, Monsieur Legrandin praises Balbec's atmospheric skies and golden beaches, but, more significantly, its geological and historical dramatics: its "terrible rocks," "eternal fogs," and "gloomy shore, famed for the number of its wrecks, where every winter many a vessel is lost to the perils of our sea. Balbec! The most ancient geological skeleton of our soil."[55] From here on, this imaginary Balbec is evoked on a number of occasions—for instance, on a stormy day on the Champs-Élysées or when news of shipwrecks was reported in the newspaper.[56] When the church appears, it springs from the remembrance of the first mention of the Norman landscape. Marcel recalls a fragment of speech, prefiguring the entanglement of architecture and place, mediated in the name: "Now, I had remembered the name Balbec, which had been mentioned to us by Legrandin, as that of a seaside resort very close to 'those funereal cliffs, famous for their many wrecks, wrapped six months of the year in a shroud of fog and the foam of the waves.'"[57]

Marcel's train journey from Paris to Normandy recapitulates the *Voyages pittoresques* launched in 1820. In this enterprise, ancient Normandy reproduced in lithography occupied the first volumes "in a nationwide movement towards the reaffirmation of regional identity, which was grounded specifically in the possession of distinctive historical monuments."[58] Raised when Norman monarchs governed England, Normandy's

monuments secured the reputation of the region "as a treasure-house of medieval antiquities." The riches of Norman architecture and the "enthusiastic response to Normandy's 'sites' and 'monuments'" depicted in the *Voyages pittoresques* were later popularized through the circulation of images in journals, such as *Le Magasin pittoresque*, with huge readerships.[59] This visual economy forms one obvious backdrop for Proust's Balbec church, as well as for the train journey through the Norman landscape. When Wolfgang Schivelbusch in *The Railway Journey* comments on this particular trip, he emphasizes Proust's preference for cars over railways. In the novel, traveling by motorcar is promoted as more "interesting" and "genuine," keeping the traveler's body closer to the ground, following "more clearly, in a closer intimacy, the various contours by which the surface of the earth is wrinkled." Marcel Proust's generation of train travelers had become accustomed to "the relative insignificance of the journey itself," says Schivelbusch. "Untouched by the space traversed," the point of departure and the destination had collapsed and deprived the in-between localities of "their old sense of local identity."[60]

Yet the opposite takes place in the depiction of the journey toward the coast. Long before going to Balbec, Marcel has been studying the train schedule, and when traversing the landscape westward he knows the name of every little town and stop by heart, while dreaming about acquainting himself "with the architecture and landscapes of Normandy."[61] The names of towns and train stations capture their essence as the train makes its stops "at Bayeux, at Vitré, at Questambert, at Pontorson, at Balbec, at Lannion, at Lamballe, at Benodet, at Pont-Aven, at Quimperlé, and moved on magnificently overloaded with proffered names among which I did not know what one I would have preferred, so impossible was it to sacrifice any of them."[62] These names, places, and churches are evoked for their particularities: "Bayeux, so lofty in its noble red-tinged lace"; "Vitré, whose acute accent barred its ancient glass with black, wood lozenges"; "Coutances, a Norman cathedral, which its final, fat, yellowing diphthong crowns with a tower of butter"; "Quimperlé, more firmly attached, ever since the Middle Ages, . . . through the spiderwebs of a stained-glass window, by rays of sunlight which have turned into blunted points of burnished silver," and so on. Via the railway, this cartography of ancient names is reminiscent of the itineraries of French artists who in the first decades of the nineteenth century set out to map and mediate Normandy—Viollet-le-Duc among them—"demonstrating the lithograph's suitability not just for documenting Normandy's heritage, but also for vividly evoking the past of the province for the benefit of the modern spectator," as Stephen Bann has shown.[63] Proust's panoramic vision of towns and landscapes as seen from the train compartment conjures up another nineteenth-century mass medium that vividly evoked the French past for modern spectatorship, namely, the plaster monuments at the Trocadéro—the fragments that Marcel strives to reassemble in one comprehensive view, a "single lasting picture."

Already in "Place-Names: The Name," architecture and landscape are conflated in the journey from the plaster monument to the real church. The landscape is subjected to art-historical style labels and placed in time, as a history of development and transition. The orientalist, archaeological, and oft-repeated "Persian in style" applies to both the church and

the town. For Proust, names are sanctuaries and repositories for desire; however, "names themselves are not very spacious; the most I could do was to include in them two or three of the town's principal curiosities."[64] In Marcel's anticipation of the sight of the site, the Balbec church in the Norman town, supposedly sitting on ancient cliffs by the sea, the name Balbec had accumulated images of "waves rising around a Persian-style church"—"as in the magnifying glass of the penholders you buy at a seaside resort."[65] In "Place-Names: The Place" this philosophy of names is developed synecdochically, exemplified by churches that were among the most important plaster monuments in Paris. The following reflection reads as a panorama of medieval monuments, as seen from the galleries at the Trocadéro, configuring the merging of place and ancient buildings. It is phrased in a vocabulary saturated by casts and the logic of the *pars pro toto*, the notion that fragments arranged in complete series would present the development of architectural sculpture: "The principal church of certain towns, Vézelay or Chartres, Bourges or Beauvais, is sometimes called, for short, by the name of the town itself. This habit of synecdochism has the result, if it concerns towns where we have never been, of sculpting the broader meaning of the name, which, when we attempt to fit the image of the whole unknown town back into it, will shape it like a mould, stamping on it the same toolings, in the same style, and turning it into a sort of great cathedral."[66]

On a grander scale, the styles of the medieval monuments become metonymical to the landscape of Normandy, as when Marcel imagines "churches as steep and rugged as cliffs."[67] By employing stylistic terminology Proust also historicizes the landscape by lifting it from ahistoricity and timelessness to a particular French, medieval history. Style temporalizes the landscape, defining it with a shifting kaleidoscope of Romanesque and Gothic traits: "finding the name of Balbec in a book was enough to awaken in me the desire for storms and Norman Gothic."[68]

> And that region, which until then had seemed to me similar in nature to the immemorial, still contemporaneous great phenomena of geology—and just as completely outside human history as the Ocean itself or the Great Bear, with those of the wild fishermen for whom, no more than for the whales, there had been no Middle Ages—it had been a great delight for me to see it suddenly take the place in the sequence of the centuries, now that it had experienced the Romanesque period, and to know that the Gothic trefoil had come at the proper time to pattern those wild rocks too, like the frail but hardy plants which, when spring comes, spangle here and there the polar snow. And if the Gothic brought to these places and to these men a definition which they lacked, they too conferred one upon it in return. I tried to picture how these fishermen had lived, the timid and undreamed-of attempt at social relations which they had made there, in the Middle Ages, clustered on a point along the shores of Hell, at the foot of the cliffs of death; and the Gothic seemed to me more alive now that, having separated it from the towns in which until then I had always imagined it, I could see how, in a particular case, on wild rocks, it had germinated and flowered into a delicate steeple.[69]

Parallel to the chronologically organized museum galleries, the monuments become metonymical for a beautified, historicized, domesticated landscape that could "take its place in the sequence of the centuries, now that it had experienced the Romanesque period, and to know that the Gothic trefoil had come at the proper time to pattern those wild rocks too." When the same scene recurs in "Place-Names: The Place," where, in white letters on a blue background, the train station sign names "Balbec, of almost Persian style," it promises a landscape made of cliffs that are "Norman," parallel to defining architecture in stylistic taxonomies.[70]

The Balbec church and portal are continually referred to as Persian. The edifice is sprinkled, however, with fluctuating style characteristics. Built in the twelfth and thirteenth centuries, it is "still half Romanesque" and "perhaps the most curious example of our Norman Gothic." Such indeterminacies are typical of Proust's ever-changing, ephemeral portrayals of artworks, places, and personalities. Here, however, it is not Proust's subjectivism that is at work. Swann's detailed description of the church brings to mind the Trocadéro's passion for meticulously authenticating transitional works and also for providing precise stylistic protocols for transitional moments in the history of French architecture.

Stephen Bann has shown how one such Norman monument, the abbey church of Saint-Georges de Boscherville, fluctuated along the same lines in fictitious paper visions. In Baron Taylor's *Voyages pittoresques*, the medieval building "re-emerged, phoenix-like," with no trace of its vandalization during the Revolution. In a later version the façade of the chapter house appeared as a palimpsest of two successive styles: "Thus we discover, in this attractive monument, the transition from *Romanesque* architecture with its barrel vaults, to Gothic architecture or to pointed arches," according to the inventive drawing's author.[71] Just so, two styles could appear in one drawing and in one sentence, as instantly echoed in Victor Hugo's description of the same building in *Notre-Dame de Paris*: "Half-Gothic," "the Romanesque layer comes halfway up the body," a topos of transition repeated in Proust, in an immortal, unchangeable plaster cast.[72]

Patina and the Work of Time

"Will the object be better off in a gallery?" asked Benjamin Ives Gilman of the Boston Museum of Fine Arts in *Museum Ideals*, written while the volumes of *In Search of Lost Time* were being published in Paris.[73] Answering this question, he addressed a number of issues integral to nineteenth-century museum culture. His first answer carries a slightly imperialist flair: "Plainly, yes, in the case of objects brought from isolated or unexpected places, the finds of explorers and excavators." The second evoked the familiar argument that preservation legitimizes confiscation: "So with objects in places grown obscure and dangerous, either no longer visible as they were meant to be, or doomed by smoke or dust or glare or frost or damp or fire or neglect or other source of decay." Gilman's third pro-museum argument entailed distinct moral implications. Objects "already exiled from the places they were made to occupy" are better off at public museums than in the capricious hands of private interest. Still, spelling out his museological ideals, Gilman concluded that works of art and

architecture "still capable of fulfilling an intended function" are best left in their place of origin, rehearsing an argument as old as the modern museum itself: "To gather such things into collections is not to promote but to hinder the cause of art." This argument asserts that art and architecture belong in a living history, and that their dislocation renders them alienated fragments among fragments, "unsupported by the environment of place and event for which the artist reckoned them." Clearly, an identity politics is lurking in the evocation of the familiar topos of the museum as a graveyard, a prison, a hospital, or, here, an asylum, depriving art of its liberty (and sanity): "The museum affords an asylum for the flotsam and jetsam of art, its waifs and strays. It restores their threatened or suspended animation, but only by offering an institutional surrogate for normal life."[74]

Between the two antithetical ways of seeing a work, at its place of origin or brought across the museum's threshold, Proust would not have chosen either. He preferred a real surrogate to "an institutional surrogate for normal life." It is unlikely that the young Marcel would have been as enchanted had Proust placed him, say, at the Philadelphia Museum of Art, where portals in stone and wood from buildings from across time and space—many of them French medieval—even appear structural, serving their intended function, dividing spaces and leading visitors through the openings between the galleries. Marcel fell in love with the portal's plaster perfection, not because it documented the form and image of an absent original, but for what it was in itself.

Plaster history presents numerous examples of lost works outlived by their plaster copies. When German bombs hit the cathedral in Reims in September 1914 and destroyed the head of the Smiling Angel, the cast made in 1881 and exhibited at the Trocadéro became the basis for the reconstruction (figure 40). This, says Isabelle Flour, attested that the museum conveyed "not only the image of heritage, but also the commemorative values attached to it," and "became the support of a narrative directed to the 'imagined community' of the nation."[75] Likewise, the Parthenon serves as a prominent example of how mutilated or lost originals are documented by casts, which form productive constellations of reproduction, restoration, and speculation.[76] The year after Charles Robert Cockerell and his fellow travelers collected pediment sculptures from the Aephaia temple at Aegina in 1811, they were sold to Ludwig I of Bavaria, and later installed in Leo von Klenze's Glyptothek in Munich. Before restoring the statues at his studio in Rome, Bertel Thorvaldsen recorded the broken fragments as casts.[77]

It was, however, neither the cast's documentary value that interested Proust, nor its use as a means to circulate architecture. For Proust, the reproduction could—and did—take the place of the original. The Balbec plaster portal is something other than a referent pointing to a lost original or a more precious edition elsewhere. In Proust, the reference of the copy to the original is broken. It is no longer a historical relationship, where the cast documents a particular moment in the trajectory of a medieval building. Instead, the cast stabilized a fragment of a building beyond the work of time. Apparently, this standpoint aligned with the ethos expressed in relation to the casts at the Crystal Palace, "wonderful monuments happily preserved from the destructive hand of Time, and

now restored to something of their original splendor by the patient and laborious researches of modern time; and, we may add, (not without some pride) by the enterprising liberality of Englishmen."⁷⁸ Proust, however, was far more uncompromising in his thinking about the "destructive hand of Time" than were the curators at Sydenham. The relationship between the cast and the church is ideal and ahistorical, hinging on imaginary pristine states and fantasies of lost completeness. The ideal unfolding in Marcel's appreciation of the timeless, universal, and perfect cast in the museum and his great disappointment with the real church echoes Viollet-le-Duc's contentious definition of restoration: "To restore an edifice means neither to maintain it, nor to repair it, nor to rebuild it; it means to reestablish it in a finished state, which may in fact never have actually existed at any given time."⁷⁹ The work of time is all about change, decay, and fragmentation. Restoration in this sense implies establishing a fictitious timelessness, a place and time outside history, rather than documenting the work of time in the life of a building.

"Rejecting both the essay and the treatise—the two traditional forms of architectural exposition since the Renaissance," Viollet-le-Duc with his *Dictionnaire* rather favored "the seemingly neutral and objectively ordered space of the alphabet," writes Barry Bergdoll. Planned as a two-volume work with 1,300 figures, it expanded over the course of fifteen years until its completion in 1868, ending as nine volumes and 5,000 pages, illustrated with 3,745 woodcut engravings. "In the course of this vast one-man enterprise, Viollet-le-Duc not only honed the theory of structural rationalism, he refined a new form of architectural writing, with text and image integrated."⁸⁰ The spatially arranged plaster monuments might be seen as part of this grand dictionary of architecture. Michael Falser suggests that the dissected architectural elements serving as the *Dictionnaire*'s illustrations and its "operational means of directing and even manipulating the viewer's gaze" later materialized in the galleries.⁸¹ The museum became, according to Jean-Louis Cohen, "a three-dimensional transposition" of the *Dictionnaire*.⁸² In this spatial, three-dimensional version the ordering principle was not the alphabet but another system, one that has also succeeded in appearing "neutral and objective" over time, namely, a style-based chronology that served to integrate text and the three-dimensional image-objects. Commenting on the contemporary lexicomania—the increasing passion for dictionaries at the time—Martin Bressani is reluctant to "associate Viollet-le-Duc the rationalist with Romantic semantic drift." However, "Romanticism's delight in language does help us to grasp the type of relation he wished to establish with the Middle Ages," namely, "a relation to history that is free of nostalgia." Further, the *Dictionnaire* "is the past *put to use*: it is future-oriented."⁸³

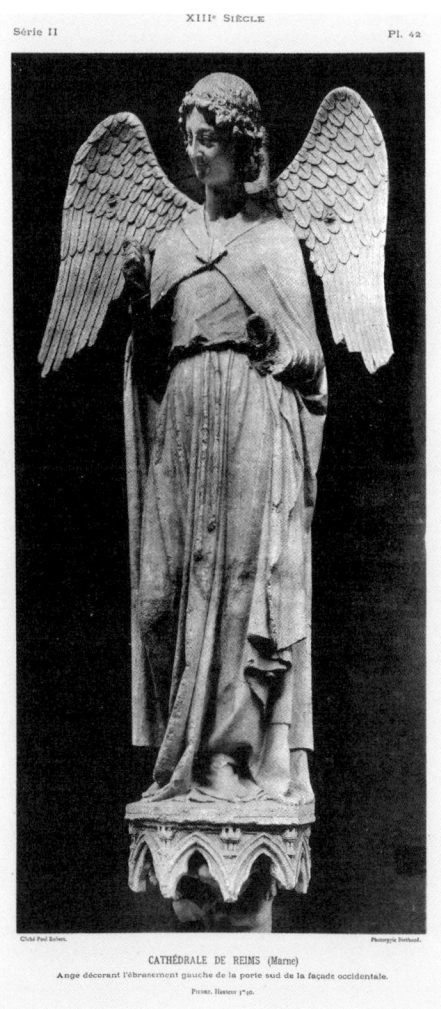

Figure 40. Smiling Angel, Reims Cathedral. From P.F.J. Marcou, *Album du Musée de Sculpture Comparée*, vol. 2 (Paris, 1897).

Figure 41.
Greek court, Crystal Palace, Sydenham. Polychrome Parthenon frieze in the rear.

The plaster monuments at the Trocadéro were not first and foremost pointing to the buildings at their original locations or documenting the ravages of time; they were fragments restored into fictitious perfection. Originally aiming to show the progression of French architectural sculpture, and used to display historical development as such along the way, the collection gravitated toward the ageless and flawless. "The appearance of the casts is sometimes different from the originals, which have received the patina of time," said Enlart. Time might give the monuments the inimitable beauty of age; however, stains of soot and moss also disfigured them, and thus a clear and uniform plaster surface better represented the work as it left the hands of its maker, he continued.[84] The question of patina is an important element in this rhetoric, corroborated by Marcel's experience of the cast as universal and unchangeable.

The ideal of presenting architecture in its assumed original state, as it left the hands of its maker, was expressed very differently at Sydenham. Arriving crisply white, the casts became important illustrations in the controversies on polychromy when the ten architecture courts, arranged by period, were inaugurated in 1854. According to Samuel Phillips, the chief editor of the Crystal Palace Library, the architectural specimens at the Crystal Palace were restored "as far as possible to their pristine state, in order that the imagination of the spectator may be safely conducted back in contemplation to the artistic characteristics of distant and distinctive ages."[85] While the whiteness of the casts signified an ideal, ahistorical state at the Trocadéro in the first decades, a different kind of idealism was displayed at Sydenham when Owen Jones took the opportunity to test out theories of the color schemes of antique and medieval architecture. "At a very early stage in the arrangements for forming in the Crystal Palace a series of reproductions of architectural monuments, I felt that to colour a Greek monument would be one of the most interesting problems I could undertake," Jones explained in *An Apology for the Colouring of the Greek Court*, "not indeed in the hope that I would be able completely to solve it, but that I might, at least, by the experiment remove the prejudice of many."[86] In many ways this enterprise explored a range of temporalities, not only by displaying several surface strategies from court to court, but also by depicting different ideals within one court and period. For instance, the Parthenon frieze, made from casts of the Elgin Marbles combined with parts in Athens, was "skillfully restored" by *formatore* Raphaelle Monti, who left some slabs white while others were painted: "The frieze has been coloured in different ways to show the various opinions that are entertained respecting the Polychromy of the ancients" (figure 41).[87]

Owen Jones's attempt to challenge prejudice was not particularly successful. If the opportunity to see the Parthenon and other antique monuments restored to their possible original color splendor was a success with the public, vituperative criticism was voiced by experts and public figures. The polychrome courts produced a "coarseness of illusion Madame Tussaud would disdain," according to the prominent critic Lady Elizabeth Eastlake.[88] George Godwin recurrently vented his disgust with the surfaces of the Crystal Palace monuments in *The Builder*. We "have never seen better executed casts than some of these here," he wrote in an early review. Without drawing conclusions about how a "cast should be preserved,"

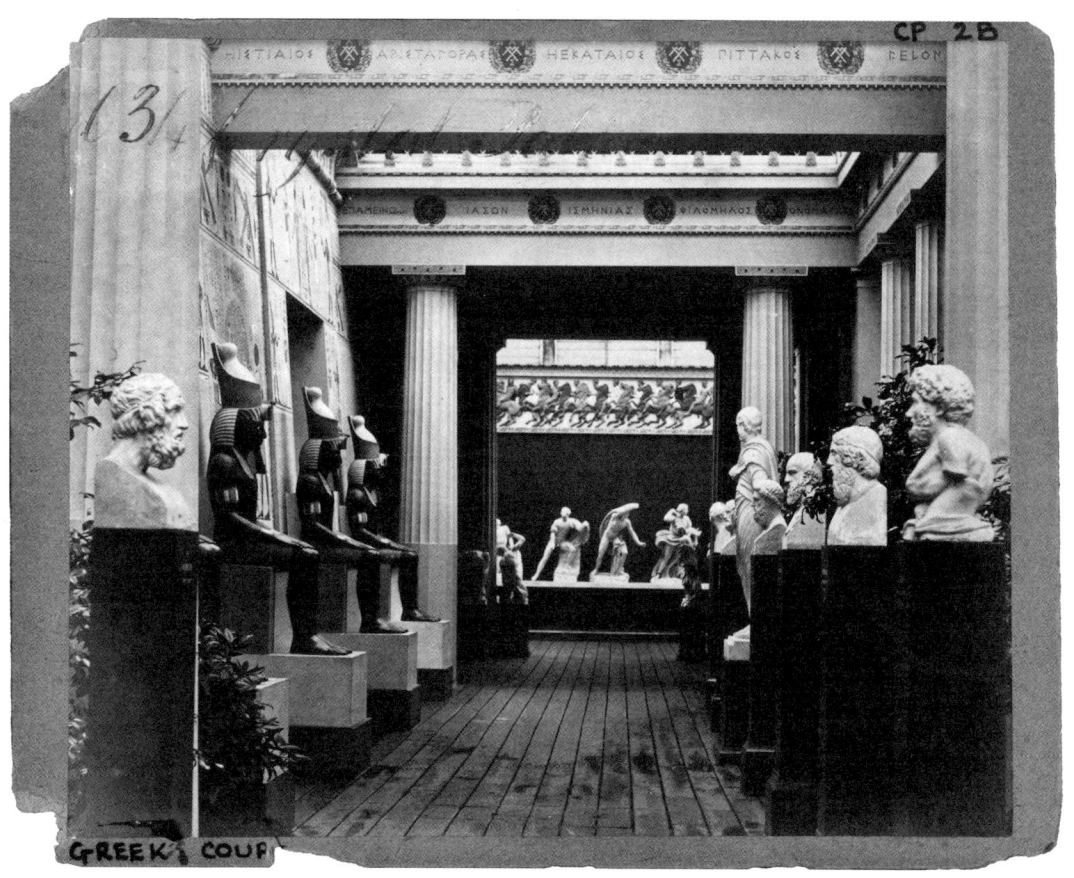

Figure 42.
Karnak-inspired colonnade, Egyptian court, Sydenham.

he complained that much of their beauty and effect "is now lost by the thick coat of yellow slime with which most of them have been covered."[89] Godwin was no more forgiving of the polychrome medieval casts; overall he found the practice of having casts mimic the material properties of the originals corrupting, and he strongly objected "to the shining coat of oil paint, used as a preservative for the casts in the Gothic courts."[90] Interestingly he ascribes authorship to the plaster monuments by naming the *formatore*. "The modeling of the sculpture from the Certosa, by [Edoardo] Pierotti, of Milan, merits all the praise given to it." Yet he found that the treatment of the delicately chiseled surfaces decreased the effect of perfection conveyed in the "naked plaster," which well conceptualized "the extraordinary beauty and workmanship of the originals."[91]

Skeptics were not calmed by Jones's *Apology*, which included a number of contributions from experts and new scholarship on antique polychromy, including Gottfried Semper's "On the Origin of Polychromy in Architecture."[92] But the *Apology* did raise a number of critical issues concerning ideality, reality, and historicity. An extract from a report commissioned by the Royal Institute of British Architects on the traces of color on the Elgin Marbles claimed that the "Greeks did not aim at reality, but at ideality; and the painting of statues is thought to be only an attempt to imitate reality."[93] Yet if fantasies of a white, pristine monochrome antiquity were conceived as more ideal than the historical reality, they were not easily overthrown even by new evidence on the material historicity of the marbles.

More often, though, ideals of truthful representation led to attempts to have the reproduction look like the original in its present state. In many collections, the plaster monuments were encrusted to resemble the weathering and properties of a variety of materials: marble, basalt, porphyry, limestone, sandstone, alabaster, terracotta, and occasionally metal or wood. James Fergusson—at the time the director at Sydenham and one of the harshest critics of what he viewed as polychromic excess—made exceptions only for the Pompeian House and Owen Jones's Alhambra Court. He did not even excuse the Assyrian court that he himself had designed in close collaboration with Henry Austen Layard. "Truth ought to be presented in its simplest and purest form, and the facts conveyed in the most direct manner to the mind," from, for instance, the colonnades from the temple at Karnak in the Egyptian court (figure 42).[94] Color "should never be introduced except where it now actually exists, and only to that extent," he stated in 1857, melancholically musing on the moment when the new white casts had arrived at Sydenham five years earlier and were still in the storeroom before being assembled into colorful, poetic fantasies (figure 43).[95] The techniques for surface treatment varied, and so did the ideals for the added patina. Thus casts from the same series—made from the same mold—could achieve individual appearances in different museum settings, reflecting particular tastes and ideals, and sometimes accidents or misunderstandings.

Overall, the plaster monument entrepreneurs displayed an intense interest in materiality. While touring Europe in 1891, Edward Robinson praised the Frieze of Archers from Susa installed in the new Persian galleries in the Louvre, but was no less effusive about its reproductions. Made by the restorer of the frieze, they were the most remarkable casts he had

ever seen—"an exact imitation of the original"—that perfectly rendered the "glazed and colored bricks."[96] In the *Catalogue of Casts* that Robinson authored for the Museum of Fine Arts in Boston the same year, the casts appear as pure transparency, opening a view straight to the originals, as in this sensual description of the materials employed by the architects of the temple-palaces of Ancient Nineveh. "Assyria was more fertile in stone, but the best quality for building purposes was found at long distances from the centers; and while the Assyrian architects did not employ clay as exclusively as the Chaldaean, they used stone only for the foundations and outer facings of their buildings, and in the interior by way of decoration." Nowhere, Robinson continued, was the choice of material so influential, and while pointing to the casts in the museum's possession, he explained in detail the use of the abundant "soft, Oriental alabaster," and the techniques of cutting, carving, and scratching "from its very softness" durable and perfected bas-reliefs.[97] This catalogue entry is typical in its oscillation between the original and the reproduction, underscoring the idea of presenting the audience with something as close to the real thing as possible.

As the plaster monuments proliferated, so did the advice on how to treat and maintain them. Recommending lateral lighting from above and warm gray walls for exhibiting casts, Charles Perkins in 1870 also advised against painting plaster. Rather, he suggested transparent stearin and boiled-down linseed oil, which hardened the surface, made it easy to clean, and gave the cast "a golden tone somewhat like that of old Attic marbles long exposed to the sun and the air."[98] While paint might suffice for school collections, "for connoisseurs, the most satisfactory way of preserving casts, and securing them originally," was to treat them with "two coats of boiled oil, at an interval of three days between each coat, and have it applied in the summer to insure absorption," according to an American book on art education from the 1870s. "Casts so prepared become gradually the color of old ivory or marble which has stood the weather: they become seasoned, and beautiful in tint, and harder than those prepared in any other way."[99] The difficulty of reproducing the texture, feel, and aura of the original in a cast was also debated. "A cast is of another tint than marble, another color than bronze, and makes no attempt to reproduce their frequent coloring and gilding," reads an early twentieth-century manual. "It is opaque instead of semi-transparent as marble is, and has less sheen and less intense shadows than either."[100] Depending on the program of the collection, the purchaser could commission a cast with a particular finish: "State whether the goods are wanted in the plain white or ivory finish," stipulated one of the sales catalogues from the Boston company Caproni & Bro.[101] Many museums, however, preferred to undertake the patination process themselves.

Mimetic aspiration and a politics of authenticity, as played out in the reproductions, took a particular twist in the bright casts at the Trocadéro. Rather than signifying a white classicism and a Winckelmannian "noble simplicity and quiet grandeur," the monochrome display gave disparate objects a unified appearance, facilitating formal comparison of sculptural and structural traits. Furthermore, it unified the collection as well as the entire French tradition. While architecture patinates, with moss and pollution, through natural disasters, war, terror, use, and restoration, the reproductions in their museum habitat were envisioned not to patinate,

Figure 43. Philip Henry Delamotte, *Storeroom with Artisans and Plaster Casts, Crystal Palace, Sydenham*, 1852. Albumen silver print from glass negative.

Figure 44.
Postcard by the Neurdein brothers showing director Camille Enlart, curator Jules Roussel, and chief molder Charles-Édouard Pouzadoux in the thirteenth-century gallery, Musée de sculpture comparée, Paris, c. 1900.

and to be something different from the works they depicted. Thus the shock and disappointment that Proust has Marcel experience is a bit surprising. As we have seen, Marcel—having studied a flawless reproduction lined up among church portals executed with similar surfaces—finds the church at Balbec unappealing in its deteriorating reality and trivializing urban context. His reaction may startle the reader, who would not expect him to be dismayed by the discrepancy between the abstracted reproduction and the weathered, stone structure. Given the plaster monuments' monotonous brightness, one would suppose that viewers were constantly aware of the their mediative purpose—as a collection of three-dimensional images of architecture residing elsewhere.

The audacity of the Trocadéro was the sophisticated, ahistorical discourse on origins unfolding in the galleries—theorizing a tangible history of French architecture liberated from accidents and alterations. This Platonic idealism, which gave form primacy over materiality, had always been at work in study collections in academies and schools. The Trocadéro collection reiterated the idea that the casts display a clarity and legibility that are rare in original works. More surprising, however, is the suggestion that the reproduction is not only more exact than the original, but, in its perfect white state, closer to the moment when it left the hands of the artist. Made from molds, the casts were clearly many times removed from the hand of the artist. Even if they might have been close to the hands of the chief molder Charles-Édouard Pouzadoux, operating in his workshop in the museum basement, they were far from their medieval makers in time and technique (figure 44). The multiple versions of a singular original were decontextualized in materiality and place, increasingly distanced as the casts traveled from their original museum setting to collections across the world. The idea of the hand of the maker and the proximity of the reproduction to the moment of the monument's making evoked the topoi of time travel, pristine states, and the atelier, just as Quatremère felt transported back to Phidias's atelier and to an ancient construction site when he saw the dismembered Parthenon fragments in London. But the Trocadéro did not single out any one individual work. The comparative foundation of the enterprise emphasized relationships, within the totality performed in series. Thus the galleries were tuned more subtly than an enfilade of unfolding centuries. In the stylistic classification system, the monuments were identified in relation to other monuments rather than solely by their individual qualities, making the entries in the series of catalogues an interesting contribution to the late nineteenth century's preoccupation with style. The filigree system of style definitions—repeated in Proust as "Persian," "half Romanesque," "Norman Gothic"—anchored the monument not only in time and place, but in the exhibited continuum.

Plaster monuments were hailed as perfectly preserved replicas of weather-beaten originals or as ideal expressions of imaginary beginnings. But even casts weather in time. Whatever ideals of originality, time, and history their patina was programmed to express, the reproductions were influenced by their new, local contexts. Just as the Elgin Marbles darkened in London smog, the plaster monuments adjusted to their new environments: "Something must be done, since the casts in the smoke of Chicago become intolerably soiled in a few years."[102] "Plaster patinated to resemble marble has an oversmooth, soapy look that offends the modernist 'truth

1044 Musée de Sculpture Comparée. — *Aile de Paris, Salle B (XIII^e Siècle)*. — ND

to materials' fetish," Calvin Tomkins observed when he came across more than eighteen hundred crumbling plaster casts from the Metropolitan collection in storage in the 1980s.[103] The art critic witnessed a twofold patination process in the century-old moisture-absorbing monuments covered in dust and dirt. Before becoming irrelevant to modernist culture, the material expression of plaster displayed many different claims to truth.

Museophilia

Modernism's troubled relation with the museum—famously exemplified in the exalted vision of burning museums in Marinetti's 1909 front-page *Manifesto of Futurism* in the *Figaro*, the polemic "Doit-on brûler le Louvre?" questionnaire Le Corbusier published in *L'Esprit nouveau*, or Paul Valéry's slapstick criticism of museums in general and Louvre in particular in his 1923 "Le problème des musées"—was lost on Proust (figure 45). Proust was untouched by the French tradition of museum critique, dating back at least to the establishment of the Louvre as a public museum in 1793 and Quatremère de Quincy's attack on the decontextualization of art, hinging on the idea of the museum as a grave. Central to this criticism was the supposition that art becomes incomprehensible when removed from its place of origin, while Rome was promoted as a veritable museum in its own right composed of everything from monuments and mountains, climate and atmosphere, to mores and costumes, furniture and utensils.[104] The sentiment that museums were lethal to art was still fueling modernism, as in Valéry's portrayal of the chaos of mutilated works and densely stored dead visions among which the visitor stumbles like a drunkard: lifeless treasures fighting for the viewer's attention.[105]

Proust considered decontextualization an indisputable advantage. Contemptuous of the idea that art belongs in a living history and should be admired in the environment for which the work was intended, he claims that only the museum, with its bare "walls unadorned by any distracting detail," can offer true delight in art. The museum evoked both the hand of the maker and the atelier; the gallery aptly symbolized "the inner spaces into which the artist withdrew to create"; further, Proust celebrated the curator when advocating the artificial museum habitat as liberating. "Our age is plagued by the notion that objects should be shown only with things which accompany them in reality, thus depriving them of the essential, that act of mind which isolated them from reality in the first place."[106]

Proust appears eccentric when conceiving a museum as a neutral space. However, he saw the art institution as a historically and culturally abstracted space that introduced a necessary distance between the object and its place of origin. By detaching art and architecture from their historical milieu, the museum weakens their cultural roots, as well as any conception of origin. "For Proust, the work of art is like a quotation that forgets its source and thereby demonstrates its own origin," Didier Maleuvre notably asserts, an observation that is even more intriguing given that a plaster copy constitutes the center of Proust's museum philosophy.[107] Proust's perverse tolerance of museums stems from his being

an admiring consumer and an amateur, Theodor Adorno brutally stated in an essay famously claiming that the relation between museums and mausoleums runs deeper than their phonetic resemblance. For Proust, artworks become "something more than their specific aesthetic qualities. They are part of the person who observes them; they become an element of his consciousness."[108] Although Adorno lingered over originals at the Louvre and the Jeu de Paume, he hints at something that may help us understand why Proust decisively preferred the reproduction to the original, and so casually manages to invert the conventional hierarchy of copies and originals.

Marcel is well aware of the cost of seeing the church in Balbec. Prosaically and psychologically, the ailment arises from separation anxiety. This is the first time the young boy has traveled without his mother: "As long as I had been content to lie in my snug bed in Paris and see Balbec's Persian church buffeted by blizzard and storm, my body had raised no objection to this journey."[109] While still ensconced in familiar domesticity, he could bravely assure himself that although the sight of Balbec had to be purchased with pain and discomfort, it seemed necessary to "guarantee the reality of the impression which I sought; and that impression could never have been replaced by some other supposedly equivalent sight, such as a 'fine view' [*un panorama*] which I might have been able to go and see without its preventing me from going home at bed-time."[110]

Figure 45. Questionnaire, *L'Esprit nouveau* no. 3 (1921).

The assumption that the reality of the impression could be guaranteed only by the real thing is reversed when the young pilgrim finds himself in front of the church. Pain abruptly converts into disappointment. The disappointment is, however, not a local one, confined to this very church. Rather, it is symptomatic of a fundamental aesthetic problem. The experience of the monument in situ could be—and actually already was—replaced by the reproduction. While the awe-inspiring effect of art is guaranteed conventionally by the singular and irreproducible work, Proust hints at another way of thinking about the convoluted relationship among materiality, context, and significance—a relationship demonstrated nowhere more richly than at the Trocadéro, by its curatorial apparatus and the historical discourse in which these casts were inscribed. In Proust, the "reality of the impression" is not guaranteed by reality but fostered by the church's "equivalent sight": the perfect plaster monument in the museum.

Claiming that the many artworks in Proust's novel operate extrinsically to formal, objective aesthetic qualities, becoming elements in the consciousness of the beholder, Adorno indirectly—if perhaps unwittingly—implies that the copy may gain primacy over the original. In Proust, the version first experienced—in this case, the replicated, curated fragment originating in the museum—has become a new original, distanced from the model's historic source. Nowhere does Proust make this clearer than

in a small detour on bibliophilia in the novel's final volume. This reflection's significance is redoubled by the fact that architectural casts, like printed books, come in editions. The aging narrator acknowledges that the book-lover's passion transcends the singular volume's inherent, objective value, and is separable from the historical value rooted in the precious object's provenance.[111] This objective value is, according to Proust, determined in "a living sense"—that is, the life of the rare book as a collector's item, analogous to an original, singular work of art. Here, however, the original has to be looked for elsewhere. A first edition is the "edition in which I had read it for the first time," the narrator states: "I would look for the original editions, by which I mean those from which I had received an original impression of the book. Because subsequent impressions are not original."[112] In the case of the Balbec church, the original edition, the edition of first encounter, is the reproduction.

"In even the most perfect reproduction, *one* thing is lacking: the here and now of the work of art—its unique existence at a particular place," Proust's first German translator, Walter Benjamin, famously declared in the mid-1930s.[113] Compared to art forms such as sculpture and painting, architecture, one would assume, is especially site-specific: immovable, inexorably subjected to gravity, place, and its own materiality. In his famous essay on the reproducibility of art, Benjamin does not list plaster casts among woodcuts, engravings, etchings, lithography, photography, and finally film, the historical media making "a mass existence for a unique existence," even though the practice of reproducing three-dimensional objects in plaster is much older than medieval woodcuts.[114] Yet, as a reproductive medium, plaster casts tend to defy the slightly slippery concept of aura and its possible withering as unique works are replicated into series. "The here and now of the original underlies the concept of [the work's] authenticity," according to Benjamin, who let phenomena like authenticity, uniqueness, authority, and aura serve as floating signifiers.[115] Even though monuments are imbued with ideas of a "unique existence in a particular place" and permanence, they are always in flux both with regard to their reception and physically, through deterioration, restoration, and environmental change. Architecture is brutally subjected to history. In the case of the singular half-Romanesque, Norman Gothic, Persian church in Balbec, Benjamin would have conferred irreproducible "here and now" quality on the medieval building facing the busy square in Balbec-en-Terre. Proust concludes differently. Marcel realizes that the "here and now" reality is incapable of guaranteeing anything of importance, not to say of permanence. As Eurydice disappears from the ambit of Orpheus's gaze, the "real" building disperses before Marcel's eyes. The monument disintegrates into history and the everyday. Marcel loses sight of the original the moment he sees it. Contrary to his earlier assumption, the original could easily be replaced, and exactly by its own copy. The plaster portal in Paris had allowed him to imagine a perfection and totality unobtainable in real life.

In Proust, authenticity springs from the first impression, not from the first version in regard to origins or provenance. The first version of the church is the fragment in Paris, which created the original impression of the building's grandeur. This first edition generated a vision that truly is something "more and different," superior to the church itself:

"When I recognised the Apostles, whose statues I had seen as mouldings in the Trocadéro Museum and who now stood to the left and right of the Virgin, waiting by the deep recess of the porch as though to pay me homage, I tried to close my mind to everything but the eternal significance of the sculptures."[116] This eternal significance is not embodied in the stone carved from the Norman cliffs and patinated through the course of history. It originates in the first encounter with the unalterable reproduction. In this tension Proust grasped an aspect of Benjamin's theory of the decline of aura that Benjamin himself overlooked. It is, writes Samuel Weber, "the very real possibility that aura will be reproduced in and by the very media responsible for its 'decline.'" For Weber, "what has become increasingly evident ever since, is *that aura thrives in its decline* and that the reproductive media are particularly conducive to this thriving."[117] This possible blooming of aura—transplanted from the original to the reproduction, and from one medium to another—is what Proust identified in the nineteenth-century mass medium of the architectural plaster cast.

In contrast to the persistent analogy linking museums to tombs, graveyards, and epitaphs, Proust sees reality as lethal for art. Face-to-face with the carved-in-stone Virgin of the Porch—the reproduction and his mind were "protecting her forever from any vicissitudes which might jeopardize them, letting her stand unscathed amid their annihilation, ideal, full of her universal value"—the narrator sees her as petrified, lifeless and accidental, drowning in context and the banality of everyday life.[118] Here, Proust's combination of idealism and subjectivism is exhibited in its purest form: in reality, across history, the original work is perpetually corrupted, while the reproduction in the museum belongs to the imagination, perfectly preserved as an element in the viewer's consciousness.

Proust captured the cast museum's raison d'être, namely, the reproduction's synecdochical function, in the young Marcel's encounter with the portal in Viollet-le-Duc's Parisian plaster heaven. Claiming that only the imagination, via a fragment, can evoke perfection and totality, he echoed Viollet-le-Duc's alignment with the French naturalist Georges Cuvier's comparative anatomy recalled in the entry "Style" in the *Dictionnaire*. "Thus, just as in viewing a single leaf it is possible to reconstruct the entire plant, and in viewing an animal bone, the animal itself, it is also possible to deduce the members of an architecture from the view of the architectural profile."[119] The authorial voice of *In Search of Lost Time* memorably compares Marcel's future novel to a medieval cathedral. More specifically its model of remembrance is compared to Viollet-le-Duc's dream of restoring "the whole edifice to the state in which it must have been in the twelfth century," as Proust paraphrases the architect. Yet the future novelist claims that he has more "precise data" to "reinstate" and "restore" the past than "restorers generally have": "a few pictures preserved by my memory" in the form of mental imprints, impressions that he compares to forever-lost originals such as Leonardo's *Last Supper* and the portal of Saint Mark's Basilica, as painted by Gentile Bellini.[120]

In Proust the part's relation to the whole does not primarily concern ruins, destruction, and restoration. It is about envisioning the whole from the fragment by an act of the imagination. He comes close to Quatremère's epiphany in the presence of the Parthenon fragments in London in 1818,

an aesthetics he had also explored in *Le Jupiter olympien*, where he claimed that "one single fragment could show us both the makeup of a chef d'œuvre and the ideals and style of the man who fashioned it."[121] This was a matter of zooming in on details, just as the founder of the museum in which Marcel first saw the Balbec portal claimed that the detail was the key to the totality: "the nature of the finished construction can be derived from an architectural member."[122] This attentiveness to details detached from their architectural body anticipated Walter Benjamin's promotion of the advantages of mechanical technologies in the experience of art. Photography "can bring out aspects of the original that are accessible only to the lens (which is adjustable and can easily change viewpoint) but not to the human eye." Further it can "use certain processes, such as enlargement or slow motion, to record images which escape natural optics altogether."[123]

Benjamin's discussion of the decay of aura as a result of mechanical reproduction was not primarily a melancholic musing on decay and loss, but a hint at the aura's possible manifestations in new media. Phenomena such as framing and enlargement of details might also capture the effects of displaced or fragmented architectural structures, without corrupting a Benjaminian aura. Indeed, the following reads as a perfect description of the effects of plaster monuments in museums: "technological reproduction can place the copy of the original in situations which the original itself cannot attain."[124] When defining an original, Benjamin carefully underscored that its physical alterations over time and also changes in ownership "can be traced only from the standpoint of the original in its present location." Physical changes "can be detected only by chemical or physical analyses (which cannot be performed on a reproduction)." Today, new media and new technologies are challenging orthodox modernist conceptions of material authenticity and the ontology of originals. As Bruno Latour and Adam Lowe propose: "A badly reproduced original, we will argue, risks disappearing, while a well-copied original may enhance its originality and continue to trigger new copies. Facsimiles, especially those relying on complex (digital) techniques, are thus the most fruitful way to explore the original and even to redefine what originality is."[125]

The nineteenth-century plaster monument was already part of this destabilization of originals and copies, and epitomized the historicist view of the *pars pro toto* where the fragment in the gallery could signify both the individual building and its place in historical trajectories. At the Trocadéro, the cast enabled an ideal perception of the real thing, and when elements were detached from an architectural structure, the curators strove to thoroughly mark at what height above the ground the cast fragments originally resided.[126] The mounting aimed at a realism in the experience of details impossible in monuments in situ.

That was not always the case, not even with singular statues. As Wolfgang Ernst has shown, the Laocoön was the basis for Lessing's radical contribution to Western aesthetics, even though his notes from his Italian journey show no evidence that he visited the Vatican, and if in fact he did, this "historical (non-)event," would hardly have changed anything. Terribly displayed in the Belvedere court, discouraging in-depth study, the Laocoön would have shocked Lessing in any case with "its fragmentary state (with the right arm still missing) and rough surfaces, which were

smoothed in the reproductions he was used to."[127] When the Trocadéro insisted that a cast was more exact than the original, the claim was not only a provocation. For Proust's Marcel, the plaster cast showed the work in an ideal version. Michael Camille describes a statue of the prophet Isaiah, a ghost of stone, floating free of its architectural anchor in an old photo from the Musée de sculpture comparée. Inspecting the original in the Romanesque-Byzantine abbey church of Souillac in Dordogne, he discovered that it is "impossible to see properly without a flashlight, which anyway flattens the stone surface, making the actual object far more distorted and theatrical than the version in the museum."[128]

Struggling to attribute his disappointment to "mere contingencies, my unready mood, the fact that I was tired, my inability to look at things properly," as he was leaving Balbec-en-Terre, Marcel concluded that he had "broken open a name which should have been kept hermetically sealed."[129] Here, Proust identified the threshold between the temperate museum and the messy outside world. He explored the ever-present danger of disillusion resulting from the pursuit of a chaotic reality beyond curated control.

Chapter 3
The Poetics of Plaster

In Brussels, a lofty room furnished with simple wooden shelves from floor to ceiling is completely filled with broken fragments. All kinds of associations spring to mind, from natural disasters and phantasmagoric ruins to large-scale contemporary art installations with archival inclinations. In the somber daylight falling from a strip of windows high up on a wall one slowly recognizes familiar forms amid the rubble: torsos, a bodiless leg tucked behind an ornamental panel, a tender medieval face buried in building debris, fluted drums, broken columns, capitals, cornices, friezes and bas-reliefs, mutilated doors and portals, remains of balustrades, mantelpieces, pulpits, sarcophagi, and miscellanea of all sorts (figure 46).

The shelves impose some order on the space. Yet on each shelf odds and ends are simply piled without any apparent system. Fragments of architecture and artworks spill out and into the narrow paths that skirt the massif of debris that fills the center of the space. From these paths, one can climb a ladder to inspect the treasures accumulated on the highest shelves. In a corner in another storeroom one of the caryatides from the Erechtheion temple in Athens is looking a bit lost, leaning toward the wall, deprived of her verticality, architectural frame, and sister columns. And then there are the adjacent spaces, which stockpile thousands of seemingly neatly arranged and numbered molds. Some of these molds are in use, as the *atelier de moulage* at the Royal Museum of Art and History still produces plaster casts. If, for instance, one should wish to procure Phidias's Demeter and Persephone from the west pediment of the Parthenon—a piece most nineteenth-century museums in Europe and the United States sought and obtained—its full-size version is on offer for €5,450. When I was visiting, the crisp plaster-white wings of the Nike of Samothrace, just lifted from their molds, were drying on the floor beside another pristine edition of the headless Hellenistic beauty, evoking Goethe's pleasure in watching "the exquisite limbs of the statues coming out of the moulds one after the other," in Roman workshops in the 1780s.[1]

Here, the rare combination of a salvaged collection, the extraordinary deposit of molds, and the present-day production of art-historical staples makes for a secluded exhibition of plaster monuments in different states—past, future, present. Yet even those made by molders in the workshop have an air of pastness, while the storerooms constitute a splendid backstage of forlorn beauty and irresistible decay in their accumulation of the derelict casts that were once part of a busy international exchange of monuments.

In the early 1970s, Calvin Tomkins experienced something similar when he encountered the Metropolitan Museum of Art's casts in storage. In a warehouse in Upper Manhattan, Tomkins made his way through "puddles of water on the concrete floors while cars and trucks thundered by overhead. The casts filled two huge rooms. They were jammed in willy-nilly, and there were some wonderfully improbable confrontations: Donatello's 'St. John the Baptist' preaching to a nude 'Aphrodite'" (figure 47).[2] Both the uncanny beauty of those Metropolitan storerooms and the shelved casts in Brussels highlight the same point. Once invested with pride, art-historical passion, and scientific value, these collections, when moved from public life to dusty obscurity, took on a new ruinous appearance—beyond that of the ruins and dilapidated fragments many of them portrayed. Following half a century of deliberation on proper surface treatment, these objects were subject to the same kind of deterioration as any neglected monument: left in storage conditions not many museum items ever endure, they were broken and waterworn, discolored, scarred, and encrusted with soot and grime. Yet the "wonderfully improbable confrontations" that Tomkins observed in storage can also be seen as a realistic reflection of the plaster monument galleries in their prime. Today, visitors to the extant cast collections might wonder why Trajan's Column is placed next to some medieval Norwegian stave-church portals in London, or why the front of the Temple of Nike Apteros is neighboring a Romanesque church façade in Pittsburgh (figure 48).

However, these spaces also perplexed their nineteenth-century visitors. The Brussels collection was first displayed in splendor, on the same premises where its remains reside today, the vast exhibitionary complex commissioned by Leopold II to commemorate the fiftieth anniversary of Belgian independence. In the 1880s casts originating from different institutions were transferred to the Musée du Cinquantenaire and installed in an enormous exhibition hall constructed of cast iron and glass, which houses an air and space museum today. But viewers of that initial display experienced it much as today's visitor does the present-day disarray of the museum's storage space. From early on the collection was criticized for being a terribly labeled jumble of monuments lacking legible curatorial order. In 1893 the Musée d'art monumental was deemed a "véritable Babel" in the Belgian Senate, and new acquisitions made the display increasingly incomprehensible.[3] This critique was typical. At the South

Figure 46.
Brussels ruin, 2015.

Kensington Museum, the Architectural Courts—measuring 135 feet in length, 60 feet in breadth, and 83 feet in height to the center of the ceiling—were tailored for the "full sized casts of architectural monuments." It was only in a court "of extraordinary dimensions that reproductions so large and high could be placed," museum staff assured the visitor.[4] The audience found the relationship between container and contained less clear. "The result conveyed to the mind of the ordinary sight-seer must be one of absolute confusion," a visitor complained in the *Times* a decade after the inauguration, describing the purpose-built galleries as "a gigantic curiosity shop arranged on no comprehensible principle."[5] In Paris, where by the end of the 1880s casts filled both wings of the Palais du Trocadéro, new monuments kept arriving until the director announced that objects of this size could not keep entering the museum indefinitely. He apologized for the erratic situating of monuments in both time and space, corrupting the ideal of French architecture as a perfectly ordered series.[6] The Metropolitan's collection, conceived in response to the lack of method in European collections, generated endless reports on the constant chaos threatening to undermine the comprehensive plans for perfect chronological displays.

Considering the storage spaces provides a window on the—mostly unintentional—depot-like qualities of the galleries. In 1857 James Fergusson remembered with longing when the casts in the Crystal Palace were still in the workshops, and far more instructive when stored "each in its own class and according to its date" than when mounted in the courts.[7] The still virtually intact Hall of Architecture in Pittsburgh—displaying the preserved "reproduced plaster bones of Western building history"—earned plaudits from James D. Van Trump in 1970: "Pittsburgh is probably fortunate in having preserved its casts *in situ*, this side of storage or the junk yard."[8] Today, at the Museum of Roman Civilization in Rome, it is difficult to distinguish between curated arrangements and the crammed deposits of casts in corridors, and to differentiate casts of ruins from ruined casts. The well-kept collection at the Slater Memorial Museum in Norwich, Connecticut, inaugurated in 1888, appears, perhaps accidentally, as a well-ordered open storage. The casts in storage at Blythe House in London—which for a century were integral to the display of antiquities at the British Museum—constitute a dismantled collection in meticulous seriality.

Order—as well as the threat of disorder—was a critical issue for the display of plaster architecture. The increasing corpus of architectural casts spawned a corpus of documents that strove to bring order to these unexpectedly unruly objects. This chapter shows how the full-scale casts were dependent on print media to explain their increasing illegibility, and explores the intermediality at work in the galleries, where scale models and photography, in particular, helped contextualize the huge fragments.

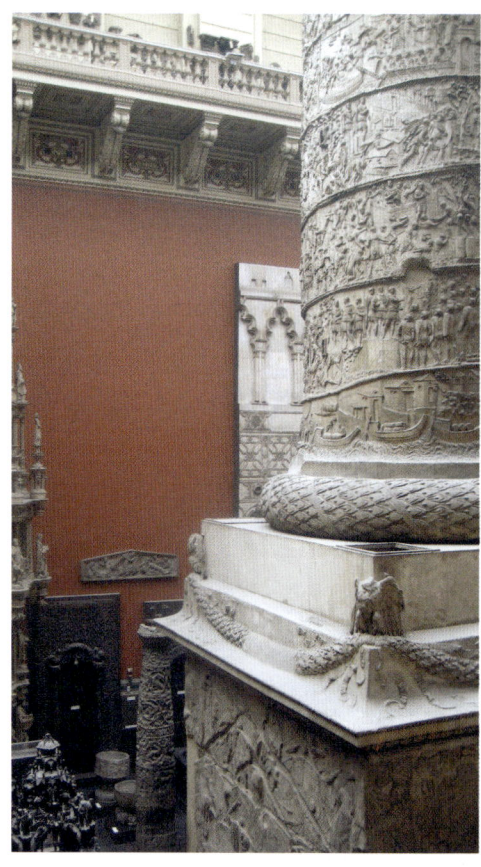

Figure 47, opposite. Broken bits of the Metropolitan's Urnes portal in storage, New York, 1990.

Figure 48, above. Trajan's Column with stave church portals, Cast Courts, Victoria and Albert Museum, London.

The Poetics of Plaster

If the ideals proposed for the displays often fell short in the galleries, the curatorial efforts and catalogue descriptions had lasting repercussions in affecting the reception of the monuments in situ, a phenomenon that the casting of four Norwegian stave-church portals readily exemplifies.

Monuments in Time

Comparison was a main purpose for the exhibition of plaster monuments. "Better than the originals," they enabled examination and comparison, the Royal Architectural Museum typically rehearsed.[9] The casts enabled in-depth study of individual monuments and permitted their proper placement in time in the gallery spaces. In the 1902 catalogue to the Brussels collection, the curator Henry Rousseau made an observation that applied beyond his local context, hinting at the complex relation of the reproduction to the original: "Our goal is to unite in the mind these objects that are inevitably separated in reality."[10] This might seem a truism. While not even the best-endowed museums, such as the British Museum or the Louvre, could display the history of art and architecture as unbroken chains, a well-organized cast collection could ideally present full historical trajectories. Reproductions could juxtapose works in museums elsewhere with parts of buildings still in use and ruins at their original location, gratifying nineteenth-century passions for continuous, legible series. Hence the cast courts were thought of as sites for the creation of order out of disorder, and the presentation of coherent sequences even of something as resistant to museum display as architecture. This coherence relied on chronology: a curatorial device that had been pioneered in Lenoir's Museum of French Monuments, where it made manifest a "new idea of history," by "breaking from traditional hierarchies."[11] For Rousseau in Brussels, the casts made it possible to present monuments in a "rational order," and to give "at least a general idea of the relations between the different and successive manifestations . . . from antiquity to the dawn of modern times."[12] While architecture at large does not come in any particular order, the reproductions could ground the works of the past as milestones in well-curated itineraries, combining several tropes of nineteenth-century historical imagination. "Our time has fantastic plaster models and artificial ruins to embody history," as a Norwegian journal aptly put it in 1873, while strongly warning contemporary architects against copying from these models of the past.[13] The plaster monuments could present history as reconstitution, reconstruction, and projection, exercising theories of history and the temporalities of architecture.

After having toured museums on the Continent, Charles Newton in 1851 appealed for a museum in London arranged "in one great chronological series," a perfection possible only with three-dimensional reproductions.[14] "Newton's was a voyage of exploration but also one of demonstration," observes Ian Jenkins, at a time when cast museums were, for architects, archaeologists, and artists, "what a Museum of comparative anatomy would be to the physiologist."[15] The demonstration would corroborate the Elgin Marbles as the standard of excellence within "a developmental view of art along evolutionary lines, foreshadowing Darwin's *Origin of Species* with its vision of the ascent of man through the process

of natural selection."[16] Comparison was at the core of the idea of aligning in the same space art and architecture from across time and place. "The great task of Archæology—comparison—though much promoted by the facility of modern travelling, is still greatly hindered by the inability of the memory to transport from place to place, and to recall at intervals of time, those finer distinctions and resemblances on which classification mainly depends."[17] In emphasizing the benefits of comparison via reproductions, with reference to the shortcomings of remembrance and the impossibility of seeing everything in original, Newton anticipated the premises for André Malraux's *musée imaginaire* conceived in the 1930s, a proposed collection of two-dimensional images that would "carry infinitely farther" than any "real museum" the unveiling of a global world of art.[18] "Visual memory is far from being infallible," Malraux asserted; moreover, for the great art experts of the past "weeks had intervened" between the inspection of different artworks that were compared (figure 49).

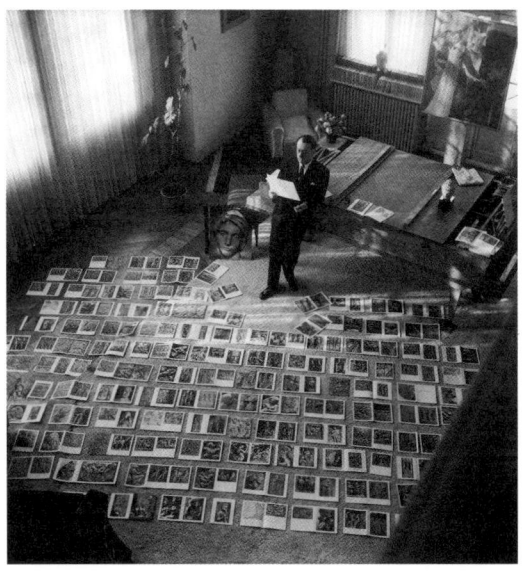

Figure 49.
André Malraux editing and curating his imaginary museum.

A century before Malraux published his imaginary museum, Newton found two-dimensional media insufficient to supply the "deficiency in the natural powers of the mind."[19] Brought together at full scale, examples of successive styles would allow for "a careful appreciation of their relative values, according to some recognised standard," and create the possibility of acquiring "a whole capable of arrangement in the mind in one chronological series."[20] The British Museum was the model, with the Egyptian antiquities "placed in immediate and instructive juxtaposition with that style to which they form the most singular contrast—the style of Phidias, as seen in the sculptures of the Elgin room."[21] The Assyrian collection—then in the process of installation at the British Museum—was described as "documents for the history of art, and perhaps, for the History of the world": documents that were about to throw "a new and unlooked-for light on the question which has occupied archæology for more than a century," namely, the origin of Greek art and architecture. Curated chronologically, the casts would "exhibit clearly to the eye the peculiarities of their style and treatment," and enable "a new comparison and a more scientific arrangement of the archaic monuments of Greece, Asia Minor, and Etruria."[22] Hence there was an absolute contemporaneity at play in this conceptualization, an appropriation of the past capable of instantly placing archaeological novelties within chronological and comparative schemes.

This new take on history was precisely what the Crystal Palace aimed at when presenting a collection that "even a Roman emperor, with all of Greece to plunder from, could scarcely have brought together."[23] The ten architecture courts not only periodized the history of architecture but also portrayed transitional styles, based on the assumption that in architecture, "there is no gap."[24] The Byzantine court, for instance, was all about exhibiting transitions. Our aim, stated the handbook to the

Byzantine court, is to gain "knowledge of all the architectural works ever produced," and in "microscopic" detail. The arrangement of the casts and the incorporation of new productions filling in gaps would supply "the series of links wanting to connect all styles; and hence the very apparent opposition existing between one ancient system—the Roman—and another—the Gothic—only renders more interesting the Byzantine style, which, with its offshoots, served to connect the two."[25]

A twofold synecdochical rationale undergirded Newton's chronological chain. First, assembled together, bits and pieces of ruined structures could stand in the place of lost totalities. This strategy was demonstrated in the Second Elgin Room in the British Museum where the legibility of the Parthenon frieze was enhanced by reproductions. New casts produced in Athens were mounted above the casts that had been made in situ in 1802, together providing "a record of the current condition of the frieze."[26] As an ensemble, the two sets of reproductions documented the deterioration of the Parthenon since the beginning of the century; thus plaster showcased the material historicity of the Parthenon and the rapid change of the marble monument in Athens. Second, the singular monuments from different places arranged in chronological series pointed to architectural history at large. Revelations of the current state of individual monuments and their placement in developmental narratives synergistically expressed, on one hand, wholeness, and, on the other, the contemporary preoccupation with systems for historicizing the past. Denoting singular monuments and series, the plaster monuments became a panorama where parts and wholes unfolded in perfect hermeneutical perspectives.

Newton's promotion of chronology had an immediate impact and became the paradigm for the exhibition of plaster monuments. Addressing in public the chaotic display of the casts at the École des Beaux-Arts, Ernest Vinet, the school's archaeologist-librarian, frequently quoted Newton in his proposal to establish a new chronologically conceived portrayal of antiquity in plaster either at the Louvre or elsewhere in Paris.[27] The founders of the Architectural Museum published their proposal to rehang the exhibits at South Kensington, hoping to better afford comparison by showing the architectural fragments in "chronological sequence."[28] At the Trocadéro the curatorial apparatus aimed to show that architecture progressed along evolutionary lines. The enfilade galleries were ordered chronologically to give "a complete idea of our French sculpture," as Viollet-le-Duc had devised its purpose, with monuments placed "in a methodical order," to reveal the relations of architectural works of different epochs and civilizations.[29] Most important, wrote Charles C. Perkins in 1870, laying out a vision for future American museums, carefully selected exhibits must be displayed chronologically, not "chosen haphazard from the originals in the Vatican or British Museum, and arranged without system."[30] When most of the Willard collection was in place at the Metropolitan Museum of Art, Arabic, Egyptian, Assyrian, Greek, Roman, Phoenician, Byzantine, Romanesque, "later Medieval styles," and Renaissance architecture were placed in alcoves under the galleries, with the bigger objects mounted on the walls or freestanding "as near as practicable, to the smaller objects belonging to the same period and style."[31] Arrangements based on mythology, typology, and other expressions of "old-fashioned theory" were finally "universally abandoned, if I am not

mistaken, and the chronological system has taken its place," Edward Robinson declared, when augmenting the Metropolitan collection in the 1890s. Chronology, he asserted, provided the antidote to the randomness that could only produce "bewilderment in the visitor's mind."[32] At the Art Institute in Chicago, the "full-sized fac-similes of original works" were shown in an order that was "approximately chronological."[33] When ordering casts at the Museum of Egyptian Antiquities at Cairo, the Carnegie Institute insisted that the works were indispensable "as a feature of the chronological scheme of the whole collection."[34]

The cast courts were all about placement, getting buildings from distant pasts and places to the right place—in time. Detached from their site of origin, the plaster monuments became means to make and expand history. Already the Assyrian artifacts had been recognized as an Achilles' heel to classicist aesthetics, and they were soon accompanied by other works that demonstrated architecture's specificity in time and place. The assortment of new monuments mirrored excavations, restoration works, and the codification of local variations and national traditions on a global scale. In 1867 temple fragments from the ancient Khmer capital Angkor in Cambodia and casts from Indian monuments as well as from Mexico were presented at the Exposition universelle in Paris, while the original, wooden Norwegian stave-church portals that had been exhibited in Paris were brought to London and cast after the exhibition closed.[35]

This geographical expansion prompted synchronizing of non-Western histories. When casts from Indian temples found their way to the Architectural Courts at South Kensington in 1870, they were folded into the history of Western antiquity. According to a catalogue of Indian art from 1874, the "gateways surrounding the great Buddhist Tope at Sanchi are wonderful records of the state of art in India at the period of the commencement of the Christian era."[36] Subdivided into periods, the genealogies of non-Western works unfolded in parallel to Western art and architecture: "To understand what is meant by Indian sculpture it is necessary to be familiar with certain types produced by different races and at different periods," said the maker of these "plaster facsimiles," Lieutenant Henry Hardy Cole, a royal engineer working with the Archaeological Survey of India.[37] Although expanded beyond the Western tradition, the canon continued to be classified within the same developmental time frame, a process mediated by exhibition and the monuments' "off site careers as object and image."[38] H. H. Cole emphasized architecture as "the material expression of the wants, the faculties, and the sentiments of the age in which it is created." Style in architecture, he said, "is the peculiar form that expression takes under the influence of climate and materials at command."[39] With this time-typical historicism, H. H. Cole was supporting the vision of his father, Henry Cole, of a virtually boundless museum. In fact, when retelling the legend of the advent of the great Buddhist teacher-prince Siddhartha—whose mother, Queen Maya, is said to have dreamed of his conception in the form of a sacred elephant descending from heaven—Cole concluded, "A representation of this dream is to be seen on the eastern gateway of the Sanchi Gate, a cast which is erected in the south court at the Kensington Museum."[40]

This dream cast in plaster was part of a far-reaching dream to incorporate all the monuments of the world into a unitary conception of time.

From the first appearance of the casts of the twelfth-century Angkor Wat in Paris in 1867, these reproductions became "a powerful translation tool used to appropriate the local built heritage of the Indochinese colonies for global representation."[41] Appropriated into world history, they were "systematically selected, organized, hierarchized and displayed according to a dominant evolutionary theory of the evolution of nature and culture."[42] When an "ageless and spotless" Angkor Wat appeared at the Colonial Exhibition in Paris in 1931, the temple had already been part of a temporalization of the exotic through its inclusion in Western galleries as global patrimony in the form of "authentic translations."[43] Transplanted to Europe as "an oriental Ruin *and* a restored monument," Angkor Wat was lifted from eternal presence to periodized chronology.[44] Similarly, the Portico de la Gloria from the cathedral at Santiago de Compostela was canonized and temporalized in a history of monuments by replication. Traveling through northern Spain in 1865, John Charles Robinson, the superintendent of the art collections at the South Kensington Museum, described the twelfth-century cathedral as a "masterpiece for all time," waiting to be "reproduced by moulding, photography and hand delineation."[45] The next fall Domenico Brucciani, together with Thurston Thompson, the museum's photographer, traveled to Spain with detailed instructions concerning what to cast and photograph. The two- and three-dimensional reproductions influenced the status and perception of the cathedral both on- and off-site. The documentary and curatorial efforts in London revived a "national and international interest in the cathedral of Santiago de Compostela as a monument, and as a pilgrimage destination."[46]

New monuments and new periods appeared in the galleries. As parts of the Pergamon Altar and the Mausoleum of Halicarnassus proliferated in museums on both sides of the Atlantic, Hellenistic architecture could smoothly mark the transition from Greek to Roman antiquity. The chronologizing desire at work created new, physical time-based categories that produced temporal gaps which the casts helped close. Cycled through time, the monuments became timely and were assigned their proper place in history by becoming exhibits. Testimony to a synchronizing contemporaneity, producing simultaneity in the perception of monuments from across time and place, the plaster monuments displayed a relativized and relational canon deprived of universal standards and historical absolutes.

Monuments in Space and Scale

In diachronic installations the plaster monuments synchronized works from across cultures. These imaginary geographies of increasingly global monuments were subordinated to a time script, and they reciprocally defined one another's temporal context. Yet the fragments also needed contextualization in regard to the place of origin of the whole of which they were parts. This was achieved through an intermedial undertaking, in which photography and scale models were of particular importance. Translated in materials, transposed in media, and transported from one place to another, incarnations of monuments became very physical manifestations of a hypersignification.

Daguerreotypes of the Parthenon were made the year the daguerreotype was invented, and the Roman ruins in Baalbek and the Hypostyle Hall at Karnak proved similarly photogenic soon after, introducing a liaison between antiquity and modernity that has never been put to rest.[47] Photography's obsession with ruins and archaeology was paralleled in casting. Yet the three-dimensional presence of a cast works at full scale. "A photograph does not give the size," and above all "not the rotundity of sculpture; it is moreover a singular view," reads a typical explanation of the benefits of casts within nineteenth-century visual culture.[48] In two and three dimensions the two mass media illustrated architecture of the past in a complementary way: "the photograph its surface, its sheen, its depth of shadow, its sharpness of line, its exact form," while the cast presented "its volume and variety." Photographs and casts shared the same advantages over the original work. Both media presented monuments of the past in versions that could "be beheld without fatigue, distraction, or limitations of time, under the best conditions of light and approach, and confronted one with another."[49] Substituting for the real thing, the representations did something the thing itself could not do. Commenting on a series of stereodaguerreotypes from the Crystal Palace in 1851, a critic in the *Illustrated London News* concluded that they "actually surpass the reality. No one has ever seen the interior of the Exhibition from end to end with such clearness."[50] The pairing of photography and casts was constantly reassessed. These "complementary modes of reproduction" documented and disseminated monuments, as in the undertaking of Brucciani and Thompson in Santiago de Compostela, or in the circulation of Indian temples as casts and photography—the latter dubbed by James Fergusson "a veritable picture Bible of Buddhism."[51]

In the galleries, photographs often appeared in combination with scale models, to more fully realize the monument in time, space, and scale. Visitors at the Crystal Palace were urged to examine the Parthenon model at scale 2:9 displayed in the Greek court to see the original position of the frieze and sculptures displayed at full scale.[52] At South Kensington the objective of the Architectural Museum was for the casts to be shown close to "models of the perfect building," complemented with photographs that documented its present state, to demonstrate for the audience the work of time in the life of a monument.[53] In the Architectural Courts the Sanchi gateway was displayed with photographs, a scale model, and most probably also a painting that documented the expedition to cast the monument (see figure 73). This ideal of contrasting scale models and full-scale casts was subsequently pursued at the Metropolitan: models afforded "ample illustration" of facets of the full-scale casts, which could otherwise not be "satisfactorily shown" (figure 50).[54] Photographs conditioned the understanding of the full-scale fragment. New shots of the Pantheon placed on the pedestal showed "how much is restored in the model," while photographs of the Parthenon visualized for the visitor the "extremely mutilated condition" of the monument in Athens in comparison to the restored model (figure 51).[55]

Most collections employed photographs as context. At the Trocadéro, however, the casts themselves became photographic subjects. There the catalogues were illustrated with photographs of the monuments as mounted in the galleries, a practice that was quite rare. Further, in

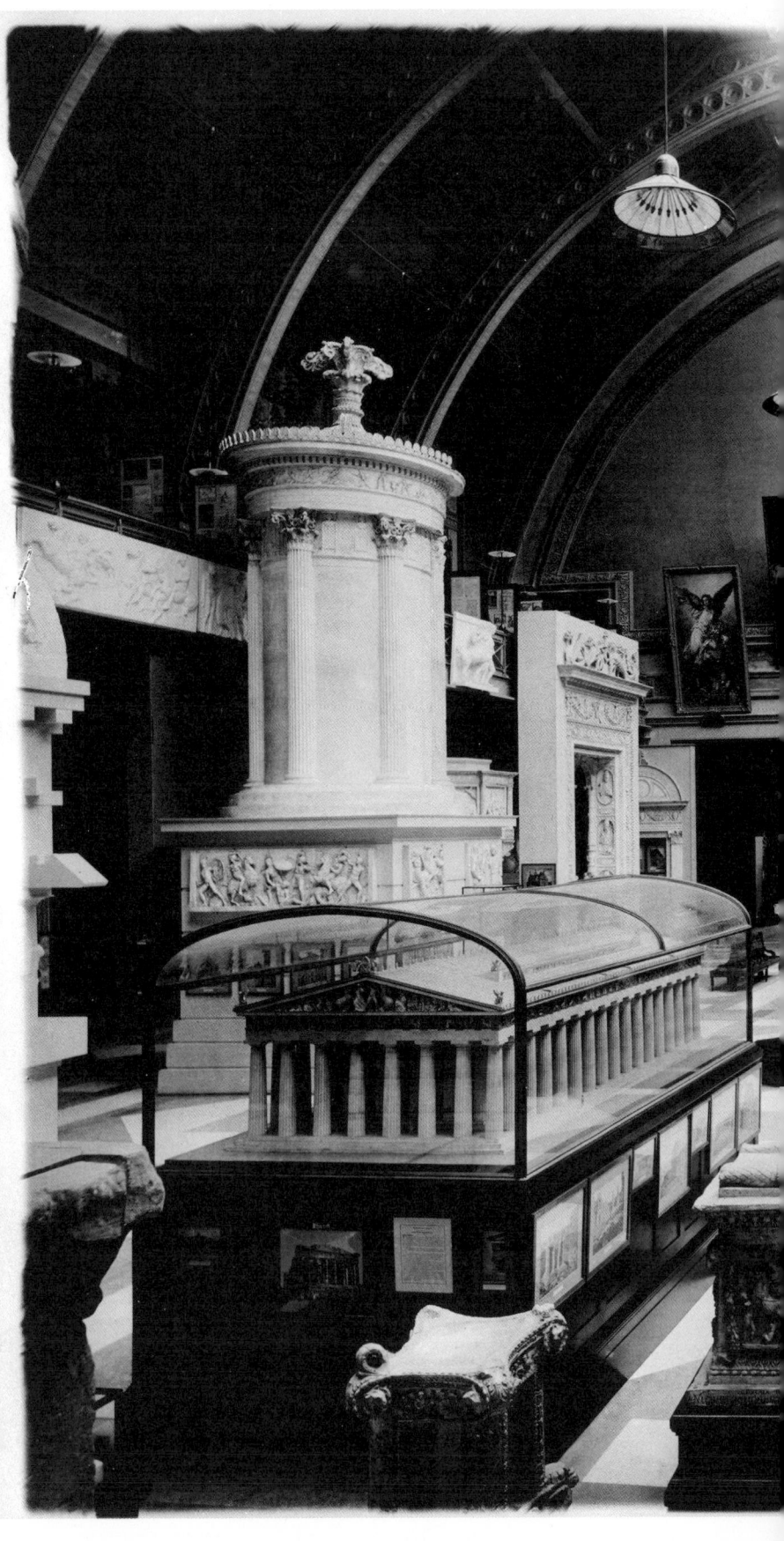

Figure 50.
Photographs on the plinths of the Parthenon, Notre-Dame in Paris, the Pantheon, and the Arch of Constantine, and in the background, the Pantheon model at the Metropolitan, 1907. The Metropolitan Museum of Art, New York.

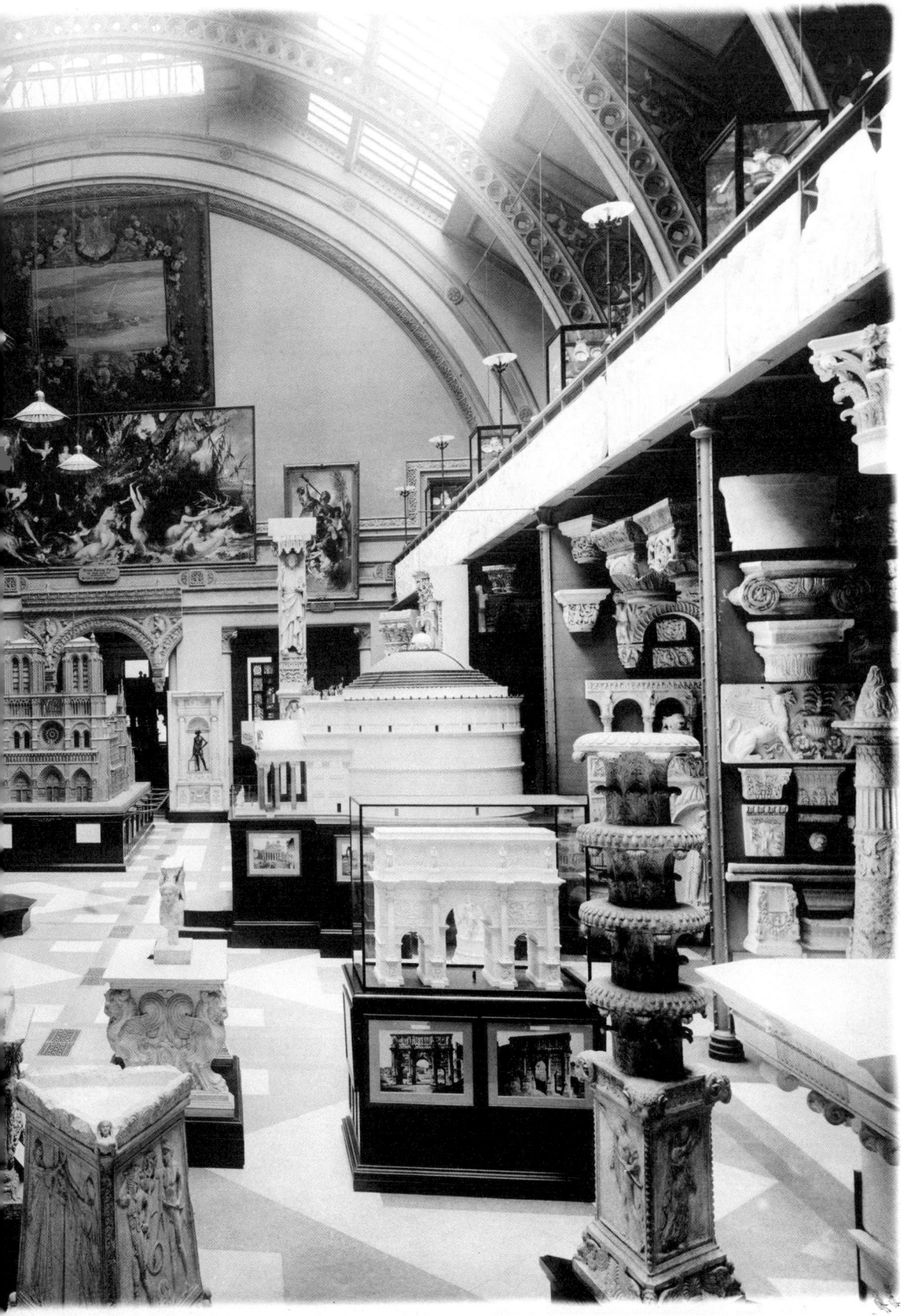

Figure 51.
Children comparing the restored Parthenon model with contemporary photographs on the plinth, the Metropolitan Museum of Art, New York, 1910.

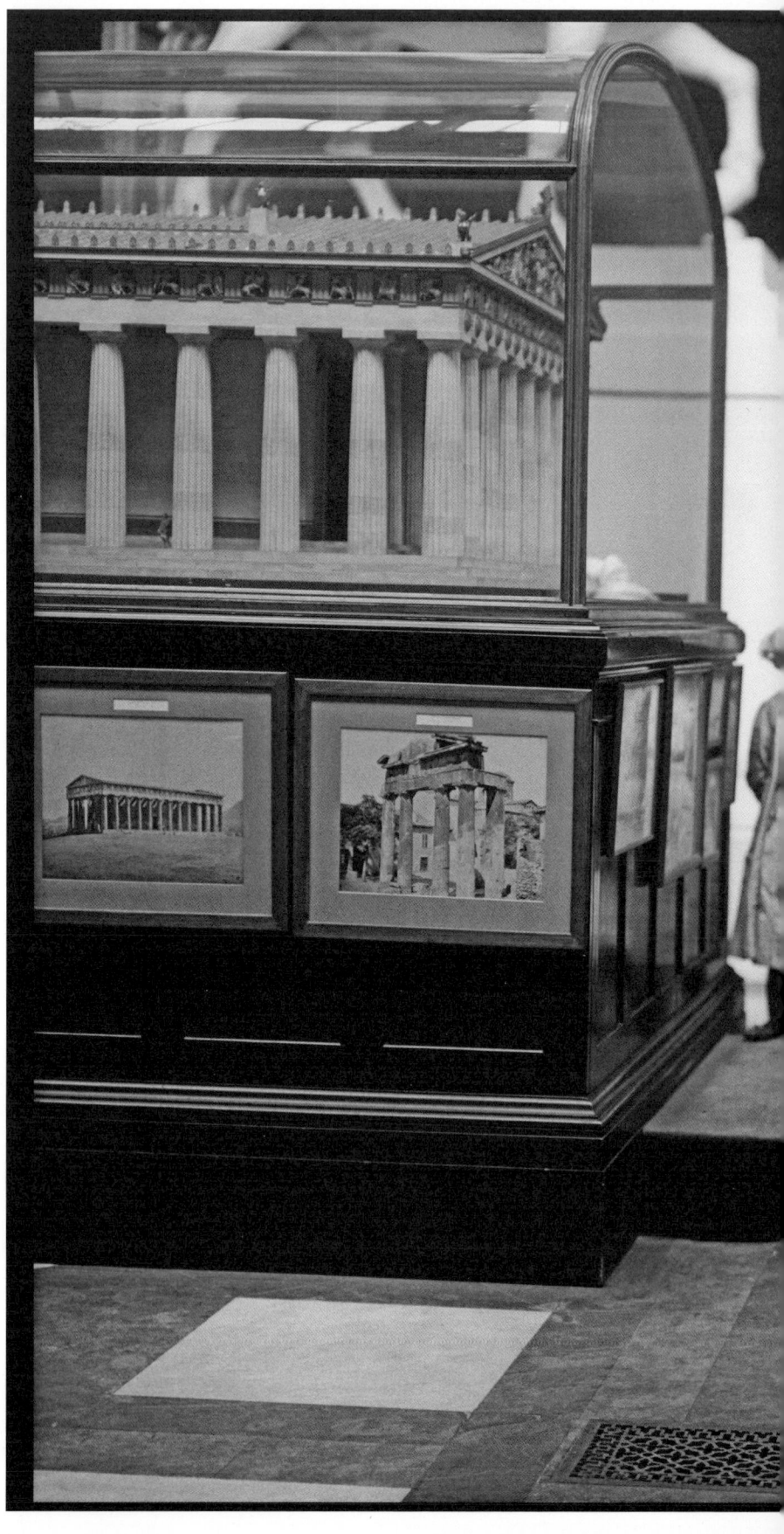

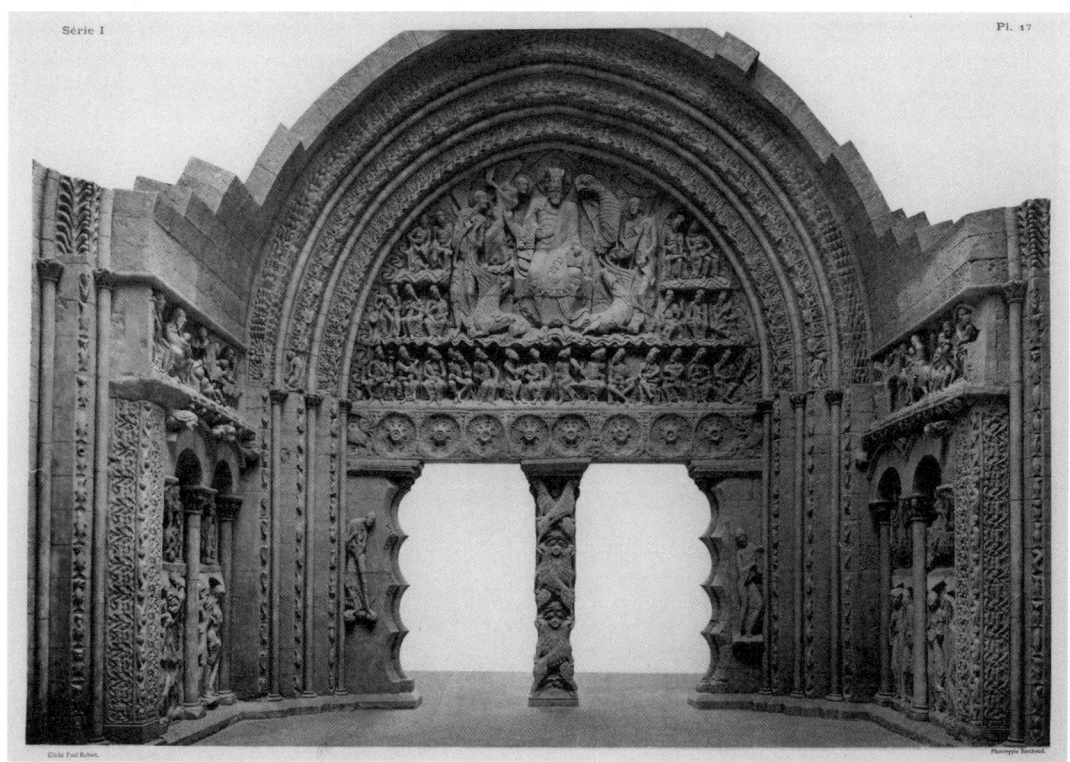

Figure 52, above. West portal, Saint-Pierre, Moissac. From P.F.J. Marcou, *Album du Musée de Sculpture Comparée*, vol. 2 (Paris, 1897).

Figure 53, opposite, top. Postcard by the Neurdein brothers, showing the woman selling postcards in the Trocadéro galleries at the north portal of the cathedral in Bourges, after 1900.

Figure 54, opposite bottom. Building Portico de la Gloria at the South Kensington Museum, London. Isabel Agnes Cowper, *Cast of Portico de la Gloria; Archivolt of Central Doorway, the Cathedral of Santiago de Compostela in Spain*, 1868. Albumen print.

1897, the museum published a five-volume album, prepared by an archivist at the Historic Monuments Commission. Thumbnail photographs of the buildings the casts were taken from were discreetly placed at the end of each album, while the abstracted plaster monuments that filled the albums, many of them presented at full-page size, were the star attraction. Eclipsing the contemporary interest in architecture as space and experience, the archivist-curator conspicuously excised the gallery context from this "musée portatif"—presenting scale-less images of the full-scale objects, made for the eyes as he put it, not to create an immersive sensory experience (figure 52).[56] The transformation from three-dimensional objects into two-dimensional images was also effected by the sixteen hundred postcards the Trocadéro commissioned at the turn of the century. A museum in miniature, the postcards circulated plaster on paper, by mail (figure 53).[57]

Yet, overall, the experience of scale and size was a major issue in the cast courts. Reporting from the Architectural Courts at the South Kensington Museum, *The Builder* compared the experience to "the first entrance to Notre Dame, Paris; the first glimpse of Mont Blanc."[58] Mesmerized by the properties of the spaces and the massiveness of the objects, the reviewer found Trajan's Column the most remarkable—a reproduction bestowing "advantages not enjoyed in Rome." For the Portico de la Gloria, the "sense of its magnitude and magnificence, the imposing character of the assemblage of representations of prophets, apostles, and other saintly or sacred personages," could not fail to command admiration (figure 54). Although he was looking at a brand-new work authored by Domenico Brucciani, the object was attributed to its supposed architect, Master Mateo, who

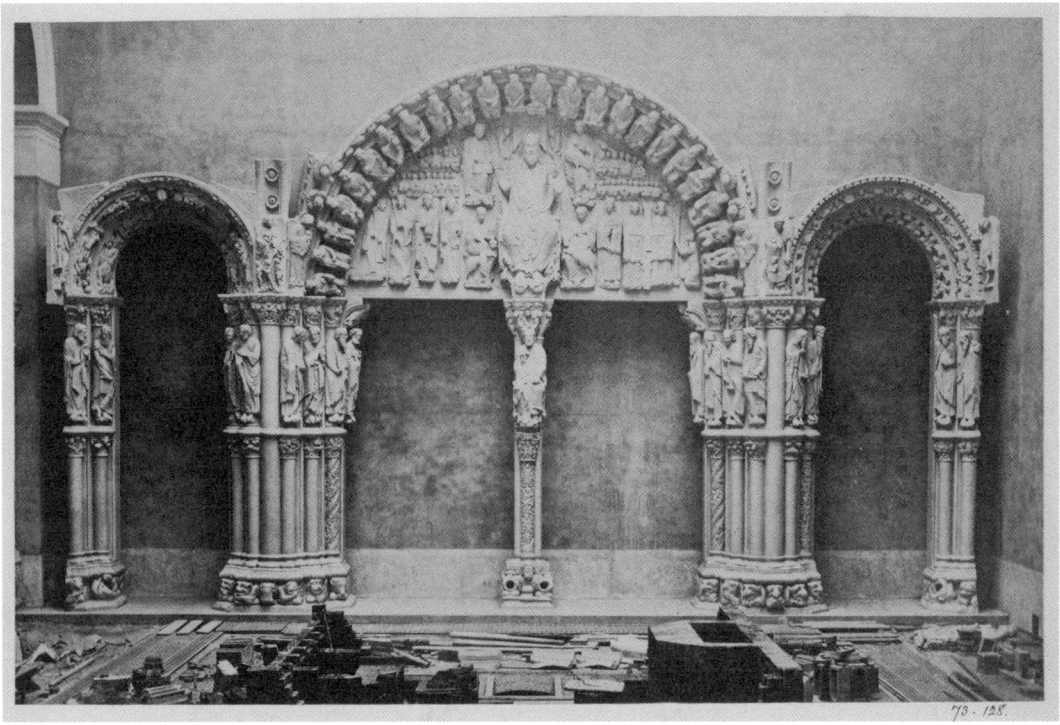

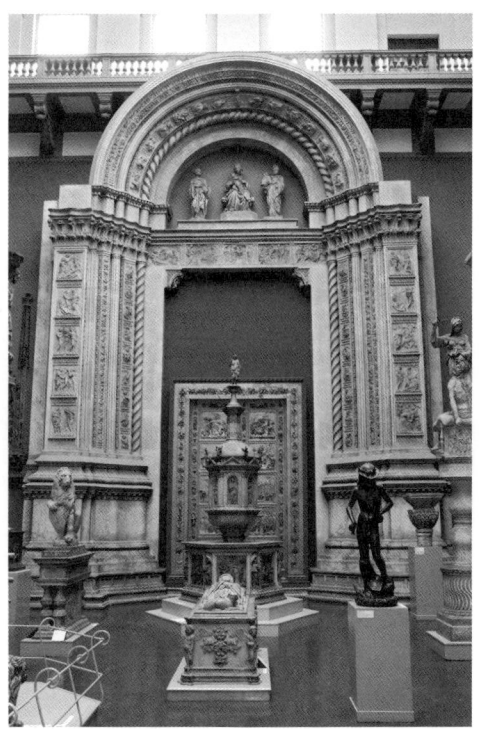

Figure 55.
The central doorway of San Petronio Basilica in Bologna framing Ghiberti's Gates of Paradise in the Italian court, prior to the 2014 renovation at the Victoria and Albert Museum, London.

"finished the work in 1188." This transparency and effortless oscillation between the original and the reproduction was typical.[59] In the galleries, the plaster monuments were perceived and discussed as architecture, but also as something more—emblematically captured by this reviewer when he underscored that the plaster version of Trajan's Column provided a better perceptual experience than the monument in Rome, and also that its immense size was even more discernible when the monument was decontextualized and domesticated into a museum.

The capacity of three-dimensional reproductions to demonstrate relations among architectural elements and their relative sizes is beautifully captured in Stendhal's *Memoirs of a Tourist* (1838). Among the monuments recorded in this fictitious travelogue figures the French architect and archaeologist Auguste Pelet's actual collection of cork models of Roman monuments executed at scale 1:100.[60] In Nîmes, the traveler described the amphitheater, the Maison Carré, the Gate of Augustus, and the ancient baths according to well-established guidebook conventions, before setting out to Pont du Gard on his way to Orange. Surprisingly, the experience of seeing the awe-inspiring ancient ruins firsthand turned out to be dwarfed by the traveler's exposure to the miniature cork versions of the monuments: "One could not see a more skillful, or exact imitation. These models, all executed on the same scale, enabled me to have an idea of the comparative size of those monuments for the first time."[61] In Stendhal's narrative, Pelet's collection both demonstrates how the miniature enables a more accurate understanding of buildings, and highlights how the comparative effects of models might radically change the perception of what is seen and experienced, beyond mere representation. Like Proust's Marcel in Balbec, Stendhal corroborates a well-known experience of architecture in situ—the feeling of the building being submerged by its context, of surprise and disappointment in the discovery that famous buildings often tend to be much bigger or smaller than expected. In their abstracted simplicity and removed from the distractions of reality, models reveal proportions, space, and scale, as Stendhal testifies when he observes that "the Arch of Triumph at Orange, a gigantic work, would easily pass under one of the lower arches of the Pont du Gard."[62]

The full-scale casts, inventively installed, achieved similar effects. At the South Kensington Museum, Giovanni Franchi's 1867 electrotype of Ghiberti's baptistery doors from Florence was displayed within Oronzio Lelli's 1886 cast of the central doorway of the San Petronio Basilica in Bologna, while the arches in the Portico de la Gloria still serve as frames for the electrotyped bronze doors from Hildesheim, Augsburg, and Verona (figure 55).[63] As such, the Spanish portico became an apparatus for scaling other works, while constituting, as Malcolm Baker puts it, "a remarkable survey of early medieval architectural sculpture."[64] Such juxtapositions reveal aspects of scale and powerful displacements. In combination,

full-scale casts, scale models, and photography allowed for glimpses into a reality that we are denied when we stand before the real monument.

Collapsing Taxonomies

Despite the conceptual clarity of chronology, the ideal of legible series constantly threatened to collapse in the galleries, and not least because of the size and weight of the exhibits. The relocation of the French monuments shown during the World's Columbian Exposition in 1893 hints at the logistic thrill of receiving such a hoard of exhibits. France and the United States had agreed that the casts should be transferred to the Art Institute in Chicago after the exhibition closed. Apprehensive about maneuvering "this remarkable collection, which is unsurpassed in its kind either in quality or extent," the director of the Art Institute reported to the trustees that the "reproduction of Cathedral doorways, &c are of great size, and it will be necessary to make special provision for their reception in our museum."[65] The official record of the 1893 exposition also highlighted the exhibit's magnitude, guiding the visitor through the history of French architecture by, in detail, giving the measurement of the replicas.[66]

In Chicago, the "entirety" of the French architectural tradition landed simultaneously and could be planned for. Yet five years later, "for want of room," only parts of the Historical Collection of French Sculpture and Architecture were in place in two corridors and a gallery, at a remove from the itinerary of galleries that led from Egypt to the Renaissance.[67] In Paris, the casting of the French patrimony was a process that spanned decades. Viollet-le-Duc's critique of the British collections' lack of method reverberated through the Trocadéro catalogues from the early 1880s on. Yet the rapidly augmented stock of monuments posed a constant threat to the method. When in 1889 the exhibition space was doubled by the expansion into the Passy Wing, it was impossible to remount the colossal and fragile monuments, and the chronological scheme was duplicated in two directions. However, the collection kept growing and the problem remained. Accordingly, the 1911 catalogue—combining a history of the museum, an overview of French monuments, and a guide to the galleries—explained that a number of Romanesque churches, among them the central portal from Saint-Gilles, had not found their proper place in either wing.[68] Begging visitors to excuse the misplaced monuments, the director had to conclude that not even cast collections could remain chronologically rigorous. The struggles to keep the monuments in their designated place, in the chronological and periodical sequences of the galleries, only became more difficult with an expanding plaster canon. The reproductions in the museum were starting to behave exactly as architecture does outside curatorial control.

Method was always an issue; it was what the audiences expected and what the curators tried to achieve. Compared to the perfect chronological layout of the casts at the Neues Museum in Berlin, the South Kensington collection appeared to be "arranged without method," a British critic complained: "the eye and the mind are alike fatigued in attempting to bring order out of this chaos."[69] The same critique was vented at the Musée du Cinquantenaire in Brussels where the east pediment of

Figure 56.
Construction of Trajan's Column, Architectural Courts, South Kensington Museum, London, 1873.

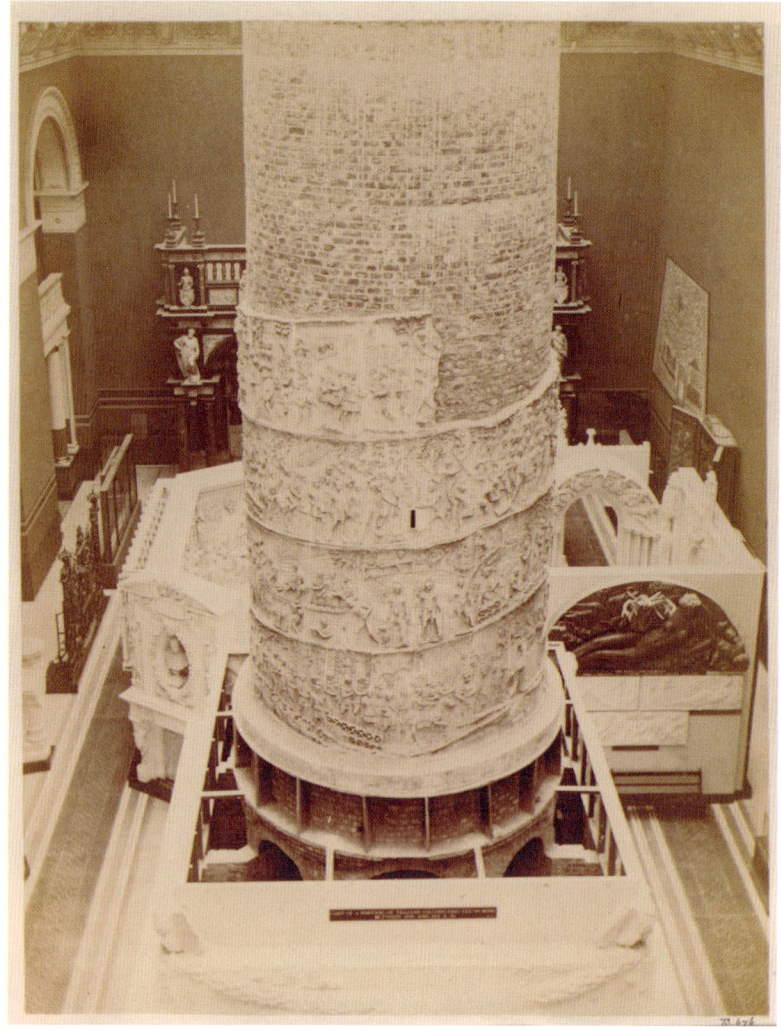

the Parthenon loomed startlingly over Pisano's pulpit from the cathedral in Pisa and Ghiberti's doors from the baptistery in Florence, as well as the eighth-century Anglo-Saxon Ruthwell Cross in the Grand Hall. In the surrounding galleries, Pompeian, Gothic, Assyrian, Romanesque, Egyptian, Roman, and Saracenic works appeared in random order. At the South Kensington Museum, it was not only the director's preferences that obstructed the founders' wish to show the Architectural Museum casts according to "their date and character."[70] Structural factors also worked against the chronological scheme. In the 1860s an imminent collapse forced museum workers to move the heaviest casts to a lower gallery, "on account of the weakness of the floor."[71]

In New York, the Metropolitan had envisioned a tabula rasa on which science, chronology, style, rigor, and perfection could be perfectly incised. Yet disorder and displacements became an issue from the very beginning: "The casts are taking far more time to arrange than what was thought possible, and the grand hall is still in a chaotic state," the *New York Times* reported the day before the opening in 1889.[72] Not only remounting, but

mounting could cause difficulties. General di Cesnola had to engage in hands-on diplomacy to ease the frustration among the increasingly agitated staff involved in transporting casts prepared for exhibition from the workshops to the gallery. For instance, one of the Parthenon pediments, badly broken during shipping and pieced together in the basement, turned out to be impossible to get out of the workshop and into the gallery. The director urged the curator at the department of casts to provide a "temporary exit . . . to transport this said cast to the Grand Hall."[73] The operation involved several alternative routes and prospects of cutting new passages in the walls, as well as enlarging existing door openings, to get the plaster Parthenon undamaged through basement vestibules, past elevators, out onto the street, through the main entrance, and finally into the Grand Hall.[74] Portions of façades, temple pediments, and cathedral portals dwarfed monumental museum doorways, resulting in the need to erect many plaster monuments in situ, temporarily turning the galleries into construction sites. At the South Kensington Museum the construction of Trajan's Column took years, and the spiraling frieze displaying Emperor Trajan's victory over the Thracians, hung on a brick cylinder, displayed Victorian craftsmanship as well as a Roman monument (figure 56).

In some ways scale models were more tractable than the enormous full-scale casts: "while relatively expensive they occupy comparatively little space."[75] Yet even the scale models could be problematic in terms of placement. For the "models of the temple al-Karnac, of the Pantheon at Rome, of the Arch of Constantine and the porch of St.-Trophime at Arles, as well as of the large cast of the transept-portal of Notre Dame . . . , there is, at present, no proper space," William Ware, who was in charge of the mounting, lamented less than a year after the opening.[76] And just like the full-scale casts, the models—intended to project a nonextant wholeness—generated confusion, disorder, and taxonomical error. The state-of-the-art model of the Parthenon, for instance, caused international embarrassment when it was installed on Fifth Avenue. The account sent by the curator of casts to General di Cesnola illuminates the complex relations between architectural representations and their referents:

> I have found the two series of Metopes—on the Eastern front and on the Western end—to be misplaced by interchange. In other words: the copies in miniature of the Metopes still existing on the eastern front of the Parthenon have been placed on the western pediment (contest between Athena and Poseidon), and, conversely, the reduced copies of the Metopes still surviving in place on the western end of the Parthenon are exhibited on the eastern front of the model beneath the eastern pediment (Birth of Athena from the side of Zeus). In speaking of the 'eastern front' and 'western end', I mean the true eastern front and western end of the monument and not the actual east and west of the Model as it stands on the floor of the Central Hall. In its present bearing the Model is completely turned about in respect to the four cardinal points of the compass; and thus diametrically opposed to the adjacent model of the Acropolis and its diminutive representation of the Parthenon.[77]

The erroneous placement of the Parthenon sculptures received ample coverage in British magazines. *The Builder* suggested that the model's maker, French architect Charles Chipiez, was to blame, ridiculing his assertion that "the Americans must have made a mistake in putting together the model, which was sent over in pieces."[78] A certain nationalist agenda might be detected, as *The Builder* also accused Chipiez of getting the entasis of the columns wrong, having worked from photographs rather than basing his model on updated "British sources of information." This was a mistake he could not "put off on the Americans." An Englishman writing at the request of the French restorer-modeler countered the English critique of "French lightheartedness," and the prejudice that a "French *savant* could not be supposed to learn anything from English sources."[79] Evoking Beaux-Arts conventions of restoration, Chipiez's British ghostwriter—perhaps a little lighthearted himself—noted that "in France, where innumerable restorations of the Parthenon have been and are being made, it is usual to say 'so many architects, so many different restorations.'" On behalf of Chipiez he explained that the model was "not a scientific study of archæological restoration, but a general idea of the complete Parthenon as a work of architecture." He did, however, insist that the metopes had been placed on the authority of the German Parthenon expert Adolf Michaelis, and added that the model had been "despatched to New York, not in one piece but in a hundred pieces, and put together again after its reception in that city."

Errors, confusion, unexpected juxtapositions, and taxonomical collapses appeared in a number of local expressions, in the placing of monuments from across time and space. Greek and Roman architecture was not dominant in the displays at South Kensington, but that did not prevent Trajan's Column from towering over medieval and Renaissance Iberian and northern European architecture; from the time of its completion in the 1870s, this "mammoth model" was ridiculed in the London press. However, when the director of the Victoria and Albert Museum in the 1920s critiqued what he described as "an anomaly as well as a Prodigious inconvenience," his problem seemed to be taxonomical. He deemed the Roman monument to be completely out of place in the midst of Gothic and Romanesque architecture, and expressed a resolute "desire to get rid of it!"[80] In fact, he suggested chopping it up into sections to exhibit the drama of the frieze, and preferably doing so somewhere else (figure 57).

Architectural Promenades

In light of the current state of the cast collection in Brussels, the title of its 1902 catalogue appears ironic, if not deeply melancholic. The *Promenade méthodique dans le Musée d'Art Monumental* had served both as an inventory and a guide to steer visitors through the galleries. The curator Henry Rousseau, who authored the catalogue, referred to the publication as "an *aide-mémoire*, a methodical guide—or rather, a rudimentary handbook."[81]

Today, the disheveled collection appears antithetical to even a vague conception of method. At its moment of publication, the *Promenade méthodique* mirrored the will-to-order that characterized most collections of plaster monuments. Whatever principle organized the display, the

Figure 57.
The spiraling frieze of Trajan's Column made from the same molds as the one in London, hung in a neon-lit corridor at the Museum of Roman Civilization at EUR, Rome.

catalogue was the vehicle of its significance and system. The visitor was invited to wander among monuments and experience a condensed architectural history. Rousseau's *Promenade* belongs to a part of architectural print culture in which catalogues were curated and galleries were edited. Symptomatically, the curator offered a promenade on paper and in plaster, both as a text to read and as a space to move through, to inspect a collection of full-scale images in three dimensions.

The tautology lurking in the title of Rousseau's 1902 catalogue could be read as a response to the relentless critique of the galleries, as a way to gloss over the lack of correlation between ideals and realities, paper and plaster. Etymologically both "promenade" and "method" denote a step-by-step movement—literally and scientifically as well as figuratively and spatially. However, the appeal to "unite in the mind these objects that are inevitably separated" turned out to apply as much to the gallery as to the uncurated world at large. As *illustrations magistrales* the casts served as spatial images, illustrating architecture as a historical phenomenon that in the end could be fully arranged only in print. The scientific ideals for most cast collections were spelled out on paper, where a perfect order was envisioned for the massive and unmanageable objects that always threatened to fall into chaos, in the hands of troubled curators and before the eyes of disoriented audiences. Only the paper versions of these imaginary museums were capable of creating the order that their plaster referents constantly conspired to destroy, and the catalogues were the haven where the dislocations in the galleries were mended, explained, and excused. When Edward Robinson in the opening section of the "First Greek Room," in the 1887 catalogue for the Boston Museum of Fine Arts, explained that "a few Assyrian Reliefs are of necessity placed in this room for the present," his words reveal not only the constant arrival of new antiquities in the market, but also the difficulties of reshuffling the galleries to keep them in the desired chronological order.[82]

Often referred to as illustrations, the casts became part of a lively publication culture aiming at editing history in museum galleries. Designating indexes of architecture, these catalogues opened a window onto a curatorial, taxonomical perfection unachievable in the real world, inside and outside the museum. The catalogue's counterpart was the gallery in

Figure 58.
Extract from the section on the Egyptian court from Samuel Phillips's *Crystal Palace Guide*, reprinted in *Illustrated London News*, August 4, 1854.

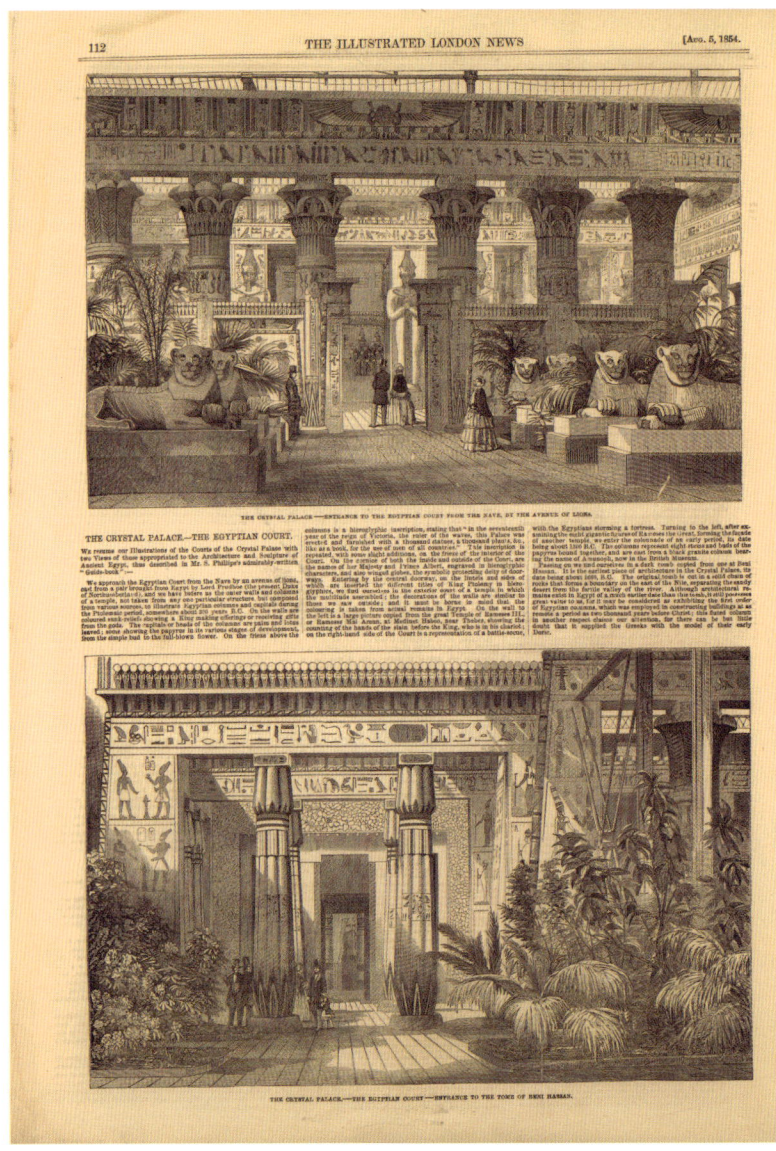

which the reader-visitor could promenade through history among three-dimensional illustrations.

The publication of architecture in the form of full-scale, spatial illustrations gained its earliest manifestation upon the opening of the Crystal Palace at Sydenham in June 1854. The ten cast courts were frequently referred to as "restorations" and "living reproductions," but first and foremost—and with great consequence—as *illustrations*. The Crystal Palace was launched as a three-dimensional "illustrated encyclopedia" in which the visitor could stroll as if meandering through the pages of a book. The perception of casts as full-scale images was consolidated in the unprecedented conflation of print and exhibition culture: this was the first systematic presentation of a progressive architectural history in plaster as sequences to walk through, with a guidebook in hand, immersed in partly fantastical environments. The press persistently encouraged

the visitors to look at the "chief" or "capital illustrations" while reading: "Never before, and in no other place, has such a *ramassement* of the works of all periods and of all nations been seen: and the architectural courts must be studied with guidebooks and correlative aid of all sorts" (figure 58).[83]

"In the Assyrian palaces we have the flesh and no bones," wrote James Fergusson.[84] That was exactly what the plaster design tried to provide by turning the Assyrian sensations into an imaginary architectural totality in "the series of architectural illustrations of ancient history and art in the Crystal Palace," as Layard noted in the handbook to the Assyrian court (figure 59).[85] Oscillating between archaeological accuracy and imaginative evocation, the court published history in the making with the casts as illustrations in a chapter of the successive development of architecture. "The Palace displays and guidebooks could be regarded as scrapbooks assembling contemporary archeological quotations," observes Kate Nichols: "They indicate that 'archeological' debates were not restricted to museum staff, but extended to the public as a matter of interest."[86]

Concretely, catalogues and guidebooks explaining the monuments' place in history were important, but in a broader perspective, metaphors of books, reading, and libraries also helped establish the arrangement of the nineteenth-century museum. The "true principle of destruction is decomposition," and to "divide is to destroy," said Quatremère de Quincy, who mobilized an ancient topos when claiming that artworks became incomprehensible within the arbitrary orders of the museum. "What is the antique in Rome if not a great book whose pages have been destroyed and dispersed," he asked in the 1790s, comparing the past to a book that will disintegrate to dust like a fragile ancient manuscript if not properly preserved—a rescue operation that could be launched only in situ.[87] The idea of the world as a book builds on the fundamental principle that reality might be interpreted and deciphered like a written text. For Quatremère the book signified a cultural-organic whole made out of monuments and artworks, climatic and topographical conditions, languages and mores. This totality disintegrates over time, but its remaining fragments and, importantly, the internal relation of these fragments, might still—and only—be understood in their original habitat. The metaphor identified the book as a frangible all-encompassing totality and the tearing out of pages as the destructive work of time, followed by the deliberate removal of bits and pieces. The trope shifted when Alexandre Lenoir, simultaneously, compared the Museum of French Monuments to an encyclopedia. Lenoir's museum-as-book did not invoke a reality disordered through time. Rather it served as an editorial and curatorial device for the organizing of salvaged monuments into historical trajectories. The introductory space should read as the preface, the sequence of galleries as chapters, while the visitors could

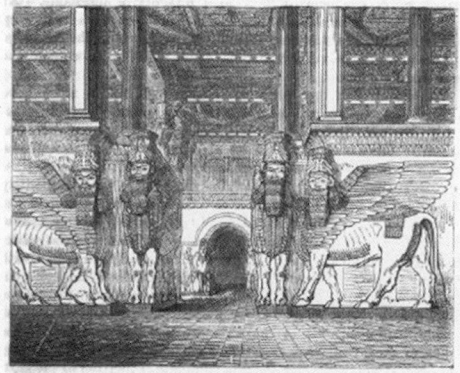

Figure 59.
From Austen Henry Layard, *The Assyrian Court, Crystal Palace* (London, 1854).

traverse the centuries "comme un livre" in which the objects could be read "word by word."[88] In short, in Quatremère's 1790s formulation, a book is an image of the past conceived as a universal but vulnerable whole, and inherently antithetical to the spaces of the modern museum; editorial or curatorial interventions would only distort its order. On the contrary, Lenoir's notion of the book as a model for the museum bespoke a spatial conception of history that could and must be edited to make the past legible, designating "a spatial narrative transparent to its historical model."[89]

If the allegorical power of the book has proved versatile in time, the printed book has remained central to the ordering of artifacts in the museum. Yet the book as a prototype for the editing of historical objects from across time and space got a fundamental twist in the way in which catalogues, inventories, handbooks, and other written scripts attempted to impose order onto the presentation of architectural casts, both factually and figuratively. These publications not only asserted that history could be ordered as a book; indeed, the book became the paradigm and the unique locus in which history could be invented, documented, and explained, with its subject matter displayed in the galleries. Rather than signifying a lost totality—divided, decomposed, or destroyed—architectural history was presented as a compendium of fragments that could be ordered only by serialization, by the act Henry Rousseau dubbed "orders of the mind": orders made of things "by nature separated" and which could appear as continua only in the museum space.

Photographs of the Cour vitrée in Paris record a collection in splendid order. Shot from opposite sides of the vast glass-roofed courtyard, they show the gargantuan Parthenon and the Temple of Castor and Pollux looming over classical statuary placed on plinths in perfect rows. The immaculate order documented in the photographs was anything but obvious in the three-dimensional world. In the late 1840s, the school was far from the orderly museum it later became. "Instead of neat rows of casts," says Anne Wagner, "we should visualize clogged passage-ways, dust and packing crates, and fingers chipped off plasters in the confusion. Even as late as 1855 the situation was still desperate; a report from the Committee on Casts is the cry of men being buried alive by plasters: 'Casts are everywhere in the École; cellars, attics, exhibition halls, all are invaded.'"[90]

A school drowning in one of its main pedagogical devices did not invalidate the possible correspondence of well-ordered collections of casts and books. The curator whose job it was to make sense of the unstructured wilderness envisioned the ideal display as analogous to specialized book series: "This collection will have the aim and the usefulness of those libraries of Greek, Latin, German, English and Italian authors which the publishers never tire of reprinting." Here, the curator, comparing casts and books as two parallel modes of reproduction, anticipated a standpoint that would gain authority over the coming decades as university cast collections were established at the new departments of classical archaeology across European universities, becoming an indispensable apparatus in the new discipline and complementary to the archaeological library. Wagner expands on the metaphor of the building as book and the casts as pages when describing "the building as the container for an instructional text, an illustrated history of sculpture"—"casts, not originals, were to fill its pages."[91] Additionally, cast collections were discussed as catalogues in

their own right. When the Louvre recurrently considered creating its own *musée du moulage*, in the interest of comparison, completeness, and historical perfection, a chronological display of the best examples from each period was described as a "catalogue de quelques pages."[92]

At the Metropolitan the core of the architecture collection was basically in place by 1895, and the Grand Hall was "more than comfortably filled."[93] Spatial constraints and illogical placing kept undermining the method and principles of display. The first complete catalogue of casts, published in December 1908, numbered more than twenty-five hundred entries. With four hundred pages and thirty-three illustrations, it was presented as a handbook that aimed at "heightening interest in the collection as a whole."[94] In the preface Edward Robinson apologetically conceded that the display "leaves much to be desired," while pointing to overcrowded galleries, unavoidable shortcomings, poor light conditions, and limited wall space, all hindering the "more systematic or effective arrangement." The chronological perfection of the catalogue was impossible to mirror in the galleries; hence the visitor "will occasionally be subjected to the annoyance of finding casts that are described in connection with one another separated by considerable intervals, and sometimes even by several rooms." Still, the catalogue influenced the galleries, making the paper version of the collection a curatorial-editorial device. While curators from different departments were preparing the entries, the galleries were closed in the summer and fall of 1908, and a number of casts were "re-hung and numbered in conformity with the classed arrangement of the entries in the catalogue."[95] Consequently, the Erechtheion porch, the restored east and west pediment groups from the Temple of Zeus at Olympia, as well as the horses from San Marco and the Nike of Samothrace on her prow, "were returned to their places in the center of the Hall," with the Olympia pediments placed "at either end of the Hall at a height which gives an idea of the effect of the originals when in the Temple front."[96] Yet chronological perfection remained an unattainable utopia. A few years later, when Wilhelm von Bode—introduced by the *New York Times* as "the most famous museum director in Europe"—toured American museums, he castigated the "empty magnificence" he detected in American institutions. Deviating from this stance, he praised the "extraordinarily progressive" Metropolitan under Edward Robinson's directorship. He did, however, find that the colossal collection of plaster casts was "badly arranged."[97]

In Paris, new monuments distorted the rigorous methodology of the Trocadéro displays. The "metonymic logic of Viollet-le-Duc was abandoned. . . . The precise grammar that had structured the initial collection was slowly replaced by a vast encyclopedia whose reading order remained obscure."[98] This broken relation between the catalogues and the increasingly dispersed monuments spurred Camille Enlart to recommend that visitors follow the itinerary suggested in the catalogue rather than the spatially organized sequences. The system that had become illegible in the galleries remained readable in the catalogue. The act of imagination that Rousseau appealed for to grasp the casts' relation to their referents in his *promenade methodique* was also needed to bring order to the unruly milestones of architectural history in the galleries.

Yet if the plaster monuments contested the desire to present the past in terms of perfect chronologies, their double representation on paper and plaster did frame a number of monuments as historical. Many of these three-dimensional reproductions testified not only to documentation but to invention. In fact, the word "reproduction" might tend to eclipse the ways in which casts participated in processes of invention and canonization. In hindsight we see that plaster was a medium in which ideas of the particular, pristine states, the unique, the authentic, the irreplaceable, and the site-specific were extensively theorized and historicized.

At Home in History: Traveling Portals

Among the fifteen signatories of Henry Cole's 1867 Convention in Paris was Prince Oscar of Sweden and Norway. The future King Oscar II was a patron of the arts and the founder of one of the world's first open-air museums outside Christiania (today's Oslo), where in 1881 a stave church dating back to the twelfth century was reerected. At the "Histoire du Travail" section of the 1867 Exposition universelle, Norway exhibited the portals from the stave churches Flå and Sauland, demolished, respectively, in 1854 and 1860. Cole seized the opportunity, brought the two wooden artifacts with him back to London, and had them temporarily displayed and cast by Domenico Brucciani, who made three copies of each.[99] Stripped of tectonic and structural qualities, the salvaged fragments as well as their reproductions were converted into exhibits and collectibles, provided with new functions as portable antiquities, as the churches themselves were vanishing. Circulation was essential in the process of inventing, reframing, and canonizing the stave churches within an early cult of monuments. As their physical reality dwindled, their historical importance increased. It was a watershed in this process of designating the small medieval structures as monuments when the Norwegian landscape painter J. C. Dahl—professor at the Art Academy in Dresden and principal in orchestrating the early Norwegian discourse on national monuments from abroad—had three stave churches measured, drawn, and published in the elaborate folio *Denkmale einer sehr ausgebildeten Holzbaukunst aus den frühesten Jahrhunderten in den inneren Landschaften Norwegens*, in 1837 (figure 60). An emerging awareness of the rapidly disappearing churches was critical when a group of artists and architects in 1844 founded the Society for the Preservation of Norwegian Ancient Monuments. Both the folio and the society instigated actual monument conservation. However, the rescue operations were often efforts to save the monuments not from demolition, but from oblivion. According to Dahl, retaining the monument's "character in the printed word" was of the utmost importance.[100] There are many parallels between the recognition of the stave churches as national heritage, when four centuries of Danish rule ended in 1814, and the way Greece designated Periclean Athens as the origin of the Greek state in 1833. Likewise there are similarities between the Norwegian designation of the monuments of the Middle Ages as indigenous and uncorrupted by foreign influence and the French canonization of, particularly, Gothic architecture as a national past—as in Victor Hugo's "War on the Demolishers" (1825), Baron Taylor's *Voyages*

Figure 60.
The Urnes portal drawn by Franz Wilhelm Schiertz. From J. C. Dahl, *Denkmale einer sehr ausgebildeten Holzbaukunst aus den frühesten Jahrhunderten in den inneren Landschaften Norwegens* (Dresden, 1837).

Figure 61, opposite top left. Urnes drawing from J. C. Dahl's *Denkmale* (1837), in Digby Wyatt and J. B. Waring, *A Hand Book to the Byzantine Court* (London, 1854).

Figure 62, opposite top right. Urnes drawing from J. C. Dahl's *Denkmale* (1837), in James Fergusson, *A History of Architecture from All Countries, from the Earliest Times to the Present Day*, vol. 2 (London, 1874).

Figure 63, opposite bottom. Stereoscopic photograph by Davis Burton, South Kensington Museum, London, before 1873.

pittoresques (1820–78), the establishment of the post inspector-general of historic monuments and the Historic Monuments Commission (1830 and 1837), and Viollet-le-Duc's initiative to establish the Musée de sculpture comparée (1882).

For the stave churches, the idea that paper lasts longer than wood or stone, and that preservation relied on mediation, was reinforced by the plaster versions of the most characteristic parts of the vanishing buildings. Appearing in collections that were accused of being hastily arranged "ready-mades" or else embedded in rigorous art-historical schemes, the plaster portals were spun into various taxonomical webs and a variety of purposes and interests. As plaster casts the portals became national, historical monuments in international circuits, fulfilling the dynamic laid out in Cole's Convention.

Even before the four stave-church portals that eventually traveled the world had been cast, the reciprocity of paper and plaster was in play in the cast courts. In the guidebook to the Byzantine court at the Crystal Palace, the portal from the eleventh-century church of Urnes figured more than fifty years before the appearance of this particular plaster portal. Walking the visitor through the three-dimensional compilation of architectural fragments from Constantinople, Venice, and Naples to Great Britain and Scandinavia, Matthew Digby Wyatt elucidated a school "remarkable for its sense of the graceful and the grotesque" that saturated Norse and North Sea culture. Some of the finest examples of "the Irish school of ornament" were to be found in the "very interesting wooden churches of Norway," and particularly at the church of Urnes along the Norwegian west coast fjords. J. C. Dahl's 1837 *Denkmale* was his source, from which one of the jambs from the north portal at Urnes was reproduced in the handbook and discussed especially in relation to Irish crosses (figure 61).[101] When James Fergusson touched upon these churches in his four-volume global history of architecture in 1874, he added unexpected exotica to what he described as curiosities, of more interest to the antiquarian than to the architect. It is unlikely that Fergusson's observations were firsthand when he described the stave churches as resembling "a Chinese pagoda, or some strange creation of the South Sea islanders." Nevertheless, he found Urnes "more sober and better," while the Burgund church was "even more fantastic in its design, and with strange carved pinnacles at its angles, which give it a very Chinese aspect."[102] Again, the illustrations were lifted from Dahl's *Denkmale* (figure 62).

Yet it was the display of Brucciani's Flå and Sauland portals at the South Kensington Museum that marked their physical inscription into global patrimony, as well as into the exhibition mania where visitors "could choose among, or combine, multiple versions of the past."[103] An early stereoscopic view depicts the Flå portal awkwardly propped against a protruding wall, casually placed between the two-horse chariot from the Vatican and Pisano's pulpit from the cathedral in Pisa (figure 63). When the Architectural Courts were later rearranged, the portal's taxonomical context was perhaps more obvious in the "North European and Spanish Court." Mounted side by side with the Ål portal, produced in Christiana when the church was torn down in 1880 and donated to the South Kensington Museum by the Royal Frederik's University in Christiania, it found new surroundings among Gothic and Romanesque specimens.

With the circular churches, and those at Wisby, these wooden churches certainly add a curious and interesting chapter to the history of Christian architecture at the early period to which they belong, and are well deserving more attention than they have received.

When our knowledge of the examples is more complete, we may perhaps be able to trace some curious analogies from even so frail a style of architecture as that of wood. Something very like these Norwegian churches is found in various parts of Russia. The mosques and other buildings erected in Cashmere and Thibet of the Deodar pinewood are curiously like them. The same forms are found in China

562. Church of Urnes, Norway.

and Burmah, and much of the stone architecture of these countries is derived directly from such a wooden architecture as this. It may perhaps be, that wherever men of cognate race strive to attain a given well-defined object with the same materials, they arrive inevitably at similar results. If this should prove to be the case, such a uniformity of style, arising without intercommunication among people so differently situated, would be quite as curious and instructive as if we could trace the steps by which the invention was carried from land to land, and could show that the similarity was produced by one nation adopting it from another, which all research has hitherto tended to prove was in reality the case.

the following characteristic piece of ornament, corresponding remarkably with some of the lacertine ornament on the celebrated cross of Cong, preserved in the museum of the Royal Irish Academy, Dublin.

Ornament Carved in Wood, Urnes Church, Norway.

The architectural subjects here collected will give some idea of the introduction of such ornament in the art of building. The Irish crosses will afford a notion of their monumental style, and the Manx crosses are interesting memorials of its external influence.

The Manx crosses are such novel objects in our collection of antiquities, this being the first time that casts of them have ever been taken, that we shall gladly avail ourselves of the information kindly forwarded to us by the Rev. J. G. Cumming, a gentleman who has devoted much zeal and learning to their illustration: premising, however, that our space obliges us to abridge it considerably. The Danes and Northmen occupied the Isle of Man from the beginning of the tenth to the latter part of the thirteenth century; and the memorials of their occupation are distinct, and numerous, both in the social institutions of the island, in the names of hills, rivers, &c.,

Its influence in the Isle of Man.

Danes and Northmen occupy the Isle.

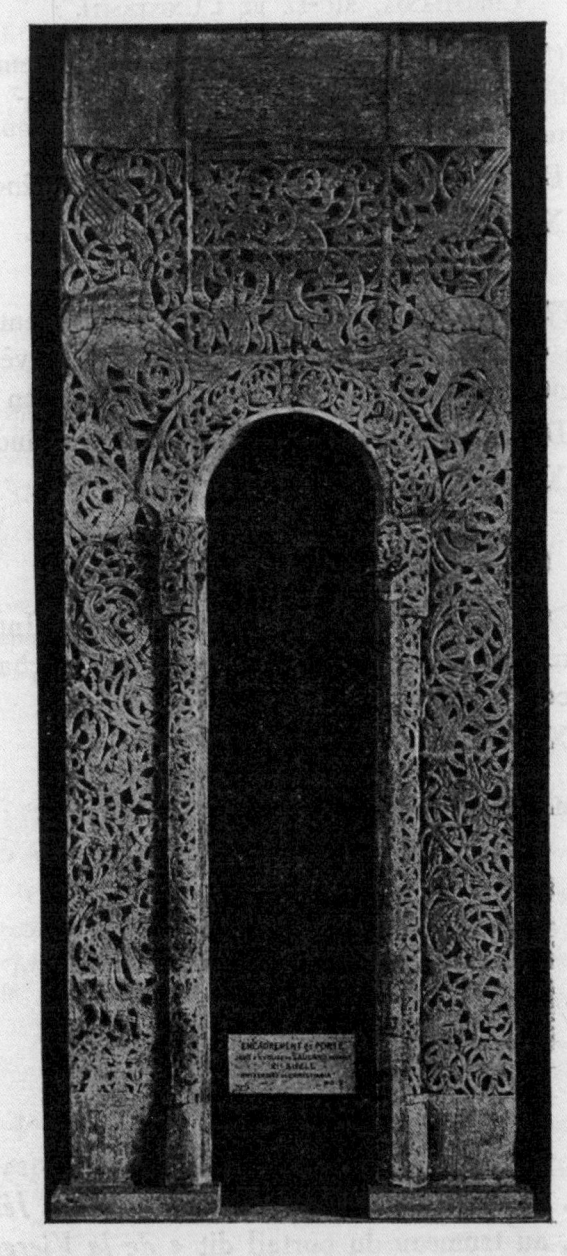

Figure 64.
Sauland portal as mounted in Brussels. From Henry Rousseau, *Catalogue sommaire des Moulages*, illustré de nombreuses planches en simili-gravure (Brussels, 1926).

In 1907 the Urnes portal was acquired as well, and the three portals are today still the closest neighbors to Trajan's Column, evincing the unexpected poetic effects of accidental taxonomical collapses.

In the Musée de sculpture comparée, the Norwegian portals stood at the entrance of the Romanesque galleries in a display that emphasized style and evolution more than geographic origin. Among the "sculptures étrangers," they helped contextualize the advancement in French medieval and Renaissance architecture. The style-based scope of development and comparison emphasized less the objects per se than their formal, relational affinities. The catalogue description of the "portails des églises de bois de la Norvège à Urnes, Sauland et Flaa" distills stylistic resemblances and influences, invoking Byzantine monuments, Carolingian manuscripts and arabesques, and the portals of the Chartres and Saint-Denis cathedrals, as well as Irish ornamental art and ancient symbols from the Isle of Man.[104] In Brussels, at the turn of the century, the Flå and Sauland portals were displayed in the "Art roman" section, as part of a panoramic showcase of a "Histoire générale de l'art monumental."[105] In the 1926 catalogue they appeared in the category "Période gothique primaire."[106] Henry Rousseau's inclusion in that catalogue of a photograph of the Sauland portal as mounted on the wall depicts a rare incident (figure 64). Today broken pieces of the church portals are recognizable amid the rubble in the storage spaces, having attained an extra dusty patina on what appears to have been light-brown-colored versions, lighter than the dark surfaces of the wooden originals.

But these fragments of Norwegian patrimony also crossed the Atlantic. Among the crates that, in 1889, were arriving at the Metropolitan Museum of Art "from different European establishments, situated in different cities of Europe from Naples to Christiania in Norway, and containing nearly 1,000 objects, large and small," were the Flå and Ål portals.[107] Up to twenty men toiled around the clock installing the casts. For the opening in November 1889, the stave-church portals were placed in the central loge under the north gallery in the section dedicated to

Norman, Romanesque, and Byzantine architecture. This Flå portal was not from the series that Brucciani had made in London in 1867, but a more recent edition. As with the Ål portal, the Flå specimen was produced by the Guidotti brothers in Christiania, working for the Historical Museum that possessed the originals.[108]

When setting up the Hall of Architecture, the Carnegie Institute in Pittsburgh was "particularly anxious" to secure the same edition of the Ål portal as the Metropolitan had on display, which was from the series that the Royal Frederik's University had donated to the South Kensington Museum in 1882.[109] "A reproduction of this monument is included in the collection of casts of which I have charged on the behalf of Mr. Andrew Carnegie for the Hall of Architecture in the new building of the Carnegie Institute shortly to be dedicated," the director John W. Beatty informed the archaeologist Gabriel Gustafson, director of the Department of Nordic Antiquities at the Historical Museum in Christiania.[110] However, Gustafson explained that most of the collection was currently in storage and about to be installed in the new Historical Museum in Oslo, that the casts were sold out, and that making new molds was no longer possible, "because the door has suffered by earlier copies."[111] Countering Henry Cole's vision of a global museum of reproductions manufactured without causing "the slightest damage to the originals," Gustafson repeatedly explained to Beatty that in "general we take no such copies anymore, because the old wooden things are suffering thereby."[112] He could, however, offer a fine exemplar of the Sauland portal, still in stock, and one of "our best, greatest most complete and most characteristic doorways." The ceilings of the first-floor galleries in the new museum building in Oslo, where the original is still on display, were designed to accommodate this imposing object, which measured six meters in height.[113] This version of the Sauland portal was made by Josef (Giuseppe) Carpanini, another Italian émigré *formatore* working for the museum in Oslo: "This copy in gypsum uncolored you can get for the price of 95 dollars incl. packing, freight and assurance delivered in New York."[114] Eventually the deal was concluded, and the portal shipped from Christiania in four crates on the steamer *Oscar II* on October 5, 1906, arriving in Pittsburgh via New York. Patinated in Pittsburgh in a much lighter brown shade than either the wooden original or Brucciani's edition of the same portal, this Sauland cast is still part of a grouping of portals mounted behind the three-arched façade of the Romanesque church Saint-Gilles-du-Gard in Pittsburgh.

The Hall of Architecture was inaugurated the same year the Urnes portal was cast. Prior to the endeavor in 1907, the director of the Bergen museum had written to museums from St. Petersburg to New York for subscriptions, to finance the casting operation on an extant church. The director and archaeologist Haakon Shetelig could not have been aware of the grand undertaking in Pittsburgh, as he didn't offer them a cast despite his eagerness to find sponsors. Likewise, Carnegie's agents in Europe could not have known of the operation along the Norwegian fjords. Based less on connoisseurship than on the canon of well-known staples in American museums, most casts were ordered from sales catalogues; thus the Carnegie Museum missed this opportunity to get a novel monument for the collection.

While both the salvaged portals and the reproductions testify to loss and decontextualization, this fourth Norwegian stave-church portal that traveled the world is still at the Urnes stave church on the Sognefjord. Dating back to 1130, Urnes appeared on UNESCO's World Heritage List in 1979. Apparently, then, the original portal can still be admired in its original context. Yet the question of origins and display unfolds in exhilarating ways through the Urnes portal. In his 1837 *Denkmale*, J. C. Dahl presented the idea that this portal, placed next to two pilasters and flanked by a circular column on the external northeast corner of the nave, might originate from an older building on the same site. This matter was far from settled when Haakon Shetelig, in his invitation to museums in Europe and America to subscribe for casts—for £25,10, packing and shipping not included—argued that the exposed fragments were unique remains of a lost group of hundreds of eleventh-century stave churches. In the end he authorized eight casts of the door with doorway, the two pilasters, and the corner column, and had the 1,500-kilo cargo shipped to Christiania, Berlin, Brussels, Paris, London, New York, and Dublin.[115]

Thus, prior to the 1909 publication of his dissertation on the "Urnes style," Shetelig promoted casts of "the oldest sculptural parts of the church Urnes," explaining that examinations had proved that the parts had been moved and reinstalled: "Specimens of this style are nowhere else present in such a large size or by such an excellent work, and the carvings of which we intend to make a cast are consequently of the greatest archaeological and historic importance."[116] Accordingly, the theory that the ornamented portions originated from an older building traveled with the casts and was imprinted in museum inventories and catalogues on both sides of the Atlantic. "Built into the north side of the wooden church of Urnes in western Norway," says the Victoria and Albert Urnes entry, while the Metropolitan Museum's 1908 catalogue states: "DETAILS, of carved wood, built into the wall of the timber church (Stavkirke), and said to be from an older building, previous to the eleventh century."[117] Successfully, Shetelig used the cast market to disseminate the theory of recycled fragments that already had a history of exhibition, in situ, in the conspicuous exposure of some of the former church's most elaborate parts. Employed as spolia, the former west portal had been substantially cropped—or mutilated, as Shetelig wrote to his colleague Reginald Smith, the keeper of British and medieval antiquities at the British Museum—to fit into the sidewalls of the new church.[118] In this rebuilding, the internal order of the fragments had been rearranged in ways it is impossible not to consider as aesthetically motivated, beyond the practical reuse of high-quality building materials.[119] Shetelig kept one set of the Urnes casts for his own museum and mounted the fragments of the former west façade in a way that evokes the ghost structure that is still covered by nine-hundred-year-old panels (figure 65).

The Royal Cast Collection in Copenhagen had turned down the offer of the Urnes casts in 1907, something the new director Francis Beckett severely lamented in 1931 when he asked Shetelig whether he would consider producing a new series of casts.[120] In the mid-1960s the Copenhagen museum was shut down and the casts buried in storage. However, in 1984 the collection was revived and reinstalled in an eighteenth-century warehouse on the Copenhagen waterfront. In 1990, the curator, archaeologist

Jan Zahle, did some excavation in New York, and found parts of the Urnes portal among other relics of the Metropolitan's collection in storage. The next year, after more than half a century in limbo, the portal crossed the Atlantic again, heading toward a new home among other medieval monuments in Copenhagen. A crammed space and a narrow stairway in the end made it impossible to mount the portal at its intended location, and the Metropolitan cast ended up behind two of the four frequently displaced San Marco horses, again testifying to the poetic, unruly, and often accidental juxtapositions that characterize the placing of the historical casts (figure 66).

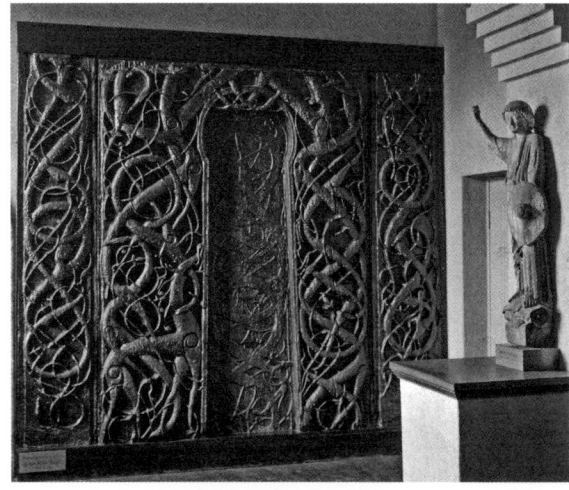

The Metropolitan's selection of stave-church portals testified to the successful realization of Henry Cole's vision of the exchange of monuments among museums, and his dream of infinite expansion within the world of plaster monuments. It was in the course of the refinement of a collection conceived as an "organic whole," and thus one in need of constant updating, that the Urnes portal was purchased as a late architecture acquisition. In London, the plaster portals became part of a global collection of postclassical architecture; in Paris, they were embedded within a rigorous style-based historical scheme; in Brussels, they formed part of a panorama of monumental art. But these replicated monuments were not only moving between distinctive and transitory totalities; they also took on individuality as they moved around. While the Metropolitan's stave-church portals purchased in the 1880s were surface treated to look like ancient tar, Edward Robinson preferred to have the Urnes ensemble "in the color of the plaster, not painted in imitation of the old wood." In this he may have been inspired by the Trocadéro ideal of uniform color to facilitate stylistic comparison in a way that neither original works nor patinated reproductions allowed for.[121] The left jamb of the Urnes portal in storage in Paris is encrusted in a light brown color that was most probably applied at the Trocadéro.[122] Shetelig's offer to have the surfaces prepared "in the dark color of the wood," and to look as though they had been treated with tar over a millennium, was turned down by the Victoria and Albert Museum as well, who instead requested a sample in plaster "painted so as to show the general tone of the color of the original," electing to have the finishing done in London.[123]

Figure 65.
Urnes portal as mounted in Bergen Museum. Destroyed in the 1980s.

Figure 66.
Resurrected Metropolitan Urnes portal as displayed in the Royal Cast Collection, Copenhagen.

The surfaces of the Urnes ensemble that traveled to Christiania were prepared in Bergen: "The color might appear very dark; it is, however, similar to the original," Shetelig promised.[124] Thus we observe the full spectrum: the resurrected pale, corpse-like Metropolitan Urnes portal later relocated to Copenhagen, the almost black version in the Victoria and Albert cast courts, the light brown surface of the Paris edition, and the coated Christiania and Bergen versions, both prepared by a *formatore* at the Bergen Museum—each copy singular despite their shared origin. Installed among portable monuments from various times and places, the replicated stave-church fragments were granted their place in history.

Preserved in Plaster

Monuments are often discussed in terms of permanence and durability, as if they were anchored in a *longue durée*, protected from the flux of time. Monuments help make sense of the past, and establish meaning and continuities across time. The historical monument sprang, according to Riegl, from a new sensitivity to relative values: "It is not their original purpose and significance that turn these works into monuments, but rather our modern conception of them."[125] First and foremost, the plaster monuments and their referents highlighted what Riegl in 1903 termed age value: a new notion in the perception of monuments that posed difficulties in the field of practical monument conservation. Revealing itself through immediate sensory perception, age value addresses the emotions by showcasing decay, destruction, damage, distortion, and "incompleteness, its lack of wholeness, its tendency to dissolve form and color."[126] By displaying historical architecture's most ornamented, characteristic parts, in different temporalities and in light of different ideals of representation, the plaster monuments presented historical narratives in the galleries by lifting architecture out of history and into the museum. They were conceived to display or defy age value. In the course of time they have themselves taken on age value, imprinted with the work of time.

Architecture gains monument status as a result of physical change and changes in perception. This status is enhanced through disruption, contingency, recovery, and restoration, rather than slow-developing traditions. For Periclean Athens the Parthenon symbolized the victory over the Persians, while Le Corbusier could extract timeless principles of architectural perfection from the timely and ruined structure. Lost from the European horizon in the Middle Ages, it reappeared in the Renaissance as a fantasy construct, and it was only in the mid-seventeenth century that Athens and the Parthenon were reunited as an empirical reality with regard to geography, topography, materials, and climate.[127] Since then the temple ruin has been invested with a variety of architectural, historical, aesthetic, theoretical, and political interests.

The history of monuments is one of destruction, disappearance, and invention. It is by curatorial intervention, in situ and in galleries, that they allow us to imagine history as a continuous space. These operations took place as physical investigations, yet the canonization of monuments most often happened off-site. The Pergamon Altar serves as an obvious example, in its trajectory of invention and reinvention, through shifting

regimes of authenticity, as Can Bilsel has shown. For instance, the temporary presentation of "a Temple of Pergamon" in Berlin in 1886 placed a reconstruction of the Zeus temple at Olympia on top of the Pergamene podium clad with casts of the Gigantomachy frieze, making an "architectural chimera, which fused two monuments of two distinct cities and two distinct historical periods into a single structure," celebrating German archaeology.[128] Indeed, monuments, in different media and formats, reversed the "Ceci tuera cela" envisioned by Victor Hugo in the 1830s. The book did not kill the edifice. Rather, "the power of the image ennobled and even immortalized the building": "a battle between two mediums ending in amicable complicity."[129]

Sometimes this amicable complicity favored the reproduction rather than the original work. In the case of the stave churches, the physical objects were reassessed and revalued, as they were about to vanish. Having once been obsolete buildings in the Norwegian provinces, of hardly any interest to the local congregations who wanted and needed bigger, better lit, and more practical churches, they became monuments through physical loss, and they survived as mediations. Within an international culture of exhibition, they became "cultural disseminators"—"portable and therefore accessible, viewed and handled more readily than large works of art rooted to their place of origin."[130] Thought to be immovable and durable in its presence, architecture and architectural heritage are shaped "where buildings in both a real and imaginary sense are collected and displayed."[131] As Thordis Arrhenius has shown, these changes happen through physical alterations as well as through legal frameworks of shifting names, classifications, or ownership: "all these can be read as curatorial interventions that affect the value and meaning of the object for the beholder in critical ways."[132]

When in 1845 the Society for the Preservation of Norwegian Ancient Monuments asserted that there are "numerous antique monuments which can not be dragged into museums—great architectural works whose meaning is so profoundly interwoven with the place where they were erected that removing them will cause serious loss," the claim is, in one sense, self-evidently true.[133] Yet rather than becoming incomprehensible in their manifold dislocations, the serialized plaster monuments took on new significance while intensifying the significance of their referents—those lost, ruined, or extant buildings. In the case of the stave-church portals, their exhibitionality pointed to their place of origin, while the plaster portals canonized the churches in the galleries and in catalogues, among monuments from across time and place. As portable documents in three dimensions, they were circulated and preserved in plaster. When he offered the Urnes casts to museums around the world, Haakon Shetelig referred to the reproductions as documents, and to the initiative as an act of preservation: "Our reason to making the cast is to preserve this valuable document, if the original by any accident should be lost."[134] Casting can be seen as a very straightforward operation, as a matter of exactness with an inbuilt resistance to interpretation: "Casting is an effort to reproduce the exact form of an object by mechanical means."[135] But such initiatives did more than produce a "security copy," the term currently used by stave-church scholars when documenting parts of demolished or extant churches, formerly in carved wood, now with digital technology.

Documentation through mediation is, however, only a part of this story. Writing on Viollet-le-Duc's use of drawings "to internalize the language of medieval architecture" and to "restore its original logic," Martin Bressani observes that these drawings were also "part of an active operation."[136] The productive, projective implications of the circulating monuments were also acknowledged.

Shetelig's conflation of documents and monuments was typical. Viollet-le-Duc also spoke of the casts as documents.[137] Similarly, when recording the exchange of French and Belgian monuments with the Musée du Cinquantenaire, the Trocadéro described the acquisitions as "documents étrangers."[138] When five French museums, including the Louvre and the Musée de sculpture comparée, in 1927 established one common atelier to produce casts from a stock of forty-five hundred molds, the catalogue speaks about reproducing "documents" in the absence of originals.[139] It is through mediation and traveling that canonization takes place, with reverberations back and forth between originals and reproductions, sites of origin and exhibitionary complexes.

Discussing the acts of the imagination prompted by the plaster monuments, an American curator mused on how the "enjoyment of these cold wraiths of life-like originals" inspired "a power of attentive vision, a productiveness of plastic fancy."[140] This productiveness of plastic fancy was frequently noted. Casting and photography marked the passage from excavated relic to portable object and image, observes Tapati Guha-Thakurta: "the transformation of Sanchi from a disused ruin and a site of ravage and pilferage to one of the best-preserved standing stupa complexes of antiquity."[141] The traveling object changed the reception of the Buddhist stupa off-site, while the "aura of the *in situ* monument [was] continuously refracted by its portability and reproducibility." The act of copying became "a primary way of arresting decay, countering damage, and documenting structures for posterity."[142] Changed in situ into a secularized aesthetic object, "the remade monument [was infused] with the aura and aesthetics of the 'ruin', making the dead relic in the present far more 'beautiful' in modern eyes than the worshipped, living stupa of the past."[143] In 1867—the year that the two stave-church portals were cast in London, introducing the recently demolished structures to an international audience—casts from Angkor Wat appearing in Paris marked the beginning of a process Michael Falser describes as appropriating the local "heritage of the Indochinese colonies for global representation."[144] The exhibition of this rapidly developing plaster monument not only influenced the reception of the Cambodian temples, but also interfered in reconstructions on-site. A plaster model at scale 1:10 depicting a gigantic gate to an Angkorian city, made from drawings by Louis Delaporte, premiered at the 1878 Paris Exposition universelle; three years later it was published among four hundred engravings in a volume with the canon-challenging title *Les arts méconnus—les nouveaux musées du Trocadéro*. Here, the Parisian model was retranslated—in fact transplanted—"back to the re-invented original site," which the draughtsman "had never visited himself" (figure 67).[145]

Berlin, not Bergama, is the place to see the Pergamon Altar; London, not Bodrum, to admire the marble fragments of the Mausoleum of Halicarnassus. In the nineteenth century they were available in major

Figure 67.
Angkor Wat fragments at the Musée Indochinois at the Trocadéro, Paris, 1920s.

and provincial museums, twisting the foundations of a site-specific and material-dependent theory of aura and authenticity. Walter Benjamin pinned the aura of the original to a "here and now" and to the work's "particular place." In the case of the Mausoleum, for instance, Benjamin's "here and now" is hard to define in regard to "a particular place," beyond the "there and then" of the originals in London, and the series of reproductions disseminated and exhibited as plaster casts. Both originals and reproductions are preserved off-site, while redounding to the glory of the places where the lost works originated.

The lives of monuments are split between originals and copies. An example of how a cast might not only invent or reinvent a nonextant monument, but shape and enhance the perception of the lost monument's place of origin is the porch of the sixth-century BCE Siphnian Treasury. Excavated as hundreds of pieces, it was translated into a plaster monument, intact with the two caryatides. When this monument premiered in Paris in 1900, it had no original and was thus an original in its own right. A French invention, reproduced at the Louvre, it traveled the world while pointing back to Delphi, rather than Paris, signifying the lost glories of a Greek polis of antiquity. Series of copies with different relations to the original render the work and its reproductions inseparable. The proximity of archaeology and casting shows the productive properties of the plaster cast, as do the fitting together of bits and pieces from celebrated ruins, the accentuating of elaborate portions of structures still in use, the appropriation of the exotic and the national, or the salvaging of parts of deteriorating buildings. The history of the plaster monuments shows that singularity relies on seriality, and that permanence and preservation are granted by ephemeral materials such as plaster and paper.

Chapter 4

Cablegrams and Monuments

Who would think twice about the person who commissioned a monument? queried a feisty, anonymous contributor to the *New York Times* in 1890: "Much more certainly and oftener will he be recalled if his name is associated with some great discovery in the arts of antiquity."[1] To a certain extent, history has proved this true. The Mausoleum of Halicarnassus, for instance, conjures Charles Newton's name before that of Queen Artemisia, the wife and sister of King Mausolus, who in the fourth century BCE erected a monumental sepulcher for her late husband at modern-day Bodrum. A specific agenda motivated the *Times* writer, namely, to encourage his fellow Americans to raise $100,000 and purchase the Greek town of Kastri southwest of Mount Parnassus: "the man who buys pictures for $100,000 and leaves them to a museum cannot hope for a tithe of the fame which awaits him who shall bid the soil of Delphi yield up its secrets."

This idea of initiating a noteworthy American dig was fueled by associations that might appear eccentric: "Why build a villa at Newport in emulation with your rich neighbor only to be saddled with an ugly building and a lot of impertinent, incompetent servants, when you can gain true distinction by encouraging archæology?" The follow-up left no doubt about the logic of the argument: "Nobody is going to be grateful to you for the big structure at Newport, unless it be the smug architect. But you will win gratitude as well as fame by excavating Delphi." More than the expression of passion for procuring precious antiquities for the museums of America, the proposal of purchasing Kastri was first and foremost presented as a business opportunity in terms of the "profits from excavations." Holding rights to the reproductions appeared more alluring than ownership of the originals: "At the present day there are so many museums in the world that a fine piece of sculpture is a profitable thing to own, because each museum wants a copy. The excavator at Delphi could turn over the originals to the Greek Government and keep the copyright. Every museum desiring a plaster cast would have to buy of him. Now,

Figure 68.
The porch of the Siphnian Treasury and the Naxian Sphinx from the Apollo temple in Delphi in the Daru stairwell, Louvre, Paris, c. 1901.

should Kastri 'pan out' anything like the quantity of antiquities expected, it would not be long before the excavator would be repaid for his outlay."

The Delphi scheme did indeed "pan out," though for the French rather than the Americans. Two years later the French School in Athens began systematic work at the site. "La Grande Fouille," the grand dig, was headed by the French archaeologist Théophile Homolle, at the time the director of the school, and from 1904 to 1911 the director of the Louvre.[2] For Delphi—a prosperous city in antiquity whose gold and silver mines subsidized a lavish building program—an agreement between Greece and France ensured that most of the finds either remained on-site or were transferred to Greek museums, above all to the Delphi Archaeological Museum, designed by the French architect Joseph Albert Tournaire and inaugurated in 1903.[3]

Yet the monuments soon started traveling. As the antique fragments were unearthed, they were immediately cast in Athens and shipped to Paris and the Louvre from 1894 onward, and first shown in a small exhibition that opened at the École des Beaux-Arts in November 1894.[4] After its debut at France's archaeological section at the 1900 Exposition universelle in Paris, the plaster reconstruction of the porch of the Treasury of the Siphnians was moved to the Louvre where it became a main feature of the Daru stairway.[5] Other casts from Delphi—also made by Tournaire, the sculptor Louis Convers, and the plaster caster Giovanni Buda, who all worked with Homolle in Athens—were placed along the stairway (figure 68).[6] These Delphi reconstitutions, made in the Louvre's plaster workshop, soon found their way to other museums. For instance, both the Siphnian Treasury and the Naxian Sphinx were purchased for the Hall of Architecture in Pittsburgh a few years later.

The prolific constellation of casting and archaeology envisioned in the *New York Times* article reflects the writer's disappointment with the modest American involvement in archaeological missions, which produced neither originals for American museums nor reproductions to circulate. The French casts from Indochina and the British casts of ancient Indian architecture expanded the canon beyond the classical tradition and the Western world. The presence of these monuments in European museums showed variation and regional development rather than standards. This global, portable heritage concretized a history that concerned the present's relation to the past as well as to the future.

American museums remained on the receiving end for monuments from across time and place. After his plaster cast acquisition tour through Europe for the Metropolitan in 1885, Pierre Le Brun concluded that reproductions would remain the core of American fine-arts institutions: "For although much of value still awaits the spade of the archaeologist . . . and although archaeological expeditions will undoubtedly be fitted out by Americans to the further enrichment of our museums, yet we cannot hope to stock them adequately with antiquities."[7] Fifteen years earlier, assessing the lack of governmental initiative, Charles C. Perkins had addressed the missed opportunities for American archaeological missions to South America: "Let us imagine," he suggested, an American politician proposing to fund "an expedition to the buried cities of Central America, with the purpose of bringing back to Washington casts of the curious temple bas-reliefs which are fast perishing in the green wilderness.

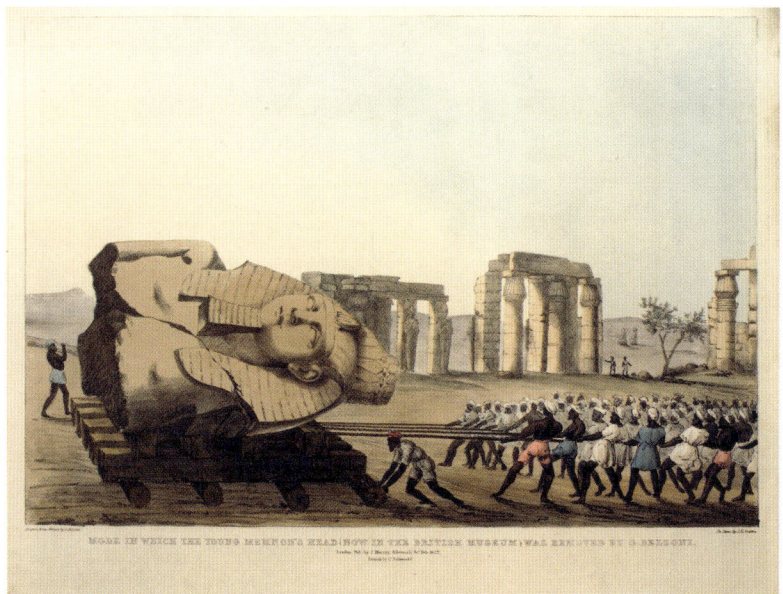

Figure 69.
Giovanni Belzoni, "Mode in which Young Memnon's Head (Now in the British Museum) was removed by G. Belzoni." From *Plates Illustrative of the Researches and Operation of G. Belzoni in Egypt and Nubia* (London, 1822).

What answer would he inevitably receive? Certainly a very different one from that given to Mr. Fergusson in England . . . after he had drawn attention to the Buddhist Tope at Sanchi."[8] Again, plaster monuments were validated as a means of preservation. The sculptures at Palenque, "of the highest value as examples of the art of an unknown period and people," would long since "have been rescued from destruction had they been in reach of any European Government." Perkins promoted archaeological expeditions as occasions to distribute the undiscovered and unrepresented, but where "will they find the means (even if they could find the men capable of doing what Botta and Layard did at Nineveh, Newton at Halicarnassus, Lepsius in Egypt, or Sir Charles Fellows in Lycia) to fit out expeditions in the service of art and archæology to distant countries?"[9]

Circulation is a condition of modernity, and flux also an important attribute of monuments. The world expositions were important sites for the display of circulating objects, both small-scale and monumental. They were "paradigmatic sites for nineteenth-century thought," and so were museums. As Alina Payne puts it, they brought "together cultures at various stages of development, collapsing geography and history at one and the same time."[10] The plaster monuments demonstrate that circulation in a most concrete sense, namely, in the form of shipping, was fundamental to these collapsing geographies, aiming to demonstrate world history in the galleries.

The relocation of architecture poses particular challenges: constant risk of breakage and loss, and innumerable mundane and dramatic difficulties. Museum history is also a history of such relocations—successful and otherwise. When Lord Elgin shipped the Parthenon marbles to London in the first years of the nineteenth century, one ship sank in transit.[11] The awe-inspiring impact of displaced huge objects also springs from consciousness of the ingenuity required to move the apparently immovable. The images of Giovanni Belzoni, the engineer, adventurer, circus artist, draftsman, and writer, pulling the seven-ton colossal head of Ramses II

Figure 70, above.
From Layard, *The Assyrian Court, Crystal Palace* (London, 1854).

Figure 71, opposite.
"Group of moulders at work at the Kutb." From Henry Hardy Cole, *The Architecture at Ancient Delhi, especially the Buildings around the Kutb Minar* (London: The Arundel Society, 1872).

from the Ramesseum at Thebes to the Nile in 1816 have become iconic, and the colossal bust's epic journey down the Nile to the port of Alexandria and shipment to London, where it was installed in the British Museum in January 1819, was a media sensation throughout Europe (figure 69).[12] "From the size and weight of these objects, and the entire absence of any mechanical contrivances in the country, considerable difficulty was experienced in moving them," Henry Austen Layard explained to the visitors to the Nineveh court at Sydenham. The Assyrian bull and lion, as well as outsized panels, had been moved onto carts constructed on-site and dragged to the riverside. In a thrilling operation, they were placed on primitive "rafts made of inflated skins bound together, and floored with beams and planks of wood," and "floated down the river Tigris," before being shipped to England (figure 70).[13] Even shipping a single statue is a daring undertaking. When the first pieces of the Nike of Samothrace were discovered by Charles Champoiseau, the French vice-consul to Adrianople, the "export to France of this unexpected, very heavy discovery was not a simple task."[14] The crated fragments were transported on three ships from Samothrace to Constantinople, via Piraeus, to Toulon, before traveling to Paris by train where they arrived in May 1864. Casts of the Elgin Marbles, the Assyrian sculptures, and the reconstructed Nike were soon offered by workshops in Paris and London.

Transporting plaster monuments proved to be no less laborious, and the logistics no less complicated. The shipping of the heavy and fragile objects required customized crates and special packaging. More than a hundred people were involved in the casting of the eastern gate of the Sanchi Tope on-site in the winter of 1869.[15] Later, H. H. Cole reported on the preparations, and on the transportation of equipment and the shipment of the object from the Indian jungle to London: "Our party left Calcutta 10th December, 1869, and Jubbulpore on the 13th, where the materials, tools, plaster of Paris, &c., weighing in all 28 tons, were transferred to country carts drawn by bullocks. Sixty carts were procured at Jubbulpore, and on 20th December the march was commenced to Sanchi about 180 miles distant. On 7th January 1870 Sanchi was reached and the work of casting commenced" (figure 71).[16] When completed, the reproduction traveled for more than three months; upon its arrival in London—it had sailed up the Suez Canal only months after its grand opening in November 1869—new editions were made to travel elsewhere: "The cast was completed on the 21st February 1870 and reached London, via Hoshangabad, Bombay, Suez Canal, and Liverpool, early in June. Three copies were made by October of the same year" (figure 72).

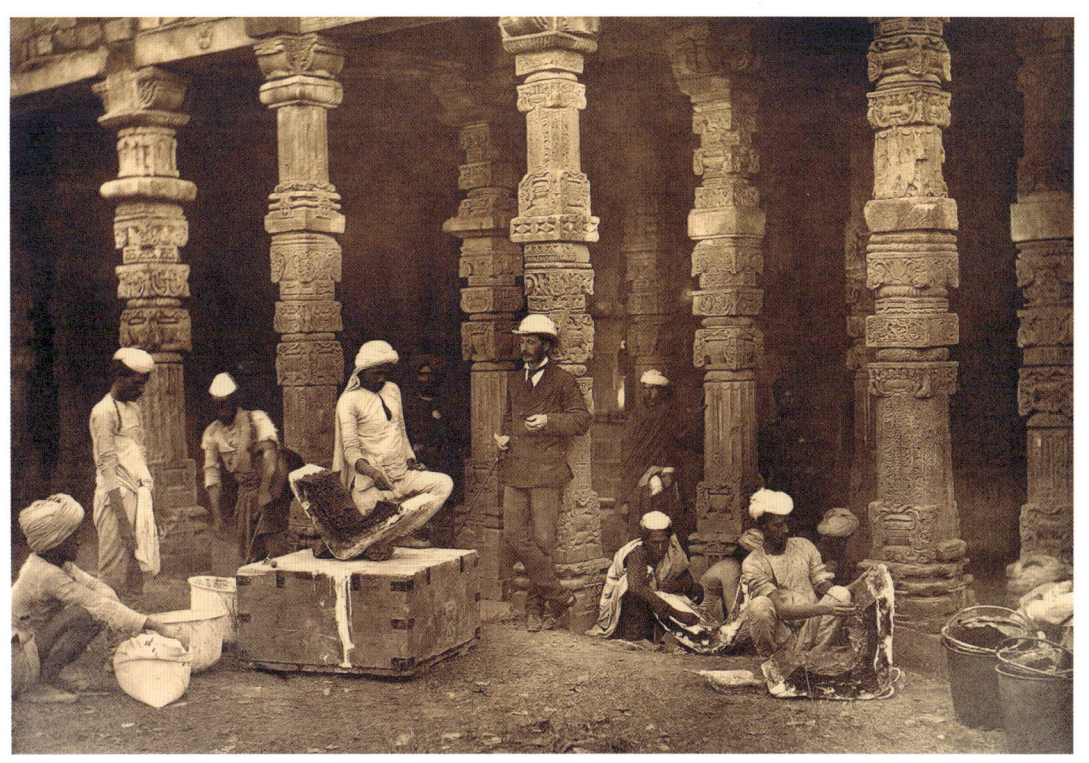

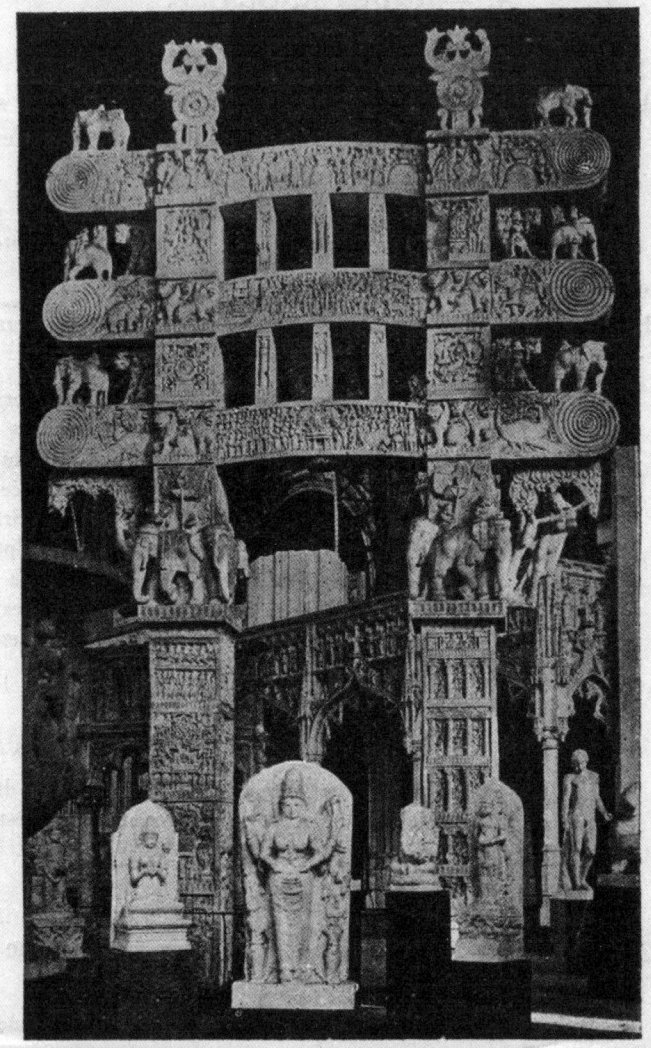

N° 1101. — PORTE DE L'ENCEINTE DU TOPE DE SANCHI.

Figure 72, opposite. The three copies of the eastern gate of the Sanchi Tope produced in London were sent to Berlin, Paris, and Brussels. The Indian monument as displayed in Brussels. From Henry Rousseau, *Catalogue sommaire des Moulages* (Brussels, 1926).

Figure 73, left. Unknown artist, *Transporting of Materials from Jappalpur to Sanchi*, 1870–74. Oil on canvas. Victoria and Albert Museum, London.

Cole's report provides wonderful insight into the dimensions of such an adventurous undertaking, with many similarities to archaeologists' accounts in terms of planning, equipment, competence, logistics, and shipping—but here the antiquities were displaced through casting, not excavation.[17] A painting documenting this large-scale operation was prominently displayed alongside the thirty-three-foot tall monument in the Architectural Courts (figure 73). From his travels in Cambodia in 1873, the French naval officer and draftsman Louis Delaporte reported on "trial and error, and the physically exhausting nature of producing moldings and casts in the tropical humidity of Angkor."[18] Michael Falser retells the story of the French artist, and later chief curator at the Musée Indochinois at the Trocadéro, traveling and casting in bad weather and under deteriorating health conditions, describing the transport of original pieces and casts to Phnom Penh, the packing, and the shipping to Paris. The press, too, spotlighted the difficulties of moving the plaster monuments. In the late 1880s, when monuments of the world arrived in New York from Europe, journalists reported not only on the objects per se, but on the "hardly less-important question of how to manage transportation from Europe at the least risk of breakage."[19]

The transportation of works of art and architecture is a perpetual concern for museums, and the logistics of circulation were no less challenging in the world of plaster monuments. The establishment of the Hall of Architecture, inaugurated at the Carnegie Institute in April 1907, reflects both the detached pragmatics and the resolute passion expressed in the proposal to buy Kastri, the dramas of shipping, and the material and artistic effort of producing plaster monuments—not to mention the difficulties in having them behave as planned both en route and in the gallery. The organization of the Carnegie collection gives a rare glimpse of nineteenth-century cast culture in decline. Not only was the collection assembled in a short time span; it was also considered done when the works were in place. It was a onetime stunt and exceptional among cast collections in that it never outgrew its designated space. Only a few pieces have been moved or have disappeared in

the course of time, making the Hall of Architecture an almost perfectly preserved time capsule.

The Hall of Architecture, Pittsburgh

Andrew Carnegie had been determined to give Pittsburgh a world-class architecture collection for more than a decade when the work finally commenced in 1904. The Carnegie Institute was expanding, and the new architecture collection was to crown the new building upon its inauguration, leaving little time for the operation. The frantic pace of the selection, ordering, casting, packing, shipping, storing, and mounting of architectural works at full scale was facilitated by a relentless stream of transatlantic correspondence, much of it in the form of cablegrams to save precious time.

The advertisement printed on Western Union Telegraph Company stationery—wordier than most of the orders, confirmations, confusions, and clarifications the Carnegie cablegrams conveyed—hints at the global scope of communication enabled by the medium: "Two American Cables from New York to Great Britain. Connects also with five American and one direct U.S. Atlantic Cables. Direct Cable Communication with Germany and France. Cable Connection with Cuba, West Indies, Mexico and Central and South America. Messages sent to, and retrieved, from all parts of the World." The first transatlantic telegraph cable, not entirely functional, was opened in 1858. It did, though, allow Queen Victoria to congratulate American president James Buchanan on the achievement with a ninety-nine word Morse-transmitted message that took sixteen hours to cross twenty-five hundred miles of submarine cables of copper and iron. Two years after Queen Victoria's verbose salute, telegraph electrician George B. Prescott advised correspondents to keep the messages concise and to avoid superfluous words: "Most despatches are contained in less than ten words, and it is surprising how much matter is often contained in this brief number."[20] From 1866 the Atlantic cable was reliable, enabling speedy messaging along the seabed, vastly improving on the ten-plus days that ocean steamers took to cross the Atlantic. This became the preferred medium of communication for setting up an ambitious collection of architectural monuments in a prosperous industrial city in Pennsylvania, far from the coast. Messages streamed through transcontinental telegraph lines from Pittsburgh—encouraging, begging, and threatening museum workshops and *formatori* from Cairo to Oslo to speed up their deliveries. "Every day counts in this work," reads an oft-repeated message: "Ship all casts quickly fast steamer" and "Hurry Trocadero casts. Let others follow," were staples (figure 74).[21]

The addressees were frequently reminded of the demanding time frame and instructed to keep Pittsburgh posted around the clock. The order for the column from the Mausoleum of Halicarnassus from Brucciani & Co. in London—with a hand drawing enclosed with the text, captioned, "I want all the parts you can make of the above column"—came with the following instruction: "If you will make the cast upon these instructions, cable me as follows: 'Beatty, Pittsburgh. Yes.'"[22] An agent was sent to the Louvre to meet with the chief molder, Eugène Arrondelle, with the

following instruction: "If he will make the seventeen casts in the time named, simply cable 'Yes.'"[23] This style of communication was typical. Brucciani & Co. received the same formula for a massive order, including a colossal Assyrian winged lion, a twenty-foot-tall, Eighteenth Dynasty, Egyptian papyrus-bud column, and many parts from the Parthenon; and the recipient was asked to promptly confirm "that the casts are to be completed and packed ready for shipment in four months, or on, or before the first day of September, 1905," by responding with three words: "Beatty, Pittsburgh. Yes."[24] Brucciani's enigmatic four-word response, "Yes best part writing," meant that there were so many details to explain concerning each and every cast that a cablegram of a few (albeit expensive) words was not really a proper medium for the communication.[25] For instance, it took the Americans some time to grasp that there no longer were casts available of the British Museum's Assyrian sculptures, and that no more molds would be made. The order for the Choragic Monument of Lysicrates and the Erechtheion porch, two staples of Greek antiquity within nineteenth-century cast culture, exemplifies the tone of the Pittsburgh enterprise. The chief molder at the École des Beaux-Arts received the following question without question mark in a cablegram: "Comme une grand faveur a Institute Carnegie de Pittsburgh pouvez-vous faire dans quatre moins les grand moulages . . . Réponse télégraphique."[26]

Figure 74. Cablegram. Carnegie Museum of Art, Pittsburgh.

In America, "telegrams are sent on an unimaginable speed," it was reported from Egypt in 1903.[27] In the old world, cast producers appeared unfamiliar with both the speed and the genre, and the bombardment of cablegrams caused confusion among small, privately run plaster cast workshops, with requests for substantial orders to be completed on very short schedules. "Your delay is seriously inconveniencing me," Beatty notified the Venetian caster at Gypsoteca, Officina di modellazione e formatura, who provided casts from the San Marco Basilica, the churches at Torcello, the Doge's Palace, and the Miracoli church.[28] Lorenzo Rinaldo, whose wife had recently passed away, assured Beatty that forty-five casts awaited shipping from Venice: "continuous family misfortunes have prevented me to attend my correspondences, besides I have very little practice in the English language."[29] The constant sense of urgency; the impatience with molds to be taken, and casts to be made and sufficiently hardened to survive shipping; difficulties with preservation authorities, customs, insurance, and agents; carpenters inconveniently dying and *formatores* falling ill—all this colors the correspondence left in the wake of this collection's creation. With one particular exception, most monuments were ordered from sales catalogues in a whirlwind of abbreviated cablegrams, with the aspiration of having the monuments in place for the inauguration of the "grand palace": "It is of the utmost importance that we have them in time, because the opening of our building is to be made a great event" is a refrain in the cablegrams that crescendoed as

Cablegrams and Monuments

the grand opening approached.[30] The gravity of this event in Pittsburgh, to which notables from all over the world were invited, reverberated through the correspondence, demanding that staffs of workshops and European museums understand that the Carnegie orders needed immediate attention and full-time priority. In a letter to the director at the Musée de sculpture comparée, ordering four monuments and guaranteeing that further orders would follow, Beatty urged Camille Enlart to confirm instantaneously that "they will be delivered in time for the event. . . . Mr. Carnegie, its founder, and a number of celebrated men of Europe and America will come here for this occasion, and you will understand how desirous I am to have these important casts in place."[31] This request was not particularly successful, as the Trocadéro had molds for only one of the four desired objects. This disappointment foreshadows the obstacles the museum would encounter over the next few years.

If the selection, ordering, shipping, and mounting were rushed, the idea behind this collection was anything but a whim. Steel magnate Andrew Carnegie had long been determined to give his hometown an exceptional architecture collection. In May 1891 he accompanied the Metropolitan Museum's Special Committee to Enlarge the Collection of Casts to the Slater Memorial Museum in Norwich, Connecticut, inaugurated in 1888.[32] After having seen France's display of more than a hundred plaster monuments from the Trocadéro at the 1893 World's Columbian Exposition in Chicago, Carnegie praised these "object lessons which gave the best possible substitute for personal inspection of the original."[33] Unlike other American bankers, tycoons, and industrialists turned art collectors, among them Henry Clay Frick, J. P. Morgan, and Andrew Mellon, Carnegie had no interest in old art. In 1895 he met with General di Cesnola at the Metropolitan—accompanied by W. R. Frew, the president of the Carnegie Library Commission, and John M. Beatty, his director of the Department of Fine Arts—with the purpose of initiating his own cast collection. At the time, the in-house molding department, which the Metropolitan had modeled after the Louvre's *atelier de moulage*, ran its business to furnish American museums and schools with less expensive casts and spare them the trouble of transatlantic shipping.[34] However, the reply to Carnegie's request to order monuments from New York was discouraging, and from the wording of director di Cesnola one may infer that the competition was not exactly welcomed. The Metropolitan had two hundred molds and two overworked molders, he explained: "I have no room wherein to make these casts as they require a great deal of space for setting them up, drying them, etc."[35] Although the cast collection project lay dormant for some years, this lack of collaboration from the Met might have heightened the philanthropic industrialist's ambitions: "We will see a collection of the greatest things in the world in this Architectural Hall," Carnegie informed his board of trustees in 1901.[36]

John M. Beatty, a Pittsburgher trained as a printmaker, silver engraver, illustrator, and painter at the Royal Bavarian Academy in Munich and director of fine arts from 1896 through 1922, was in charge of building the collection. The Carnegie International, a still extant flagship of the Carnegie art system, was established during the first year of Beatty's tenure. Together with the Venice Biennale, established a year earlier, it became a leading international venue of contemporary art. Consequently,

Beatty was deeply familiar with the logistics of organizing big international events. From 1904 he worked closely with a select group to set up the collection. Most importantly, Henry Watson Kent, the first curator of the Slater Memorial Museum, who had worked with Edward Robinson at the Boston Museum of Fine Arts, assisted him in installing casts at the Metropolitan in 1894, and had otherwise been involved in a number of other American cast collections.[37] In 1900 Kent published a pamphlet dispensing advice on how to establish and maintain a cast collection, and, issued half a century later, his impassioned autobiography gives an account of American cast culture at its peak.[38] Beatty hired several agents who worked tirelessly for three years; in particular, Roland F. Knoedler of the New York art dealership M. Knoedler & Company and *emballeur-expéditeur* Paul Navez in Paris became crucial to the success of the operation. Knoedler did the on-the-ground power brokering, while Navez organized innumerable practicalities. The elaborate letterhead of Navez's stationery spelled out his invaluable expertise: "Correspondants dans les principales Villes de France et de l'Estranger," "Spécialité d'Emballage d'Object d'Art," as well as "Déménagements en Caisses & Wagons."

In January 1904 Beatty and Kent discussed "the scope of a collection of architectural casts that can be secured in one year."[39] Drawing on his substantial experience, Kent expressed doubt about the likelihood of fulfilling Carnegie's demands. The next spring, only two years before the opening, he was still pessimistic. "The difficulties of setting up the Architectural casts will be these: many of them will be in innumerable small pieces, some in several thousand, and it will require not only a long time for each cast, but many men to do the work. It is doubtful if we can find enough men to do so large a piece of work so quickly."[40] He advised that they prioritize sculpture over architecture. Yet Beatty—who soon micromanaged the entire operation—was steadfast in supporting Carnegie's decision that architecture was the main concern, and that the task would be completed whatever the cost. In the process of turning the Carnegie Institute into a leading American venue for contemporary art, it is unlikely that Beatty shared Carnegie's passion for historical reproductions. Still, he carried out the operation with tireless devotion: "Since the opening of the great Palace I have been out of the city. I was much overworked and in need of rest," he confided to a creditor upset about unpaid bills.[41] Three years after the mission was completed, he revealed his ambivalence: the "Institute's dependence on casts, reproductions, and paintings of a rather sentimental Victorian tradition would seem to be one of the weaknesses of the permanent collections."[42] Although the Hall of Architecture in Pittsburgh was among the last major cast collections to be mounted, its curator was among the first to deem it obsolete.

A Readymade Monument

Built up from scratch, the Pittsburgh collection of plaster monuments could have been informed by any guiding principle. Franklin Toker claims that Beatty was particularly interested in exhibiting recent archaeological discoveries.[43] That would have been a strong concept: exhibiting history as contemporaneity by mirroring late nineteenth-century archaeological

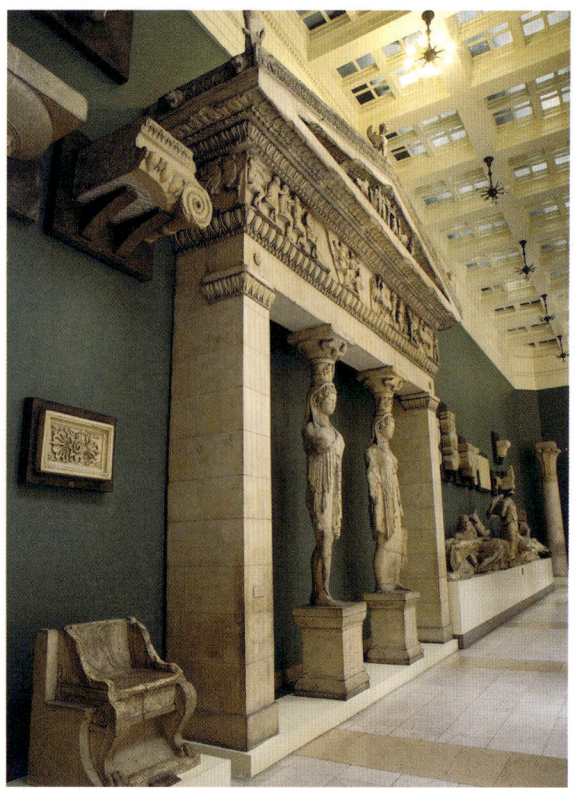

Figure 75.
Porch of the Treasury of the Siphnians, Hall of Architecture. Carnegie Museum of Art, Pittsburgh.

novelties in a late nineteenth-century mass medium. Fulfilled, it could have posed a subtle retort to the desire to harmonize architecture into periods, influences, and developments, by instead emphasizing ancient structures as novelties thrown back into existence and assembled in the only place possible, the gallery, and as reproductions. The purchase of the porch of the Treasury of the Siphnians indeed belonged to that category—recently revived in plaster perfection and depicting a nonextant original (figure 75). Likewise, the Nike Apteros front is a modern invention, reconstructed as part of the classicizing of the Acropolis under Otto I, complicating the time of monuments beyond straightforward chronologies. The Athena and Zeus groups from the Pergamon Altar belong to the same category of antiquities as novelties, as do the two pediment sculptures from the Temple of Athena at Aegina; the latter were displayed in the sculpture court. On display, too, were the Mesopotamian friezes of Archers and Lions from the great hall of Darius I's palace at Susa, found in the 1880s and recently reconstructed and mounted in the Persian galleries at the Louvre. There is, however, not much evidence to support this idea that would have distinguished the Hall of Architecture conceptually and intellectually among leading collections at the time: the atmospheric galleries at Sydenham; the imperial, eclectic assemblies at the South Kensington Museum (at the time renamed the Victoria and Albert Museum); the contextualization of style-based, national development at the Trocadéro; and the all-encompassing Metropolitan collection.

There is little evidence that testifies to any kind of historical or theoretical reflection, or to a particular taste, program, or scientific ambition for setting up the collection, except for a vague idea of a chronological pedagogy representing the great buildings of the world. A letter to the curator of the Department of Sculpture at the Metropolitan Museum hints at this unqualified open-mindedness: "Can you, off hand, and without much trouble, suggest ten names of sculptors, who, in your opinion were the greatest sculptors of all time," Beatty queried: "If you will do this, we will be grateful."[44] As the names were to feature on a frieze on the new building, one might have expected a less arbitrary mode of selection—indeed, a selection that would reveal the institution's ideological, aesthetic, and historical program, publishing its ethos to the city.[45] Yet this apparent lack of scholarly interest resulted in a unique collection, one that first and foremost mirrored a cast market in decline, in which desired works were often randomly replaced with whatever happened to be available.

The Carnegie Institute's modus operandi was twofold. First, they got hold of Edward Robinson's *Tentative Lists* from 1891. Initially intended for "private circulation," it was for sale at the Metropolitan for years, and was also sold in London and The Hague—serving as an international reference for the European cast market.[46] From Robinson's address list they ordered numerous sales catalogues; they then sent open requests to a myriad of European cast producers. This strategy produced much useful information. The chief molder at the Trocadéro, Charles-Édouard Pouzadoux, replied with an enlightening letter. He had tagged the museum's sales catalogues with the "corresponding number in the Album of M. Frantz Marcou," as well as indicating the dimensions, the price of crating for America, the cost of transportation and freight, and the price of the casts themselves; he also mentioned that the production time varied from two to six months. Importantly, he enclosed a second list of objects on display at the Trocadéro in which the Carnegie had expressed particular interest, "but which are not on sale because the Museum does not have the molds."[47]

These communications on orders and deliveries—which produced an archival panoply of ornate *formatore* stationery—were practical in regard to price, measurements, weight, and the time it would take to get the goods to Pittsburgh. The Carnegie letters were more elusive concerning what they actually wanted to procure. The reply from Ettore Malpiere in Rome—from whom a cloister bay from the Basilica di San Giovanni in Laterano was later purchased—exemplifies the confusion resulting from the imprecise requests. "According to your request I am sending you enclosed my catalogue, containing the best classic works of the museums of Rome, and I hope you will give me an order, since you know my casts very well. As to the dimensions, I cannot send them to you, not knowing which plaster-casts you desire. Neither can I tell you the cost for shipment, as I do not know the weight of the casts you are going to order."[48] This inability or unwillingness of the Americans to specify the desired building fragments continued until the very end. While orders were placed, what was missing were criteria to prioritize their importance. In spring 1906, when the mounting was about to commence, Beatty spotted unfortunate gaps in the selection and contacted Brucciani & Co.: "With a view of ordering more casts, I desire a list of the most important ones of which you can furnish casts, together with photographs, (or sketches), of the following periods: Egyptian, Phoenician, Persian, Cypriote, Etruscan and Byzantine." "If I am able to place orders for the casts in the limited time at my disposal, I must make selections within a few weeks, and I therefor urge your forwarding list and photographs as soon as possible."[49] Three weeks later he ordered twelve casts, "finish pure white," and asked for exact measurements of both casts and pedestals, as the floor plan was rapidly evolving (figure 76).[50] In Pittsburgh, the canon was still in the making, and in this case to a great extent based on contingencies and circumstance.

Even later, in the fall of the same year, Beatty wrote to Cecil Smith, the keeper of the Department of Greek and Roman Antiquities at the British Museum: "I desire two or three important cast representations of the most beautiful specimens of architecture in England or Scotland." Size was the main criterion: "The casts may be twenty feet high, but I would prefer




Screen H. 291 ins Saint Gilles
L 309 "
D 128 " 18 months

Left margin:
Well of Quentin Matsys
made by Brussels Museum

Sculpture Hall.


Screen

Dancer Temple of Gnidus — ordered
Acanthus
Column
Louvre
8 weeks
6 months

Lucca
Siena X
Siena Pulpit
Bishop's Throne — ordered
Ulm Brussels

ordered
SPHINX on Column

Erechtheum
Caryatides Porch
E. B. A.
$1,200.00
4 months
six months, yes

ordered
Parthenon X
Column
"Ionic Column from
Mausoleum Halicarnassus"

Brucciani
about 1,000.00


Notre Dame ordered
du
Port
Trocadero

3 months
21-7 inches high
14-1¼ " wide

ordered
Siena
Baptistery
Font
✓ Berlin Museum
45000

(or Lille?)
Font by
Federighi

Ilaria
del
Caretto ✓
Lille
Ordered.

Ordered
Pisano
Pulpit ✓
museum Berlin
£625.00

Ordered
Parthenon X


Cathedral of Vez
St Gilles
Portal
Trocadero
ordered

Henri II
Tomb
(François II, Na
Trocadero
Ordered.

ordered
Monument
of
Lysikrates
E. B. A.
$97.00
6 months, yes

Sicilian
Greek
Sarcophagus
Palermo

Entrance

Figure 76.
Undated working plan for the purchasing of monuments, c. 1905. Marked with the price of the objects, where to get them, as well as documenting what was at the time confirmed ordered. Carnegie Museum of Art, Pittsburgh.

that they do not exceed twelve or eight feet in height; however they may be smaller." Smith was asked to suggest "several important specimens," and to "instruct Messrs. Dicksee and Company, 7, Duke Street, St. James, London to secure photographs and forward them to me quickly," adding that "Dicksee will be instructed to obey any orders you may give."[51] This way of orchestrating the world from Pittsburgh often proved successful, but not always. It is impossible not to sense a certain dryness in Smith's reply. He was "sorry to say that there appear to be no molds existing of any of the specimens of architecture which would answer your purpose"; however, he had inquired as to whether the manager at Brucciani & Co. might have something "suitable" at hand.[52] The Department of Greek and Roman Antiquities at the British Museum was hardly the obvious place to look for British medieval casts; similarly, Beatty kept trying to order classical works from the Trocadéro, well known for its unparalleled collection of French medieval monuments. It took time to gain an overview of this "province of reproductions," time that Beatty did not have the luxury of spending.

Canvassing was a parallel strategy to make selections from the cornucopia of sales catalogues. In April 1904, Beatty sent a letter including a list of possible monuments to twenty-five American architects, asking them to prioritize and suggest pieces they would like to see exhibited in the Hall of Architecture. At least ten of them answered. Elener & Andersson in Cincinnati found that the Erechtheion porch "has been shown so much, that it would be refreshing if you could find something else," and advised against the Cathedral of Saint-Pierre de Beauvais, "being really a transitional detail."[53] Charles McKim of McKim, Mead & White recommended that Beatty talk with his friend Camille Enlart at the Trocadéro.[54] Boston-based Alexander Longfellow, Jr., forwarded his letter to Matthew Prichard, who was at the time fighting to deaccession the casts from the Boston Museum of Fine Arts. Although Prichard could hardly conceal how unimpressed he was with the list of possible acquisitions, he gave a sincere reply. The "problem is important and deserves great caution for its solution. If disposed of hastily, the Institute will obtain the most conventional of ready-made collections," he wrote, and notably added that "the problem demands a knowledge not only of architecture but of its reproduction in plaster."[55] As a start Prichard recommended that the Institute's staff peruse the Metropolitan's 1891 *Tentative Lists*, the South Kensington Museum's 1873 catalogue of architectural casts, the Trocadéro's 1900 catalogue, and the 1902 guide to the Brussels collection. Further, he proposed that they look into the possibility of obtaining new works that were "occasionally available," among them casts from a series of Syrian churches made under the supervision of Howard Crosby Butler at Princeton University, and casts of the Arch of Benevento, made under the direction of the American School at Rome, and that they also check on whether there might exist reproductions from Ara Pacis in Rome. Longfellow passed Prichard's letter on to Beatty. None of his interesting recommendations of rare and seldom-displayed casts were followed.

Although fewer than half of the addressees replied, the questionnaire greatly influenced the course of the selection. Beatty soon realized that four monuments were of primary importance, namely, the portals of the

cathedral in Bordeaux and the abbey church in Saint-Gilles in southern France, as well as the tomb of François II and the Well of Moses. In the early spring of 1905 a massive order of twenty-four casts had been placed at the Trocadéro. After the questionnaire responses were received, the order was canceled and the Parisian molders were asked to concentrate on the four casts: We "desire them . . . because they are needed to complete our central hall plan."[56] The difficulties Beatty faced in procuring these objects amounted to a full education in the art of acquiring plaster monuments; the bureaucratic runaround eventually necessitated Andrew Carnegie's personal intervention. Beatty experienced numerous frustrating failures to procure disappearing, irreproducible objects. When he tried to get a version of the Metropolitan's famous (and scandalous) Parthenon model, the process was hindered by the fact that its maker, Charles Chipiez, had passed away, and that all his documents were "sold and scattered."[57] The sculptor who built the Parthenon model had also passed away, and only in the early 1930s did a model of the Parthenon at scale 1:20, made especially for the Carnegie Institute, enter the Hall of Architecture.[58] Except for the one extraordinary exhibit that eventually sprang from these initial preferences, the collection in many ways became exactly what Matthew Prichard feared: a readymade, the sum of the casts available in the market and during the time available to effect such a grand-scale operation. The word "readymade" was certainly derogatory, denoting a collection made without taste or vision. But it does evoke a larger trajectory for the plaster monuments, namely, the way illustrated treatises of the Renaissance reduced "the infinite universe of architectural creation to the closed world of a catalogue of ready-made parts."[59]

When Camille Enlart praised the Hall of Architecture for evidencing "indubitable taste," his encomium could partly be explained by the fact that a number of objects from his own museum in the end furnished the room, and that the Carnegie Institute, with his help and that of his staff, had secured "the magnificent cast" from Saint-Gilles, "of which no other museum possesses more than a third, or some of the smaller parts."[60] The collection sprang from the preferences of contemporary American architects. Their plaster monument preferences were influenced by the collections at the Art Institute in Chicago and at the Metropolitan, which ultimately defined the canon at full scale and in three dimensions in America. Additionally, the taste on display in Pittsburgh reflected American Beaux-Arts conventions, tying the European tradition to contemporary American architecture at the turn of the century, as yet another displacement performed in plaster.

Beaux-Arts Contemporaneity

Designed by the Boston office Longfellow, Alden and Harlow with explicit references to Davioud's 1878 Trocadéro Palace, the Carnegie Institute and Library was dedicated in November 1895.[61] The next step in the building program was the museum, a lavish Beaux-Arts exercise in Italian Renaissance style in which the two central spaces, the Hall of Architecture and the Hall of Sculpture, were modeled on the Mausoleum

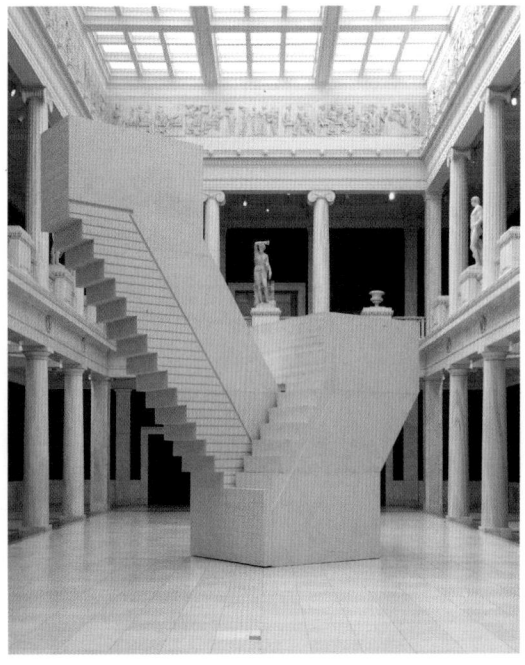

Figure 77.
Rachel Whiteread, *Untitled (Domestic)*. Cast plaster with various armatures, 2002. Hall of Sculpture, 2007–8. Carnegie Museum of Art, Pittsburgh.

of Halicarnassus and the cella of the Parthenon, respectively (figure 77). Both galleries were purpose-built for the casts, even if the building was designed before the Institute had even a vague idea of what works would furnish the spaces. The reconfigured firm Alden & Harlow finalized the plans for the galleries in 1904, when the making of the collection commenced. Particularly in the Hall of Architecture this came to cause certain problems.[62]

Longfellow, Alden and Harlow split up in 1896 when Alden & Harlow relocated to Pittsburgh, and remained exponents for American Beaux-Arts architecture. Longfellow was partly trained in Paris, and Alfred B. Harlow had worked with McKim, Mead & White. They are seen as the successors to Henry Hobson Richardson's Romanesque revival, importantly exemplified in the 1888 Allegheny County Courthouse in Pittsburgh, on which Alden and Harlow had worked. Richardson was the second American to study architecture at the École des Beaux-Arts in Paris and returned to the United States in 1865. A major work informed by his characteristic medievalism, dubbed Richardsonian Romanesque, was the Trinity Church in Boston, completed in 1877. The three-arched entrance inspired by the western façade of Saint-Gilles was added posthumously in the 1890s.[63] Richardson made the Romanesque pilgrim church in southern France a pilgrimage destination for American architects as well, something to which the questionnaire testifies. So this cynosure of the Hall of Architecture was a specific choice, expressing a contemporary American taste for French medieval architecture that would characterize the selection of architectural objects (figure 78).

Acquiring the Saint-Gilles cast initially appeared easy. The main portal was in place at the Trocadéro in 1887. It figured on the Metropolitan's 1891 *Tentative Lists*, and the Art Institute in Chicago obtained an edition with the rest of the monuments France had displayed at the World's Columbian Exposition in 1893. The Bordeaux portal was also on display in Chicago, while the Metropolitan had the central pier and a part of the tympanum. Sometimes, though, the molds of casts on display at the Trocadéro were not in the museum's possession: the Vézelay portal, for instance, had been cast while Viollet-le-Duc was restoring the church in the 1840s. For "Bordeaux and Vézelay, request must, first of all, be made to the Minister of Public Instruction," the Carnegie was informed.[64] However, permission to make new molds in Bordeaux was "absolutely refused,"[65] and Beatty had to make alternative plans to secure the monument. In April 1905 he cabled the director at the Art Institute of Chicago: "Where secured Bordeaux cast? How long to make? Answer collect."[66] William M. R. French replied the next morning: "Bordeaux portal from French Government through Colombian Exhibition."[67] Later the same day French wrote Beatty a letter elaborating a bit on the north transept of the Bordeaux Cathedral: "as you no doubt know, it is an immense cast 36 ft. high, 32 ft. long and perhaps

THE CHURCH AT ST. GILLES

Figure 78.
Photograph of the west façade of the church in Saint-Gilles-du-Gard, published in Edward Robinson et al., *Catalogue of the Collection of Casts* (New York, 1908).

8 ft. in the other dimension." They had gotten the French casts for "a small fraction of their value," and he thought that it cost "$2500 or $3000, to which must be added a like amount for packing and transportation."[68] The importance of this monument was never in doubt; however, more questions followed concerning how long mounting would take. French explained, "I should think it would naturally take something like a month, although it could be put up much more quickly."

Plying the Trocadéro director to secure the four monuments that had crystallized in the questionnaire, Beatty learned that the museum had molds only for the tomb of François II and was not willing to endanger their own casts by making new molds from them. Enlart suggested that the Carnegie Institute should have new molds made from "the originals after having obtained the permission of the proper authorities."[69] But he had talked with the undersecretary of the Beaux-Arts, who could not grant such authority, and advised Beatty to approach the owners of the monuments directly for the Bordeaux portal, and "for every other cathedral where you might wish to work": the director general of the Ministry of Worship in Paris. For the Well of Moses, a fourteenth-century sculpture from a Carthusian cloister that was partly destroyed during the Revolution, the Institute contacted the mayor of Dijon, only to learn that the authorization to permit new molds rested with the department of Côte-d'Or. The mayor added that "the work has undergone serious deterioration," as a result of earlier casting operations, that it was unlikely that they would get permission, and that others had tried, unsuccessfully.[70] After appealing to have new molds made anyway, the Carnegie ultimately realized that this French mayor was completely immovable, only referring them back to the Trocadéro.[71] Thus Beatty repeatedly approached Pouzadoux, trying to persuade him to make a reproduction from the cast in the Trocadéro galleries. The chief molder did not give in and, with

reference to both the Well of Moses and the Bordeaux and Saint-Gilles portals, asserted, "I repeat again once more, the Museum of Comparative Sculpture does not posses the mould, nor am I able to furnish you it."[72]

Undaunted, Beatty moved on from the molder to the director: "I will not urge you to make a mold if you feel that there is serious danger, but assure you that the favor will be a great one, and highly esteemed by the Institute and Mr. Carnegie as well," adding that they are "willing to assume any reasonable expenses."[73] Eventually, and for the sum of thirty-five thousand francs, Beatty got his way.[74] In the summer of 1906 Enlart assured Beatty that Pouzadoux had "expended every care upon" a perfect edition of the Well of Moses, that he had personally supervised the work, that "your model is in all respects identical" to the Parisian one, and finally that the Carnegie representative could collect the proof at the Trocadéro workshop.[75]

Beatty failed to get permission to make new molds from the cathedral in Bordeaux, and with little hope of obtaining authorization to cast Saint-Gilles from the original, he met with the director at the Art Institute in Chicago to look into the possibility of casting the two French portals from their casts. That meeting went well. Chicago did not share the Trocadéro's reluctance to make casts from casts. Informing his American agent in Paris that the Chicago Art Institute had allowed them the "inestimable favor" of copying their casts, to be sure to have them in place for the opening, Beatty added—perhaps mostly to comfort himself—that the "safe course is probably the wise one." He saw the bright side of casting from casts to get doppelgänger copies from Chicago for both Bordeaux and Saint-Gilles: at the Art Institute there would be no unforeseen impediments, not even "unfavorable weather," as the new molds would be made indoors.[76] Yet Beatty instructed the agent to notify him immediately should Pouzadoux change his mind: "If your cable advises me that they will make this agreement, I will decide quickly and cable you my decision promptly."[77] He had not given up hope of acquiring the original French editions of these plaster monuments, and in the case of Saint-Gilles events would indeed deviate far from the "safe course." After a high-level political, economic, and legal tour de force, the façade of the abbey church with all three arches became the crown jewel of the Hall of Architecture.[78] Reconstructed inside an interpretation of a Hellenistic tomb and glancing at Richardson's Trinity Church, the Romanesque monument enhanced Beaux-Arts aesthetics, combining antiquity and medievalism as vivid sources for contemporary architecture.

In 1918, discussing ideal light conditions in museums, Benjamin Ives Gilman of the Boston Museum of Fine Arts argued that the "reputation of museums as mausolea of art, cold storage warehouses for their content," was caused by the predominant use of top light.[79] Derived "from the style of which the Mausoleum of Halicarnassus was a capital example," this tomb typology identified museums as "the resurrection places" for objects "whose natural life was ended," many of them sculptures "from architectural monuments now dismembered." "A mausoleum looks straight at death; but a cathedral through death at immortality," Gilman claimed, with a pathos that evoked yet another museum topos, and one that applies particularly to the plaster monuments, dismembered and displaced in both medium and time. Fully understanding works of art and

architecture in museums "requires an imaginative effort, a detachment from the here and now, and an immersion in the there and then."[80] In many ways, this was exactly what took place in Alden & Harlow's museum, with its eclectic actualizing of historical style repertoires. With its new building, the Carnegie Institute bridged "the change in taste toward the end of the nineteenth century from Richardsonian Romanesque to Beaux-Arts classical."[81] The wrapping in a neo-Renaissance façade of the two galleries inspired by two major classical Greek and Hellenistic monuments expressed a Beaux-Arts contemporaneity. Both container and contained staged the history of architecture. Two dimensions were at work, one temporal and one spatial, gathering the "there and then"—architecture from remote times and places—into a "here and now," and the mediated presence in the gallery where it all could be experienced simultaneously. Thus this recontextualization of dismembered architectural fragments within a museum environment deconstructs conventional conceptions of site and place, be it geographical or archaeological.

Move Every Stone!

As the Carnegie Institute recurrently discovered, new legislation and ideas about preservation, in different ways, were permeating the museum world as much as the "real" world of buildings and ruins in situ. Casting of a number of pieces was terminated, making popular staples in the cast market hard to get. When Henry Cole in the 1867 Convention declared that the reproduction of monuments did not cause damage to the originals, he was reiterating a belief typical of his time. The 1854 handbook to Owen Jones's Greek court at Sydenham stated that "now that the art—or rather the science—of moulding has attained such perfection, the most delicate objects may be cast without the slightest injury."[82] Even if casting techniques differed through the centuries, this reads like wishful thinking. The fact that molding changed the fragile surfaces of stone and other materials was well known: "Considering how moulds damaged and discolored the original marbles," in early eighteenth-century Rome connoisseurs already "reckoned that good casts would be less easy to acquire in the future."[83] In 1860, the Norwegian philosopher Marcus Jacob Monrad advised the National Gallery in Oslo to immediately secure editions of important works of antiquity, as it was common knowledge that "the originals suffer from the molding, and it is becoming increasingly difficult to obtain permission to make new molds from the most famous works, and as far as I know, several museums have already terminated casting." Soon the only versions available would be copies made from copies or inferior casts made from worn-out molds.[84] Still, purchasing plaster architecture in Europe in the 1880s, Pierre Le Brun found that the "rules governing reproductions are generally very liberal." Casting was permitted under the control of the museum holding the original and by "*formatores* who are authorized to cast under certain restrictions."[85]

Yet several cases show that casting jeopardized the originals—Ghiberti's Gates of Paradise, commissioned by the South Kensington Museum the same year Cole's Convention was signed, being a case in point. The gilded bronze doors, depicting biblical scenes over twenty panels, were

electrotyped during an unusually cold Florentine winter, and "fragments of gold-leaf from the original doors came away with the doors."[86] The Historical Museum in Christiania tenaciously resisted the demands from Pittsburgh to provide the stave-church portals that were on display at the Metropolitan, explaining that no more molds would be made, as casting had already harmed the wooden objects. The South Kensington laid restrictions on casting from their originals, as "the wretched processes employed in making the moulds had left a disagreeable yellowish bloom, which can be removed only with the most careful labor, and at considerable expense."[87] Complaints were voiced that one had to go to Cairo to see "the Egypt of the past rehabilitated," and that hardly any discoveries from recently opened tombs found their way to European museums: "These figures are colored, so that their reproduction by casts is forbidden."[88]

The resistance to having new molds made from objects in museums, as well as from buildings, led to debates on casting methods. In London in 1891, Edward Robinson was disappointed to learn that many of the objects that were "still advertised in Brucciani's catalogue, no longer exist." He critiqued the resolution passed by the trustees at the British Museum banning new reproductions of the Assyrian collection, as the first molds made were by then exhausted. Robinson did not dispute the fact that the extensive casting of the monuments of ancient Nineveh had harmed the polychrome surfaces and profiles of carved alabaster and limestone, but he indicted what he considered "old-fashioned" casting techniques, involving water in the making of the molds: "One of the chief objects which I hoped to accomplish at the British Museum was a reconsideration of the restriction against having new casts made of the Assyrian sculptures." From what museum officials told him, "I cannot doubt that injury has been done by this means in the past: but with the various processes of dry moulding now used generally upon the Continent, there is no reason why objects of the greatest delicacy should not be cast without danger, and it is to be hoped that these processes will soon be introduced at the British Museum.[89]

England and France passed laws on monument protection, respectively, in 1882 and 1887.[90] Museum officials and monument owners, private and public, had become increasingly reluctant to have new molds made from buildings and antiquities, as well as from casts. Casting was seen as no less damaging to a reproduction than to the original, and at the turn of the century the dichotomy of copies and originals was deconstructing itself in the galleries, complicating notions of originality and authenticity. Both molds and casts were in the process of becoming irreproducible, rare objects in and of themselves at the end of the heyday of the trade in plaster monuments.

The Carnegie Institute found that many casts listed in sales catalogues were out of stock, or simply off-limits. While in Paris, Edward Robinson had praised the Frieze of Archers from Darius I's palace at Susa in ancient Mesopotamia as the "most remarkable reproduction" he had seen.[91] It was produced at the Louvre, and on display at the South Kensington Museum and the Edinburgh Museum. Beatty greatly desired both the Frieze of Archers and the Frieze of Lions, assuring the chief molder at the Louvre that they would "occupy a prominent place in the collection for our grand palace."[92] Arrondelle responded that although the Persian works

still figured in their catalogues, the molds were worn out, and that they did "not authorize anyone to cast a mold of the original."⁹³ Pressed to have the Louvre make new molds anyway, Arrondelle disclosed that an artist in Paris was in possession of a mold and, for a thousand francs, could make them a new cast, "provided that it be made like the original in the Museum, i.e. colored with enamel paint."⁹⁴ This episode reveals that there were ways to locate a cast outside official channels, particularly when the buyer was resolute, powerful, wealthy, ruthless, and well-connected—all qualities decisive for procuring the casts in the Hall of Architecture.

After the questionnaire responses had highlighted the Saint-Gilles portal as particularly attractive, there was never a moment's doubt about the Institute's determination to obtain the portal: "This we want first, and ahead of everything else." "Even if no others can be made in time, we want this," Beatty announced, adding that "we will meet any condition with reference to payment."⁹⁵ "The splendid Saint-Gilles will be an unique exhibit, and the most important of its kind in the world. It alone would give distinction to any museum," he proclaimed in fall 1905.⁹⁶ The question was what cast to get and where to get it. So eager was the Carnegie Institute to get Saint-Gilles that Andrew Carnegie personally wrote to the Metropolitan Museum asking whether the Carnegie might borrow the Metropolitan's edition in the event that their own did not arrive in Pittsburgh on time. "Such action would only be that measure of courtesy and helpfulness which all museums should entertain and practice towards another," answered a polite secretary at the Metropolitan, nonetheless adding that the new director, Sir Purdon Clarke, had just decided to have this yet-uninstalled portal mounted, and that "paintings are already being removed from our grand hall to make room for it."⁹⁷ That piece of information did not cool the Carnegie Institute's desire to get a version of the monument, although it was made clear early on that the Trocadéro could not and would not provide the original cast of the central portal, and would not renounce their decision to refrain from endanging the monuments in their own galleries by replicating them (figures 79 and 80).⁹⁸

"Pouzadoux letter received," Beatty cabled his agent in Paris in April 1905: "Ask if can make St. Gilles complete nine months."⁹⁹ Eager to hear back from the Trocadéro, Beatty transmitted a new question from Pittsburgh to Paris three days later: "Will Pouzadoux make St. Gilles nine months if authorization secured. Cable answer."¹⁰⁰ A year earlier it had been explained to Beatty that making new molds "on the spot—that is on the monument itself, at Bordeaux as well as at Vezelay"—could prove difficult, not least because "modellers are not easily found for they take

Figure 79.
Close-up, central portal, Saint-Gilles, Trocadéro. From P.F.J. Marcou, *Album du Musée de Sculpture Comparée*, vol. 2 (Paris, 1897).

Figure 80.
Central portal, Saint-Gilles, Trocadéro. From Enlart and Roussel, *Catalogue Général du Musée de sculpture comparée au Palais du Trocadéro* (Paris, 1910).

the risk of injuring the monument and that is a responsibility they prefer to evade."[101] Pouzadoux was willing to take on the commission if special authorization were acquired, but he would need eighteen months to carry out the work.[102] The following day Beatty was asked to wire ten thousand francs, a 50 percent down payment on the job.[103] In this stream of transatlantic high-speed communication, it became clear that if permission were forthcoming for the creation of the molds, the earliest possible moment to start the work would be in late June, "and the essential time for making the monument before winter is lacking, for it is impossible to carry on the work during frost." Realistically, then, Pouzadoux could manufacture the monument in spring 1906 for delivery in Pittsburgh by September, wrote the agent, who added an update on other Parisian works-in-progress: at the Louvre Arrondelle was two months delayed on the porch of the Treasury of the Siphnians, while de Sachy at the École des Beaux-Arts "has put in work the Portico of the Erechtheum," while figuring out how to "reconstruct" the twenty-seven fragments of the Monument of Lysicrates.[104] Beatty cabled Pouzadoux straightaway: "Order and money cabled Director. Commence St Gilles first others after. Will forever remember favor if you will do Saint-Gilles in one year."[105]

These fragments from a flow of correspondence, along with the meetings the agents had with a number of people in Paris in the spring of 1905, set the pace and style for the behind-the-scene effectuation of the Hall of Architecture. The lavish budget provided by the museum's founder was fundamental to the building of this collection at such a tempo, and to the acquisition of the Saint-Gilles cast, and so were Carnegie's authority, influence, and celebrity. The whole operation of circumventing French monument legislation is sprinkled with references to "gifts," "favors," and "gratefulness," with Beatty flattering, persuading, and threating people in his way to get this obsession realized.[106] To avoid legal obstructions, Beatty and Carnegie approached several French ministries; heads of various public authorities, including the preservation authorities; various municipalities of the French *departements*; and local politicians and bureaucrats, most importantly the mayor of Saint-Gilles-du-Gard who finally, in response to suitable inducements, allowed the Carnegie Institute to make a mold from the full western façade. When he asked the mayor to authorize the molding, Beatty assured him that "the Carnegie Institute will esteem it as a great favor if your authorization may be accorded them immediately," and suggested he telegraph his decision instantly.[107] From this point on, however, things did not proceed at the tempo Beatty desired. It took more than nine months to conclude the deal. Writing to Beatty from an ocean liner en route from Cherbourg to New York, Knoedler expressed his pleasure "to learn that you were satisfied with what we had done in the St Gilles matter. When I see you, I will give you the particulars of our negotiations," and he hinted that the inhabitants in the French town were upset by the operation.[108] "Cabled two thousand francs transmit Mayor Saint Gilles for authorization casting Saint Gilles mould," Beatty informed Navez in March 1906, and the agent replied that he would soon "deliver this sum of Mr. Carnegie to the mayor as a gracious gift to the city."[109] The Carnegie Institute was careful not to account these expenses with the rest of the budget, as it was "a separate fund, given by

Mr. Carnegie for this particular purpose, and the account of it must not be mixed up with our other accounts."[110]

With fierce determination Beatty apparently devoted every waking moment to the mission. "Move every stone in order to secure the Porch of St. Gilles, packed and ready for shipment, by May 1st, or not later than June 1, 1906," he ordered Knoedler in May 1905.[111] Every stone was indeed moved to get this splendid plaster monument to Pittsburgh. Knoedler and Navez in Paris were implored to "bend every energy to secure permissions to the moulds," to remember that this is a matter of "special haste," and to keep on paying visits to any French official with any say in the decision, equipped with letters from the American ambassador at Paris, whose assistance had also been directed "to securing the necessary authorization."[112] "Present and urge our request for special haste," the ambassador was instructed. The American minister of foreign affairs was also involved, as was his Russian colleague. Beatty seemed increasingly certain that the operation would succeed.[113] "When permissions have been secured and the Director of the Trocadéro agrees to finish the casts..., cable me this information quickly, and I will promptly cable you whether or not the date is satisfactory," he commanded Navez a month later.[114]

The authorization to reproduce the façade of the church that had been listed as a historical monument in 1840 was granted in August 1905. Beatty received the good news in a cablegram: "Permission granted St Gilles Pouzadoux promises delivery June first cost forty thousand francs suggest giving order after all official intervention cable if want whole porch or part."[115] Beatty indeed wanted the whole porch; in fact he wanted more than that, asking the experienced molder to do something he had never done before—namely, to reproduce not only the whole façade with the three arches, but the three wooden doors with their ironwork as well. After Beatty had paid Pouzadoux a visit in Paris, the molder confided in a letter that he, while casting the façade, had had no idea that the Carnegie Institute would be interested in the modern doors as well, and that he had cast the landing and the steps "under the supposition that the object would be placed against the wall and then these steps and the landing, elevating the objects, would give it more amplitude. When I learned of your wish to have also the wooden doors, I stopped the work on the steps which became useless for you and hurried with the moulding of the doors by adding more workers."[116]

Despite unexpected challenges, Pouzadoux in the end beat the deadline for finalizing this most desired plaster monument. Still, before the Carnegie Institute could enjoy "the triumph of having this splendid work in our midst," there intervened the painstaking process of packing and transportation.[117] In January 1906 "the first part of the church of St. Gilles, i.e., the upper part of the monument," embarked from Marseilles, and in April the second shipment, in 62 crates, was sent off.[118] In early May, 28 crates containing a third installment were heading toward New York; a week later 20 more crates, "the 4th installment which will complete the monument," sailed from Le Havre, before the fifth and last installment sailed from Marseilles on May 18.[119] After arriving in New York, the 195 crates traveled by train to Pittsburgh, with only one major challenge remaining: mounting the largest cast monument for posterity.[120]

Cast in Situ, Lost at Sea

The Metropolitan's *Tentative Lists* proved invaluable for the Pittsburgh operation. Edward Robinson had located the best makers of casts and the provenance of the best editions, personally visited the leading actors in the business, and calibrated his selection according to what he saw and learned in Europe.

One would expect Robinson's warning to carry weight: "There is, to be sure, a popular impression, among those who have not tried it, that the purchase of casts is like that of any other merchantable commodity." If you know what you want, "one need only look up an address, go there, and buy."[121] Indeed, addresses of workshops and museum outlets circulated through numerous inventories, catalogues, and collections. For instance, an 1807 catalogue raisonné for a private Danish art collection gave the provenance of the casts by including the location of their makers, among them "Getti, mouleur de musée Napoléon [Louvre], hotel d'Angiviliers, rue de l'oratoire a Paris."[122] To "a certain extent," continued Robinson, "this is true, but the extent is very limited. Even in a small collection there are always sure to be a few objects which are matters of especial and often lengthy negotiations." He was reporting on some difficulties in regard to "one of the monuments on our Renaissance List," currently "the subject of negotiations between the ambassadors of two European powers, a prominent official at the South Kensington Museum, and the Italian Minister of Public Instruction."[123] Carnegie's involvement in high-level politics and clandestine diplomacy to gain permission to cast Saint-Gilles outstripped the Metropolitan's efforts to secure their selection of high-quality casts. But these negotiations were exceptions. Records of the majority of the purchases reveal that buyers did not even need to show up in person, as most of the goods were not only ordered by mail, but sometimes, it seems, without the buyers having seen the originals, the casts, or even images of them.

"A good mould is a costly implement, and will never be found in the hands of any but first-rate workmen; and it is impossible to get a good cast from a bad mould."[124] This insight was core to nineteenth-century cast culture. Where should one buy a cast when editions were available from different vendors? The Carnegie Institute wanted the best casts the market could provide. By the early twentieth century several American workshops could supply at least some of the monuments that found their way into the Hall of Architecture. C. Hennecke Co. of Chicago and Milwaukee specialized in architectural ornament, while Caproni & Bro. in Boston had become a leading American producer of architectural casts. Florentine émigré Pietro Caproni and his brother Emilio took over a plaster cast workshop in Boston in the early 1890s. The Caproni Gallery showcased and sold both contemporary and classic sculptures, with its core stock of molds taken from works in the Louvre, the Uffizi, the Vatican, the Archaeological Museum in Athens, and the British Museum. They produced casts for museums, schools, and private homes; while their catalogues provided little information on the objects besides size, price, shipping costs, and discounts, they advertised casts "made from the originals," and announced them as works of art, owing to a "subtleness of treatment, a certain feeling," in the reproduction.[125] Their

stock was often updated, and the 1911 catalogue was soon followed by a supplement presenting "Casts of models which we purchased during our recent visit to the Museums of Europe," stressing their "exclusive right" to make and sell a number of casts.[126] This valorization in terms of closeness to the original work was typical in cast advertisement. For instance, L. Castelvecchi, "manufacturer and importer," established in New York in 1857—specializing in fine arts and miscellanea, and with only a few architectural specimens in the assortment—pledged that frequent "visits to the centers of Arts, London, Paris, Rome, Pompeii, Florence, Milan, Turin, Berlin, Vienna and elsewhere" guaranteed "copies superior in artistic finish and truthfulness in detail to any made in the United States."[127]

The Carnegie collection reflects the ideal that a cast produced at the site of the original monument is more authentic and attractive. August Gerber in Cologne, Sabatino de Angelis in Naples, Gilliéron and Son in Athens, Giuseppe Lelli in Florence, Pietro Pierotti in Milan, Lorenzo Rinaldo in Venice, the Guidotti brothers in Christiania, and so forth, provided the Hall of Architecture with monuments from their city, region, or country. Ghiberti's doors for the baptistery of the cathedral in Florence arrived in Pittsburgh from Florence, the capitals from the cathedral in Hildesheim from Hildesheim; the Venetian fragments were indigenous Venetian. The copyright to the molds and the recognition of expertise and proximity to the place of the original work certified the cast. Of course, this place of origin could be a museum, reflecting the period's trade in antiquities, making the provenance of casts a point of departure for expanded readings of nineteenth-century excavations, explorations, and geopolitics.

There are, however, exceptions, deviations from this ideal. The order placed at the Museum of Egyptian Antiquities in Cairo was canceled when Beatty learned that he could get similar casts in Germany: "The only reason for changing my order is the shorter distance of Berlin to the United States."[128] The column from the Vesta temple at Tivoli was in the end an American production: at least, the capital arrived from Boston, as did the podium on which to place it, as well as "some pieces" of the Nike Apteros temple.[129]

One exception is particularly notable, namely, the placing of the order for the Parthenon casts from Boston. For the frieze the order simply read, "35 ft. Eastern, 35 ft. Western, 92 ft. 8 in. Southern, 92 ft. 8 in. Northern"—the measurements corresponding to the Pittsburgh Parthenon cella.[130] Domenico Brucciani had been the official caster of the Elgin Marbles since 1857, when the molds at the British Museum were transferred to his workshop, and they appeared in different editions in his sales catalogues.[131] After Brucciani passed away in 1880, Brucciani & Co., still in close collaboration with the British Museum, remained the obvious place to get them.[132] From Boston, Caproni confirmed, "We have all the slabs with the exception of three of the Southern frieze which we would have to import if you should decide to place the order." Here Caproni refers to the "import" to the United States of the British Parthenon casts, struck from a Greek monument imported to England a century earlier. Perhaps not surprisingly, Caproni strongly highlighted the benefits of ordering the Parthenon from Boston. The slabs were both much cheaper and easier to transport—the cost of the frieze "packed and delivered onboard train

at Boston would be $575,00." More surprising is Caproni's assurance that the American editions were much better than the British ones: "The way they make them, they are all twisted and uneven, some of the slabs higher than others, which makes the cost of putting them into place almost as much as the original cost of the reliefs and they are cast of clear plaster without reinforcement at the back so that there is generally a great deal of breakage while in transit, while our slabs are made on a wooden frame, reinforced with burlap and are made all same height."[133]

In Cole's 1867 Convention the distinction between a monument and its reproduction is clear, even though both originals and copies traveled and to a great extent served the same purposes in museums. In the Pittsburgh correspondence this distinction collapses with great consequence and in fascinating ways. Though sometimes unintentionally comical, the conflation implies more than careless phrasing or linguistic lapses. In the Pittsburgh correspondence the idea of monuments in flux and circulating architecture unfolds in a very concrete sense. When pursuing the Well of Moses, Navez assured Beatty that he was doing his utmost to ensure "that you may have your monument on the day you wish."[134] "Referring to the measurements and costs of the different monuments, kindly refer to the catalogues, in which you will find the information," Beatty instructed.[135] "I desire to call to your attention that these Monuments are to be paid for one half on the placing of the order—the other half on delivery."[136] "I have cabled you today concerning the 3 monuments ordered at the Beaux-Arts: they have assured me that all of it will be delivered in 6 months, as you desire."[137] Also, the notion of the original location of the monument becomes unstable. In regard to Saint-Gilles the agent assured Beatty that he "will go and pack this monument at the place."[138] Here the place of origin is the Trocadéro in Paris, where the monument had been cast from the molds made in southern France. The oscillating sites endowed the plaster monuments with a reality of their own, beyond time and place. This conflation of monuments and the plaster casts runs through the flurry of communiqués exchanged in the course of bringing the grand assembly of reproductions to Pittsburgh. "Will you kindly oblige me by sending as soon as possible, the necessary instruction for the shipment of the monuments, which are ready and packed, as we will lack space. . . . It is necessary to have them go at once, to avoid the cost of storage."[139] "All the other monuments ordered are under way and I shall pack them in order as they are finished."[140] Beatty was endlessly impatient with the need to defer packing and shipping until the monuments were "entirely hardened," and Navez's expertise in the art of packaging proved invaluable. His reports to Beatty give a glimpse into the effort spent "on the handling and packing of the goods": "Take for instance the packing of the frieze of the Archers and Lions, which you find too dear. These mouldings were very difficult to handle before packing, owing to their size and the small space available at the Louvre for getting them out and packing them. I employed 5 men for 4 days for this work alone. The same remark applies to cases 94 and 95, and the cost price of the mouldings must not always be taken as a basis for the packing and handling. All depends on the fragility, the time spent, and the amount of material applied."[141] The Pittsburgh correspondence makes references to monuments in various conditions. The agents kept the buyer informed about their state of production, movements, crating,

and shipping, as well as regulations on taxation and discounts, problems with customs, storage concerns, delays, and accidents, including a monument thought to be lost at sea.

Storage was always an issue, both at the place of production and prior to mounting in the gallery. With reference to the Well of Moses and the Clermont-Ferrand portal completed at the Trocadéro, orders were eagerly awaited "to ship these two monuments, for we lack space."[142] In the summer of 1905 monuments were arriving from ports all over Europe—Christiania, Piraeus, Marseilles, Hamburg, Genoa, Venice, and Le Havre—while the museum was still under construction. Beatty turned to Caproni for advice on storage: "Will you tell me in a word, will there be danger to our casts if we store them in a common barn, or stable, through the coming winter, without unpacking them? The building is water tight, and we can put tar paper on the floor, but there will be no artificial heat in the building."[143] The vision of these new editions of the grand monuments of the past wrapped and stacked in a stable or a barn in Pennsylvania becomes a sort of Nativity scene emblematizing architecture's humble beginnings in the New World; and this barn is yet another ephemeral storage space in the trajectory of the plaster monuments.

Remounting Monuments

Identifying and shipping the casts was only half the job. Just as daunting was what Beatty called "remounting the monument," which meant reassembling numerous small pieces into monumental integrity.[144] The task required specialists willing to work under time pressure. In June 1905 Beatty sent Caproni the gallery plan, asking whether they were interested in the commission and what they would charge. Having "given the matter a great deal of thought," Caproni reveals a lot about the art of mounting plaster monuments. It is, he replied, impossible to give an estimate for the installation: "The first reason is that I am not acquainted with many of the subjects; second, there is no way of knowing in what condition they may arrive, that is, they may be all broken to pieces where it would take several days to do the necessary repairing; third, we do not know how the pieces have been cast or whether they have been fitted by the cast makers. The manner in which the walls are constructed where these pieces are to be hung or fastened is another point to be considered. We also notice that you intend regulating the tinting of the casts. We did not know this could be done if the casts are to be sprayed with the Van Dechand process."[145] Yet Caproni ultimately accepted the job, asking for eighty dollars per week for his services and forty dollars per week for each of his men, and assuring Beatty that "none of our men whatever, are members of the Union."[146]

Photography plays a big part in the Pittsburgh correspondence. Most sales catalogues did not include images, and Beatty was constantly begging museums, dealers, and plaster cast companies to send more photos to help him decide what to buy. Obviously, photographs were as important in the process of remounting the monuments, and when construction work started, a new flow of demands for images crossed the Atlantic. "It is extremely important that I have quickly photographs of the following casts," reads a panicky letter dated August 1906, in the middle of

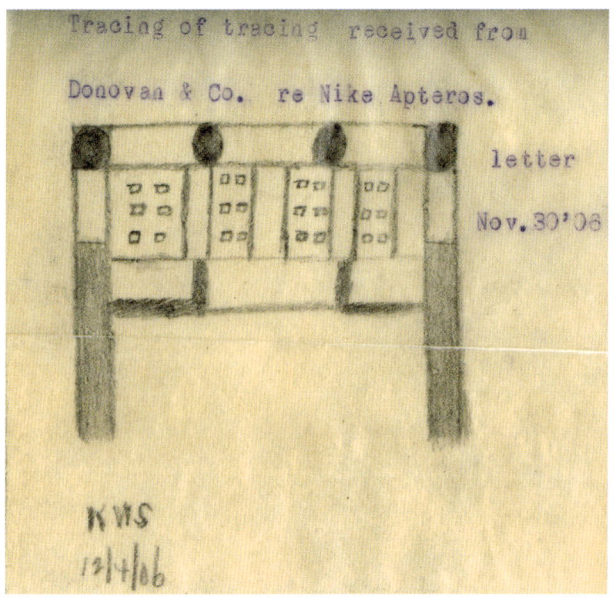

Figure 81, above.
Hand-drawn plan for the erection of the Nike Apteros portico, by D. F. Donovan & Company, Plain and Ornamental Plasterers, Cement Work, Boston. Carnegie Museum of Art, Pittsburgh.

Figure 82, opposite.
R. Herlaux, Saint-Gilles construction drawing. Ink and watercolor on paper. Carnegie Museum of Art, Pittsburgh.

the installation; the list includes major works such as the Erechtheion porch and the column from the Vesta temple at Tivoli.[147] Matters of scale appear to have been confusing during both the selection and the mounting. In 1904, Brucciani & Co. had assured Beatty that "the casts are the same size as the original."[148] In the fall of 1906 Beatty asked the London firm to provide photographs of all the casts, carefully numbered.[149] Yet even when photographs were secured, it remained difficult to match the images with the monuments arriving in numerous pieces; as a result, a panel from the temple of Apollo at Didyma was hung upside down, Benedetto da Maiano's portal from Palazzo Vecchio in Florence sat on a pedestal, while a window from the Certosa in Pavia was placed on the floor (figure 81).[150] Mounting casts was in general acknowledged to be demanding; it was even a challenge to understand what pieces belonged together and how they were expected to look in the end. While the architecture museum containing the Willard collection was being installed at the Metropolitan, Pierre Le Brun reported to the trustees that the "lists of objects and the bills of sale furnished by the makers of these casts proved to be barely sufficient to identify the pieces, and gave little information as to the date, the history, or the significance of the different objects, or as to the places where the originals were to be found. All this had to be supplied by prolonged study and research, involving a corresponding expense of time, labor and money."[151]

The construction of Saint-Gilles far exceeded the competence of Caproni's crew. In November 1905 Beatty asked Pouzadoux for plans "to facilitate the remounting of St. Gilles," and queried whether he could spare one of his best molders to "come to America for the purpose of superintending the remounting."[152] During Christmas that year, Pouzadoux was taken aback when Beatty wrote that the façade would not "be placed against the wall, but will stand alone, several feet from the wall"; moreover, it was to "serve as a passage way for the people, with the three doorways open; and the doors will be in position, but open." This daunting plan called for an arrangement "to prevent damage by the people as they pass through the doorways," and he assured Pouzadoux that advice on how to protect the open doorways "will be highly esteemed."[153] This plan to reproduce a monument's spatial qualities and function in plaster is rare in the history of architectural cast courts. In the end they succeeded in placing the façade away from the wall, but the open doors proved impossible.

In the summer of 1906, Beatty was in desperate need of plans for a number of monuments, resulting in a new flow of cablegrams: "Ask Pouzadoux hurry plans for Saint-Gilles," and "Urge Pouzadoux to send floor plans Saint-Gilles immediately."[154] A few days later Pouzadoux affirmed not only that he had sent the plans, but also that his molder M. Boucholtz

Figure 83.
Duplicating a reproduction. The Art Institute in Chicago making the Bordeaux portal for the Carnegie Institute. *Chicago Daily Tribune*, February 22, 1906.

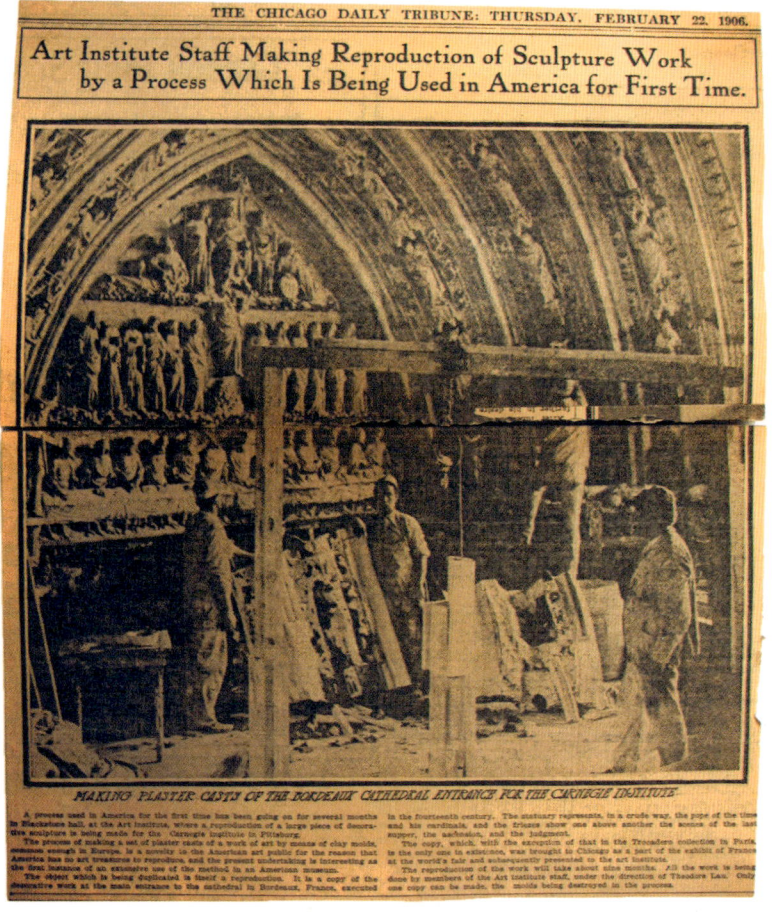

had sailed for the States, and that a M. Sadoaune was about to depart to help mount the casts from the École des Beaux-Arts (figure 82).[155] The French crew stayed for the summer, constructing a special framework of timber and wire for the façade of the French abbey church, on which the plaster pieces were joined into a coherent whole. This hiring of European museum personnel to superintend the construction circulated skill and plaster competence with the circulating monuments. The brownish coloring was applied in Pittsburgh, adding a local touch to the Romanesque monument as it was resurrected on American soil.[156]

For the Bordeaux portal Beatty asked whether the Art Institute could send the molds to Pittsburgh to preclude the transportation of bulky, fragile casts. The request was declined, though the director offered to send a molder to Pittsburgh to mount the portal that had been cast in many pieces in Chicago (figure 83).[157] After the World's Columbian Exposition, nine men had been working for nearly a year to mount the French architectural collection at the Art Institute in Chicago. W.M.R. French loaned Beatty his model of the Chicago galleries and the wooden pieces made on a scale of four feet to an inch on which were pasted sketches of the monuments, including Saint-Gilles and Bordeaux, used during the installation of the casts in Chicago. I "moved the models around until I got them right" (figures 84 and 85).[158]

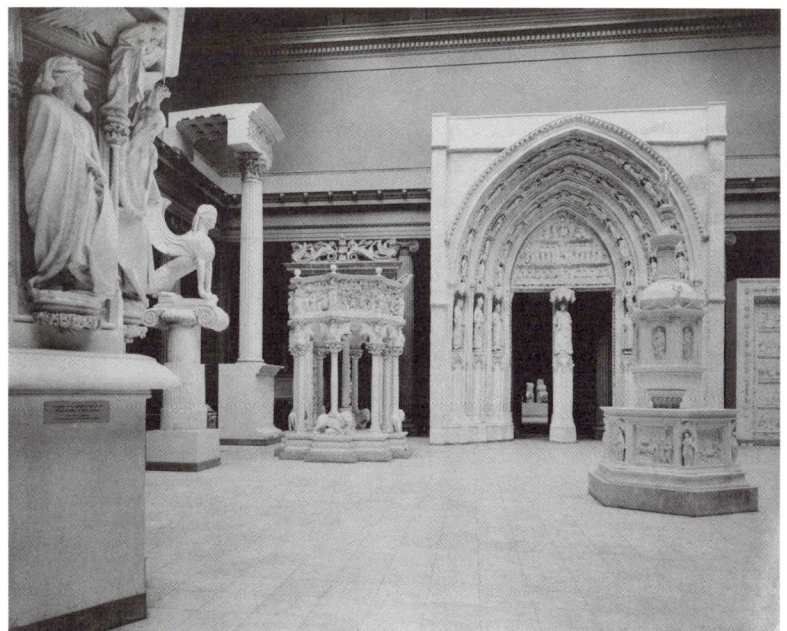

Figure 84.
Panorama: the Well of Moses, Naxian Sphinx, Vesta temple column, Bordeaux portal, and Ghiberti's Doors of Paradise. Carnegie Museum of Art, Pittsburgh.

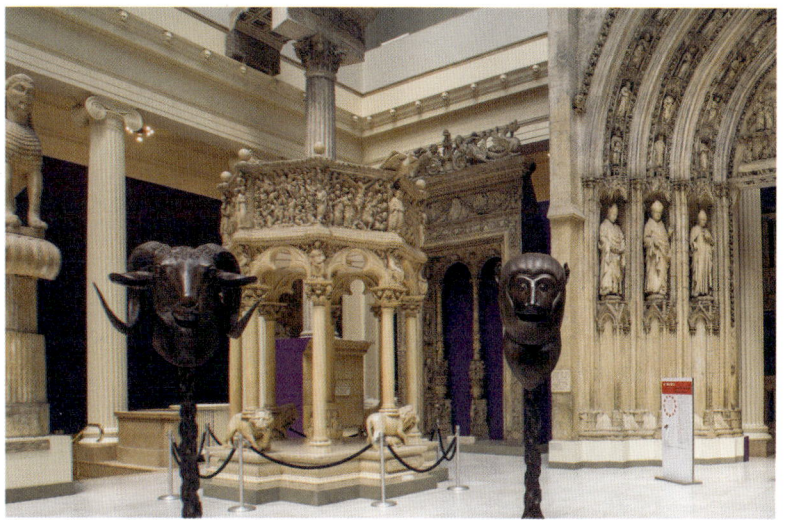

Figure 85.
Ai Weiwei, *Circle of Animals/Zodiac Heads*. Hall of Architecture, May 28–August 29, 2016. Carnegie Museum of Art, Pittsburgh.

The Trocadéro director lingered in the background of the whole operation. For instance, he prevented Beatty from cropping the colonnade of the Temple of Castor and Pollux from below when he realized that the more than eighteen-meter-tall object couldn't fit under the domed ceiling: "This order of architecture deprived of the base would lose in harmony," he explained to his American colleague, and it would be utterly "out of place in a museum composed of selections of beautiful models." However, Enlart advised on how to deal with the problem while aiming to "preserve the full value." The most convenient thing to do would be to reproduce "the upper and the lower part of a column and a short part of the entablature; you would have the scale and the base with a portion of the shaft, another portion of the shaft with a cut showing clearly that the middle of the shaft is only in part; the capital and a piece of the architrave." This solution, which shows the *pars pro toto* logic at work in the architectural cast collections, "would enable the spectator to easily restore in thought the complete order." If the height of the gallery permitted, Enlart also suggested that they instead "exhibit an angle of the Parthenon, which Mr. de Sachy can also furnish you." He proposed to shorten it, by leaving out the steps, and further also crop the pediment, a solution that would still evoke "the aspect of the whole."[159] De Sachy at the École des Beaux-Arts had in fact already tried to simplify matters by offering Beatty the "Base, capital and Entablature of Jupiter Stator" for 350 francs in lieu of the gargantuan colonnade, as well as "that corner of the Parthenon" for 15,000 francs. He underscored that the latter was slightly different from the Parisian version—parts of it had "been adjusted, with Roman mounting"—yet another reminder of the mutability of plaster monuments.[160]

None of this happened in the end. The immense endeavor of securing and installing the French Romanesque façade had perhaps quenched the passion for oversized classical monuments. For the opening of the Hall of Architecture 70 of the nearly 150 objects were in place; the rest were subsequently installed. In the course of time, and with new additions to the Carnegie Museum in Pittsburgh, the museum entrance has changed. Today visitors to this beautiful gallery are deprived of the experience of ascending the stairway from Forbes Avenue, and seeing the phantasmagorical reality of an abbey church from southern France flooded in natural light, enveloped in the abstracted exterior of an ancient tomb (figures 86, 87, and 88).

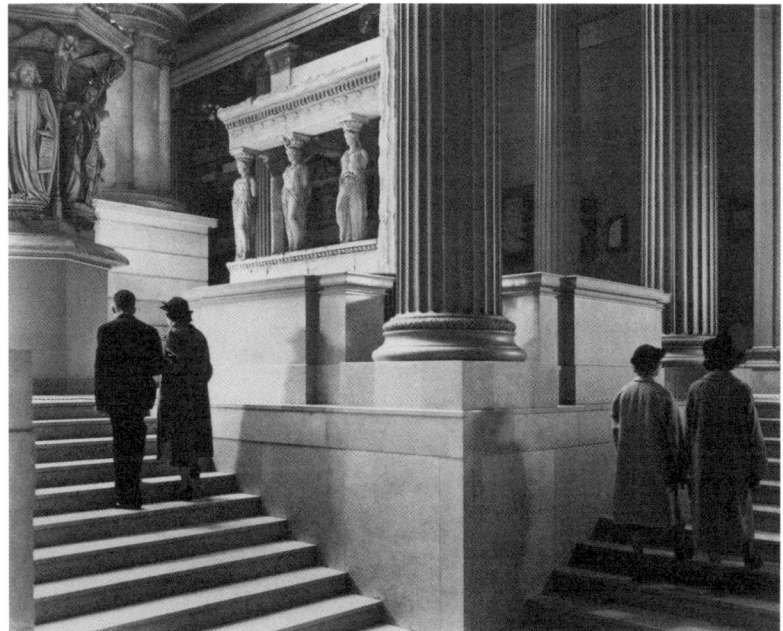

Figures 86 and 87, left and below left.
Upon completion in 1907, the original entrance from Forbes Avenue led straight into the Hall of Architecture. The Erechtheion porch stood to the right as one ascended, while the Naxian Sphinx purchased from the Louvre was placed to the left of the stairs, echoing its placement in the Daru stairwell. Carnegie Museum of Art, Pittsburgh.

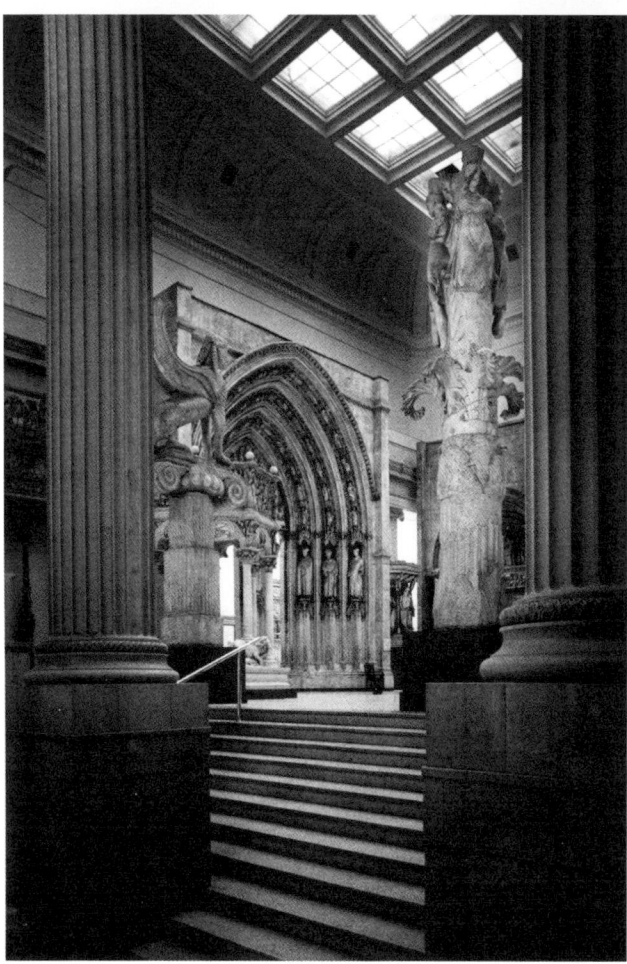

Figure 88, overleaf. Bordeaux portal, Saint-Gilles façade, and Nike Apteros porch upon completion, c. 1907. Carnegie Museum of Art, Pittsburgh.

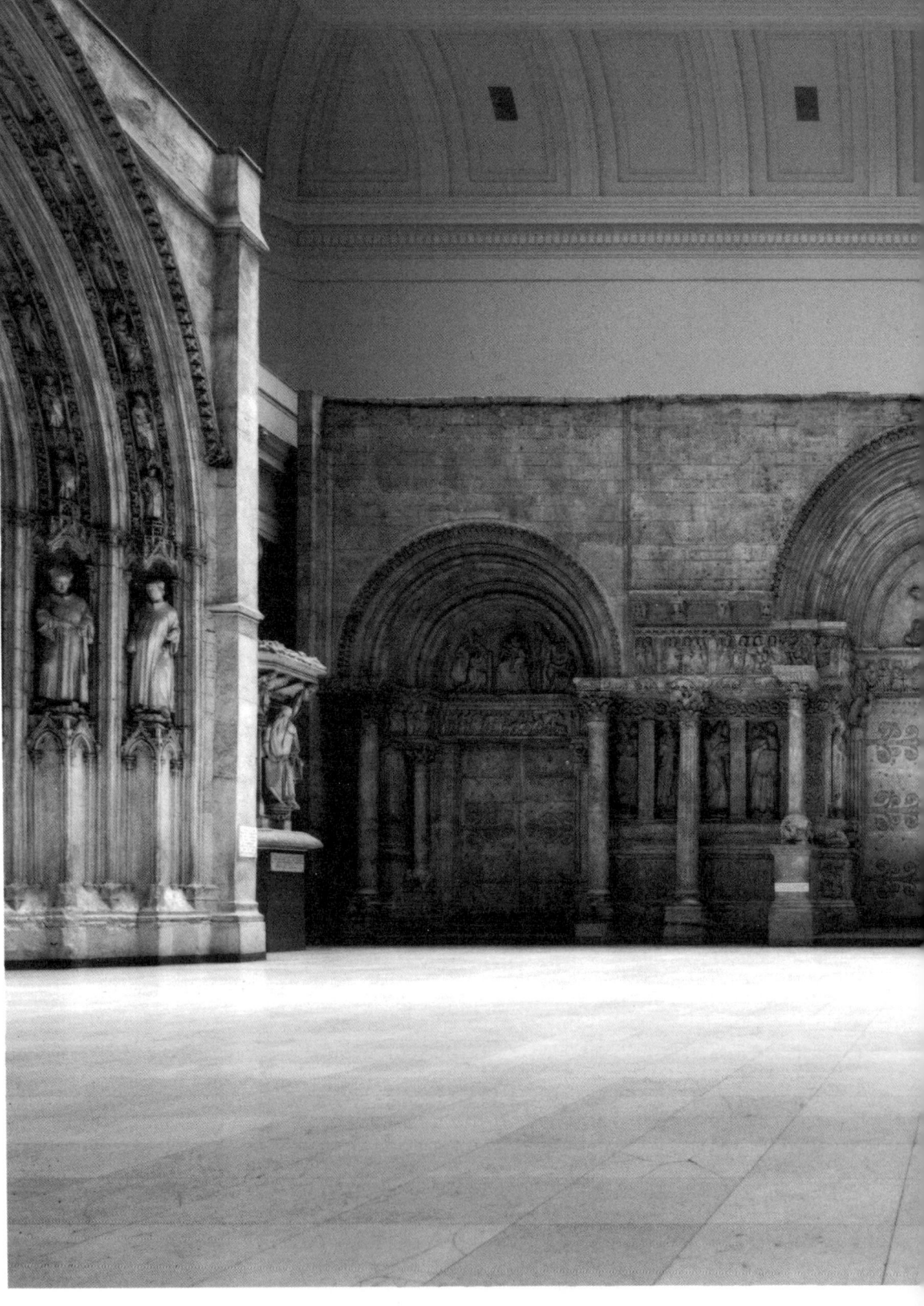

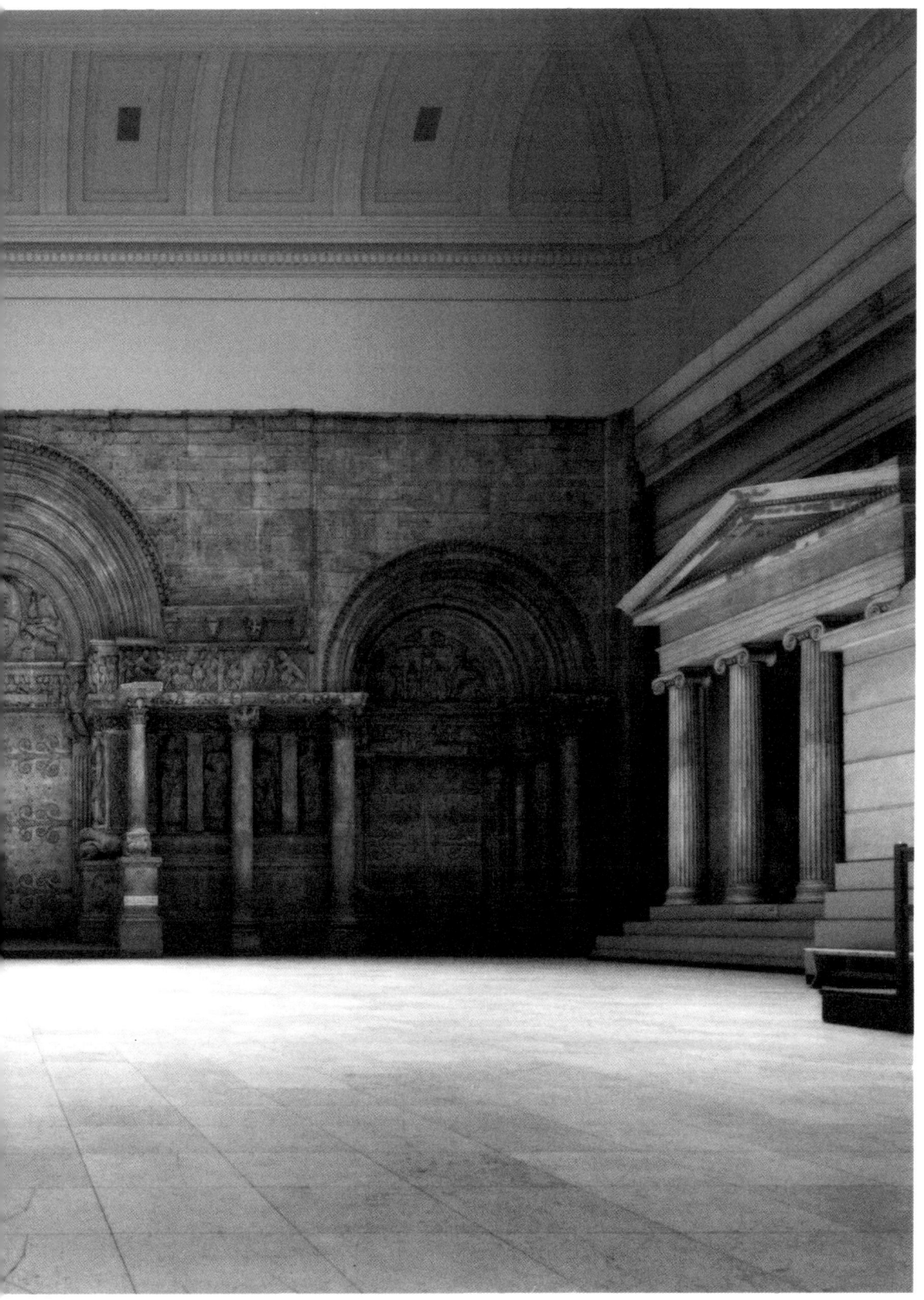

After Fire, Yale Smolders

By JOSEPH LELYVELD
Special to The New York Times

NEW HAVEN, June 25—A stately marble statue of the goddess Minerva presides over the charred rubble on the two floors of Yale's School of Art and Architecture that were swept by a fire just before dawn on June 14.

The statue, the only object of any consequence on the two floors that survived intact, is now doubly appropriate. Minerva was a goddess who both protected the arts and went to battle.

For more than a month before the blaze broke out, the School of Art and Architecture had been embattled by a complex of academic issues with strong political and racial overtones.

The sharpest of several simultaneous controversies concerned a decision taken jointly by the faculty and students of the department of city planning to reserve 10 places in an incoming class of 20 next fall for black and Spanish-speaking students.

The aroused university community still finds it hard to separate the fire from the unrest that preceded it, partly because of a provocative broadsheet that received wide circulation the week before the fire.

Arson Suspected

"Why has Yale not gone up in smoke?" it asked.

"See the A and A [Art and Architecture] building," the broadsheet advised. "See every building. See them soon."

Those words and the controversies that had swirled around the building were fresh in many minds the morning after the fire — including that of Fire Chief Michael J. Sweeney, who said he strongly suspected arson.

But Fire Marshal Thomas Lyden, who is in charge of the investigation, is understood to have turned up no physical or other evidence of arson. He says he will have no comment until his investigation is finished, in about two weeks.

Five Yale students were responsible for the broadsheet. None was enrolled in the School of Art and Architecture; all are known to the authorities.

One member of the group declared that their intentions were the opposite of inciting violence.

He said they had meant merely to call attention to the deterioration of communications among students, faculty members and administrators on a campus that so far has escaped violent unrest. The fire, said the student—who insisted that his name be withheld—was "an extremely unfortunate coincidence."

The suspicion of arson still lingers like the stench of smoke in the building (itself a provocative and controversial structure, designed by the architect Paul Rudolph).

In the long run, the suspicion could do more damage to the school than the fire did to the building, unofficially estimated at more than $500,000.

Even before the blaze, fumes of suspicion filled the school.

The faculty and students of the city planning department, who were trying to run the department as an experiment in participatory democracy, denied they were instituting a quota system by dividing the class on racial lines. Their decision, they said, reflected their sense of the urgent need for black professionals to work in slum neighborhoods.

Before the decision was taken, eight students—seven whites and one black—had already been admitted. The remaining 12, therefore, would have had to be nine blacks and three whites.

Administration Bridles

The administration bridled at the whole procedure on the ground that students could only advise the faculty on admissions, not share its responsibility for them. It maintained also that the department's limited budget would not allow it to underwrite the scholarships the 10 black students would need.

A clash came when the students and faculty members went ahead and sent out letters of admission to the 12 without the approval of Dean Howard S. Weaver or the signature of the faculty member who normally signed admissions letters.

Kingman Brewster Jr., Yale's president, responded

Continued on Page 74, Column 7

C. A. Richardson

A statue of Minerva stands above the charred rubble of Yale's School of Art and Architecture, swept by fire June 14. Mrs. Pamela Moore, secretary at university, is at left.

Chapter 5

The Yale Battle of the Casts: Albers vs. Rudolph

Witness the dramatic spectacle: a photograph of Minerva looking down at the burned-out interior of the Art and Architecture Building at Yale University in June 1969 (figure 89). It is a spectacle with an allegorical dimension, for this was the second time in two decades that this Minerva statue had survived disaster. Previous threats had come from an entirely different danger, no less lethal to a plaster cast. Before surviving the inferno that devastated the concrete building, she was almost eliminated by Bauhaus pedagogics, personified by Josef Albers, who had arrived in New Haven in 1950. The first attempt at liquidation was almost successful, and the goddess's presence center stage at the Art and Architecture Building was the result of a rescue operation mounted by an unexpected savior. Together with approximately two hundred plaster casts—Egyptian, Assyrian, Greek, Hellenistic, Roman, medieval, and Renaissance—the Minerva was reintroduced into public life when Paul Rudolph's celebrated and controversial school was dedicated on November 9, 1963. "I wanted the Athena very much," said the architect, who always referred to the goddess by her Greek name. While designing the Art and Architecture Building, Rudolph had come across the casts in the basement of Street Hall, the former premises of the school from which Albers had evicted a collection of casts, dating back to the 1860s: "nobody wanted her at the time [but] I thought she was just splendid."[1] Today she looks perfect standing on a tall plinth, her panoramic perspective taking in the complex spatiality of Rudolph's contested monument of postwar brutalism. Still, repairs after the fire, combined with deliberate vandalism and random reparations before the casts were partly restored and partly replaced during the 2008 building restoration, have complicated the provenance of these objets trouvés that are distributed across the thirty-seven levels and nine floors of what was rededicated as Paul Rudolph Hall.

Figure 89.
Facsimile *New York Times*, June 27, 1969.

As survivors of shifts in pedagogical ideals and a fire, followed by repeated attempts at restoration, the extant casts display the allegorical pulse Walter Benjamin found at work in the baroque German *Trauerspiel*. As transient and profoundly historical objects, they are fragments of fragments, mutely pointing to lost contexts, worldviews, and systems of meaning, not unlike the bodies and almost unintelligible objects and emblems that were spread across the scene at curtain fall in the obscure theater tradition Benjamin studied in the mid-1920s. Probing the staged "allegorical physiognomy of the nature-history," Benjamin was interested in how history "physically merged into the setting," in the form of scattered ruins.[2] Translated from an obsolete literary genre of the German baroque to a postwar concrete building in New Haven, a similar allegorical physiognomy is detectable in the combined theatricality of the architectural structure and the ways in which fragments of a mostly lost collection are dispersed—creating unexpected vistas, sensual surprise, bodily experience, vast spaces, intimate moments, labyrinthine circulation, and dramatic juxtapositions. Rudolph's massive concrete apparatus displaying these modern ruins has proved to be no less fragile than its plaster holdings. In the course of only half a century both the architectural structure and the casts have been oscillating on the border of nature and history, following a trajectory of ruination and repair. "The building Rudolph had designed was buried, if not dead," asserted a commentator in 1998.[3] At one point it was under threat of demolition; it survived "because it would be too expensive to tear down," according to Robert A. M. Stern, dean at the school from 1998 to 2016.[4] History "does not assume the form of the process of an eternal life so much as that of irresistible decay," Benjamin memorably declared.[5] Irresistible decay was also on the mind of Paul Rudolph, who at the building's completion said that he wished for his buildings to end as "beautiful ruins."[6] A conflicted venue from its inception, the building soon began to deteriorate, and the result was not particularly beautiful: "ruined concrete, while quite possibly sublime, is not beautiful, and so risks letting architecture down," says Adrian Forty.[7] Only four years after a glamorous opening, the school was described as a "*favella*, a spontaneous shantytown," and photographs were published showing dilapidated interiors, with concrete walls and plaster casts covered with graffiti.[8]

The battle over the Yale cast collection and its main protagonists emblematically reveal modernism's unease with a system of reproduction seen as synonymous with Beaux-Arts training. The discarded collection's reappearance within the frame of poetic brutalism did, however, unexpectedly inscribe these casts into an attempt to escape the cul-de-sac of modernism, "limited now to goldfish bowls, buildings on stilts, and the efforts of structural exhibitionists," as Rudolph polemicized when assuming the chairmanship of the Department of Architecture in February 1958.[9] In the hands and historical imagination of Paul Rudolph, these resurrected Beaux-Arts relics transcended an obsolete tradition. The Yale plaster casts and their cast-concrete container were engaged to formulate a modernism beyond the orthodoxy of the International Style.

The Yale Cast Collection

Most of the casts that Rudolph recovered and displayed throughout the A&A Building originated from a collection that had been planned since the Yale School of Fine Arts was incorporated into Yale University in 1864. The school's name echoed that of its Parisian model; moreover, during and after the four-decade tenure of its first director, the painter John Ferguson Weir, Yale offered a rigorous Beaux-Arts education with a curriculum fashioned after that of the École des Beaux-Arts in Paris. Weir built one of the largest American university collections of casts; for the inauguration of the school's first building in 1869, reproductions "from celebrated antique marbles" that have "come down to us from a remote antiquity" were in place in Street Hall. In one of his lectures steering students through the works of the past, Weir explained that the aim in forming the collection "was to secure representative examples of the greater periods of Greek, Roman and Renaissance sculpture, principally with reference to their excellence as works of art, and also indicating distinctions in motive and technical qualities, with a few connecting links, of archeological interest."[10] No other American art school so thoroughly emulated French academic teaching methods as did Yale.[11] The students sketched from casts three hours each morning for two years, before turning to live models. Architecture had for decades been part of the curriculum when a fully furnished Department of Architecture was established in 1916. Yale sustained its reputation as a leading American Beaux-Arts school. In homage to its students' success in the competitions for a two-year residency at the American Academy in Rome, the Prix de Rome was dubbed Prix de Yale in common parlance.[12] Until 1950 both art and architecture students were "pretty much drawing from casts and from the old Beaux-art tradition," according to art history professor Charles H. Sawyer, dean of the School of Fine Arts from 1947 through 1956.[13]

In 1867, two years before Street Hall was completed, a wish list for the collection had been presented to the school council, drawing partly on catalogues, partly on the advice of Charles C. Perkins, then in Paris; the US ambassador in London, Charles F. Adams; and Arthur M. Wheeler, Yale University's first full-time professor in history, at the time in Berlin. Although it took the Cour vitrée as its model, this American Beaux-Arts collection was conceived as profoundly historical, in contrast to the Greco-Roman profile of the Paris collection. The Yale committee started from scratch in a burgeoning market of casts, and Perkins aspired to a historicist and developmental outlook that was intended to document the great periods in chronological order: "In purchasing casts I should think it of the utmost importance to aim at having the chain complete, and should therefore select a few examples from every school—Egyptian, Assyrian, Etruscan, Phoenician, Greek (from the archaic down to the latest period), Roman, and Mediæval Italian, making at first broad divisions, and then filling gaps as far as funds would allow to show the different phases of developments in each."[14]

Perkins was assigned to make the purchases, "being in Paris, and having correspondence in London, where the original monuments of the plastic arts of the Greeks are chiefly treasured up."[15] But Perkins was actually also in England while selecting and placing orders for the

collection, a fact that prompted deliberation on the idea that reproductions should preferably be made as close to the originals as possible. The British Parthenon casts were considered more authentic than those manufactured elsewhere: "our casts from Paris, which are of monuments existing in London, are believed to be faithful copies of the originals, yet, had we known that Mr. Perkins would himself be in London, he would have been requested to buy them there."[16] Thus the Yale collection was seminally French, and many of its casts were produced at the workshops of the École des Beaux-Arts, where John Ferguson Weir's brother Julian Weir studied in the 1870s. If funding limited the first selection to mostly "specimens of the plastic art of the Greeks," the initial vision of a collection "of an historical character" was never eclipsed.[17] New works—"Oriental, Etruscan, Græco-Roman, Medieval Italian, and modern"—were constantly incorporated from a number of sources. Many of them were first-edition casts taken from the originals, and the collection was updated in parallel with archaeological excavations. One after another was characterized by Weir as "an exceptionally fine cast."[18] While the works acquired in the earliest decades were mostly produced in Europe, several later acquisitions were ordered from Caproni & Bro. in Boston, made from the molds Pietro Caproni had struck in the Louvre, the National Museum in Athens, the Vatican, the Uffizi, and the British Museum, and thus considered authentic, authorized casts. The Caproni firm were suppliers of casts to a number of American museums and universities, among them the Pennsylvania Academy of Fine Arts, Rhode Island School of Design, Princeton, Brown, MIT, Columbia, Harvard, and Cornell.

There was nothing unusual about having comprehensive cast collections in American art and architecture schools. Oldest among these institutions and serving as both an academy and a museum was the Pennsylvania Academy of Fine Arts in Philadelphia, founded in 1805, but embryonically dating back to 1791.[19] Before the Academy's first building was completed, the painter, scientist, and collector Charles Willson Peale purchased a selection of casts from the studio of Monsieur Getti, the official caster of Musée Napoléon, as the Louvre was renamed in 1803.[20] In 1847 the first Academy building was destroyed in a fire, clearing the way for a new building better suited for both teaching and exhibitions: "However, in one respect the fire had proved a disadvantage, as the casts were destroyed by it."[21] New casts were immediately ordered; among them, Ghiberti's Gates of Paradise "made from the original bronze" soon arrived in Philadelphia. In 1856 a number of replacements were sent from Paris, and more than thirty pieces of the Parthenon sculptures from the British Museum.[22] The following description hints at the extent to which plaster casts visually, spatially, and pedagogically characterized these American Beaux-Arts environments, and how a visitor in the 1870s would immediately feel immersed in a landscape of reproductions: "He soon finds himself in the hall of antiques, lighted by a large skylight. To the left is the 'Dying Gladiator,' before which two or three young people have erected their easels and are working in crayon. The right wing of the hall is lined with casts from the 'Venus of Milo' and Myron's 'Discobulos,' past the Roman emperors and down to very late work, and including, of course, casts for beginners. The students are taking their

choice, and are scattered in every direction, getting each his or her favorite view of some cast."²³ In Philadelphia casts were displayed in the galleries among original works, and in the 1882 catalogue, originals and reproductions coexisted as "Marbles, Bronzes, Plaster Casts." Eventually the casts were transferred to the studios and used only as pedagogical tools. However, new specimens were purchased for the collection until about 1920, many of them from Caproni & Bro.

The Pennsylvania Art Academy collection included many celebrated statues, such as the Belvedere Torso, the Venus de' Medici, the Laocoön, the Borghese Gladiator, and the Nike of Samothrace, along with some architectural fragments and ornaments and a fine collection of architectural cork models.²⁴ A more ample architecture collection was required when the first American school of architecture was founded in 1866, as a department within the School of Industrial Science at the Massachusetts Institute of Technology. Thousands of objects and four hundred plaster casts were part of the multimedia Museum of Architectural Appliances that its founder and first professor of architecture William Robert Ware had purchased in Europe. The collection permeated the school, according to Mark Wigley: "These objects packed together systematically so obscured the walls that the collection became the walls, defining, subdividing and rearranging the space." The "space of architecture in the university literally became the space of the collection."²⁵ By the 1880s the school was crammed, and for "want of space" parts of the collection were transferred to the Museum of Fine Arts in Boston.²⁶

Figure 90 (a/b). Ghiberti's Gates of Paradise, with the Parthenon frieze and pedimental sculptures, at Street Hall, Yale University.

While the collection at MIT was itself becoming architectural and spatial, the collection at Yale was filling Street Hall to the brim with casts. "On their arrival from abroad they were placed throughout the building wherever there was available space," according to Weir.²⁷ One can only imagine how sordid this monument to Beaux-Arts training must have appeared to a Bauhaus teacher landing in this historicist landscape in the late 1940s (figure 90 a/b). Appointed the first chairman of the new Department of Design at the Yale School of Fine Arts in 1950, Josef Albers immediately disposed of the casts, and in a most concrete way. "Albers decided to throw out the collection of plaster casts," recalled George Heard Hamilton, professor of art history at Yale. "He literally threw them out on High Street. They were very old casts. Probably 100 years old. It just happened overnight."²⁸

The Yale Battle of the Casts: Albers vs. Rudolph

Historical or Contemporary

From the perspective of art and architecture schools it is tempting to see the sudden urge to get rid of the casts as springing from the historical collision of two paradigmatic pedagogical systems, Bauhaus versus Beaux-Arts. Versions of Bauhaus teaching had been transplanted to American soil by the school's famous faculty of émigrés. Former Bauhaus students and teachers changed the course of American art and architecture training: Josef Albers was appointed professor of art at Black Mountain College in 1933; in 1937 László Moholy-Nagy founded the New Bauhaus in Chicago, and Walter Gropius became professor at the Graduate School of Design at Harvard University; while Mies van der Rohe was appointed director of the Department of Architecture at the Illinois Institute of Technology in Chicago in 1938. Metonymical to historicist teaching ideals, the casts appeared irrelevant to the training of modern artists and architects.

Still, the picture is more complicated, as Jill Pearlman has shown in challenging the modernist myth "that Bauhaus founder Walter Gropius transformed Harvard's old Beaux-Arts School of Architecture into a 'Harvard Bauhaus.'"[29] Joseph Hudnut, educated at Harvard, the University of Michigan, and Columbia University—all with curricula modeled after the École des Beaux-Arts—was "the first to attack the French system in a decisive way" when he was appointed dean at the Faculty of Architecture at Harvard in 1936. Transitioning from the deanship of the School of Architecture at Columbia University, Hudnut had already done away with the collection of casts that William R. Ware had gathered during his tenure as Columbia's first dean after leaving MIT in 1881. In Cambridge, Hudnut reorganized Harvard's Faculty of Architecture into the Graduate School of Design (GSD), adapting courses in architecture, landscape architecture, and urban planning through the implementation of new teaching methods corresponding to the needs of modern life. "Harvard is filled with cries of alarm and the noise of falling columns and arches, while I lead the attack against the Theseum and the Nike Apteros, which have stood for generations in plaster form under our lofty ceiling," he exclaimed, when clearing Robinson Hall of the architectural fragments that had furnished the double-height foyer since the building's inauguration in 1904 (figure 91).[30] A year before Gropius's arrival in Cambridge, Hudnut "immediately began sweeping away the Beaux-Arts teaching methods—competitions, juries, elaborate design problems, and formal renderings—and ushering in the modern era."[31]

It was the Beaux-Arts-trained Joseph Hudnut, then, rather than the founding director of the Staatliches Bauhaus in Weimar who authorized the extermination of the Hall of Casts at Harvard. At Yale, on the other hand, it was a Bauhaus proponent, the new chair of the Department of Design, who had a very physical hand in discarding the collection. Albers made clear "that the French Beaux-Arts casts had no place in the methods of the German Bauhaus."[32] Dean Charles H. Sawyer, who invited Albers to Yale, summed it up as follows: "The art school at Yale needed a little shaking up, a little different perspective."[33] Albers's arrival caused a revolution, according to Sawyer, "because it was a fairly conservative group at that time, and it was fairly strong for the status quo, the old Beaux-arts tradition, which was not exactly my ball of wax." From 1947 Sawyer directed

Figure 91.
Robinson Hall with casts, Harvard University, c. 1925.

the so-called Division of the Arts, aiming at closer collaborations among the departments of painting, sculpture, architecture, drama, and art history, as well as the Yale University Art Gallery: "I believed fervently that the boundaries between the arts needed to be broken down, and that the painters and sculptors and architects could learn from each other. Having people like Albers and Lou Kahn and Bucky Fuller around was part of a fermentation that was breaking those barriers down."[34] Thus while the change in the curriculum coincided with Albers's arrival in New Haven, it was carefully and institutionally planned. "One has to know design, not only copy models and plaster casts," as Sawyer stated.[35] According to Brenda Danilowitz, it became Sawyer's mission to bring modernism to Yale and to dust off the "Beaux-Arts cobwebs."[36]

Still, Albers had been part of the preparations that led to the change in the school's name, organization, and curriculum. As a visiting critic in 1948 he was invited to sit on the "sub-committee on Architecture, Painting and Sculpture" to rethink the curriculum.[37] Danilowitz shows how Albers's voice is recognizable in the first report issued by the committee in 1948: "No artistic formulas, present or past, would be presented

for the student to copy," it stated, recommending a curriculum that allowed the student to "develop his own procedures and judgments from direct experience [and] learn to think in situations, not by predigested theory."[38] Thus Albers was implicated in these changes in a variety of ways, and not least in the destiny of the old cast collection: "Albers came and shook it up. Blood was spilt and feathers flew."[39]

Albers's canonical *Interaction of Colors* of 1963 reads as a retroactive pedagogical manifesto of his ambition "to open eyes and minds," as this was done at the German Bauhaus, at Black Mountain College, and at Yale.[40] Anchored in John Dewey's maxim of "learning by doing," Albers's claim was that "all education is self-education"; he promoted "a basic step-by-step learning" by "thinking in situations," presented assignments as "problems to be solved," and propagated "search instead of re-search." "Naturally," he wrote, "practice is not preceded but followed by theory. Such study promotes a more lasting teaching and learning through experience." Albers's distinction between the factual and the actual is crucial to his perceptual aesthetics, with the factual defined as that which is "not undergoing changes," while the actual "is something not fixed, but changing with time."[41] Eeva-Liisa Pelkonen summarizes this distinction as one "between passive copying and a more invested form of re-presentation; the former described mere information, while the latter had the ability to enter the realm of imagination."[42]

From this perspective hardly any pedagogical device could appear more obsolete than a plaster cast, seen as an expression of the absolute standards governing the Beaux-Arts system. Predetermined form was not of much interest to the artist-teacher Albers; nor was history, which he understood as simply the opposite of contemporaneity. "Too much history leaves little room for work," he claimed early on, in the 1924 essay "Historisch oder Jetzig?" published while he was teaching in Weimar. Traditional art education was "at least three hundred years behind the times," all about "note-taking and copying," while the Bauhaus aimed at reintegrating art education and practical action "into harmony with the actual demands of contemporary life."[43] The themes of this essay, Danilowitz writes, are ideas that "Albers would rehearse, refine, and repeat in countless articles, lectures, and statements for half a century: an abhorrence of 'retrospection' or 'backward-looking' education and an embrace of the present."[44]

If Sawyer succeeded in dusting away the Beaux-Arts cobwebs of the Yale curriculum, Albers's jettisoning of the dusty relics symbolized the demise of Yale's Beaux-Arts system. In 1950 the epithet "fine" as well as the word "art" disappeared from the school's name. The renamed School of Architecture and Design was divided into three departments: Architecture (including city planning), Design (painting, sculpture, basic design, drawing, and graphic arts), and Drama. "Design" had come to connote modernity and progress, as reflected in the name change at Harvard's architecture school in the 1930s and in the establishment of a Department of Design at Yale in 1950. Thirty years after Albers took over the *Vorkurs* from Johannes Itten and introduced basic design in Weimar in 1923, "Basic Design had become the centerpiece of foundations education throughout the United States, and Albers's name was inextricably identified with it."[45] When George Howe in 1950 became chair of

the Architecture Department, all first-year architecture students took courses in the Design Department, including Albers's Basic Freehand Drawing, Interaction of Color, and, from 1957 on, his third basic design course, "Structural Organization.[46] Hence Sawyer's choice of Albers succeeded in dismantling a "conservative system of education," replacing it with a perception-based approach to "integrate all the arts and architecture, with design as the common denominator."[47] Albers's interest in essence, experience, and exercises represented a profound change at Yale: "Developing the ability to conceptualize, visualize, form, and hold an idea in the mind, Albers's disposing exercises trained perceptual skills while simultaneously moving into design territory. Drawing forms that shifted, slanted, overlapped, reversed, or flipped upside down pushed and tested seeing beyond where it likely had been."[48] Again, one can only imagine how inept the casts must have appeared, as exercises in historical emulation and appropriation of history by repetition and imitation, and bound in tradition rather than individuality.

If Albers at Black Mountain College occasionally toured the students in the landscape sketching or at Yale from time to time sent them to the Peabody Museum of Natural History to have them draw a dinosaur skeleton, his teaching methods aimed to "wrest the students' minds away from entrenched, conceptualized images."[49] The objects involved were anything but canonical: commonplace materials such as paper, wire, and cardboard served as the media, and variation and the relational displaced absolute standards. Discernible figuration could have no place in this, either idealized as in classical sculpture or in living models. Frederick Horowitz, himself a student of Albers's, recalls that Albers's drawing classes instantly displaced the study of the nude, core to academic drawing.[50] Yet it took a bit longer to dismiss the live nudes than the plaster casts. Albers "didn't like nudes," according to Bernard Chaet, whom Albers hired to teach drawing in 1951 even though he insisted on using living models.[51] Chaet recalled how Albers "had these women pose in their underwear." "I kept telling him 'You know this is more . . . is more erotic . . . than having them naked' . . . he just didn't get it."[52] However, the idea that students "would draw the way the underwear fit around the body . . . the way the brassieres fit" somehow appears classical, if in a slightly surreal way. After all, drawing lingerie on a living model is not at such a great remove from capturing the flowing folds in Demeter's and Persephone's dresses from the pediment of the Parthenon or the textile draped over the hips of the Venus de Milo. Soon, the live models, too, were exiled from Street Hall.

Street Hall must have appeared an awkward teaching environment for the restrained modernist aesthetics and pedagogy. Characterized by a passion for the asymmetrical, the "strange and unexpected," crescendos for "overemphasis, whenever possible, projections intensely stressed by square or polygonal shapes which pretend to be buttresses and turrets," Peter B. Wight's building was American historicism *en miniature*, according to Nikolaus Pevsner, who unexpectedly praised the abandoned Street Hall in his laudatory address at the inauguration of the Art and Architecture Building in 1963.[53] Albers spent most of his tenure at Yale teaching Bauhaus pedagogies inside this "absolutely insufficient" and "terribly crowded" building, complaining about unhealthy, dangerous, and depressing spaces with dreadful light conditions.[54] Yet he appears

to have succeeded in effecting a sort of Corbusian Ripolin whitewash of the historicist atmosphere of Street Hall, having students sanding floors and painting walls: "Apart from a small bulletin board outside the office, the walls and hallways of Street Hall in the 1950s were white and bare."[55] When Louis Kahn's Yale University Art Gallery and Design Center was completed in 1953, Albers and his students relocated to the new building, and the casts that had survived the iconoclasm remained in the Lombardic-Romanesque manse.

Beaux-Arts Brutalism

More surprising than Josef Albers's compulsion to get rid of the casts was Paul Rudolph's recovering of the remnants that he "re-excavated from the bowels of Yale," and the way he integrated the casts into a masterwork of American brutalism.[56] As chairman of the Architecture Department at Yale from 1958 through 1965, Rudolph found himself in a position with few predecessors. Like Schinkel in Berlin, Gropius in Dessau, and Mies van der Rohe in Chicago, Rudolph was to design a school he himself was to direct with the prospect of presenting a pedagogic vision in built form. During his thirteen-year tenure A. Whitney Groswold, the president at Yale University beginning in 1950, commissioned buildings from architects such as Louis Kahn, Eero Saarinen, Marcel Breuer, Gordon Bunshaft, Philip Johnson, and Kevin Roche, giving contemporaneity to the Georgian and Gothic Revival fabric of the campus.[57] In this context, Rudolph's school appeared as a modern pedagogical object at full scale, with the abandoned Beaux-Arts attributes creating continuity and proposing a future for the past.

Upon his arrival in New Haven, Rudolph published an article in the Yale journal *Perspecta* that anticipates the ethos of the Art and Architecture Building. "Modern Architecture is here to stay but it is still a timid, monotonous thing," he stated, lamenting that contemporary architecture had come to "ignore the particular," lacked "a feeling for plasticity," and had forgotten "many of the basic principles of architecture, such as scale, proportion, the relationship between parts, and most important of all, how to create living, breathing, dynamic spaces of varying character."[58] What were to become formal, spatial peculiarities of the new building were addressed through history and the recent past: "The box has been under heavy attack recently, although boxes such as the Parthenon have intrigued and nursed man's spirit for many a year." Anyone who has walked up the great ramp of Le Corbusier's Villa Savoye and "experienced its unfolding qualities and changing vistas would agree that a box can have never-ending interest."[59]

Beaux-Arts-trained at the Alabama Polytechnic Institute before studying with Walter Gropius at the GSD, Rudolph recalled in 1952, "In 1941 there was a sense of urgency at Harvard. Most had lost faith in the École des Beaux Arts systems, but what was to fill the vacuum?" While adding that "geniuses probably should not be burdened with any kind of school" he never stopped returning to the ideals of the Beaux-Arts system, and the unfulfilled potentials that had been lost with modernism.[60] "Modern architecture is still a gangling, awkward, ungracious, often inarticulate,

precocious, adolescent thing, which has not yet begun to reach full flower," he declared in his acceptance speech for the chairmanship, suggesting a reevaluation of still-valid theories: "This is not a plea for a return to the École des Beaux Arts' concepts, which no longer work, but a reminder that architects have traditionally determined three-dimensional design on the largest scale and this is still our responsibility."[61] References to the Beaux-Arts are ubiquitous in Rudolph's writing of the time: "One of the most serious charges against Modern architecture is its failure to produce understandable theories about the relationship of one building to another. The École des Beaux Arts was actually very rich in this aspect."[62] Aligned with this view, there followed a manifesto-like passage of 1958 that appeared with variations in a number of texts. It reads as the vision for the school that he started designing the same year:

> We need desperately to relearn that art of disposing our buildings to create different kinds of space: the quiet, enclosed, isolated, shaded space: the hustling, bustling space, pungent with vitality; the paved, dignified, vast, sumptuous, even awe-inspiring space; the mysterious space; the transition space which defines, separates, and yet juxtaposes spaces of contrasting character. We need sequences of space which arouse one's curiosity, give a sense of anticipation, which beckon and impel us to rush forward to find that releasing space which dominates, which acts as a climax and magnet, and gives direction.[63]

Hardly anything written on the A&A Building sums up its spatial qualities more precisely than these lines. The unexpected mounting of the casts allowed these imagined qualities to become manifest as experienced space.

For example, the Assyrian, Egyptian, Greek, and medieval casts in the narrow, enclosed, antimonumental stairwell—a transitional space that is indeed awe-inspiring, mysterious, and anticipation-inciting—provide focal points while making the mundane function of vertical circulation a sensual experience. Across the building, the casts distinctively punctuated vastness with intimacy. These works, Rudolph explained, "have been used to reduce the scale of the interiors, which is, I believe, the basic relationship between all ornament and architectural space."[64] She "clearly demonstrates a problem in scale," he said, referring to Minerva, whom he deployed to optically reduce the scale of the enormous double-storied drafting room: "She somehow manages to dominate a very large space even though she is only 14 ft. tall. Her pedestal and placement, as well as the quality of light, allow her to dominate. It seems to me that this is itself a lesson."[65]

Furthermore, the casts twisted and enhanced perceptions of horizontality and verticality, and nowhere more strikingly than in the audacious mounting of bas-reliefs from Queen Hatshepsut's funerary temple at Deir el-Bahari in the Theban Necropolis. Both in its ancient, original version and as a cast, the narrative of the relief was played out in the horizontal, documenting an expedition to Punt in East Africa during the Eighteenth Dynasty, that is, in the fifteenth century BCE, under the reign of the female pharaoh. The polychrome relief depicts the Egyptian deities of writing and numbers, a fleet of ships and travelers, Puntian and

Figure 92.
Joseph Molitor, penthouse with Hatshepsut relief, Yale University, 1963.

Figure 93.
Penthouse with Hatshepsut relief, Yale University, 2016.

Egyptian tools, fish in the sea, wild animals, and treasures to be brought back home to Hatshepsut's kingdom in the Upper Nile. The painted relief came in approximately two hundred plaster pieces to be laboriously joined together. Rudolph, however, installed the huge piece at five different locations in the building, to very different effects.[66] "They were used at the stairway," he said, taking advantage of the vertical possibilities proposed by the many pieces: "because they were quite vertical, they start at the stairs and come up into the more brilliantly lit space so it goes from dark to light."[67] Here he refers to the monumental, vertical hanging of seventy-two pieces of the Egyptian wall on the double-height wall on the fifth and sixth floors. On the fourth floor he hung twelve pieces depicting trees in a completely abstracted way that allows for a close look at the ancient Egyptian vegetation. Five pieces were hung as an artwork over a sofa in a little lounge one passes when heading toward the roof terrace, while the rest of the relief was installed in the penthouse. Working with an architectural element hidden behind the southern, middle portico of the terraced, collonnaded temple, Rudolph inventively used the fragments to accentuate the transition from a darker to a lighter plateau in the glamorous penthouse overlooking the Yale campus, where the deep orange carpet used all over in the building makes the Egyptian relief glow (figures 92 and 93).

The casts helped define scale, while their materiality and "very delicate color," in juxtaposition to the play of light and shadow on the concrete walls, heightened the material perception of the spaces. Together they aimed at bringing out the "unique forms inherent in every material," as they were displayed in the elaborate work in both concrete and plaster.[68] Rudolph's curatorial concerns and the installation of the casts across the interior embody his idea of an unfulfilled potential in Beaux-Arts theory and practice that could help form a more situated and rich modernism.

Cast Concrete and Plaster Casts

Yale's Art and Architecture Building is monumental and itself a monument to materiality. A modern version of High Renaissance rustication, Rudolph's school "flip-flops between hard and soft, texture and substance, accent and background," as Kurt Forster has described it. "If it weren't for its corner window at sidewalk level, its generous low steps, and the deep cleavages in its body, little would countermand the impression of excessive mass and brute force. From the ground up, the building is a tantalizing exercise in fortresslike closure and pinwheel levity."[69]

The rustication effect was achieved by the characteristic corrugated concrete surfaces of the interior and exterior walls, and the surface was the result of a new technique for casting concrete in a labor-intensive, handicraft endeavor. Aggregate was poured into specially designed, vertically ribbed molds, and after twenty-four hours the striated concrete was meticulously hand-hammered, making every detail in the continuous ridged surface of coarse concrete different, with particular optical, haptic, and tactile effects.[70] Inside and outside, the surface texture allows for a dramatic play of light and shadow, and the weathering of the exterior is ever changing through the day. "An architect should be concerned with how

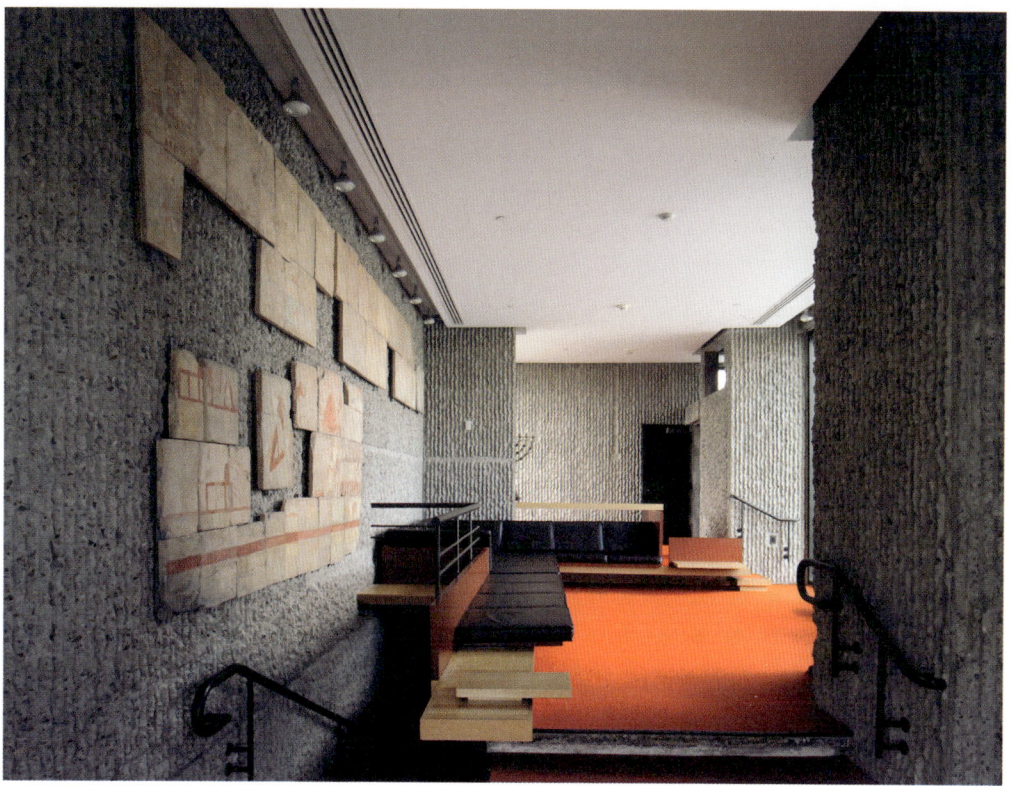

Figure 94.
Corduroy concrete.

a building looks in the rain or on a summer day, its profile on a misty day," according to Rudolph, who saw the honing of visual perception as foundational for architecture, and visual delight as "the architect's prime responsibility."[71] The distinct quality of the bush-hammered walls soon introduced "concrete corduroy" into architectural parlance, along with other references to manly textiles. The young Charles Jencks mocked Rudolph for making concrete look "like corrugated paper, corduroy and tweed"; another reviewer described the material as "ribbed and fuzzy looking, like a collegiate Shetland sweater" (figure 94).[72] In contrast with stairways, railings, and a few other elements in smooth concrete, the relief walls took on a striking ornamental quality.

Rudolph's interest in light and shadow, in weathering and optical delight, was expressed in the layering of casts, with the plaster casts mounted on the cast concrete walls. The weatherability of both concrete and plaster, and the material historicity of the casts in different states and manifesting a range of techniques of patination, added texture, nuance, color, and atmosphere to the building. Already when the first casts arrived in the late 1860s, their surface treatment had been debated. The casts were finished according to various conventions: "All those from London were done over with boiled linseed oil, to give them a tinge like that of ancient marble, and to allow of their being washed; and Mr. Perkins advised that those from Paris ... should be similarly treated. Accordingly, some of these, also, were oiled; but before the work was finished, two objections to this treatment were apparent; first, that it confounds the lights and shades; and, second, that it savors of false pretense; and under these circumstances, it was thought proper to submit the question, at this time, to all concerned, whether the casts which are still plaster white should be simply done over with linseed oil, or be painted in a very light grey tint ... or whether they should be left white."[73]

Almost a century later, the work of time had changed the surfaces of the artifacts. The "patina and obvious antiquity of these plaster sculptures attested to the passage of time just as the shattered and irregular surfacing of the walls amounted to a sort of 'antiquing.' "[74] Yet so crowded was Street Hall with casts that some of those that Rudolph retrieved from the basement were still in their crates, and thus brand-new, appearing as time capsules when premiering in the A&A Building: "I found there plaster casts which had never been opened, the bas-reliefs of Queen Hatshepsut's temple had never been unwrapped but apparently they'd been ordered and once they arrived at Yale either the idea of such things being of interest or used had gone down the drain. In any event they still had their original French return address, they were delicately carved and I thought very beautiful, really exquisite."[75]

Here, either Rudolph is confusing other unopened crates from the École des Beaux-Arts with this reproduction from Thebes, or the person transcribing these recollections got it wrong. These Egyptian casts were not made in Paris. Throughout the nineteenth century high-quality Egyptian casts were greatly desired and much in demand by both museums and

schools to establish full chronological, genealogical chains.[76] The Egyptan court at Sydenham, a Karnak-inspired fantasy temple environment, had not changed the influx of Egyptian casts in the market. Except for the Rosetta Stone and a few other objects, it contained few movable, serialized works, and the Abu Simbel Ramses II colossi and the Avenue of Sphinxes in the nave were singular, site-specific productions. Despite the massive relocation of Egyptian antiquities to European museums during the nineteenth century, Edward Robinson, when in 1891 he was planning the collection of plaster monuments for the Metropolitan Museum of Art, had to aknowledge that the most desirable Egyptian objects "are in Egypt, and casts of them are to be had only there if at all."[77]

The Hatshepsut casts were, however, of a more recent date. During excavations in the Theban Necropolis led by Flinders Petrie and the Egyptian exploration fund, the young Canadian archaeologist Charles Trick Currelly was working on the female pharaoh's funerary temple. A few years before an expedition from the Metropolitan Museum of Art continued the work on the temple, the New York museum secured permission to "take impressions of a portion of the bas-reliefs."[78] The British landscape painter Walter Tyndale spent two seasons making and hand-coloring three editions of the cast, on the spot, at the temple. In his 1907 memoir *Below the Cataracts*, Tyndale gives wonderful testimony of the whole operation: of making the molds of beeswax and tinfoil, on the difficulties of working with wax melting in the heat, on sagging molds, and the colors of the original and his own coloring of the casts: "Where these paintings have been protected from rain, sun and more or less from the wind, they have all the freshness of colour they had 3500 years ago, when the artists in Hatshepsut's employ were adorning her sanctuary," he writes, promising that when assembled the two hundred pieces "will give New Yorkers an opportunity of studying the most delightful bit of wall decoration of the eighteenth dynasty."[79] In 1908 the relief was in place in New York.[80] Currelly brought one edition to the Royal Ontario Museum, where he became the first director. This version is still intact and on display. One full set found its way to Yale, unseen and untouched since it was shipped from Luxor more than fifty years earlier when installed for the first time in 1963 after the Metropolitan's edition was dismantled (figure 95). According to Gibson Danes—the dean of the Yale School of Art and Architecture beginning in 1958, and who recovered the Egyptian relief with Rudolph in the Street Hall basement—they were given to Yale as a "contribution to the expeditions we did in Egypt." The casts were "marvelous," Danes remarked, and "Paul used them very effectively on the top floor."[81] Over the years many of the panels were wrecked (figure 96). Today 148 out of 200 restored fragments of this rare cast hang as a ruin of a ruin, extensively perforated and thus revealing the concrete relief background—having attained an eerily contemporary feel.

The A&A Building was "intended to be filled with the unexpected. I supposed some would say with the dramatic," said the architect.[82] The reappearance of a century-old cast collection at a time when nobody would expect or even wish to see such a thing, heightened that drama. In 1812 John Soane had speculated on what posterity would make of the casts in Lincoln's Inn Fields in London when his collection came to fall into ruin.[83]

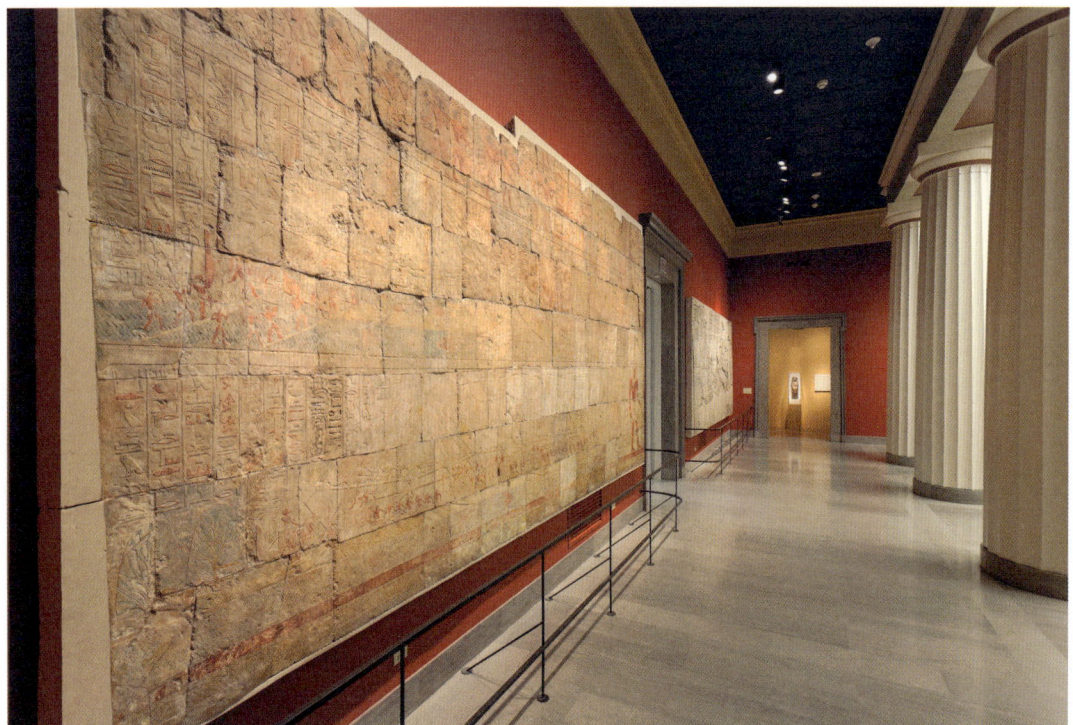

Figure 95, top.
Punt reliefs from Temple of Hatshepsut at Deir el Bahri. This Metropolitan cast has been on loan to the Museum of Fine Arts in Virginia since 1952.

Figure 96, above.
Punt reliefs at Yale, 2006, before restoration of 2008.

Figure 97, opposite.
Tagged Minerva, 1967.

Rudolph—in 1963 musing about the future state of his buildings as "beautiful ruins"—did not have to wait long for an unexpected, if not particularly poetical, deterioration process to start. This involved the defacing of the casts: for instance, "derogatory comments about the building" appeared under the armpit of "the Leonardo figure, while the Minerva's eyes were 'blunked out'" (figure 97).[84] Among the art students—working in increasingly bigger formats, and crammed together under the low-ceilinged, hot upper floor—displeasure soon turned to aversion. The architecture students were not much happier and repeatedly built provisional partition walls in the double-height drawing room and elsewhere. Neither the gallery nor the jury pit worked as planned. Confrontational graffiti was generously tagged on the striated walls ("What would Paul Rudolph think? Does Paul Rudolph think?"), as well as on the casts.

The fire in 1969 was speculatively discussed as arson, and the rumor that the school was deliberately set on fire soon found its way into mainstream historiography.[85] This was not, however, by any means the first time that a cast collection went down in flames. The Berlin Academy lost its entire collection in a fire in 1783.[86] A fire at Sydenham on December 30, 1866, left the Assyrian, Alhambra, and Byzantine courts in ashes, and in 1936 the Crystal Palace burned to the ground (figure 98). In 1960, thirteen sculptures from the Carnegie collection, moved to Saint Vincent

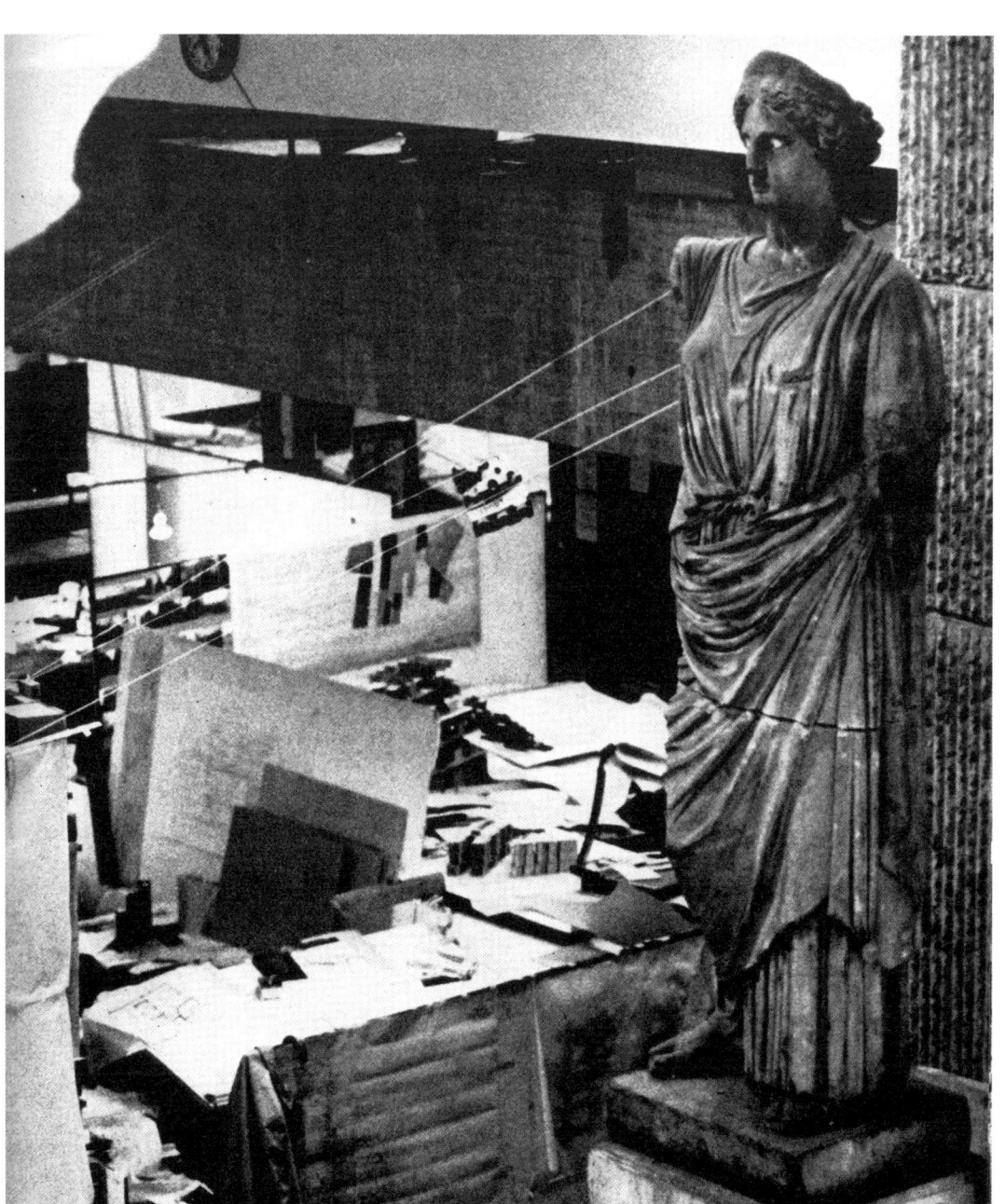

Figure 98.
Henry Negretti and Joseph Warren Zambra, Remains of the Ramses II Colossi, Abu Simbel, after fire at Crystal Palace, Sydenham, December 30, 1866.

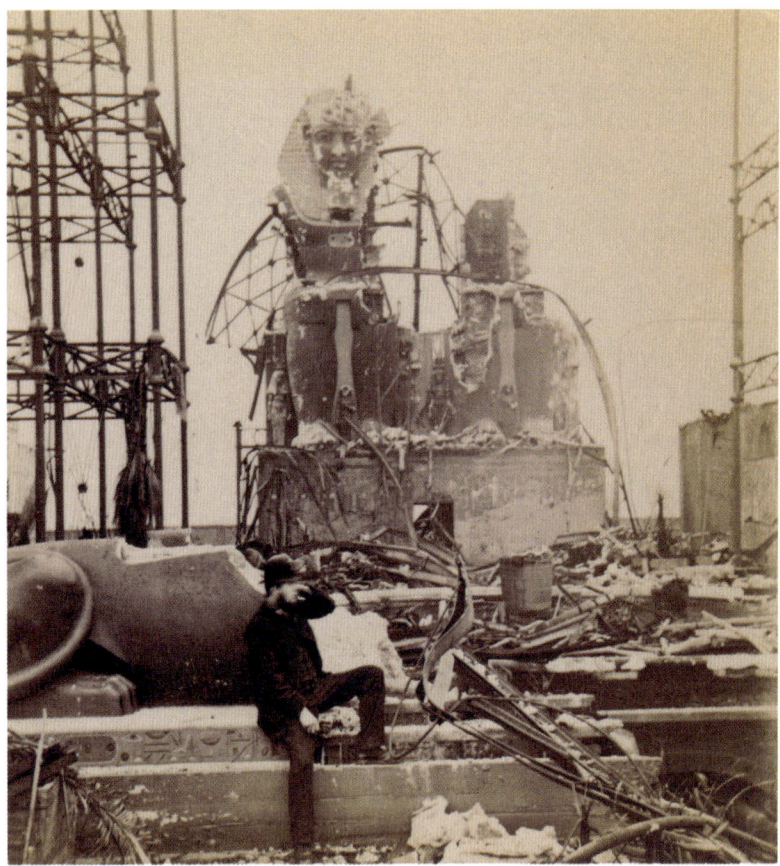

College in Pennsylvania, were consumed by flames.[87] At Yale, though, many of the casts miraculously survived the 1969 blaze.[88]

A number of the casts in the building today are the original ones. Some of them were replaced after the fire, or else during the 2008 restoration of the building, when the entrance, and thus the vantage point for several casts, were changed by Charles Gwathmey's new building for the Art History Department. There is, however, a thread of continuity in this story of disruption and destruction. The casts provided by Caproni are easily identified by their brass plaques, "PP CAPRONI & BROTHER PLASTIC ARTS, BOSTON, MA," or by Caproni's signature carved into the cast (figure 99). From 1950 the firm's former premises were run as the Giust Gallery, before the sculptor Robert Shure took over the business, with the Caproni casts and molds, in 1993, under the name Skylight Studios, located in Woburn, Massachusetts. In 2006 Shure deinstalled the 216 remaining casts (many of them fragments of larger works), before presenting a plan for cleaning, preserving, and restoring the derelict objects, "aesthetically unattractive due to past damage, graffiti, accumulation of dirt, and in some cases, deterioration of previous coatings."[89] Vandalism but also unfortunate mounting had taken their toll on the fragile objects. Many of the casts had been glued on plates hung on the walls, and later reinforced by screws through both the casts and the plates, while the heavy pieces of the Parthenon frieze, for instance, had been bolted straight onto the wall with metal brackets, no less damaging to plaster than to

marble. Structural cracks, missing pieces, bits that threatened to fall off—many had already fallen, posing danger when they did—evoke the reality of unsecured on-site ruins. If destroyed beyond repair, casts were replaced with new editions made from the surviving Caproni assortment of molds or models—an operation we have seen align with nineteenth-century ideas of seriality, materiality, and replaceable authenticity.

Few would disagree with Betsy Fahlman's characterization of Rudolph's school as "un-Victorian." It is harder to follow the claim that the casts were "distributed unsympathetically throughout Paul Rudolph's decidedly un-Victorian Brutalist Art and Architecture Building."[90] The striation of the concrete surface accentuated a mounted cast's vertical effect: "the walls in back of it will be plaster casts themselves," said the architect.[91] The varying depth of the plaster fragments emphasized the relief of the corrugated concrete, causing visual and tactile delight in this "intricate essay in flowing space and weighty mass."[92] Spotting a monument at a distance or encountering unlikely assemblages of antiquities close up while traversing the building, the visitor experiences these interpenetrating spaces as an ever-changing event. Within these spatial intricacies, the ancient remnants are decidedly sympathetically and discreetly displayed as a fragmented continuum.

Figure 99. Plaster cast seriality. Replaced panel from Luca della Robbia, Cantoria, with hallmark "Guist, Caproni reproduction."

Chance Encounters

On the building's twenty-fifth anniversary, Rudolph reiterated how he sought to build his pedagogical ideals into the structure. His pedagogy was poured in place, as it were. For example, with the jury pit placed centrally in the second-floor exhibition space, all students would be visually connected to learn from each other. More importantly, he declared, "I believe that you learn about things in mysterious ways, and that the chance encounter can be as important as the formal lecture."[93] The mounting of the casts throughout the building was meant to foster chance encounters, surprises, and unexpected exposés.

Three panels from Pausanias's high relief frieze of the temple of Apollo at Bassae from the British Museum are mounted in the rear gallery in Hastings Hall. The best vantage point for their viewer is from the perspective of the lecturer (figure 100). Entering the room, one cannot miss the two wooden Ionic capitals, placed on iron stilts, flanking the screen—according to Rudolph, "a mannerist lesson on the strength of materials."[94] Nine of the ten panels from Luca della Robbia's Cantoria from the cathedral in Florence float high above the floor in the library (figures 101 and 102). Deprived of the balcony that serves as their architectural frame in the cathedral, they are mounted in their original order, with the two side

Figure 100, above. Pausanias's high-relief frieze of the temple of Apollo at Bassae from the British Museum, mounted on the rear gallery in Hastings Hall, 2016. Yale School of Architecture.

Figure 101, right. Joseph Molitor, library with panels from Luca della Robbia's Cantoria, 1963. Yale School of Architecture.

Figure 102, opposite. Library with panels from Luca della Robbia's Cantoria, 2016. Yale School of Architecture.

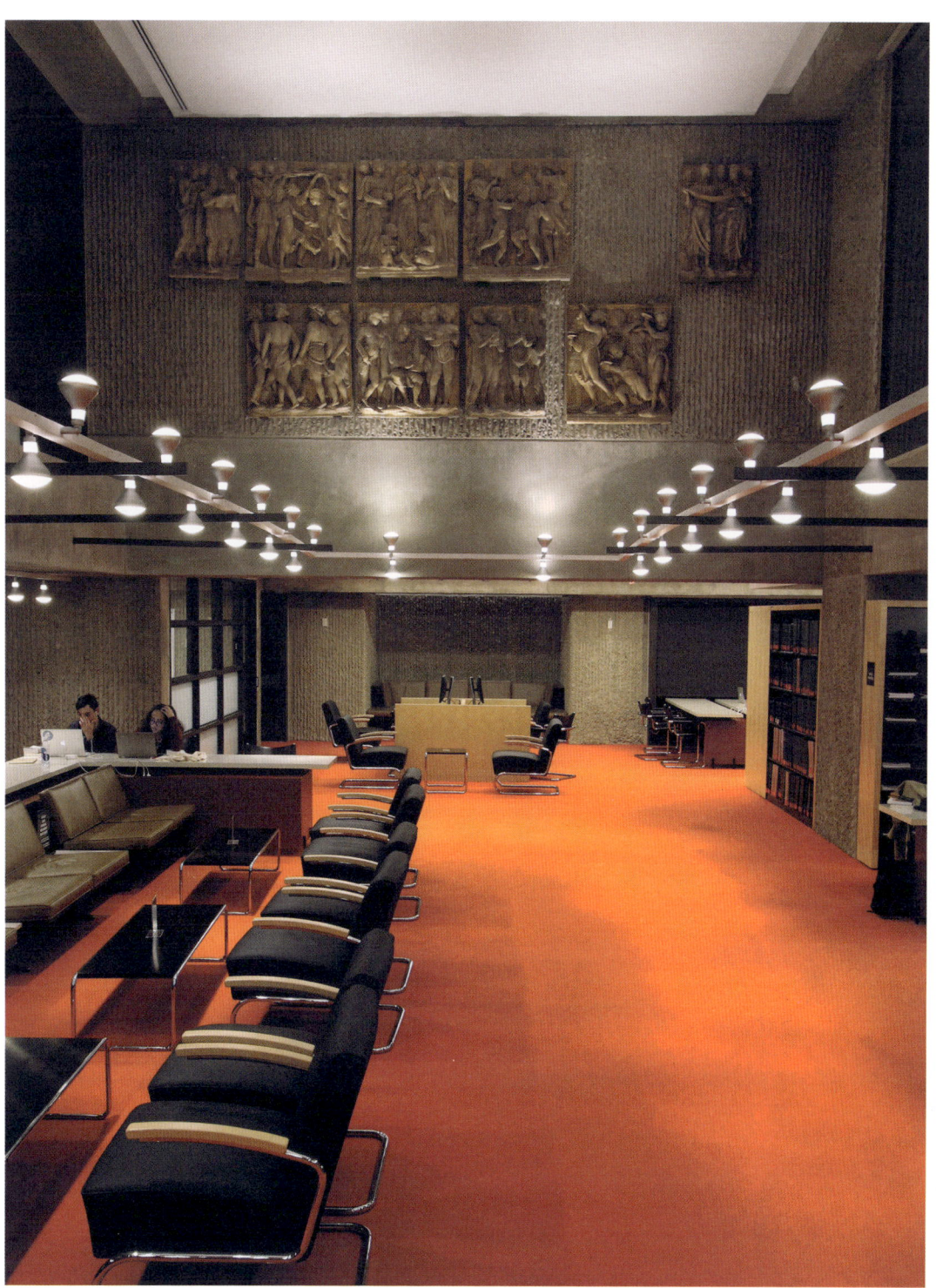

Figure 103.
Luca della Robbia, Cantoria in wing C, room 24, looking southwest, 1925. Metropolitan Museum of Art, New York.

Figure 104.
Parthenon frieze in stairwell, 2006, before 2008 replacement. Yale School of Architecture.

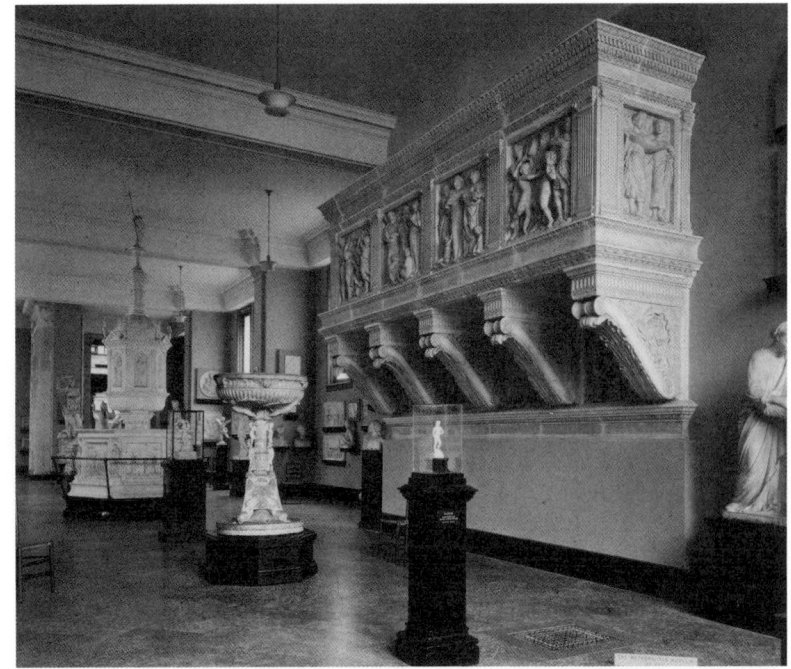

Figure 105.
Minerva today. Yale School of Architecture.

panels flanking the two series, and an empty space left for the one lost high relief (figure 103). Conspicuously—and, one must believe, deliberately, to heighten the impact of the lost and found work—the upper panel to the right sits in the place of its lost neighbor, forming a vertical line with a slightly damaged panel in the row below. After the 2008 restoration of the casts, they were rehung as originally mounted by Rudolph. On a golden backdrop this panel carries an almost absurd identification: "Casts from the choir screen in the cathedral in Florence" is carved into the plaster. Above the table in the seminar room, Greeks and Amazons are fighting on the Amazonomachy frieze from the Mausoleum of Halicarnassus, while Greeks are battling Centaurs on the metopes from the south wall of the Parthenon above the Xerox machine outside the dean's office. The Panathenaic frieze stacked in rows in the narrow stairwell is overwhelming yet also strangely unobtrusive (figure 104). Two unidentified ornamented terracotta elements lying on top of cubicle partitions on the third floor, crowning their doorways, resemble leftover building materials. The recurrent sudden discovery of casts comes as a surprise. Most surprising of all is their unceremonious presence—they are simply there.

The chance encounters that Rudolph orchestrated would in time also come to be epitomized by one single cast, anchoring these artifacts in the tradition of unruly developments through complexes of lost, sometimes multiplied, originals and fluctuating copies. The Minerva had survived the flames in 1969. Yet this was only one of several traumas in the life of this particular statue. "A replica of the original statue of Roman goddess Minerva was restored to her post overlooking the great hall," stated a group of experts assessing the 2008 renovation in a preservation journal (figure 105).[95] Unwittingly, this brief statement evokes the status of originals in antiquity, as well as their century-long history of plaster reproduction. The presumption that the Minerva in question is a replica of an

Figure 106.
Shelved Athena Velletri head at Skylight Studios, Woburn, Massachusetts.

original statue hints at critical issues in the trajectory of plaster casts and the relation of reproductions to assumed original works. The Yale plaster Minerva is most probably a version of a Roman marble copy of a lost Greek bronze Athena, found near Velletri in 1797. It was restyled many times (the helmet, an arm, a hand, the snake, etc.) before Napoleon brought it to the Louvre in 1803. Plaster reproductions of this statue found their way to plinths in numerous collections, including the École des Beaux-Arts in Paris and the Metropolitan Museum of Art in New York. At Yale, the goddess's current head—the original most probably misplaced over the years—makes her look more like a Roman matron than a Greek goddess, and she has lost all of Athena's typical attributes, most strikingly, perhaps, her helmet. A virtually identical—if headless—Roman second-century CE marble version is on display in the Yale University Art Gallery, across the street from Rudolph Hall. According to Robert Shure, who recast the goddess in 2008 using molds made from the existing, dilapidated copy, the neck and head of the statue perfectly fit the dimensions of the head of the Athena Velletri, yet her dress is simpler than the original copy in the Louvre (figure 106).

It would not have been surprising if her lost head had been replaced at some point during the fifty-odd years that she has resided in the school's drawing space, periodically undergoing the indignities of getting her eyes blanked out and being tricked out with hats or cigarettes.[96] But that is not what happened, as photographs from 1963 show the same head, in a former edition. Wherever this head comes from and whenever the body and head were united, this perhaps accidental invention only places her more firmly in a classical tradition that saw these collections of antiquities—whether in marble or plaster—as an opportunity not only for teaching, but also for research and experimentation. When Adolf Furtwängler, professor of classical archaeology at the University of Dresden and the director of the Glyptothek, while studying different Athena types, in 1880 mounted a cast of an ancient head from Bologna onto the combined bodies of two Athenas in Dresden—one headless and one with a badly broken head, both supposedly marble copies of the same lost original—he found that "the two fitted fracture by fracture."[97] He designated this new goddess, made from three sources, as a copy of Phidias's bronze Athena Lemnia at the Acropolis, an invention that became canonical, and soon the Lemnian Athena traveled the world.[98] Small differences, such as in her curly hair, Furtwängler explained by the idiosyncrasies of the copyists: "Yet the correspondence between these two copies is more exact than is usual in antiquity, and goes to prove that each is a fairly accurate rendering of a common original."[99] Various copies differ from one another,

confirms Salvatore Settis: "even if they are derived from a remote archetype, they bear the visible imprint of their most recent craftsman and reflect the taste of the public for whom they were created."[100] In this case, local events in New Haven, and the hands and imagination of the statue's latest caster, have yet again changed the appearanceof the Minerva-Athena, a classical work still subject to change and in flux.

Such developments in the life of a statue are independent of their materiality. Speculation about the appearance of ancient originals shows how facsimiles, replacements, and new conceptions of authenticity are part of the biographies of objects and the invention of monuments. "Before the last judgment, before sane critical appraisal is possible," Quatremère de Quincy pondered in the 1790s, "all these mutilated and decomposed bodies must return to their integral state." He was reflecting on the future possibilities of a fractured antiquity: "How many of these figures must still demand a head, limb, or attribute from the earth in which it is buried or from some other figure? How many figures are rendered unrecognizable by the presence of the wrong limb or the absence of the right one? So many alterations and replacements are needed!"[101]

Mirroring the difficulties of establishing certainty in "original" works of antiquity, a reasonable piecing together of fragments of sculpture and architecture has been a perpetual challenge in the fragmented world of casts. The history of autopsy and plaster prosthetics that Wolfgang Ernst unfolds in Lessing's (unseen) Laocoön in the Vatican, and the no less prosthetic plaster history Jan Zahle has documented in the many editions of the Trojan priest, are only fragments in the history of fragments.[102] An 1883 libel suit against director di Cesnola at the Metropolitan for destroying statues by excessive restoration is another. In New York, a witness testified to having seen badly broken statues, "which had previously been without such appendage," under the hands of a skillful restorer growing noses, hair, faces, hands, arms, and legs.[103] Misplacements, transpositions, conflations—pieces gone astray, confused labels, lost crates, missing limbs, and mislaid parts—have conditioned the reproductions as well. The first shipments of casts of art and architecture to Yale in the late 1860s played out like a thriller: "On opening the boxes, notwithstanding every precaution had been taken to avoid mishaps, several were found badly broken; and the spectacle which presented itself, of maimed and halt figures, broken heads and feet, and the like, was, it may be well believed, not a little disheartening." However, the services of the New York–based sculptor Edward J. Kuntze were engaged, and his familiarity with antique works "and patient perseverance in the somewhat uncongenial work of restoration, have enabled us to exhibit all the casts in about as good condition, for our main purposes, as if they had never been broken."[104]

This confession testifies to the ambiguous state of these objects. Many of them depict fragments from ruined structures, and even before their first display they had already been destroyed and restored. This bespeaks a kind of *toujours déjà* mechanism intrinsic to the plaster cast medium, and a precarious material history that makes the casts a realistic reproductive medium, with their inbuilt ruinous vulnerability. Accidents and confusion twisted their indexicality, and rendered it an effort in its own right to keep bits and pieces reasonably ordered and standard, mimetic of their referents. At the Crystal Palace at Sydenham, "surgery" was

recommended for missing noses, fingers, ears, limbs, and other parts in the plaster environment.[105] The arrival of several architecture collections at the new South Kensington Museum provoked the following desideratum: "To keep together the various parts of the same monument, which are in many instances now scattered; and, where possible, to combine these into complete orders, columns, or entablatures, &c., as the case may be. Otherwise they are only fragmental and deficient in the sentiment and meaning conveyed by the entire work. If the head of the Apollo Belvedere or Venus di Milo were placed on one screen, the arms on another, and the torso in a third compartment, no one could form an idea of the beauty and harmony of these noble statues, and much even of the beauty of detail in the fragments themselves would be lost in the absence of their proper relation and significance. The analogy exists with regard to architectural fragments."[106]

The gaze of Yale's plaster goddess has retained the force of its spell over her realm. Vincent Scully has commented on her "white-painted eyes," Timothy Rohan on her "benevolent but no-nonsense gaze," while Rudolph saw her as integral to the teaching environment, where she "casts a benign eye on the shenanigans."[107] Kurt Forster holds Rudolph's studies of Bavarian baroque churches—with their "infinite refinement of suspended stucco figures, perforated vaults, and light-filled alcoves," and the "Piranesian perforations of space"—to be key to the building.[108] The presence of the casts is part of this kaleidoscope of spatial complexity, allowing for chance encounters with historical objects of an increasingly ambiguous status. Rather than serving as historical illustrations, the plaster fragments casually point to history as a possibility and toward complex conceptions of time and temporalities, rather than displaying lessons in style, comparison, chronology, and development.

The Man, the Symptom

Rudolph frequently emphasized architecture's emotional dimension: "All architecture is a highly emotional affair. I believe it is the most so of all the arts, as a matter of fact. Even more emotional than, shall we say, painting and music. Architecture obviously deals with a lot of things, including a lot of mundane aspects, but the final result is highly, highly emotional."[109]

The emotional impetus of the Art and Architecture building has affected its critics as well. They reacted to the school with a rare passion that imprinted its historiography. The building was interpreted as a personal effort, even as a self-portrait, and its reception history reads as something of a Freudian, exceedingly gendered, (homo)sexual psychodrama in which haptic, tactile, and optic effects, as well as sensual, physical, and perceptual qualities, have persistently been conflated with the architect's persona and personality. Venerable historians and critics of various positions have shared a remarkable urge to psychologize the architecture, and the presence of the casts appears to be part of what makes the reviewers so troubled, agitated, and occasionally overinterpretive in this fascinating trajectory of architectural criticism.

Sir Nikolaus Pevsner initially set the tone in his dedication speech of November 8, 1963. Palpably ambivalent about the individuality of Rudolph's structure, he asked whether it would be "too potent" for the

students, "too personal as an ambience." "You will worship him, you will tear him to pieces," Pevsner said, with reference to their dean, asking the students to promise not to "imitate what you now have around you: The result will be a catastrophe. The great individualist, the artist-architect, who is primarily concerned with self-expression, is inimitable."[110] Observing that "the client is the architect and the architect is the client," Pevsner hinted at something grotesque—an inbred entity. The architect's persona as expressed architecturally was rehearsed from many positions. Critiquing modern architecture for having become the passion of "structural exhibitionists," Rudolph was himself repeatedly accused of being ostentatious and theatrical. "Where does legitimate expression stop and exhibitionism begin? Here! Here is a new high standard of exhibitionism in America."

Already in 1964, the title of his review made it clear that Charles Jencks simply detested the building: "Esprit Nouveau est mort à New Haven or Meaningless Architecture." Considering that Jencks's name would later become closely associated with postmodernism also in its most playful versions, it is worth noticing that one reason he was appalled by Rudolph's school is that he found the building illogical and dysfunctional. "The monument was built for architectural delectation not use"; it was meaningless for teaching purposes, senseless in its use of materials, and absurd in regard to circulation, in its Piranesian nightmare of "false entrances," "blank walls," innumerable detours, and unapproachable spaces.[111] "Now every space is different," Jencks continued, steering his readers through the plans of a building he characterized as iconoclastic and a mockery of modern architecture: "every turn brings new confusion, another daring tour-de-force, another jacked corner, another borrowed conceit. How exciting! We have returned to the age of mannerism."[112] This "four million dollar architectural potpourri" created a vulgar, nihilistic environment where the casts, including the "brown Greek casts on the roof," appeared as "tasteless exhibits." The Minerva and "various work from artists of the past" were deemed to be sheer decoration. "Finally the supreme insult of all, the modular man, Le Corbusier's proposal for natural scale and order is incised in the concrete. What possible meaning can a symbol of order and manmade measure have in this willful chaos?"[113] For Jencks, at the time a student at the GSD, the school was an absurdity, a "modern formalism that is reducing architecture to whim and fashion design."[114]

Rather than psychologizing on an individual level, Sibyl Moholy-Nagy—reviewing recent work of Saarinen, Johnson, Rudolph, and Kahn in New Haven—detected an Oedipal drama in the new feeling for history emerging among "continuity-starved" architects, and in the "embarrassed nod to cultural continuity" in recent architectural education after a "new species of men assumed design leadership, fancying themselves their own beginning," in the early 1920s. "The purity of their Muse," she offered, "was uncompromised by illicit love affairs with past practitioners."[115] In her generation of top designers she saw "a harmonic triad of contemporaneousness, projection into the future, and responsibility toward the past, that expresses not feelings of superiority but an appealing cultural pride."[116] Together with his generation of Harvard graduates, Rudolph had been "indoctrinated with a guilt complex toward this American longing for a specific local response."[117] Here, the local cannot be reduced

to the urban environment. The "forbidden delights of historical continuity" perceived in Rudolph's work are played out in the presence of the casts in the A&A Building. This is beautifully summed up in the title of Moholy-Nagy's 1961 essay "The Future of the Past," in which she launches T. S. Eliot's theory of the Oedipal drive of tradition into architectural discourse, a concept later taken hostage by postmodernism with the 1980 Architecture Biennale in Venice. At Yale, Eliot's stance on tradition concerns modernism's relation to the past. In Rudolph, the illicit love affair with the past became manifest by reintroducing the anathema of modernist pedagogies into a school building.

Both the psychological and the physical effects of the building were ventilated. The textured surface "repels touch: it hurts you if you try," observed Scully.[118] Later he characterized the building as "disturbingly aggressive; its hammer-bashed, striated concrete is visually expressive but physically dangerous." In fact, he called it "truly 'sadomasochistic.'" Again evoking Oedipal motifs, the architect, in an act of "heroic confrontation" and with an "unnecessarily competitive attitude," was "ready to take the European masters on."[119] Scully, who started teaching at Yale in 1947 and relocated with the Art History Department to the new building in 1963, effortlessly amalgamated architect and architecture: "Rudolph himself has continued to pursue his lonely compulsion, a solitary performer, whose buildings always tend to look better than most of those around them, the work of a man with remarkable optical gifts and an unerring instinct not so much for creating space as for positioning objects in it."[120] Scully's eye for the effects of object placement in space and the plasticity of both space and sculptural experimentation captures the spatial impact of the casts—driven, as it were "toward stronger and stronger plastic sensation for its own sake and without foreseeable end or rest."[121] Scully also labeled Rudolph's work as "exhibitionistic." Detecting echoes of Frank Lloyd Wright, Louis Kahn, and Le Corbusier, he asserted that Rudolph expressed a particular American consciousness: "Hence he tends to emulate and to compete; architecture becomes a kind of heroic contest, an *agōn*. The self tries to encompass the whole of things."[122]

The sensuality articulated in the juxtaposition of concrete and plaster may also have inspired Kurt Forster's attention to the architect's "thin lips," his shoes, his "slightly watery eyes," his crew cut. At least he identifies something "very masculine" that points metonymically to both the building and its maker, "so freighted with ambition and historical allusions and so deeply evocative of conflicting desires."[123] Homoerotic psycho-hermeneutics is comprehensively explored by Timothy M. Rohan: "Rudolph's Brutalism should be seen as an expression of hypermasculinity—it is the working-up into form of anxieties about methods of architectural representation, competition with other forms of modernism, and the Oedipal struggle with the first generation of modern architects."[124] The plaster casts are interpreted both as a provocation directed against Gropius's generation and the banishing of casts from modernist curricula, as well as an expression of Rudolph's sexuality: erotica tying back to another genealogy, that of the closeted, homosexual architect. Rohan sees the casts and the concrete as a reexamining of the ornament—"in a clandestine way, as though it were indeed a criminal act"—while detecting humor and irony in "the installation

of these outdated pedagogical tools that may have been an instance of homosexual camp."[125]

Characterized as "iconoclastic, individualistic, yet decidedly having a sense of progression from the wellheads of the modern movement," the A&A Building was, upon its completion, seen as the culmination of Rudolph's architectural philosophy to date: "an architecture in which the personality of the designer decidedly asserts itself."[126] As interesting as this autobiographical psychodrama is the question of what kind of history lesson and architectural philosophy might be lingering in the pairing of cast concrete and plaster casts. Vincent Scully described Rudolph as a "physical historian" who dealt with historical problems, with "the past and, a function of the past, with the future." He constructed "relationships across time: civilization in fact," and as civilization is based on acts of remembrance, "the architect builds visible history."[127] If one looks at Rudolph's school through the lens of the casts, a radical physical history emerges. This is a visible history, aimed at rethinking relationships across time, that was eloquently performed by the architect's curatorial operations.

Polychronic Wonders

"'All kinds of conceits,' says Rudolph, puckishly pointing out fish-bones, seashells and coral in the concrete, 'are buried in the walls.'"[128] He was explaining the presence of a few bisected shells in the concrete walls, and the shimmering of mica and corals that were blended into the aggregate before it was poured into the molds.[129] One green and two purple pieces of mineral are embedded in the smooth concrete wall beside the Nike Apteros panel in the stairwell on the second floor. Just as easily overlooked is the shell on the first floor, inserted next to a little Gothic saint (figure 107). A second shell is lodged in the wall above a door next to technical installations and cleaning equipment in the subbasement, like a sanctified object in a temple accessible only to insiders—or to somebody completely lost in the labyrinth (figures 108 and 109). "Its polished pearly interior contrasts with the rugged texture of the building's concrete, exposed similarly inside and outside," which prompted a writer for *Progressive Architecture* in 1964 to suggest a greater wholeness evoked by the little detail: "the internal structure of the shell, with its legendary sails revealed, is an epitome of the larger structure."[130] Rohan sees the shell as epitomizing the "spiraling form of the pinwheel plan of the building," while pointing toward Frank Lloyd Wright's Guggenheim Museum in New York and Le Corbusier's chapel at Ronchamp.[131] Indeed, Rudolph's much-discussed Oedipal agony vis-à-vis the European modern masters readily situates the shells in relation to the concrete scallop shell on the east door of the Notre Dame du Haut chapel, completed a decade before the school in New Haven. Le Corbusier's version marks the object's translation from nature to culture, with the natural form melted into the concrete structure (figure 110).

At Yale, these sediments and fossils evoke a Benjaminian "nature-history" and the *longue durée* that Fernand Braudel has called geographical, geological, even oceanic time. Their shimmering presence opens an immense time span in the brutalist structure. If the oceanic sediments in

Figure 107, opposite.
Scallop shell and Gothic saint, 2016. Yale School of Architecture.

Figure 108, left.
Shell, subbasement, 2016. Yale School of Architecture.

Figure 109, below left.
Close-up, shell, subbasement, 2016. Yale School of Architecture.

Figure 110.
Close-up of concrete cast struck from a scallop shell on Le Corbusier's chapel at Ronchamp, as depicted on the cover of Adrian Forty's *Concrete and Culture: A Material History* (2012).

the concrete transcend historical time, the presence of the scallops also binds a profane building to the religious, historical circuit and medieval European spatiality of the Camino de Santiago. Marked by scallop shells along the way, this pilgrimage route runs from Santiago de Compostela in northern Spain to the northernmost Gothic cathedral in the world, Nidaros in Trondheim, Norway. Ronchamp is part of the web of pilgrimage routes across Europe, and the concrete cast of the *coquille Saint-Jacques* symbolizes the relics of the apostle Saint James, buried, according to legend, at Santiago. Since the Middle Ages pilgrims have marked churches with shells, decorated their hats and bodies with them, and used them as drinking vessels en route. Rudolph, interestingly, inserted the shell itself into the wall, not as a cast, but among the plaster casts. In an act that resonates beyond Le Corbusier's little concrete scallop shell cast, Rudolph secularized a religious emblem while symbolically inscribing an American art and architecture school into long-established European itineraries.

Multiple temporalities are at play in the A&A Building: in addition to its now-iconic 1960s contemporaneity, and nineteenth century-conceptions of antiquity, and the leftovers from an evolutionary canon; the fossils in the cast concrete wall invoke geological time. Contemporary art contributed additional temporalities. Over what Vincent Scully has called the "most dramatic entrance in the United States of America" hovered Joseph Albers's steel sculpture *Repeat and Reverse*, commissioned for the building, along with new works by Willem de Kooning and Alexander Liberman. Robert Engman's perforated concrete sculpture *Column*, facing Chapel Street, is engraved with names, including Paul Rudolph, Josef Albers, and George Kubler, Yale faculty from 1938.[132]

The *agōn* at work in the A&A Building presents a dialectics on history that challenged modernism's reluctance to engage in figurative, historical representation. Part of this anachronic approach, the throwing together of works from across time and place, extends to Le Corbusier's Modulor Man—incised on smooth concrete in a corner seen only by the students working there—whose presence so upset Charles Jencks; Jencks apparently held this figure to be sacrosanct and thus grotesquely displaced. Contemporary with the new artworks of the 1960s were the Sullivan casts that blended seamlessly into the old cast collection. Wrought-iron elevator grilles from Louis Sullivan's Chicago Stock Exchange are used as entrance gates to the faculty and administration offices, where they function as spolia in their new context. More interesting still is the frieze from Sullivan's second skyscraper, the 1892 Schiller Theater Building in Chicago, later called the Garrick Theater and demolished in 1961. Together with the demolition of Penn Station, under way as Rudolph's building was inaugurated, the razing of the Garrick was a seminal event in modern American preservation. Before the Sullivan building was torn down, casts were made of its most ornamental parts.[133] As such, the

Figure 111.
Ezra Stoller, Parthenon metopes and Sullivan frieze, 1963.

Figure 112.
Parthenon metopes and Sullivan frieze, 2016. Yale School of Architecture.

Sullivan pieces were novelties when mounted in the A&A Building in 1963 (the fact that some of them were replaced with new editions during the 2008 restoration adds to their temporal relativity). The thirty panels, painted white, are hung in two sections outside the dean's office (figures 111 and 112). The Sullivan casts establish the school's place in a particular American trajectory. Insofar as the casts were objects of "fetishistic fascination," their manipulation "could be interpreted as Rudolph realigning his genealogy away from the Bauhaus and back toward his American forebears."[134] For Timothy Rohan, they represent a "sophisticated form of quotation that tells of the renewed importance of history for postwar modernism."[135] Still, the inclusion of these brand-new casts operates beyond the American context. Juxtaposing the Sullivan frieze with the metopes from the Parthenon and six panels from the Donatello Cantoria frieze—a specialty of the Florentine *formatore* Giuseppe Lelli—at the

Figure 113.
King Ashurnasirpal II with a winged god worshipping the sacred tree (Nimrud, c. 870–860 BCE), 2016. Cast from the original in the British Museum. Yale School of Architecture.

third-floor offices Rudolph expanded the canon in its cast trajectory, including the recent past by invoking contemporary debates and failures in the field of preservation.

Rudolph's mounting of the casts was not intended to display historical narratives. His installation of historical artifacts was completely detached from the original collection's idiom of forming a canon of masterpieces and the will to demonstrate historical systems by style, nation, evolution, and comparison. Reintroducing these obsolete pedagogical objects in a school building was not intended to provide a lesson in nineteenth-century conceptions of history. Rudolph's mounting was polychronic, not chronological. Dehistoricized as the casts were, their historicity became legible. "Everything past is definitely *anachronistic*: it exists or subsists only through the figures that we make of it," says Georges Didi-Huberman; "it exists only in the operations of a 'reminiscing present,' a present endowed with the admirable or dangerous power, precisely, of presenting it, and in the wake of this presentation, of elaborating and representing it."[136] This well captures Rudolph's operation, although coexisting temporalities rather than anachronism are the issue here. Delays, as in the resufacing of the fresh Egyptian bas-relief, and obsolescence empowered the resurrected collection, involving unseen novelties, and their historicity has grown more complex with the decay, vandalism, and replacements since the 1963 installation. With an eye for the objects' media specificity Rudolph's mounting of frescos, friezes, metopes, capitals, and other architectural elements took on the form of a Bakhtinian chronotope, a time-space concept borrowed from Einstein's theory of relativity that was "almost a metaphor (almost, but not entirely)," as Bakhtin saw it.[137] Fused into a carefully thought-out concrete whole, "time, as it were, thickens, takes on flesh, becomes artistically visible; likewise, space becomes charged and responsive to the movements of time, plot and history."[138]

Transposed from narratology to architecture, Bakhtin's chronotopicity explicates fundamental effects of Rudolph's pairing of cast concrete and plaster casts, and the ways in which fractured temporalities articulated spaces of a weird contemporaneity: "Time becomes, in effect, palpable and visible; the chronotope makes narrative events concrete, makes them take on flesh, causes blood to flow in their veins."[139] Because "each piece was roughly the same size it made a kind of checker board pattern and became all of a sudden familiar and very modern," said Rudolph about the placing of casts in the narrow stairwell, probably with the Parthenon frieze and the fragmented Egyptian bas-relief in mind.[140] The vertical stacking of eighteen slabs of the Parthenon frieze—famous for its proto-cinematic horizontality—on the wall of a narrow, double-height stairway is striking. Two of the Assyrian panels that the Metropolitan Museum was disappointed not to get for their all-encompassing architectural collection are part of the ensemble. One from the palace of Ashurnasirpal II at Nimrud, ancient Kalhu, fills the entire wall on the first floor, while the Lachish relief from the Palace of Sennacherib in Nineveh hangs in a wooden frame, opposite a bas-relief of Venus and the three Graces from the fifth-century BCE Harpy tomb of Xanthos in Anatolia, mounted above the door to the fourth floor (figure 113). Ascending and descending, one passes medieval saints, "Nike

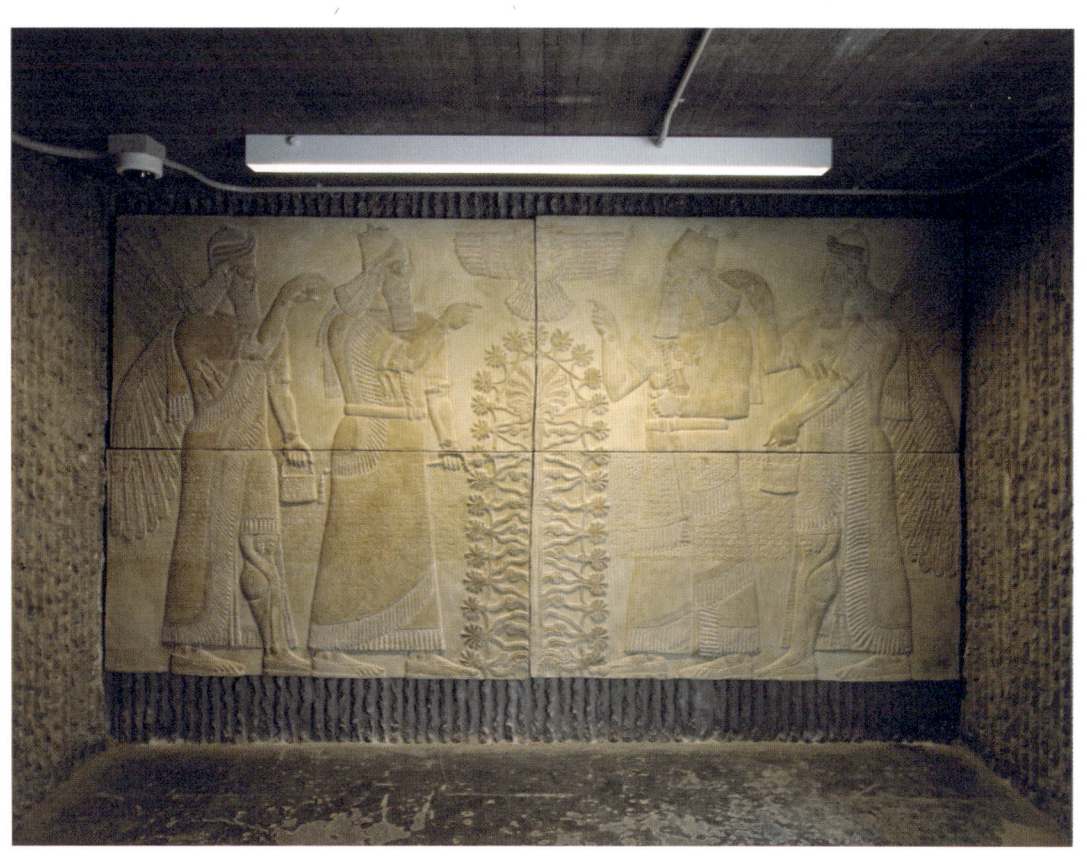

adjusting her sandal" from the Nike Apteros temple at the Acropolis at Athens, the colorful Egyptian reliefs, the currently bright-white Parthenon frieze, and other pieces: a condensed, yet splintered, historical spectacle.

Installed as objets trouvés, the surviving items from Albers's local iconoclasm were treated as individual pieces rather than canonical specimens in a developmental series. "Gesturing at a flat space," Rudolph told a journalist how he had worked: "I think I'll put a Grecian nude reclining statue there"; he then took the reporter to the roof terrace where "all hell breaks loose."[141] This kind of flamboyance might have exasperated critics such as Charles Jencks, who saw the scattering of the casts "as if they were toys," as a desire to "appear different, important, exciting new."[142] It is no surprise that high-modernist ideology found this splintering of canon performed in an obsolete medium unbearable, anachronistic, and incomprehensible, and as irrelevant as the nineteenth century's suggestions on how to order history through chronology and style by reproductions. It is this script of fragments, torn apart by Bauhaus aesthetics and changes in taste, that Rudolph exposed architecturally when harking back to the old tradition of picturesque and idiosyncratic assemblies of plaster casts. His installation produced the kind of unexpected views, surprising constellations, and play with scale that we can still admire in Sir John Soane's Museum in Lincoln's Inn Fields.

There is yet another predecessor tradition for the architect-curator Rudolph's plaster intervention, namely, the very school from which many of the casts originated. Writing on the *musée des modèles*, Anne Wagner defines Félix Duban's Beaux-Arts building as a "container for an instructional text, an illustrated history of sculpture"; "its purpose was the incorporation of the history of art within the École itself."[143] Theoretically, the Parisian school became "a self-contained and self-sufficient entity, confident of its ability to present appropriate models." The polychronic display of the casts at Yale, enacted after modernism had lost interest in nineteenth-century taxonomies, placed Rudolph's school in the trajectory of institutions such as the Parisian Beaux-Arts that offered a "version of the past to their inmates": "that version not just accessible but unavoidable; make the past the present. This was how students were *meant* to learn."[144] The aesthetic pedagogy, this history lesson, was not lost on those who articulated the contemporary reception: "Planted in the walls are teaching tools that turn his floating lofts into a vast textbook."[145] "Above all, it is proof that the mock gargoyle now belongs to history."[146] Interestingly, the "mock gargoyle," signifying the neo-Gothic campus, now appeared outmoded, while the plaster casts emerged as contemporary within their new architectural framework. The coexistence of the Parthenon and the Sullivans, the Donatellos and della Robbias, medieval, Assyrian, and Egyptian fragments, and contemporary artworks invoked a "great continuity of architecture and art."[147] Rudolph built the site-specific history of this very school and its historical collection, the history of an abandoned pedagogical regime, and nineteenth-century historical imaginations into the building itself.

Fractured Temporalities (Learning from History)

In American cast history, the "battle of the casts" refers to the ambush that the visionary cast thinker Edward Robinson was subjected to while touring European museums in 1904. Trained as an archaeologist, Robinson had built an exquisite collection of casts at the Boston Museum of Fine Arts while serving as the curator of classical art and antiquities. He resigned as the museum's director in 1905, as a consequence of the battle of the casts. Acting as assistant director while Robinson was abroad, Matthew Stewart Prichard described the casts as "trite reproductions," "data mechanically produced," and compared them to "the player piano, the squawky cylinder-disk phonograph, and other mechanical vulgarities."[148]

The Boston battle of the casts draws a backdrop for the Albers-Rudolph dialectic at Yale half a century later. Besides detesting the presence of reproductions among original works, Prichard argued that museum displays demand "much space for few objects," and should show only pieces "which reflect, clearly or dimly, the beauty and magnificence to which life has attained in past times."[149] As we have seen, even though they were conceived according to historical systems, most cast collections eventually became chaotic and crammed storage-like galleries. Street Hall at Yale was a good example. Museums are about "joy, not knowledge," according to Prichard, who saw no use for casts except as educational tools.[150] When Rudolph reinstalled what had survived of the Yale collection, he abandoned every convention governing the display of nineteenth-century casts. In the new context the indexicality of the salvaged objects was redirected. Their purpose had been to replicate originals. The casts were fragments pointing to works of the past, lost or otherwise out of reach. Rudolph's curatorial act highlighted the reproductions qua reproductions by accentuating their significance and meaning as parts of an abandoned pedagogical system, rather than as lost works of art or architecture. "It's not the idea of using something old just because it's old, for me it has to be an integral thing, it's a question of how it's used."[151] Through picturesque composition he deprived the casts of their intended place in historical chains and treated them as precious originals. Accordingly, the seriality of multiplied versions of singular originals was broken, as he installed the casts exactly as a museum would handle original works, so that each piece might produce its full effect upon the spectator. Their 1963 display exhibited an early sensibility for the rarity of artifacts from a declining paradigm, impregnated with age value, patinated through the course of history and even more so in their resurrected time.

"Albers had no use for the art of the past," recalled George Heard Hamilton, a former colleague of Albers's.[152] Albers retired from his chairmanship the year Rudolph arrived at Yale, assured that the faculty had "realized that a subsequent specialized study depends on a thorough training in observation and articulation instead of a directionless and aimless laissez-faire of so-called self-expression."[153] This polemics on "directionless and aimless laissez-faire" and "self-expression" was obviously not directed against Rudolph. Still, it is tempting to see the different ways in which Albers and Rudolph approached the casts—a collection that for both of them belonged to an obsolete pedagogical system—as emblematic

of two distinct different ways of thinking about history, materiality, and authenticity. "The feeling and respect for materials elude most students and, one fears, some architects," said Rudolph: "The unique forms inherent in any given material and the construction process must be more clear. In this case, learning by doing probably has little validity because of the number and complexity of the various trades involved."[154] By criticizing the credo of "learning by doing" that Albers subscribed to, Rudolph announced an alternative system of thought and teaching by underscoring the complexity of architecture as a system of production as well as a historical phenomenon.

Albers removed the casts for pedagogical reasons. Rudolph reintroduced them for reasons that resonated with his ideas not only of contemporary architecture, but also of urban planning, ornament, and history. He incorporated them into the building as part of his program for the training of architecture students. While from a Bauhaus perspective the casts could only connote backwardness, in Rudolph's built vision they pointed to history in the service of the present and the future. Obviously, their disposition played a critical role in this vision, displaying a site-specificity that referred back to the Beaux-Arts tradition in general but also to the history of the school for which he was designing this new building.

The casts show "the historic standards, with the understanding that art is not newly arrived in the world," John Ferguson Weir stated in 1916, at the fiftieth anniversary of the Yale School of Fine Arts. Looking back on half a century of cast collecting, he posited that the objects "still speak to us out of the past, in forms which command our admiration."[155] Rudolph, half a century later, shared Weir's awe. He let the casts speak out of a past that certainly must have carried an even stronger sense of temporal distance in the 1960s. Rudolph's building was a delightfully "modified Beaux Arts," according to Gibson Danes, "but that point seems to escape a number of people."[156] The historical sense that Rudolph displayed in the mounting of the casts evokes T. S. Eliot's musing on the notion of "a perception, not only of the pastness of the past, but of its presence," a feeling for history "which is a sense of the timeless as well as of as the temporal and of the timeless and of the temporal together," which makes an artist "most acutely conscious of his place in time, of his contemporaneity."[157]

"Josef didn't like the history of this or that," according to Vincent Scully; both "his strength and his limitation was his Bauhaus approach to things."[158] Albers was characterized by an "intense sense of everything affecting everything else, so that there was no absolute.... there's no absolute color; there's no absolute effect; everything is relative; every color changes in relation to every other color, so on"; he was not "interested in associational values."[159] Contrary to classical aesthetics, where art is understood to have "an absolutely fixed primal value," Albers's worldview, as Scully delineated it, was centrally informed by relativism: "everything in him was relative."[160] It's unnecessary to establish a dichotomy between Albers and Rudolph in regard to the significance of the casts. However, the dichotomy proposed in Albers's 1924 essay—an ever-unresolvable, mutually exclusive "Historical or Contemporary"—in Rudolph's scheme resurfaced as both historical and contemporary, encompassing the past and the future.

"It is, of course, easy to criticize the use of the plaster casts," said Rudolph, "but I believe that the rather purist arguments against using them are outweighed by the effect of their 'presence' in a building devoted to learning."[161] He was clearly not aiming at reestablishing a timeless, classicist aesthetics in the 1960s. That would have been both anachronistic and meaningless. Rather, the anachronic effect at work in the installation is one that depends precisely on associational values as well as a deep sense of the historicity of the fragile objects. "I am interested in history, but not in the ways that art historians are interested in history. As a matter of fact, I slowly but surely have come to the conclusion that art history is the exact opposite of architecture," Rudolph said. "I don't give a tinker's damn, frankly, about history in the usual sense. I really don't. Sorry. I am interested in what I can use."[162] An art-historical display, relying on style, comparison, and chronology, could not serve Rudolph's purpose and program. No less interested in essences than Albers was, he held the manipulation of space to be the essential element in architecture: "it is this essence which separates it from all other arts."[163] The placing of the "untimely" casts was a way of modeling and modulating space, and the impressionistic, intensely spatial use of the casts reclaimed the collection for architecture and history, the present and the future (figure 114). This act exhibited a projective sensitivity, pointing toward our own time, when we again can appreciate and admire the immense endeavor of nineteenth-century cast culture, not only as an integral part of architectural history, but also in terms of the significance of the individual, serialized object. It evokes Walter Benjamin's claim that the only way to the past, thus to the future, is via the ruin. Paul Rudolph "wanted the Athena very much," acknowledging that "nobody wanted her at the time." It is impossible not to think of Hegel's famous dictum about the owl of Minerva spreading her wings, from the ashes, the ruins, the rubble—an allegorical event that led to the invention of art and architecture history.

Figure 114.
Egyptian reliefs, stairwell.
Yale School of Architecture.

Coda
Lost Continents, Fluctuating Objects

In 1764, Johann Joachim Winckelmann concluded his *History of the Art of Antiquity* by characterizing this history in the making as a history of destruction. He compared his account of the art of antiquity to a contemplation of the collapse of art, and the historian to a lover at sea, looking back at his beloved on the shore and seeing in the distance "only a shadowy outline of the subject of our desires."[1] Yet loss, Winckelmann stated, only "arouses so much the greater longing for what is lost and we examine the copies we have with greater attention than we would if we were in full possession of the originals."

A decade earlier, in Dresden, Winckelmann had theorized the "noble simplicity and quiet grandeur" radiating from the art of the ancient Greeks by studying a white plaster antiquity.[2] In Rome he conceptualized the rise and fall of classical art by looking at Roman versions of lost Greek originals. The acknowledged loss of the subject matter in Winckelmann's history of art problematizes conceptions of origins, originals, and material authenticity. But melancholy sharpens the senses. When suggesting that we look more carefully at copies, and that they might let us discover things we would not see face-to-face with the originals, Winckelmann anticipated ideals governing the collecting and display of architectural casts a century later. Importantly, he pointed to the fact that even the most singular works have always been copied and modified, and that the understanding of the fragments of the past relies on surrogates, replacements, and substitutions. This insight also helps us see continuities between nineteenth-century cast culture and contemporary architectural reproductions, performed in new media and technologies. The practice of replicating art and architecture introduces a profound hermeneutical definition of tradition as a process of continual reinvention. Exploring how the handing down of monuments and documents relies

Figure 115.
Boris Johnson unveiling a replica of an arch from the Temple of Bel, Palmyra, at Trafalgar Square, London, April 2016.

on their reactualization in interpretation, Hans-Georg Gadamer argued that "ideas are formed in tradition," shaping relative meanings in a history conceived of as a fluctuating whole.[3]

There is nothing new in the insight that works of art and architecture are lost and destroyed, and that monuments are recovered, rediscovered, restyled, and reconstructed elsewhere.[4] Buildings are subject to the law of gravity and will eventually fall apart. Even buildings expressly designated as monuments are suddenly demolished, slowly ruined, or discreetly or radically altered as a result of changing regimes of taste, politics, technology, and conservation. Monuments and their reception change in the face of natural disasters, pollution, war, and archaeology. The Taliban's dynamiting of the Bamiyan Buddhas in Afghanistan in 2001 and the recent demolition of ancient ruins in the Middle East have received massive media attention. While the loss of these works is globally mourned, their fame has increased with their destruction and the debates on their reconstruction. A replica of an arch from the long-lost temple of Bel at Palmyra, destroyed by the self-styled Islamic State in the fall of 2015, was erected in Trafalgar Square in London in April 2016 (figure 115). Produced by the Institute for Digital Archaeology—a collaboration among Harvard University, the University of Oxford, and the Museum of the Future, Dubai—the event was an example of the power of reproduction and its popular appeal.

The dichotomy of originals and copies has cast a strong spell on the Western mind, anchored in philosophical constructions as old as the Parthenon. Such constructs allow for the envisioning of permanence and uniqueness as attributes of the original work. But change is part of the originality of any monument, as both a physical and a cultural object. Such changes are expressed not least in their fluctuating representations, suggesting possible pasts and futures of buildings across time. The concept of age value—influentially articulated by Alois Riegl in the early twentieth century and intended for practical conservation purposes—has expanded beyond the singular object to its historical permutations. With time, age value transposes even reproductions to the realm of originals. That was the case for the works Winckelmann studied in Rome, and it still holds true for the plaster monuments discussed in this book. The ancient Roman copies were archaeological objects that had lain "inactive for at least a thousand years before returning to a new life."[5] Resurfaced and inscribed into new contexts of collecting and valuation, they testified to the effects of age value, as well as the reproducibility of precious antiquities. "Archaeology deconstructs this false uniqueness," observes Salvatore Settis: "It does so by discovering and demonstrating the seriation of copies from the originals, the iterative production of originals in ancient workshops, and the convergence of the artist and public in the perception of art."[6]

The plaster monuments reproduced architecture that had recently been endorsed as historical monuments, and they also circulated antiquities as novelties at the pace of nineteenth-century excavations. Today, they have become "archeological things in their own right."[7] A few of the reproductions discussed in this book were singular sensations, such as the Portico de la Gloria in London and the façade of Saint-Gilles in Pittsburgh. Most of them were multiplied, made in series from the same

mold or in different editions. In their prime, curatorial issues—selection, judgment, inventory, patronage, provenance, authentication, copyright, transport, and insurance—pertained as much to the plaster monuments as to any other museum item. Copying was a serious matter. In the early 1890s Brucciani & Co. won two plagiarism lawsuits that had been brought against them, the verdict declaring their copyrighted copies to be "protected by statute."[8] When many museums exiled their casts from the galleries as an awkward liability, the scientific aspiration, theoretical speculation, historical imagination, and aesthetic appreciation embedded in these objects were shunted to the backstage of historiography.[9]

Museum Vogues

Alexander Nagel may be right when he suggests that the museum is a historical parenthesis, "a convenient fiction," not least in light of the modernist critique of the institution.[10] Similarly, upon his retirement in 2008 Philippe de Montebello, the director of the Metropolitan Museum of Art for more than three decades, characterized the Western construct of the museum as "a fiction."[11] Parenthesis or not, fictional or imaginary, the presence of plaster monuments was central to the nineteenth-century museum, with their promise of perfect displays that allowed the visitor to traverse whole spans of history and experience the monuments of the world in one synoptical view.

This paradigm of reproductions fell out of vogue in the first part of the twentieth century. The sudden eviction of the Yale collection around 1950 and the furious attack on the casts at the École des Beaux-Arts in 1968 exemplify how outdated the casts appeared as teaching tools for modernist pedagogies. The Bauhaus-inspired teaching that replaced the Beaux-Arts system in architecture schools around the world brought with it an emerging preoccupation with space rather than ornament. It made the plaster cast collections—consisting after all of fragments of the most ornamental parts of historical buildings—obsolete as a source of inspiration for architects. "It was precisely in opposition to this culture of models of emulation, of classical casts and relics as exemplars and as trophies of culture, that the modern movement in architecture established its credo of invention without models, of an architecture that could unburden itself from tradition," as Barry Bergdoll sums it up.[12] Yet if the critique of the cast collections coincided with the hegemonic emergence of modernism, the reasons for their dismantling were often local. For instance, an unexpected catastrophe brought about the final end of the architecture courts at Sydenham, when the Crystal Palace burned to the ground in 1936.[13]

"It is only the burglar who disdains plaster and cannot fully appreciate the obvious value of the cast collection compared to a museum of originals": so asserted the director at the Musée de sculpture comparée in 1911.[14] History would prove him wrong. In Brussels, the dismantling of the collection started in the 1930s. In 1947, John Summerson, at the time curator at Sir John Soane's Museum, characterized the peripatetic collection of the Royal Architectural Museum as "a sad Victorian elephant depressing the aspirations of another age."[15] Eric Maclagan, the director

of the Victoria and Albert Museum for two decades from 1924, saved the Cast Courts from demolition yet resorted to the same metaphor to express his aversion to Trajan's Column, calling it the "incongruous white elephant."[16] In 2014, after years of restoration of both the casts and the gallery, the Italian court (renamed the Weston Cast Court) presents a more original display. Strangely, perhaps, such a reversion may elicit a surprising conservatism in viewers who find that the aura of the reproduction has somehow decreased in beautifully restored casts, and also the surprising sentiment, no less conservative, that things should be in their—arbitrary—place. It is, for instance, easy to lament the rearrangement of Oronzio Lelli's 1886 doorway of the San Petronio Basilica in Bologna and Giovanni Franchi's 1867 electrotyped, gilded doors from the baptistery in Florence. Formerly, Lelli's doors were placed within Franchi's portal, enhancing the immensity of the early Renaissance Porta Magna on the Gothic brick basilica in Bologna, and reminding us of the unique capability these monuments have to make scale manifest, visually and bodily.

In their perceived obsolescence, the plaster monuments underscore the historical character of the public, modern museum itself. Only a decade after the "THE MOST IMPORTANT COLLECTION OF CASTS IN ANY PART OF THE WORLD" was installed in New York City, taste—as well as fortunes—was changing, and in 1905 the position of curator of casts was abolished.[17] "There was money in the air, ever so much money," Henry James mused in a portrayal of the marble halls at the Metropolitan in 1907: "And the money was to be all for the most exquisite things.... The Museum, in short, was going to be great."[18] The Metropolitan never succeeded in obtaining Brucciani's much-desired Assyrian panels and Lamassu in the 1890s. In 1932, however, two original alabasters—a lion and a bull, both winged and human-headed—from the palace of Ashurnasirpal II arrived as a gift from John D. Rockefeller, and are still to be admired at the Assyrian Royal Court in the first-floor galleries.[19]

In New York the process of devaluation unfolded over decades. In the early 1930s the Persian and Egyptian casts were transferred to storage, the Karnak model was placed in the Egyptian Department, and the main cast hall became the Gothic and Renaissance art gallery.[20] In 1938 many of the former cast galleries became the Hall of Arms and Armor. Still, incrementally expelled from the galleries, the casts were not forgotten. Their removal triggered numerous complaints from the audience, including architects and artists, and plans were proposed to establish a city museum of casts in New York.[21] Many of the Greek casts remained on display, and their dilapidated state and subsequent restyling caused new debates on tinting methods and patination.[22] In the 1940s, the Metropolitan's director Francis Henry Taylor, and Robert Moses, then the commissioner of parks, discussed the possibility of weatherproofing the casts and placing them around the city—animals at the zoo, athletes at stadiums, and so forth. Had the scheme been realized, aesthetic ideology would have come full circle, as it was exactly this kind of thematic and typological display that Edward Robinson deemed outmoded in the early 1890s and wanted to supersede.

Other collections have survived unexpected challenges. The biggest collection of Parthenon casts in the world, dating back to the 1830s, survived a 1937 referendum when the people of Basel suggested drowning it

Figure 116.
From the bicentennial exhibition *Viollet-le-Duc, Visionary Archaeologist*, Cité de l'architecture et du patrimoine, Trocadéro, Paris, 2014–15.

all in the Rhine. After turbulent decades, the display at the Skulpturhalle Basel remains a unique depository, although, sadly, the provenance of this serialized assemblage is not documented with details on editions, makers, and dates of reproduction. In EUR on the outskirts of Rome, the Museum of Roman Civilization closed its doors in January 2016 with no official plans for reopening. Thus we are deprived of the hallucinatory experience of seeing the neon-lit, crisply white panels of the frieze of Trajan's Column displayed as a comic strip in a subterranean gallery in the city that holds the original.

The Politics of Reproductions

In September 2007 Nicolas Sarkozy launched his Operation Grand Paris in the new architecture museum at the Trocadéro, where 350 restored casts had been reinstalled a few years earlier. Among the grand monuments and in the presence of the international architectural elite, the casts—having in the meantime featured as ruins in Chris Marker's 1962 postapocalyptic time-travel movie *La Jetée*—proved yet again to be powerful tools—even politically, reactualized, as they were, as a means to shape history.[23] President Sarkozy laid out his architectural vision by harking back to the determination of Viollet-le-Duc and Jules Ferry, the minister of education who secured the original Palais du Trocadéro for the collection in 1879 (figure 116).[24]

No less political is the use of plaster in the new Acropolis Museum in Athens, designed by Bernard Tschumi and inaugurated in 2009. In polemic contrast to the mounting of the Elgin Marbles in the British Museum's Duveen Gallery—as artworks, at eye level and in artificial light—this Greek "Imaginary Parthenon" reestablishes the internal order and architectural dimensions of the frieze, metopes, and pediment sculptures in Attic light.[25] Ghostly white casts standing in for missing parts speak with roaring pathos of loss and imperialism, and read as yet another request for repatriation—this time by means of patina. In contemporary Athens, the

casts signify inauthenticity and banality. This rhetoric of absence eclipses the rich history of plaster in which the modern Parthenon was shaped and understood. It was, after all, the international exchange of casts in which Greece participated that allowed the ever-changing Parthenon to travel the world. The nineteenth century celebrated the possibilities of exhibiting lost architectural totalities by means of reproductions, while the Acropolis Museum places itself on one side of a dichotomy recently described as "a neoliberal model of free circulation" versus "a fundamentalist belief in art's belonging to a unique place" (fig 117).[26] Seductive and beautiful, Tschumi's installation works its magic, having made both specialists and audiences with no particular interest in repatriation politics crave the return of the marbles.[27] Perhaps unwittingly, the display highlights the poor state of the Greek originals in comparison to casts in London and elsewhere, and thus by extension the importance of casts in the reception and preservation of this fluctuating, multimedia monument.

Even behind the Islamic State's bulldozing of excavation fields at Nimrud in March 2015 lurks a history cast in plaster. During his 1840s excavations, Layard apparently had some molds made in situ, cast in London, and built into the atmospheric Assyria at the Crystal Palace.[28] Counterfactually speaking, these reproductions would have been the only documentation of what is now irreversibly lost, had not both molds and casts been long since lost. Yet the story has another twist. In 2004 the Madrid-based studio Factum Arte commenced high-resolution scanning of all elements from the throne room of Ashurnasirpal II at Nimrud, replicating originals from the British Museum, the Pergamon Museum, the Staatliche Kunstsammlungen in Dresden, the Sackler Collection at Harvard University, and the Art Museum at Princeton University. Rematerialized, the recorded data are aimed at turning discrete objects back into complex subjects, re-creating dispersed parts of a lost totality of stone and alabaster, that "in a familiar migration of museum objects" had been dispersed.[29] Such attempts to assemble dispersed original pieces by means of reproductions are firmly anchored in the tradition of the architectural casts. When Brucciani & Co. combined fragments of two shafts of columns from the doorway of the Treasury of Atreus at Mycenae, in the British Museum, with new casts of pieces "in Athens and elsewhere" and "restored" missing parts, the new, portable ensemble constituted a fragmentary totality available only in the province of reproductions.[30] In other respects as well, the scanning of Ashurnasirpal II's throne room aligns with nineteenth-century cast culture. New recording techniques have realized earlier aspirations to reproduce without harming the fragile surfaces of antiquities, while fulfilling the late nineteenth century's demand for Assyrian works.[31]

Historical monuments "live their modern lives primarily as images," says Tapati Guha-Thakurta: "They survive and resonate in popular public memory as a body of readily available, reproducible imagery."[32] We witness today a new interest in the history and historicity of reproductions. Discarded archaeological collections are pulled out of storage and restored: "Even a cast sometimes needs some tender loving care," as the sentiment is expressed on the website of the Museum of Classical Archaeology, Cambridge University.[33] In addition to their resurrection

Figure 117.
Lawyer Amal Alamuddin Clooney advises Greek officials on return of Parthenon Marbles (2014), in front of the frieze of combined marbles and casts in the Acropolis Museum, Athens.

through auction houses in recent decades, more than a hundred casts from the Metropolitan collection were introduced into semipublic life in a sixth-floor gallery at the Institute of Classical Architecture and Art in Manhattan in fall 2016, among a few architectural pieces, such as bits of the entablature from the Erechtheion temple.³⁴

These nineteenth-century architectural casts belong to a wider tradition of reproduction, one that was exquisitely displayed in the exhibitions *Portable Classic* and *Serial Classic* at the Prada Foundation in Venice and Milan, respectively, in 2015. While the Milan exhibition revolved around scale, media, and materiality in classical sculpture, the one in Venice displayed seriality at full scale in antiquity, problematizing hackneyed conceptions of originality. To see classical statues restored to their presumed original polychromy induces the same feeling of unease and surprise as did Owen Jones's experimentation with color on ancient monuments at Sydenham in the 1850s. Other recent exhibitions have also recovered reproductions of the past. When the Victoria and Albert Museum was represented at the Venice Architecture Biennale for the first time in 2016, with the exhibition *A World of Fragile Parts*, historical plaster casts were framed within discourses of preservation of world heritage, exposed to destruction and loss.

The "admirable substitutes" that Henry Cole envisioned in the 1860s relied on the "various modes of reproduction [that] are now matured and employed."³⁵ Today, new reproductions of different quality and importance proliferate, as 3D printing enables individuals to download monuments rather than ordering them by mail. "Looking in museums is great, but people want to touch, own and bring these works home," said

Lost Continents, Fluctuating Objects

3D printing artist Cosmo Wenman, having scanned the Venus de Milo and the Nike of Samothrace—not in the Louvre but from the casts in the Skulpturhalle Basel.[36] In 2016, the head of Nefertiti at the Neues Museum in Berlin was scanned by guerilla tactics, presumably with a simple camera developed for the Xbox 360. In fact, the quality of the reproduction awakened suspicion that the two activists had hacked their way into the museum's own high-resolution scans of the Egyptian queen.[37] Whether or not the data were stolen, the operation aimed at addressing copyright and cultural ownership, agitating for the original's return to Egypt.

Way more sophisticated, as to both the quality of the works and their scholarly and intellectual implications, are the rigorous facsimiles carried out by Factum Arte/Factum Foundation for digital technology in conservation. A key object that has drawn attention to shifting conceptions of originals and reproductions in art and architectural space is their facsimile of Paolo Veronese's *Wedding at Cana*, which was re-created in its original setting in 2009 (figure 118). A site-specific work, the painting was commissioned by Andrea Palladio for the refectory of the San Giorgio Monastery in Venice in 1553. In 1797 the nearly seventy-square-meter painting was cut into six parts to be brought by Napoleon to the Louvre, where it has subsequently undergone a series of restorations. Given the compromised status of the original painting, the facsimile problematizes notions of originality. Presented in its intended architectural setting—without the gilded frame and glass, at the right height and lit by the bright light of the laguna—the new Venetian Veronese not only allows for a deeper understanding of the painting; it has also changed the perception of its tortured Parisian counterpart. While heavy-handedly restored original works of art and architecture risk disappearing, "a well-copied original may enhance its originality and continue to trigger new copies."[38]

The "art of reproduction has been brought to such a point of perfection, that excellent plaster copies can be had of nearly all the great works of antiquity . . . rivalling in many cases even those of the classical period itself," stated a curator at the Southampton Museum in New York in the 1890s.[39] Echoing this sentiment, new versions of lost or existing monuments are overturning modern notions of origins, originality, and authorship, while highlighting the historicity of reproductions and, equally important, their *timeliness*. The new tomb of Tutankhamun, installed at the entrance to the Valley of the Kings in the Theban Necropolis in 2015—the result of scrupulously and scientifically recorded, stored, and rematerialized data—demonstrates the critically historical status of reproductions. This facsimile evokes the historicity of both the old and the new, and addresses questions of perception and reception history in the biographies of things replicated in time. However exact the copy, reproductions carry an inherent productive and liberating distance from their sources.[40] When Giovanni Belzoni "discovered" the tomb of Seti I in October 1817, he was thrilled to be "presenting the world with a new and perfect monument of Egyptian antiquity," one "appearing as if just finished the day we entered it."[41] He spent a year drawing and making impressions from the walls with wax: "The drawings show the respective places of the figures, so that if a building were erected exactly on the same plan, and of the same size, the figures might be placed in their situations precisely as in the original, and thus produce in Europe a tomb, in every point equal to that in

Thebes, which I hope to execute if possible."[42] A few years later two of the chambers were displayed in the Egyptian Hall in London. Belzoni did a lot of damage to the tomb while preparing to make the London "*fac simile*." Employing cutting-edge noncontact technologies, Factum Arte has recorded these breathtakingly beautiful spaces, including the destruction that has taken place over two centuries. Today the tomb is mostly closed for visitors because of its vulnerability. For the bicentennial of the opening of the tomb, several of the chambers, including the substantial pieces of the elaborately painted and sculptured plastered walls that were early on cut out and moved to the Louvre and other museums, as well as Seti's alabaster sarcophagus, which Sir John Soane acquired for his collection in 1824, will reappear together. The first presentation of these fragments and spaces, with their very different trajectories of preservation and destruction off- and on-site, premiered in an exhibition in Basel, November 2017; thereafter, this lost totality is destined for the entrance to the Valley of the Kings, where it will be installed adjacent to the Tut facsimile (figure 119).

Figure 118. Factum Arte, facsimile of Paolo Veronese's *The Wedding at Cana*, 2009, San Giorgio Maggiore, Venice.

High-quality contemporary reproductions such as these help us see, look, and think differently about the material historicity of artifacts of the past. They prompt rethinking values such as irreproducibility, aura, integrity, originality, origins, and authorship. "The cult of authenticity needs to be rethought," says Adam Lowe: "People need to start separating the idea of authenticity from that of originality."[43] In the service of heritage, artists, conservators, archaeologists, art historians, and technicians digitize, create, re-create, and replicate spaces, surfaces, and objects. Rather than fantasizing about pristine states or restoring away the work of time, such reproductions might bring art and architecture back to life in ways that original works, for many different reasons, are incapable of. Perhaps the most striking aspect of these contemporary Egyptian facsimiles is their reproducibility. This reproducibility gives the new object a projective quality that at least conceptually transcends its local Luxor context. They might, as Belzoni envisioned in the early nineteenth century, potentially, head toward new audiences, detached from its local place of origin, providing yet another variation of the unruly temporal effects of circulating architecture. As such they demonstrate that reproductions are artifacts that in their own right sign up for inclusion in the history of art and architecture.

Across languages, the nineteenth-century plaster monuments were referred to as casts, facsimiles, models, reproductions, and reconstitutions. To these terms can be added more, such as replicas, repetitions, multiples, and variants. Interchangeable, this nomenclature reflects objects that document, preserve, and hand down works of the past, while destabilizing positivist conceptions of authenticity, permanence, and originality.

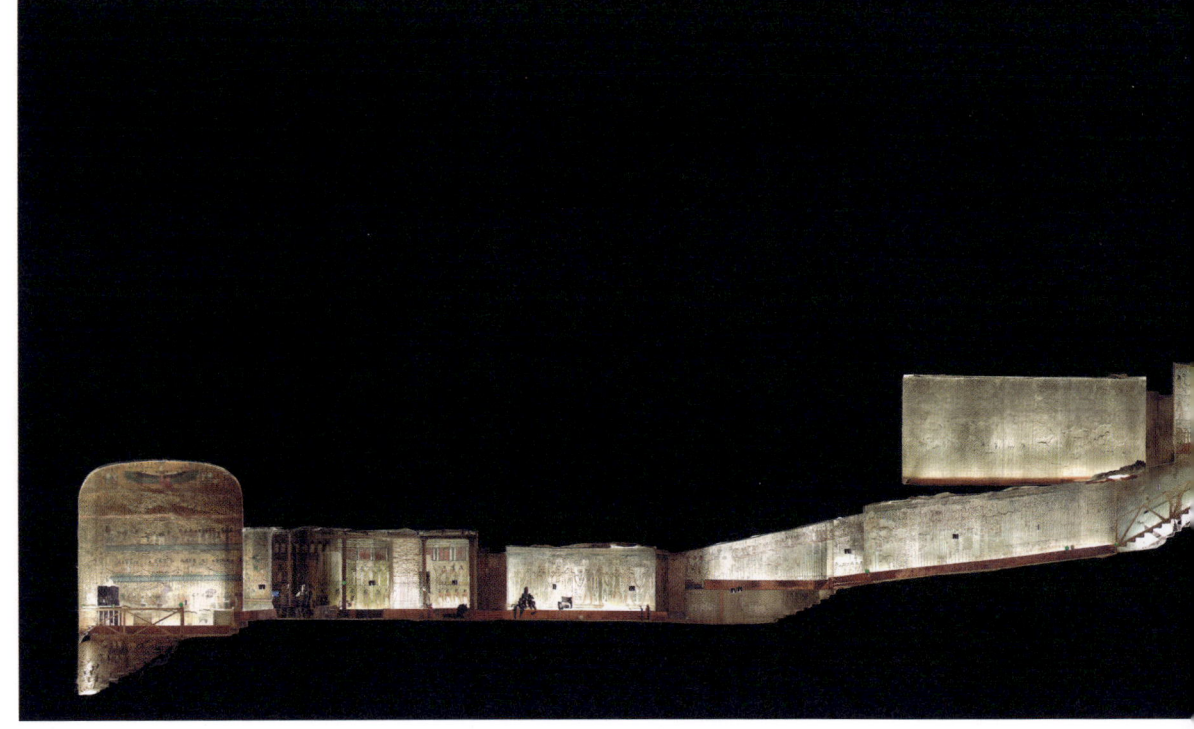

Figure 119.
Factum Arte, facsimile of the tomb of Seti I, 2017, to be placed at the entrance to the Valley of the Kings, Luxor.

When the Cathedrals Were White

Speeding in his car down the Left Bank toward the Eiffel Tower in the spring of 1936, looking up at the new tower of the Palais de Chaillot under construction, Le Corbusier conceived the thematic trope of his book on the American skyscraper, *When the Cathedrals Were White*. The Palais du Trocadéro, with its characteristic silhouette crowned by two minarets—promoted as a Parisian monument comparable to Sacré-Cœur and the Eiffel Tower—was again under reconstruction for a new international exhibition the following year.[44] This was the moment when the non-French monuments were in the process of being exiled and the institution was renamed Musée des monuments français. Looking across the Seine toward "a white point in the sky; the new tower of Chaillot," the architect pondered while driving: "I slow down, I look, I plunge suddenly into the depths of time: Yes, the cathedrals were white, completely white, dazzling and young—and not black, dirty, old."[45]

"Atmospheres," the first part of Le Corbusier's book, celebrates the international style of the Middle Ages and the historical momentum of the Gothic cathedral as the spiritual forerunner of the skyscraper: "When the cathedrals were white, Europe had organized the crafts under the imperative impulse of a quite new, marvelous, and exceedingly daring technique the use of which led to unexpected systems of forms—in fact to forms whose spirit disdained the legacy of a thousand years of tradition."[46] Variations on these theme resound throughout the book: "The cathedrals were white because they were new," an insight that led him to a musing on the particular joy of new and flawless materials. "The freshly cut stone of France was dazzling in its whiteness, as the Acropolis

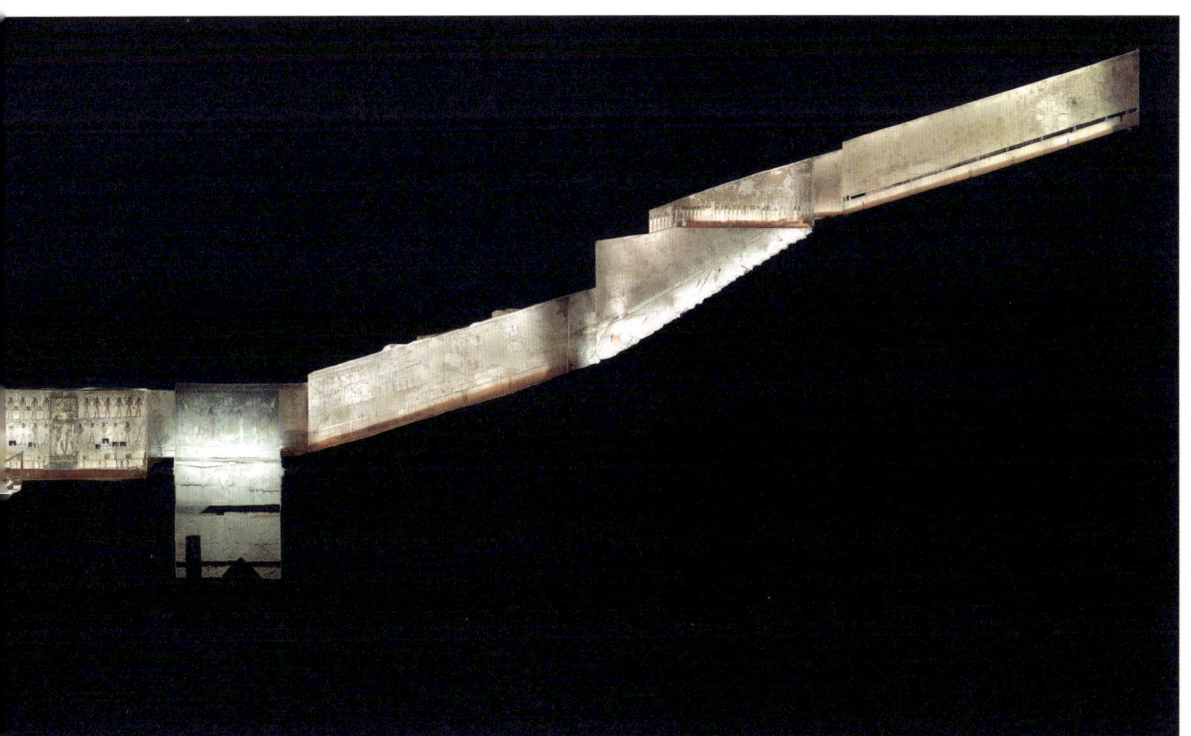

in Athens had been white and dazzling, as the Pyramids of Egypt had gleamed with polished granite."[47] This sparkle was long since lost. Now the cathedrals belonged to the dead—"they are black with grime and worn by centuries. Everything is blackened by soot and eaten away by wear and tear."[48]

Le Corbusier's exalted vision of architecture uncorrupted by the work of time, at the idealized moment in a building's life before deterioration begins and architecture falls from contemporaneity into history, was part of the intended effect of the Trocadéro apparatus. It might be seen as a tribute to Winckelmann, adding simplicity and grandeur to French heritage, but first and foremost it can be understood as an attempt to historicize French architectural sculpture by placing its origins outside history, in that "more original than the original" state that made Viollet-le-Duc notorious as a restoration architect. Le Corbusier's historiographical Ripolin whitewash of historical monuments, and that "white point in the sky" seen at a distance from his car in 1936, evoked an unweathered vision of history.[49] It is precisely this vision that is so beautifully preserved in Proust, when the young Marcel experiences the cast of the Balbec portal as perfect, universal, and timeless.

Today, we might take more joy in acknowledging the historicity of the casts themselves than in seeing them as vehicles capable of evoking the imagined pristine state of their originals. The casts convey their own history of making and building. Jorge Otero-Pailos's latex cast of the interior of the upper half of Trajan's Column, hung from the ceiling next to the original at the Victoria and Albert Museum in 2015, did not depict traces of the spiraling frieze of this Roman war monument (figure 120). Rather, it displayed quantities of perfectly preserved dust and dirt accumulated

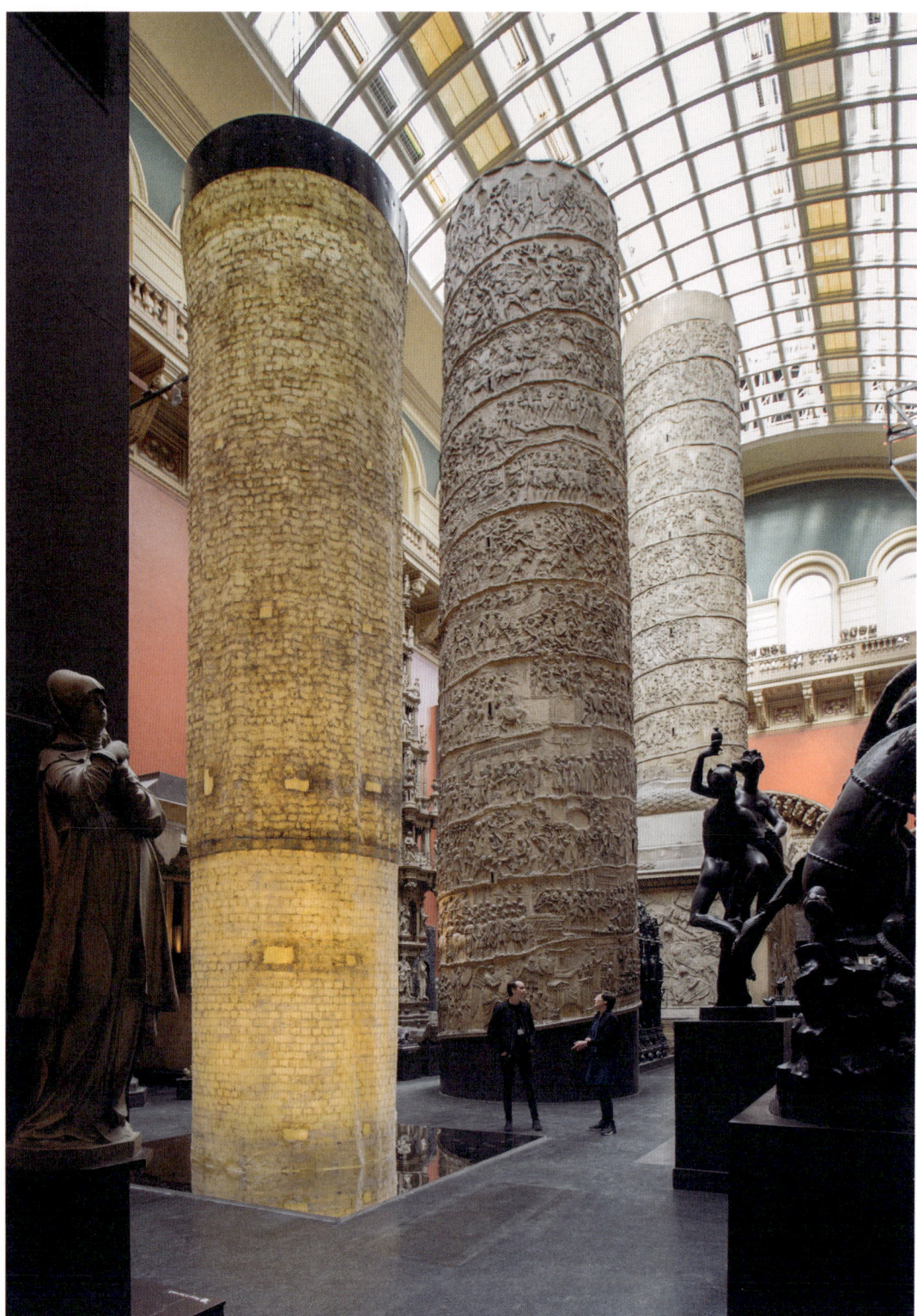

from the 1860s, gathered in the relief of its cylindrical brick core. Thus this cast from a cast—displaying yet another odyssey in materiality—revealed in its captivating flimsiness the very concrete conditions of its construction, while adding to the biography of this moving monument. Before an image, however old, "the present never ceases to reshape," says Georges Didi-Huberman; likewise, before an image, however recent, "the past never ceases to reshape."[50] Exposed to an image-object from among the nineteenth-century architectural casts, we might also "humbly recognize" that "before it we are the fragile element, the transient element, and that before us it is the element of the future, the element of permanence. The image often has more memory and more future than the being who contemplates it."[51] In ephemeral reproduction, monuments gain an enduring effect, far from their historical and geographical origin. Traveling through media and materials, objects attain unstable temporalities, according to Alexander Nagel and Christopher S. Wood: "they are brand new, and yet they make claims on antiquity—they have never been assimilable to ordinary art-historical narratives."[52] Made to show chronology and development, the plaster monuments depict various states and imaginations that complicate and enrich the experience of architecture and the work of time.

When I first visited the Hall of Architecture in Pittsburgh in 2008 and slowly realized that I had entered a plaster phantasmagoria, a little sign caught my attention. Leaning toward the base of the cast of an ancient column, it read, "Do not touch." When I last visited the Acropolis in 2016, a new sign was mounted at the passage through the nearly completely rebuilt Propylea, with the exact same warning. In concert the signs say something about the material integrity of both "originals" and reproductions, testimony to the power reproductions have to expose us, over and over, to ever-fluctuating monuments.

Figure 120. Jorge Otero-Pailos, *The Ethics of Dust: Trajan's Column*, 2015, latex cast. Victoria and Albert Museum, London.

Notes

Introduction: Monuments in Flux

1. Alexander Nagel, *Medieval Modern: Art Out of Time* (New York: Thames and Hudson, 2012), 14.
2. Camille Enlart, Le *Musée de sculpture comparée au Palais du Trocadéro* (Paris: Librairie Renouard, 1911), 2.
3. Marcel Proust, *In the Shadow of Young Girls in Flower*, vol. 2 of *In Search of Lost Time*, trans. James Grieve (London: Penguin, 2005), 238.
4. Pierre Le Brun's report to the Willard Architectural Commission, August 14, 1885. Cast Collection Files, Office of the Secretary Records, The Metropolitan Museum of Art Archives. Hereafter, "Met archives."
5. Charles Callahan Perkins, "American Art Museums," *North American Review* 111, no. 228 (July 1870): 9–10.
6. Charles Newton in an unprinted report to the trustees of the British Museum. Quoted from Ian Jenkins, *Archaeologists & Aesthetes in the Sculpture Galleries of the British Museum 1800–1939* (London: British Museum Press, 1992), 58.
7. Charles Newton, "Remarks on the Collections of Ancient Art in the Museums of Italy, the Glyptothek at Munich, and the British Museum," *The Museum of Classical Antiquities: A Quarterly Journal of Architecture and the Sister Branches of Classic Art* 1, no. 3 (July 1851): 226–27.
8. Walter Smith, *Art Education, Scholastic and Industrial* (Boston: James R. Osgood and Company, 1873), 244.
9. Quoted from Jenkins, *Archaeologists & Aesthetes*, 34.
10. Thordis Arrhenius, *The Fragile Monument: On Conservation and Modernity* (London: Blackdog, 2012), 6. A pioneering study that informs contemporary discussions of the modern monument is Françoise Choay, *The Invention of the Historic Monument* (1992), trans. Lauren M. O'Connell (Cambridge: Cambridge University Press, 2001).
11. Alois Riegl, "The Modern Cult of Monuments: Its Character and Its Origin" (1903), trans. Kurt Forster and Diane Ghirardo, *Oppositions* 25 (1982): 21.
12. For a comparative study of public European heritage strategies, see Astrid Swenson, *The Rise of Heritage: Preserving the Past in France, Germany and England, 1789–1914* (Cambridge: Cambridge University Press, 2013).
13. Michael Falser, "From Gaillon to Sanchi, from Vézelay to Angkor Wat. The Musée Indo-chinois in Paris: A Transcultural Perspective on Architectural Museums," *RIHA Journal* 0071 (June 19, 2013): 1.
14. Richard Wittman, *Architecture, Print Culture, and the Public Sphere* (New York: Routledge, 2007), 213.
15. Pliny, *Natural History* 35.44, trans. H. Rackham (Cambridge, MA: Harvard University Press, 2003), 375.
16. For a rich new collection on the repeatability, versatility, and adjustability of the classical tradition, see Salvatore Settis, ed., *Serial/Portable Classic: The Greek Canon and Its Mutations* (Milan: Progetto Prada Arte, 2015).
17. For a standard history of cast statuary, see Francis Haskell and Nicholas Penny, *Taste and the Antique* (1981) (New Haven, CT: Yale University Press, 2006), particularly chapter 11, "The Proliferation of Casts and Copies."

18. Decades later in the same city, a collection of more than eight hundred casts from Rome provided Friedrich Schlegel with "the basis for his studies of classical antiquity." Suzanne L. Marchand, *Down from Olympus: Archaeology and Philhellenism in Germany, 1750–1970* (Princeton, NJ: Princeton University Press, 1996), 67.
19. Ibid.
20. Claudia Sedlarz, "Incorporating Antiquity—The Berlin Academy of Arts' Plaster Cast Collection from 1786 until 1815: Acquisition, Use and Interpretation," in *Plaster Casts. Making, Collecting and Displaying from Classical Antiquity to the Present*, ed. Rune Fredriksen and Eckart Marchand (Berlin: De Gruyter, 2010), 208.
21. The casting techniques enabling the creation of bigger and lighter casts were developed by Alexandre de Sachy, the chief molder at the École des Beaux-Arts in Paris from 1858, and patented by his successor Eugène Arrondelle. Christiane Pinatel, "La 'Restauration' en plâtre de deux colonnes du temple de Castor et Pollux dans la Petit écurie Royale de Versailles: Histoire et archéologie," *Revue archéologique* 1, no. 35 (2003): 75.
22. Stephen Bann, *The Clothing of Clio: A Study of the Representation of History in Nineteenth-Century Britain and France* (Cambridge: Cambridge University Press, 1984), 3.
23. Mari Hvattum, *Gottfried Semper and the Problem of Historicism* (Cambridge: Cambridge University Press, 2004), 166–67.
24. Anne Bordeleau, *Charles Robert Cockerell, Architect in Time: Reflections around Anachronistic Drawings* (Farnham: Ashgate, 2014), 4.
25. Malcolm Baker, "The Reproductive Continuum: Plaster Casts, Paper Mosaics and Photographs as Complementary Modes of Reproduction in the Nineteenth-Century Museum," in Fredriksen and Marchand, eds., *Plaster Casts*.
26. Flinders Petrie, *Racial Photographs from the Egyptian Monuments* (London: British Associations, 1887).
27. Benjamin Ives Gilman, *Manual of Italian Renaissance Sculpture as Illustrated in the Collection of Casts at the Museum of Fine Arts, Boston* (Boston: Museum of Fine Arts, 1904), v–vi.
28. "The Parthenon Frieze: Effects of a Century of Decay," *Illustrated London News*, May 18, 1929, 839–41.
29. Ian Jenkins, *Cleaning and Controversy: The Parthenon Sculptures 1811–1939* (London: The British Museum, 2001).
30. Ian Jenkins, "Acquisition and Supply of Casts from the Parthenon Sculptures from the British Museum, 1835–1939," *Annual of the British School at Athens*. 85 (1990): 89.
31. Antoine-Chrysóstome Quatremère de Quincy, "Letters to Canova," in *Letters to Miranda and Canova on the Abduction of Antiquities from Rome and Athens*, trans. Chris Miller and David Gilks (Los Angeles: Getty Research Institute, 2012), 137.
32. Stanislaus von Moos, " 'Ruins in Reverse': Notes on Photography and the Architectural 'Non-Finitio,' " in Ernst Scheidegger, *Chandigarh 1956: Le Corbusier and the Promotion of Architectural Modernity* (Zürich: Scheidegger und Spiess, 2010), 47.
33. Quatremère de Quincy, "Letters to Canova," in *Letters to Miranda and Canova on the Abduction of Antiquities from Rome and Athens*, 137.
34. Henry Rousseau, *Promenade méthodique dans le Musée d'Art Monumental* (Brussels: Musées Royaux des Arts Décoratifs et Industriels, 1902), II.
35. Victor Hugo, *En voyage. Alpes et Pyrénées* (1843) (Paris: J. Hetzel & Cie, 1890), 426.
36. Rudolf Keyser et al., "Indbydelse til en Forening for norske Fortidsmindemærkers Bevaring," *Skilling-Magazin,* April 5, 1845.
37. James Fergusson, *On a National Collection of Architectural Art* (London: Chapman and Hall, 1857), 4.
38. Harald Hals, "Et norsk arkitektur- og bygningsmuseum," *St. Hallvard* (1934): 4.
39. Barry Bergdoll. "Introduction," in *Home Delivery: Fabricating the Modern Dwelling*, ed. Barry Bergdoll and Peter Christensen (New York: Museum of Modern Art, 2008), 9.
40. Wall label, the Metropolitan Museum of Art. For the "salvage" of these temples and their relocation to New York, Leiden, Berlin, Madrid, and Turin, see Lucia Allais, "Integrities: The Salvage of Abu Simbel," *Grey Room* 50 (Winter 2013).
41. See Mari Lending, "The Art of Collecting Architecture," *Volume* 44 (2015).
42. W.L.R Cates, "The Berlin Photographs of Great Pictures," *Fine Arts Quarterly Review*, no. 1 (1866): 216.
43. Wallis Miller, "Cultures of Display: Exhibiting Architecture in Berlin, 1880–1931," in *Architecture and Authorship*, ed. Tim Anstey, Katja Grillner, and Rolf Hughes (London: Black Dog Press, 2007), 103.
44. "The Crystal Palace Expositor," *Illustrated London News*, October 6, 1855, 419.
45. Kate Nichols, *Greece and Rome at the Crystal Palace: Classical Sculpture and Modern Britain, 1854–1936* (Oxford: Oxford University Press, 2015), 108.
46. Isabelle Flour, "Orientalism and the Reality Effect: Angkor at the Universal Expositions, 1867–1937," *Getty Research Journal*, no. 6 (2014): 64.

47. Mario Carpo, *Architecture in the Age of Printing: Orality, Writing, Typography, and Printed Images in the History of Architectural History* (Cambridge, MA: MIT Press, 2001), 6.
48. Andrew Carnegie, "Value of the World's Fair to the American People," *Engineering Magazine* 6, no. 4 (January 1894): 421.
49. Andrew Carnegie, "Presentation of the Carnegie Library to the People of Pittsburgh," November 5, 1895.
50. John Soane, "Crude Hints towards a History of My House in L[incoln's] I[nn] Fields," in *Visions of Ruin: Architectural Fantasies and Designs for Garden Follies*, ed. Helen Dorey (London: Sir John Soane's Museum, 1999), 69.
51. "Fine Arts," *Illustrated London News*, July 24, 1867, 90.
52. George Scharf, Jun., *The Greek Court Erected in the Crystal Palace, by Owen Jones*, Crystal Palace Library (London: Bradbury & Evans, 1854), v.
53. Austen Henry Layard, *Nineveh and Its Remains: A Narrative of an Expedition to Assyria during the Years 1845, 1846, & 1847* (London: John Murray, 1867), 374.
54. Austen Henry Layard, *The Monuments of Nineveh: From Drawings Made on the Spot by Austen Henry Layard* (London: John Murray, 1849), v.
55. The latter was a compilation of the ruins at Khorsabad, Kouyunjik, and Nimrud combining fragments from the Louvre's alabaster panels from the French excavations at Khorsabad in the early 1840s and sculptures at the British Museum.
56. Austen Henry Layard, *The Assyrian Court, Crystal Palace*, Crystal Palace Library (London: Bradbury & Evans, 1854), 34, 52.
57. Alina Payne, "Portable Ruins: The Pergamon Altar, Heinrich Wölfflin, and German Art History at the Fin de Siècle," *RES*, Spring/Autumn 2008, 170.
58. Most of the illustrations came from the 1880 *Jahrbuch der Königlich-Preußischen Kunstsammlungen*, dedicated to documenting the excavation and the marbles.
59. Charles Callahan Perkins, "The Pergamon Marbles. II—The Gigantomachia and Other Sculptures Found at Pergamon," *American Art Review* 2, no. 5 (March 1881): 192.
60. This collection could be admired for a few decades before being transferred to storage. Reinstalled in 1978, the Horace Smith collection displays a rare cast sensitivity, with labels attributing the objects to their makers, such as Brucciani & Co. in London, Oronzio Lelli in Florence, de Sachy in Paris, P. P. Caproni in Boston; and even noting lost provenance: "Origin of the cast unknown."
61. John Hungerford Pollen, *A Description of the Trajan Column* (London: George E. Eyre and William Spottiswoode, 1874).
62. Johann Wolfgang von Goethe, *Italian Journey*, trans. W. H. Auden and Elisabeth Mayer (London: Penguin, 1962), 152.
63. Calvin Tomkins, "Gods and Heroes," *New Yorker*, September 15, 1986, 82.
64. Eve M. Kahn, "Josh Sapan's 'Big Picture,' on Group Photos as Collectibles," *New York Times*, October 11, 2013. *Angkor: The Birth of a Myth, Louis Delaporte and Cambodia* was shown at the Musée Guimet, October 2013–January 2014.
65. Advertisement, *Times*, June 27, 1822.
66. A Constant Reader, "Letter to the Editor of the Times," *Times*, July 19, 1823.
67. Alina Payne, *From Ornament to Object: Genealogies of Architectural Modernism* (New Haven, CT: Yale University Press, 2012), 11.
68. Christopher S. Wood, *Forgery, Replica, Fiction: Temporalities of German Renaissance Art* (Chicago: University of Chicago Press, 2008), 19.
69. Bruno Latour and Adam Lowe, "The Migration of the Aura, or How to Explore the Original through Its Facsimiles," in *Switching Codes: Thinking through Digital Technology in the Humanities and the Arts*, ed. Thomas Bartscerer and Roderick Coover (Chicago: University of Chicago Press, 2011), 278.
70. George Kubler, *The Shape of Time: Remarks on the History of Things* (1962) (New Haven, CT: Yale University Press, 2008), 8.
71. Edward Robinson, "Report of Mr. Edward Robinson," November 13, 1891, in *Special Committee to Enlarge Collection of Casts* (New York: Metropolitan Museum of Art, 1892), 9.
72. Letter from Matthew Prichard, assistant director of the Boston Museum of Fine Arts, to Mr. Longfellow, April 20, 1905, Hall of Architecture Archive, Heinz Architectural Center Library Collection, Carnegie Museums of Pittsburgh. Hereafter, "Carnegie archive."

Chapter 1
Travels in the Province of Reproductions

1. Frank Salmon, "'Storming the Campo Vaccino': British Architects and the Antique Buildings of Rome after Waterloo," *Architectural History* 38 (1995): 150.
2. David Watkin explains the rhythm, order, content, and images used in the lectures in *Sir John Soane: The Royal Academy Lectures*, ed. David Watkin (Cambridge: Cambridge University Press, 2000), "Introduction."
3. Soane, "Lecture II," *Royal Academy Lectures*, 58.

4. Digging increased during the era of Napoleon and continued under Roman command after the French emperor was defeated at Waterloo. For the Roman Forum excavation history, see Ronald T. Ridley, *The Eagle and the Spade: Archeology in Rome during the Napoleonic Era* (Cambridge: Cambridge University Press, 2009).

5. Both names—Temple of Jupiter Stator and Temple of Castor and Pollux—were in interchangeable use after the Italian archaeologist Carlo Fea attributed the temple ruin to the Dioscuri in 1816. For these casts and models, see Helen Dorey, "Catalogues of Drawings, Models and Plaster Casts from the Temple of Castor and Pollux, Forum Romanum, in Sir John Soane's Museum, London," appendix 3, in *The Temple of Castor and Pollux III: The Augustan Temple*, ed. Kjell Aage Nilson et al. (Rome: L'Erma di Bretschneider, 2009).

6. These "plaster casts from Italy" originated from the collection of the architect Willey "The Athenian" Revelay, purchased at Christie's in 1801. The catalogue says "dimensions unknown (inaccessible) but probably full scale." Dorey, "Catalogues of Drawings," 282.

7. The makers of these models are unknown. In 1834 Soane bought twenty ancient monuments "reconstructed" by François Fouquet, who made models for architects, collectors, and schools from the 1790s to the 1830s. Helen Dorey, "Sir John Soane's Model Room," *Perspecta* 41 (2008): 93.

8. Quoted from Watkin, "Introduction," in Soane, *Royal Academy Lectures*, 20.

9. For an in-depth study, see Alexandra Stara, *The Museum of French Monuments, 1795–1816: 'Killing Art to Make Art History'* (Farnham: Ashgate, 2013).

10. Alexandre Lenoir, *Description historique et chronologique des monumens de sculpture, réunis au Musée des Monumens Français* (Paris: Gide libraire, 1800), 6.

11. Edward N. Kaufman, "A History of the Architectural Museum: From Napoleon through Henry Ford," in *Fragments of Chicago's Past: The Collection of Architectural Fragments at the Art Institute in Chicago*, ed. Pauline Saliga (Chicago: The Art Institute of Chicago, 1990), 23.

12. Eugène-Emmanuel Viollet-le-Duc, "Restoration," in *The Foundations of Architecture: Selections from the Dictionnaire raisonné*, trans. Kenneth D. Whiteland (New York: George Braziller, 1990), 207–8.

13. Stephen Bann, "Historical Text and Historical Object: Poetics of the Musée de Cluny," *Lotus International* 35 (1982): 39–41. See also Bann, "Poetics of the Museum: Lenoir and Du Sommerard," in *The Clothing of Clio* (Cambridge: Cambridge University Press, 1984).

14. Stara, *The Museum of French Monuments*, 81.

15. Choay, *The Invention of the Historic Monument*, 19.

16. Important examples are French designs collected by Tessin the Elder and Tessin the Younger in Stockholm, and those assembled by William and John Talman in London. John Harris, "Storehouses of Knowledge: The Origins of the Contemporary Architectural Museum," in *Canadian Center for Architecture: Buildings and Gardens*, ed. Larry Richards (Montreal: CCA, 1989).

17. Boullée and Ledoux quoted from Anthony Vidler, "Architecture in the Museum: Didactic Narratives from Boullée to Lenoir," in *The Writing of the Walls: Architectural Theory in the Late Enlightenment* (Princeton, NJ: Princeton Architectural Press, 1987), 166.

18. Ibid.

19. J.-G. Legrand, *Collection des chefs-d'oeuvre de l'architecture des différens peuples, exécutés en modèles, sous la direction de L.-F. Cassas, auteur des voyages d'Istrie, Dalmatie, Syrie, Phœnicie, Palestine, Basse-Égypte, etc.* (Paris: De imprimerie de Leblanc, 1806), xvii–xviii.

20. Fergusson, *On a National Collection of Architectural Art*, 14.

21. For a detailed history of the Architectural Museum, see Edward Bottoms, "The Royal Architectural Museum in the Light of New Documentary Evidence," *Journal of the History of Collections* 19, no. 1 (2007).

22. President of the Society [Earl de Grey], "The Architectural Museum, South Kensington," *Illustrated London News*, July 25, 1857, 87.

23. John Ruskin, "The Deteriorative Power of Conventional Arts over Nations," delivered at the opening meeting of the Architectural Museum, South Kensington Museum, January 1858, in *The Complete Works of John Ruskin*, ed. E. T. Cook and Alexander Wedderburn (London: George Allen, 1905), 16:284.

24. John P. Seddon, *Caskets of Jewels: A Visit to the Architectural Museum* (London: The Architectural Museum, 1884), 22. Parts of the Temple of Castor and Pollux traveled in an institutional rhizomatics unfolding over the following decades. For instance, "Cast of a part of the caliculæ of the capital of the column of Temple of Jupiter Stator" was part of the Royal Institute of British Architects' collection that was transferred to the Royal Architecture Museum. *Catalogue of the Medals, Busts, Casts, Marbles, and Stones in the Collection of the Royal Institute British Architects* (London, 1874), 8. In 1903 the expanded collection became an in-house museum, when the Architectural Association took over the museum's premises on Tufton Street. Peter Wylde, "The First Exhibition: The Architectural Association and the Royal Architectural Museum," *Architectural Association Annual Review*

(1981). In 1916, the casts were "returned" to the Victoria and Albert Museum, concluding a "tortuous journey towards a long-cherished ideal of a National Museum of Architecture." Isabelle Flour, " 'On the Formation of a National Museum of Architecture': The Architectural Museum versus the South Kensington Museum," *Architectural History* 51 (2008): 212.

25. Fergusson, *On a National Collection of Architectural Art*, 15.
26. Ibid., 14.
27. Ibid., 15–16.
28. Ibid., 13. The future museum of full-scale architectural casts Fergusson anticipated in 1857 was different from the full-scale plaster building elements that appeared in various exhibition venues in Berlin at the turn of the century. Here, archaeological reconstructions or contextualizing regional architecture constituted the artifacts: "the architectural constructions transformed the exhibit into a spatial experience of the topic at hand, making the exhibit legible to the general public." The casts were not the main attraction and thus avoided "the constraints of accuracy and authenticity that shaped the exhibitions of objects." Wallis Miller, "Cultures of Display: Exhibiting Architecture in Berlin, 1880–1931," 98.
29. Fergusson, *On a National Collection of Architectural Art*, 11.
30. Ibid., 13.
31. Ibid., 18.
32. Ibid., 16.
33. Ibid., 15.
34. "La restauration d'un édifice antique ou d'un ensemble d'édifices antiques de l'Italie, de la Sicile ou de la Grèce, comprenant l'état actuel et l'état restauré avec des études de détails: un mémoire historique et explicatif sera joint à ce travail," reads one such assignment. Henry Guédy, *L'Enseignement à l'école nationale et spéciale des Beaux-Arts. Section D'architecture. Admission.—2nd Classe.—1re classe.—Diplôme-prix de l'Académie et prix de Rome avec leur exposé pratique* (Paris: Libraire de la construction modern, 1899), 440.
35. Camille Enlart and Jules Roussel, *Catalogue Général du Musée de sculpture comparée au Palais du Trocadéro* (Paris: Libraire Alphonse Picard & Fils, 1910), preface. Lenoir, however, tried to convince Louis XVIII to cast the collection before it was dissolved in order to "keep together an outstanding historical overview of French sculpture." Axel Gampp, "Plaster Casts and Postcards: The Postcard Edition of the Musée de Sculpture Comparée at Paris," in Fredriksen and Marchand, eds., *Plaster Casts*, 504.
36. David Van Zanten, *Designing Paris: The Architecture of Duban, Labrouste, Duc, and Vaudoyer* (Cambridge, MA: MIT Press, 1987), 74.
37. The Arc de Gaillon was dismantled in 1978 and returned to the municipality of Gaillon. Ibid., 81.
38. The school's Conseil, quoted in ibid.
39. Pinatel, "La 'Restauration' en plâtre de deux colonnes du temple de Castor et Pollux," 74.
40. David Van Zanten, "Architectural Composition at the École des Beaux-Arts from Charles Percier to Charles Garnier," in *The Architecture of the Beaux-Arts*, ed. Arthur Drexler (London: Secker & Warburg, 1977), 79.
41. Pinatel, "La 'Restauration' en plâtre de deux colonnes du temple de Castor et Pollux," 78.
42. The plaster Parthenon is 16.10 meters tall, the Castor and Pollux reconstruction 18.615 meters. Ibid., 74.
43. An edition of this cast is still on display in Moscow. One copy was ordered by the British Museum, and elements were incorporated into the displays of the Second Elgin Room. For the debates on this display in the 1850s, see Jenkins, *Archaeologists & Aesthetes*, 91–96. Parts of this colossus are still on display, tucked away in a corner in a corridor outside the Duveen Gallery, accompanied by a diagrammatic explanation of the elements of the Doric order. Combined with a marble capital and a drum, it mutely reenacts the museum's tradition of displaying the Parthenon in assemblages of originals and casts. A wall label reveals an episode in the life of this traveling monument: "The cast of the triglyphs, the sculpted metopes and the lion head spout were purchased for the British Museum in 1844 from the expedition led by the archaeologist Phillip Le Bas, who had been charged with making molds for casts to be displayed at the École des Beaux-Arts in Paris."
44. Quoted from Pinatel, "La 'Restauration' en plâtre de deux colonnes du temple de Castor et Pollux," 89.
45. Coquart started to work on the Parthenon at the same time. Ibid., 74.
46. Alexandre de Sachy, *Catalogue des moulages provenant des monuments, musées, collections, etc.* (Paris: Imprimerie nationale, 1881), 151–52. The catalogue emphasized that most of the casts offered for sale at the École were made following the procedure invented by Alexandre de Sachy in 1858.
47. "De Jupiter Stator ou de Castor et Pollux. Copie au quart restaurée. M. Dutert." Ibid., 152.
48. Undated drawing, Carnegie archive.
49. Letter from Camille Enlart to John W. Beatty, October 30, 1906. Carnegie archive.
50. Ibid.

51. Letter from Camille Enlart to John W. Beatty, November 24, 1906. Carnegie archive.
52. Ibid.
53. Gillian Darley, "Wonderful Things: The Experience of the Grand Tour," *Perspecta* 41 (2008), 23.
54. Salomon Reinach, in *The Nation*, 1885. Undated clipping, Met archives.
55. Quoted in Robinson, "Report of Mr. Edward Robinson," 15.
56. *Metropolitan Art-Museum. Proceedings of a meeting held at the theater of the Union League club, Tuesday evening, November 23, 1869, including addresses, remarks, and letters* (New York: Printed for the Committee, 1869), 17.
57. Perkins, "American Art Museums," 8.
58. Pamela Born, "The Canon Is Cast: Plaster Casts in American Museum and University Collections," *Art Documentation: Journal of the Art Libraries Society of North America* 21, no. 2 (Fall 2002).
59. Perkins, "American Art Museums," 5.
60. *Metropolitan Art-Museum*, 3.
61. Ibid., 20.
62. Ibid., 9.
63. Ibid., 12.
64. Ibid., 13.
65. Ibid., 14.
66. Morrison H. Heckscher, "Metropolitan Museum of Art: An Architectural History," *Metropolitan Museum of Art Bulletin* 53, no. 1 (1995): 9.
67. The collection was exhibited, and parts of it auctioned, in Paris and London in the 1870s. Charles Newton had parts of it photographed as *The Antiquities of Cyprus Discovered by General Luigi Palma di Cesnola* (London: W. A. Mansell and Co., 1873).
68. Posthumous letter from Levi Hale Willard to Napoleon Le Brun, November 25, 1881. Met archives.
69. *American Architect & Building News*, April 7, 1883.
70. Pierre Le Brun, "A Collection of Plaster Casts. Report of the Agent," August 15, 1885. Read to the Trustees at the quarterly meeting held November 22, 1885. Met archives.
71. Pierre Le Brun visited the Paris exhibition to look for new casts in the market, equipped with ten thousand dollars for purchases. William R. Ware, "Report of the Committee on Sculptures and Casts," May 28, 1894. Met archives.
72. William R. Ware, "3rd AD Interim report," November 7, 1889. Met archives.
73. William R. Ware, "Report of the Committee on Sculptures & Casts," November 16, 1891. Met archives.
74. Note, General di Cesnola, December 29, 1893. Met archives.
75. Letter from General di Cesnola's private secretary to Mrs. D. E. Carson, September 28, 1899. The Belgian government did, however, order an edition of the Parthenon model for the Musée du Cinquantenaire in Brussels while it was on display in Paris. William R. Ware, chairman of sculptures and casts, "Second Interim report," March 8, 1889. Met archives.
76. It began "on the right of the entrance with Egyptian and Assyrian casts, and continuing around the hall, with the Renaisance [sic] placed at the left of the entrance." Indian and Saracenic works "were placed near the old entrance of the Museum at the western end." William R. Ware, "3rd AD Interim report," November 7, 1889. Ware also outlines the installation elsewhere. The space beginning at the right "of the principal entrance is given to Arabic, Egyptian, Assyrian and Phoenician examples. The remaining alcove on the South side and the first to the North is given to Grecian, the next to Roman, the central two to Byzantine works and the Romanesque, the remaining two on this side, to the later medieval styles, and the rest to the various styles of the Renaissance, chiefly Italian, French and German." Note from William R. Ware to President Marquand, 1890. Met archives.
77. In 1889 architect and trustee Theodor Weston's South Wing in French Renaissance style was added to Vaux and Mould's first building. Over the next decade various additions to the rapidly enlarging museum were completed, partly in parallel. In 1904 the North Wing was completed, designed by Weston and Arthur L. Tuckerman. Richard Morris Hunt's East Wing with the Grand Hall and staircase and the monumental entrance toward Fifth Avenue was completed by his son Richard Howland Hunt after Hunt's untimely death. The firm of McKim, Mead & White became the Metropolitan's architects in 1904, designing a new master plan and adding five wings and the library, a building program that continued into the 1920s.
78. William R. Ware, "Report of the Committee on Sculptures & Casts," November 16, 1891. Met archives.
79. Ibid.
80. Henry G. Marquand et al., "Report to Members and Subscribers. February 1, 1892," *Special Committee to Enlarge Collection of Casts. Report of Committee to Members and Subscribers, February 1, 1892* (New York: Metropolitan Museum of Art, 1892), 5. The committee was chaired by Henry G. Marquand, and its members were Robert W. de Forest, Edward D. Adams, Howard Mansfield, George F. Baker, John S. Kennedy, Pierre L. Le Brun, Allan Marquand, Augustus C. Merriam, Francis D. Millet, Frederick W. Rhinelander, Augustus

80. St. Gaudens, Louis C. Tiffany, John Q. A. Ward, and Stanford White.
81. Henry G. Marquand et al., "Why the Metropolitan Museum Should Contain a Full Collection of Casts," statement published by the committee in March 1891. Ibid., 35.
82. George Parsons Lathrop, "The Progress of Art in New York," *Harper's Monthly Magazine* 86, no. 515 (April 1893), 750.
83. Robinson, "Report of Mr. Edward Robinson," 8, 10.
84. Ibid., 8.
85. Marquand et al., "Why the Metropolitan Museum Should Contain a Full Collection of Casts," 35.
86. Robinson, "Report of Mr. Edward Robinson," 9.
87. Ibid., 9.
88. Quoted from Pinatel, "La 'Restauration' en plâtre de deux colonnes du temple de Castor et Pollux," 111.
89. Robinson, "Report of Mr. Edward Robinson," 25.
90. Professors Arthur L. Frothingham Jr. and Allan Marquand of Princeton University had advised on and drafted, respectively, the early Christian and medieval French and Italian lists, the German Renaissance list, and the Egyptian lists. Edward Robinson, *Tentative Lists of Objects Desirable for a Collection of Casts, Sculptural and Architectural, Intended to Illustrate the History of Plastic Art* (New York: Metropolitan Museum of Art, 1891), "Explanatory Preface," iii.
91. Ibid.
92. Ibid., iv.
93. Ibid., iii.
94. Marquand et al., "Report to Members and Subscribers. February 1, 1892," 3.
95. Jenkins, *Archaeologists & Aesthetes*, 69–70.
96. Newton, "Remarks on the Collections of Ancient Art in the Museums of Italy, the Glyptothek at Munich, and the British Museum," 227.
97. Samuel Phillips, *Crystal Palace: A Guide to the Palace & Park*, illustrated by Philip H. Delamotte, Crystal Palace Library (London: Bradbury & Evans, 1854), 16.
98. Ibid., 17.
99. Quoted from John Kenworthy-Browne, "Plaster Casts for the Crystal Palace, Sydenham," *Sculpture Journal* 15, no. 2 (2006): 174.
100. Kenworthy-Browne has found what still remains of the inventory from the trip, which probably followed their itinerary: a document providing rare testimony of a changing market at a time when plaster casts were considerably cheaper than in the eighteenth century. Ibid., 178.
101. Phillips, *Crystal Palace*, 17.
102. Ibid., 18.
103. Ibid.
104. In Florence they met with L. Statesi; in Turin they obtained Egyptian sculpture; in Milan they met with L. Torini; in Venice they ordered the equestrian statue of Bartolomeo Colleoni from A. Giordani and E. Tombola's cast of Donatello's equestrian statue of Gattamelata, both made from fresh molds. In Prague F. Pellegrini was commissioned for the fourteenth-century bronze St. George and the Dragon; in Dresden they selected a number of modern works, and in Munich J. Hautmann's cast of Ludwig Schwanthaler's Head of Bavaria. In Berlin the Prussian government provided casts from Schinkel's Royal Museum (later renamed Altes Museum) and Baron von Humboldt's museum in Tegel, and from *formatore* A. Mitsching parts of Rauch's monument to Frederick the Great, a brand-new work erected in 1851; and in Nuremberg the great doorway to the Frauenkirche was ordered from W. Fleischmann.
105. Robinson, "Report of Mr. Edward Robinson," 15.
106. Winifred E. Howe, *A History of the Metropolitan Museum of Art, with a Chapter on the Early Art Institutions of New York*, vol. 1 (New York: Metropolitan Museum of Art, 1913), 252.
107. Special Committee on Casts. Minutes 1891–1895, January 24? (unreadable), 1891. Met archives.
108. "The New Cast Galleries of the Metropolitan Museum," *The Art Interchange* 37 (July 1896): 4.
109. Robinson, "Report of Mr. Edward Robinson," 21.
110. Robinson, "III. The Parthenon," in *Tentative Lists*, 20.
111. Robinson, "Report of Mr. Edward Robinson," 21.
112. Ibid., 22.
113. Ibid., 23.
114. G.W.E. Field, "Willard Architectural Commission. The Architectural Models in the Metropolitan Museum of Art, New York," in *Souvenir of the XXVIIIth Annual Convention of the American Institute of Architects to be held at the American Fine Arts Building, 215 W. 57th St., New York, October 15th, 16th, 17th 1894* (New York: Nicoll & Roy Co., 1894), xxxv.
115. William R. Ware, "Report of the Committee on Sculptures & Casts," November 16, 1891. Met archives.
116. Robinson, "Willard Architectural Collection—Greek," in *Tentative Lists*, 99.
117. Another double historical panorama later realized in plaster, at scale 1:250 and covering an impressive two thousand square feet, is the model of Rome commissioned by Benito Mussolini to celebrate the bimillennium of Emperor Augustus in 1937. "The aesthetic, archeological, and political implications of the model's mixed message are significant," observes Victor Plahte Tschudi, in its mediation of two pasts,

meticulously reconstructing ancient Rome while inventing a "Fascist city *all'antica*." Tschudi, "Plaster Empires: Italo Gismondi's Model of Rome," *Journal of the Society of Architectural Historians* 71, no. 3 (2012): 387, 390.
118. Robinson, "Report of Mr. Edward Robinson," 24.
119. Edward Robinson et al., *Catalogue of the Collection of Casts*, 2nd ed. with supplement (New York: Metropolitan Museum of Art, 1910), entries 468–74, 57.
120. He particularly praised the portico of the Pandroseion, with the cornice, the Erechtheion porch, and the Choragic Monument of Lysicrates. Perkins, "American Art Museums," 13.
121. Letter from William R. Ware to President Marchand, December 28, 1891. Met archives.
122. Robinson, *Tentative Lists*, 104.
123. William R. Ware, "Report of the Committee of Sculptures and Casts," November 16, 1891. Met archives.
124. Robinson, "Report of Mr. Edward Robinson," 16.
125. John Ruskin, *The Seven Lamps of Architecture* (New York: J. Wiley, 1849), 218.
126. Ibid.
127. Isabelle Flour, "National Museums of Architecture: The Creation and Re-Creation of a New Type of National Museum in the 19th Century, London and Paris," in *Comparing: National Museums, Territories, Nation-Building and Change*, ed. Peter Aronsson and Andreas Nyblom (Linköping University Electronic Press, 2008), 158.
128. Further, the Sorbonne's cast collection, relocated to the Institute of Art and Archaeology in the early 1930s, was attacked in 1968 and moved to Versailles. Jean-Luc Martinez, "La gypsotèque du musée du Louvre à Versailles," *Comptes rendus des séances de l'académie des Inscriptions et Belles-Lettres* 154, no. 3 (2009): 1130.
129. Quatremère de Quincy, "Letters to Canova," in *Letters to Miranda and Canova on the Abduction of Antiquities from Rome and Athens*, 130.
130. Ibid., 131.

Chapter 2
Trocadéro: Proust's Museum

1. The first volume of *À la recherche du temps perdu* was published in 1913. The publication of volume 2 was delayed by World War I, and the last six volumes appeared from 1919 onward. The three final volumes were published posthumously, in 1923, 1925, and 1927.
2. Marcel Proust, *The Way by Swann's*, vol. 1 of *In Search of Lost Time*, trans. Lydia Davis (London: Penguin, 2002), 388.
3. Ibid., 295. Davis translates as "real historic buildings" Proust's "de vrais monuments." Marcel Proust, *À la recherché du temps perdu* (Paris: Gallimard, Bibliothèque de la Pléiade, 1987), 1:287–88. The monuments Swann particularly mentions are Beauvais and Saint-Loup-de-Naud, both part of the Trocadéro collection.
4. Proust's museum far transcends the collection catalogued by Eric Karpeles as *Painting in Proust* (London: Thames & Hudson, 2008). Karpeles includes only paintings that are identifiable by artist or title. Works alluded to or evoked by ekphrasis are not part of this inventory.
5. Proust, *In the Shadow of Young Girls in Flower*, 224.
6. Ibid., 234. The full meaning is partly obscured in the newest Proust translation. In French it reads: "une vue totale et un tableau continu." Proust, *À la recherche du temps perdu*, 2:16.
7. Proust, *In the Shadow of Young Girls in Flower*, 228.
8. Ibid.
9. Ibid., 230.
10. Ibid., 237.
11. Ibid., 238. According to Stephen Bann this scene reprises Proust's arduous search for and subsequent disappointment with a minuscule figure in the Bookseller' Portal in the cathedral in Rouen, after he had read John Ruskin's description in *The Stones of Venice*. Bann, "Proust, Ruskin, Stokes, and the Topographical Project," in *Literature & Place, 1800–2000*, ed. Peter Brown and Michael Irwin (Bern: Peter Lang, 2008), 130–33.
12. Proust, *In the Shadow of Young Girls in Flower*, 238.
13. Ibid., 239.
14. Ibid.
15. Ibid.
16. Quoted from Walter Muir Whitehill, *Museum of Fine Arts Boston: A Centennial History*, vol. 1 (Cambridge, MA: The Belknap Press of Harvard University Press, 1970), 202.
17. Arthur Drexler, "Engineer's Architecture; Truth and Its Consequences," in *The Architecture of the Beaux-Arts*, ed. Arthur Drexler (London: Secker & Warburg, 1977), 21.
18. Louis Courajod and P.-Frantz Marcou, *Musée de sculpture comparée (moulages). Palais du Trocadéro. Catalogue raisonné publié sous les auspices de la commission des Monuments historiques. XIVe et XVe siècles* (Paris: Imprimerie Nationale, 1892), III.
19. Ibid.
20. Enlart, *Le Musée de sculpture comparée au Palais du Trocadéro*, 3.
21. Eugène-Emmanuel Viollet-le-Duc, "Sculpture," in *Dictionnaire raisonné de l'architecture française du XIe au XVIe siècle*, vol. 8 (Paris: Edition Bance-Morel, 1866), 152–53.

22. Ibid., 152–53n1.
23. Ibid., 173.
24. Ibid., 172.
25. Ibid., 164.
26. Ibid., 185.
27. Ibid., 272–73.
28. Ibid., 250.
29. Viollet-le-Duc, "Restoration," in Viollet-le-Duc, *The Foundations of Architecture*, 199.
30. Ibid., 202–3.
31. Ibid., 197.
32. Ibid., 198.
33. R. Howard Bloch, "Viollet-le-Duc's 'Republic of Architectural Art': The Greco-Gothic Revival and Building in Modern France," *Perspecta* 44 (2001): 13.
34. Viollet-le-Duc, "Musée de sculpture comparée appartenant aux divers centres d'art et aux diverses époques," first report, June 11, 1879. Gallica, BNF.
35. Enlart, *Le Musée de sculpture comparée au Palais du Trocadéro*, 6. Among the works in place for the opening were the tympanums from Moissac and Notre-Dame-du-Port de Clermont, the portal from Vézelay, and statues from the cathedrals in Laon, Paris, Chartres, Amiens, and Reims.
36. Flour, "National Museums of Architecture," 158.
37. Victor Hugo, "Sur la destruction des monuments de France" (1825), expanded version printed as "Guerre aux Démolisseurs," *Revue des Deux Mondes* 5 (1832): 610.
38. Commission des Monuments historiques/Ministère de l'instruction publique et des beaux-arts, *Musée de sculpture comparée (moulages), Catalogues des sculptures. Appartenant aux divers centres d'art et aux diverses époques, exposées dans les galeries du Trocadéro* (Paris: Palais du Trocadéro, 1883), VII.
39. As was the case for the first short-lived Museum of French Monuments. On Alexandre Lenoir and Winckelmann, see Stara, *The Museum of French Monuments*, 19 and 91, and Francis Haskell, *History and Its Images: Art and the Interpretation of the Past* (New Haven, CT: Yale University Press, 1993), 242.
40. Enlart and Roussel, *Catalogue Général du Musée de sculpture comparée au Palais du Trocadéro*, vi. This was repeated from the first catalogue, issued in 1883.
41. The architects Louis-Hippolyte Boileau, Jacques Carlu, and Léon Azéma reused the iron skeleton for the new Palais Chaillot on the Trocadéro hill.
42. Paul Frantz Julien Marcou, *Album du Musée de sculpture comparée* (Paris, 1897), 1:2.
43. Enlart, *Le Musée de sculpture comparée au Palais du Trocadéro*, 2.
44. Ibid., 4.
45. Newton, "Remarks on the Collections of Ancient Art in the Museums of Italy, the Glyptothek at Munich, and the British Museum," 226.
46. Ibid.
47. Enlart, *Le Musée de sculpture comparée au Palais du Trocadéro*, 6.
48. Ibid., 7.
49. Kevin D. Murphy, *Memory and Modernity: Viollet-le-Duc at Vézelay* (University Park: Pennsylvania State University Press, 2000), 4–5.
50. Ibid., 71.
51. Flour, "National Museums of Architecture," 157.
52. Robinson, "Report of Mr. Edward Robinson," 23.
53. Fernand Braudel, *The Mediterranean and the Mediterranean World in the Age of Philip II* (1949), trans. Siân Reynolds (New York: Harper & Row, 1975), 23.
54. Michael S. Roth, "Irresistible Decay: Ruins Reclaimed," in *Irresistible Decay* (Santa Monica, CA: The Getty Research Institute for the History of Art and the Humanities, 1997), 17.
55. Proust, *The Way by Swann's*, 131–32.
56. Ibid., 387.
57. Ibid., 388.
58. Stephen Bann, "Representing Normandy," in *Distinguished Images: Prints in the Visual Economy of Nineteenth-Century France* (New Haven, CT: Yale University Press, 2013), 47. The young Viollet-le-Duc drew monuments for the series in the 1830.
59. Ibid., 53.
60. Wolfgang Schivelbusch, *The Railway Journey: The Industrialization and Perception of Time and Space in the 19th Century* (Berkeley: University of California Press, 1986), 38–40.
61. Proust, *The Way by Swann's*, 392.
62. Ibid., 389–90.
63. Bann, "Representing Normandy," 49.
64. Proust, *The Way by Swann's*, 393.
65. Ibid.
66. Proust, *In the Shadow of Young Girls in Flower*, 237.
67. Proust, *The Way by Swann's*, 390.
68. Ibid., 391.
69. Ibid., 388–89.
70. Proust, *In the Shadow of Young Girls in Flower*, 237.
71. Bann, "Representing Normandy," 64.
72. Ibid.
73. Benjamin Ives Gilman, *Museum Ideals of Purpose and Method* (Cambridge, MA: The Riverside Press, 1918), 124–25.
74. Ibid.
75. Flour, "National Museums of Architecture," 159.

76. For a detailed study of the many series of Parthenon casts, and their instrumental importance for the scholarship on the temple, see Jenkins, "Acquisition and Supply of Casts from the Parthenon Sculptures from the British Museum, 1835–1939."
77. For the restoration of the pedimental sculptures by means of casts, see Jan Zahle, *Thorvaldsens afstøbninger efter antikken og renæssansen* (Copenhagen: Thorvaldsens museum, 2012), 25.
78. Phillips, *Crystal Palace*, 38.
79. Viollet-le-Duc, "Restoration," 195.
80. Barry Bergdoll, "The *Dictionnaire raisonné*: Viollet-le-Duc's Encyclopedic Structure for Architecture" (introduction), in Viollet-le-Duc, *The Foundations of Architecture*, 1–2.
81. Falser, "From Gaillon to Sanchi, from Vézelay to Angkor Wat," 19.
82. Jean-Louis Cohen, "From the Ground Down: Architecture in the Cave, from Chaillot to Montreal," *Log*, no. 15 (Winter 2009): 28.
83. Martin Bressani, *Architecture and the Historical Imagination: Eugène-Emmanuel Viollet-le-Duc, 1814–1879* (Farnham: Ashgate, 2014), 237.
84. Enlart, *Le Musée de sculpture comparée au Palais du Trocadéro*, 3.
85. Phillips, *Crystal Palace*, 46.
86. Owen Jones, *An Apology for the Colouring of the Greek Court*, Crystal Palace Library (London: Bradbury & Evans, 1854), 5.
87. Scharf, *The Greek Court Erected in the Crystal Palace, by Owen Jones*, 93.
88. Quoted from Shawn Malley, who discusses the coloring of the courts in light of class issues, and how these colored versions of antiquity were conceived as "a freakish modern simulation that dazzles the eyes of the laboring classes. Malley, *From Archaeology to Spectacle in Victorian Britain: The Case of Assyria, 1845–1854* (Farnham: Ashgate, 2012), 148.
89. George Godwin, in *The Builder*, June 10, 1854, 398.
90. George Godwin, in *The Builder*, September 16, 1854, 482.
91. Ibid.
92. Semper had published *Vorläufige Bemerkungen über bemalte Architektur und Plastik bei den Alten* in 1834.
93. G. H. Lewes, "Historical Evidence," in Jones, *Apology*, 27.
94. Fergusson, *On a National Collection of Architectural Art*, 16.
95. Ibid., 17, 15.
96. Robinson, "Report of Mr. Edward Robinson," 29.
97. "Of the few Assyrian statues we possess, that of Assur-nazir-pal (No. 8) is perhaps the most important, and its inferiority to their relief-work is very striking." Edward Robinson, *Catalogue of Casts. Part II. Chaldæan and Assyrian Sculpture* (Boston: Houghton, Mifflin and Company, 1891), 24.
98. Perkins, "American Art Museums," 14.
99. Smith, *Art Education, Scholastic and Industrial*, 257.
100. Gilman, *Manual of Italian Renaissance Sculpture*, v.
101. P. P. Caproni & Bro., *Catalogue of Plaster Reproductions from Antique, Medieval and Modern Sculpture* (Boston, 1911), 234. Sales catalogues also advised on how to style and maintain casts, ranging from domestic objects (for instance, a private, down-scaled Laocoön) to large museum pieces. "We make a specialty of coloring our casts for home decorations, to correspond with their environment; such as terra cotta, bronze, or a light and soft, cream color. This has the effect of taking from the cast the dazzling white appearance." P. P. Caproni & Bro., *Catalogue and Price List of Antique and Modern Sculpture* (Boston, n.d.).
102. "Treatment of Plaster Casts," *Bulletin of the Art Institute of Chicago* 6, no. 2 (October 1912): 27.
103. Tomkins, "Gods and Heroes," 87.
104. Quatremère de Quincy, "Letters to Miranda," in *Letters to Miranda and Canova on the Abduction of Antiquities from Rome and Athens*, 101.
105. Paul Valéry, "Le problème des musées," in *Pièces sur l'art* (1923), *Œuvres*, vol. 2 (Paris: Gallimard, Bibliothèque de la Pléiade, 1960), 1290–93.
106. Proust, *In the Shadow of Young Girls in Flower*, 224 and 223.
107. Didier Maleuvre, *Museum Memories: History, Technology, Art* (Stanford, CA: Stanford University Press, 1999), 72.
108. Theodor W. Adorno, "Valéry Proust Museum" (1955), in *Prisms*, trans. Samuel and Sherry Weber (Cambridge, MA: MIT Press, 1997), 181.
109. Proust, *In the Shadow of Young Girls in Flower*, 224.
110. Ibid., 224–25. Referencing the panorama, Proust evoked another popular nineteenth-century optical-aesthetic device, which, like the plaster monuments, provided grand audiences an illusion of far-flung landscapes and buildings.
111. Marcel Proust, *Finding Time Again*, vol. 6 of *In Search of Lost Time*, trans. Ian Patterson (London: Penguin, 2003), 195.
112. Ibid.
113. Walter Benjamin, "The Work of Art in the Age of Its Technological Reproducibility," 2nd version, in *Walter Benjamin, Selected Writings*, vol. 3, *1935–1938*, trans. Edmund Jephcott et al. (Cambridge, MA: The Belknap Press of Harvard University Press, 2002), 103.
114. Ibid., 104.
115. Ibid., 103.

116. Proust, *In the Shadow of Young Girls in Flower*, 238. *À la recherché du temps perdu*, 2:20.
117. Samuel Weber, "Mass Mediauras, or: Art, Aura and Media in the Work of Walter Benjamin," in *Mass Mediauras: Form, Technics, Media* (Stanford, CA: Stanford University Press, 1996), 101.
118. Proust, *In the Shadow of Young Girls in Flower*, 238.
119. Viollet-le-Duc, "Style," in *The Foundations of Architecture*, 242.
120. Proust, *The Way by Swann's*, 166–67.
121. Antoine-Chrysòstome Quatremère de Quincy, *Le Jupiter olympien, ou l'Art de la sculpture antique* (Paris: Firmin Didot, 1814), i.
122. Viollet-le-Duc, "Style," in *The Foundations of Architecture*, 242.
123. Benjamin, "The Work of Art in the Age of Its Technological Reproducibility," 103.
124. Ibid.
125. Latour and Lowe, "The Migration of the Aura," 278.
126. Courajod and Marcou, *Musée de sculpture comparée (moulages)*, III.
127. Wolfgang Ernst, "Not Seeing the Laocöon? Lessing in the Archive of the Eighteenth Century," in *Regimes of Description: In the Archive of the Eighteenth Century*, ed. John Bender and Michael Marrinan (Stanford, CA: Stanford University Press, 2005), 123.
128. Michael Camille, "Prophets, Canons, and Promising Monsters," *Art Bulletin* 78, no. 2 (1996): 198.
129. Proust, *In the Shadow of Young Girls in Flower*, 239.

Chapter 3
The Poetics of Plaster

1. Goethe, *Italian Journey*, 152.
2. Tomkins, "Gods and Heroes," 84. The condition of the storerooms on Riverside Drive near 158th Street was questioned from early on. They "seemed dry," was the irresolute verdict in 1942: "The attendant says that there is no deterioration due to dampness or vermin, and casts not crumbling away or being eaten by rats as reported to me in the way of club gossip." Letter from Morris and O'Connor to William Church Osborn, July 22, 1942. Met archives.
3. Valérie Montens, "La création d'une collection nationale de moulages en Belgique. Du musée des Plâtres à la section d'Art monumental des Musées royaux des arts décoratifs et industriels à Bruxelles," *In Situ. Revue des patrimoines* 28 (2016): 9.
4. John Hungersford Pollen, *A Description of the Architecture and Monumental Sculpture in the South-East Court of the South Kensington Museum* (London: George E. Eyre and William Spottiswoode, 1874), 1.
5. Oliver Wainwright, "V&A's Cast Courts of Beautiful Fakes Reopen after Three Years," *Guardian*, November 25, 2014.
6. Enlart, *Le Musée de sculpture comparée au Palais du Trocadéro*, 7, 9.
7. Fergusson, *On a National Collection of Architectural Art*, 15.
8. James D. Van Trump, *An American Palace of Culture: The Carnegie Institute and Carnegie Library of Pittsburgh* (Pittsburgh: Carnegie Institute, 1970), 29, 41.
9. John P. Suddon, *Caskets of Jewels: A Visit to the Architectural Museum* (London, 1884), preface.
10. Rousseau, *Promenade méthodique*, II.
11. Stara, *The Museum of French Monuments*, 91.
12. Rousseau, *Promenade méthodique*, II.
13. Th. H., "Norsk Arkitektur i det 19de Aarhundrede," *Norsk Folkeblad*, October 25, 1873, 263.
14. Newton, "Remarks on the Collections of Ancient Art in the Museums of Italy, the Glyptothek at Munich, and the British Museum," 227.
15. Jenkins, "Acquisition and Supply of Casts from the Parthenon Sculptures from the British Museum, 1835–1939," 94.
16. Jenkins, *Archaeologists & Aesthetes*, 69.
17. Newton, "Remarks on the Collections of Ancient Art in the Museums of Italy, the Glyptothek at Munich, and the British Museum," 226.
18. André Malraux, "Museums without Walls," in *The Voices of Silence* (1953), trans. Stuart Gilbert (Princeton, NJ: Princeton University Press, 1978), 16.
19. Newton, "Remarks on the Collections of Ancient Art in the Museums of Italy, the Glyptothek at Munich, and the British Museum," 227.
20. Ibid., 206.
21. Ibid.
22. Ibid.
23. *The Ten Chief Courts of the Sydenham Palace* (London: G. Routledge & Co., 1854), 51.
24. *The Builder*'s reviews of the courts were quick to point out chronological lapses. The review of the Renaissance court lamented the lack of "adherence to chronological order": "It would have helped many to understand much that in the case of this style may appear anomalous." *The Builder*, September 9, 1854, 481.
25. Matthew Digby Wyatt and J. B. Waring, *A Hand Book to the Byzantine Court*, Crystal Palace Library (London: Bradbury and Evans, 1854), 8.
26. These casts, mostly from the west frieze, were commissioned through the British consul at Athens and made by the Athens-based molder Napoleone Martinelli, who, beginning around 1870, provided

institutions around the world with Parthenon casts. Jenkins, "Acquisition and Supply of Casts from the Parthenon Sculptures from the British Museum, 1835–1939," appendix 2, 111.

27. Ernest Vinet, "L'art Grec au Palais de l'Industrie," *Journal des Débats*, November 28, 1860.
28. T. L. Donaldson, George Godwin, and F. C. Penrose, "The Architectural Collections in the Museum at Brompton: 'A National Museum of Architecture,'" *The Builder*, September 17, 1859, 614.
29. Viollet-le-Duc, "Musée de sculpture comparée appartenant aux divers centres d'art et aux diverses époques."
30. Perkins, "American Art Museums," 8, 9, 11.
31. Letter from William R. Ware, Chairman of the committee of sculpture, to President Marquand, December 29, 1890. Met archives.
32. Robinson, "Report of Mr. Edward Robinson," 8 and 11.
33. *Catalogue of the Objects in the Museum*, part 1, *Sculpture and Painting*, 2nd ed. (Chicago: The Art Institute, 1896), 9.
34. Letter from Beatty to the director at the Museum of Egyptian Antiquities, Palace of Gizeh, January 12, 1906. Carnegie archive.
35. For the French casts from the temple of Quetzalcoatl at Xochicalco in Mexico, see Flour, "Orientalism and the Reality Effect," 64.
36. H. H. Cole, *Catalogue of the Objects of Indian Art exhibited in the South Kensington Museum* (London: George E. Eyre and William Spottiswoode, 1874), 13.
37. Ibid., 88.
38. Tapati Guha-Thakurta, "The Production and Reproduction of a Monument: The Many Lives of the Sanchi *Stupa*," *South-Asian Studies* 29, no. 1 (2013): 16.
39. H. H. Cole, *Catalogue of the Objects of Indian Art*, 7.
40. Ibid., 9.
41. Michael S. Falser, "Krishna and the Plaster Cast: Translating the Cambodian Temple of Angkor Wat in the French Colonial Period," *Transcultural Studies*, no. 2 (2011): 6.
42. Ibid., 11. During the 1878 Exposition universelle the augmented collection of casts was displayed in the Passy Wing at the Trocadéro in the *Exposition historique et ethnographique*, before becoming part of the Musée Indo-chinoise at the Palais du Trocadéro.
43. Ibid., 41, 44. Along a Beaux-Arts axis Angkor Wat reappeared as a "functional pavilion" and a "scenographic fabrication" in the Parc de Vincennes, according to Patricia A. Morton, *Hybrid Modernities: Architecture and Representation at the 1931 Colonial Exhibition, Paris* (Cambridge, MA: MIT Press, 2000), 250–51.
44. Falser, "From Gaillon to Sanchi, from Vézelay to Angkor Wat," 1.
45. John Charles Robinson quoted from Baker, "The Reproductive Continuum," 497.
46. Only two decades earlier the Galicia region had been characterized by its "impenetrable obscurantism" in Richard Ford's 1845 *Handbook for Travellers in Spain*. Lindy Grant and Rose Walker, "Accidental Pilgrims: 19th-Century British Travellers and Photographers in Santiago de Compostela," *British Art Journal* 1, no. 2 (Spring 2000): 10.
47. See Claire L. Lyons et al., *Antiquity and Photography: Early Views of Ancient Mediterranean Sites* (Los Angeles: Getty Publications, 2005).
48. Gilman, *Manual of Italian Renaissance Sculpture*, v.
49. Ibid., vi.
50. Quoted from Thomas L. Hankins and Robert J. Silverman, *Instruments and the Imagination* (Princeton, NJ: Princeton University Press, 1995, 2014), 169.
51. Thompson's photographs were published in a lavish folio by the Arundel Society, founded in 1849, specializing particularly in the representation of chromolithographs of art, for their preservation. Among its members were John Ruskin and Charles Newton. For a study of James Fergusson's translations of architecture from stone to paper in India, see Tapati Guha-Thakurta, "The Compulsion of Visual Representation in Colonial India," in *Traces of India: Photography, Architecture and the Politics of Representation, 1850–1900*, ed. Maria Antonella Pelizzari (Montreal: Canadian Center for Architecture; New Haven, CT: Yale Center for British Art, 2003).
52. Scharf, *The Greek Court Erected in the Crystal Palace, by Owen Jones*, 94.
53. Donaldson, Godwin, and Penrose, "The Architectural Collections in the Museum at Brompton," 614. For a detailed overview of the complex history of scale models in the South Kensington Museum, their origins, uses, and shifting taxonomies, see Fiona Leslie, "Inside Outside: Changing Attitudes towards Models in the Museum at South Kensington," *Architectural History* 47 (2004).
54. Letter from William R. Ware to President Marquand, December 29, 1890. Met archives.
55. Robinson et al., *Catalogue of the Collection of Casts*, 63–64 and 190.
56. Marcou, *Album du Musée de sculpture comparée*, vol. 1, preface.

57. For the history of this rare collection, see Dominique Jarrassé and Emmanuel Polack, "Le musée de Sculpture comparée au prisme de la collection de cartes postales éditées par frères Neurdein (1904–1915)," *Cahiers de l'Ecole du Louvre, recherches en histoire de l'art, histoire des civilisations, archéologie, anthropologie et muséologie*, no. 4 (2014). See also Gampp, "Plaster Casts and Postcards."
58. "The Architectural Courts, South Kensington Museum: The Trajan Column and the Portico de la Gloria, Santiago de Compostela," *The Builder*, October 4, 1873, 789.
59. John Hungersford Pollen, assistant keeper at the South Kensington Museum from 1863 and editor at the Science and Art Department, published two books with the museum in 1874, the year after the Architectural Courts were inaugurated, that both display this transparency of the cast pointing straight to the original. *A Description of the Trajan Column* starts by stating that the cast column "forms the subject of these pages," while the rest of the 181-page text does not make one reference to the objects in the gallery. Similarly, in *A Description of the Architecture and Monumental Sculpture in the South-East Court of the South Kensington Museum*, a five-page preface about the cast concludes with a little note in italics: "*The descriptions in the following pages refer to the original objects, of which casts are exhibited in the Museum.*"
60. Twenty-five of these models were purchased by the French state the year after they appeared in Stendhal's memoir. For a description of the collection, see Pelet's posthumously published *Description des monuments grecs et romains exécutés en modèles à l'échelle d'un centimètre par mètre* (Nîmes, 1876).
61. Stendhal, *Mémoires d'un touriste*, in *Oeuvres completes*, vol. 16 (Geneva: Slatkin Reprints, 1986), 135–50. This part is omitted in the English translation. Stendhal quoted from Renzo Dubbini, *Geography of the Gaze: Urban and Rural Vision in Early Modern Europe* (Chicago: University of Chicago Press, 2002), 159.
62. Ibid.
63. Lelli later reproduced Ghiberti's doors in plaster, and the cast was offered for sale in *Catalogo dei Monumenti, Statue, Bassirilievi a altre sculture de varie epoche che si trovano formate in gess nel laboratorio di Oronzio Lelli* (Florence: Pei Tip di Salvadore Landi, 1894).
64. Baker, "The Reproductive Continuum," 490.
65. W.M.R. French, *Annual Report of the Art Institute of Chicago, 1892–1893*, Institutional Archives of the Art Institute of Chicago.
66. One, "41 × 24 feet, shows a portion of the Church of St. Gilles; one, 20 × 36 feet, is from the gallery of Limoges Cathedral; one from the 'Portal of the Virgin,' from Notre Dame, Paris, is 18 × 25 feet, etc." Trumbull White and Wm. Igleheart, *The World's Columbian Exposition, Chicago, 1893. A Complete History of the Enterprise* (Chicago International Publishing Co., 1893), 350.
67. W.M.R. French, "The Permanent Collections at the Art Institute of Chicago," *Brush and Pencil* 1, no. 4 (January 1898): 84. The collection is described in Alfred Emerson, *Illustrated Catalogue of the Antiquities and Casts of Ancient Sculpture in the Elbridge G. Hall and Other Collections*, part 1, *Oriental and Early Greek Art* (Chicago: The Art Institute of Chicago, 1906).
68. Enlart, *Le Musée de sculpture comparée au Palais du Trocadéro*, 9.
69. Lionel G. Robinson, "The Berlin Museum of Casts," *Art Journal* (March 1883): 68.
70. Donaldson, Godwin, and Penrose, "The Architectural Collections in the Museum at Brompton," 614.
71. Quoted from Flour, "'On the Formation of a National Museum of Architecture,'" 219. When the Architectural Museum regained autonomy in 1867, and was heading towards new building in Westminster, sufficient space was immediately a problem. "Already the museum is full," and the institution started fund-raising to enlarge the new building, to possibly arrange the works "in the order of their date." "Fine Arts," *Illustrated London News*, July 24, 1867, 90.
72. "Opening of the Museum," *New York Times*, November 3, 1889.
73. Letter from di Cesnola to P. A. Paine, April 17, 1892. Met archives. 2391.
74. Letter from Paine to di Cesnola, April 18, 1892. Met archives. 2392.
75. William R. Ware, "Report of the Committee of Sculptures & Casts," November 16, 1891. Met archives.
76. Note from William Ware to President Marquand in 1890 (n.d.). Met archives.
77. Letter from J. A. Paine to General di Cesnola, March 18, 1892, 2365–66. Followed by a "Special Report of the Curator, Dept. of Plaster-casts," March 18, 1892. Met archives.
78. "Notes," *The Builder*, March 19, 1892, 292.
79. William H. White, "M. Chipiez's Model of the Parthenon," *The Builder*, March 19, 1892, 230.
80. Letter from Eric Maclagen to Georg Hill, the director at the British Museum, February 6, 1934, quoted from Diane Bilbey and Marjorie Trusted, "'The Question of Casts': Collections and Later Reassessment of the Cast Collections at South Kensington," in Fredriksen and Marchand, eds., *Plaster Casts*, 474f.
81. Rousseau, *Promenade méthodique*, II.

82. Edward Robinson, *Descriptive Catalogue for the Casts from Greek and Roman Sculpture* (Boston: Alfred Mudge & Son, 1887), 7.
83. *The Builder*, June 10, 1854, 297.
84. James Fergusson, *The Palaces of Nineveh and Persepolis Restored: An Essay on Ancient Assyrian and Persian Architecture.* (London: John Murray, 1854), 85.
85. Layard, *The Assyrian Court, Crystal Palace*, 52.
86. Nichols, *Greece and Rome at the Crystal Palace*, 82.
87. Quatremère de Quincy, "Letters to Miranda," in *Letters to Miranda and Canova on the Abduction of Antiquities from Rome and Athens*, 100.
88. Lenoir, *Description historique et chronologique des monumens de sculpture*, 48–49.
89. Vidler, *The Writing of the Walls*, 173.
90. Anne Middleton Wagner, *Jean-Baptiste Carpeaux: Sculptor of the Second Empire* (New Haven, CT: Yale University Press, 1986), 97.
91. Ibid., 98.
92. Albert Dumont, "Les moulages de musée du Louvre," *Gazette des Beaux-Arts. Courrier Européen de l'art et de la curiosité* 11, no. 2 (1875).
93. Robinson et al., *Catalogue of the Collection of Casts*, viii.
94. Ibid., vi.
95. "Opening of the Hall of Casts," *Metropolitan Museum of Art Bulletin* 3, no. 12 (December 1908): 232.
96. Ibid.
97. Wilhelm Bode, "Dr. Bode, German Art Expert, Criticizes Our Museums," *New York Times*, January 28, 1912.
98. Dominique de Font-Réaulx, quoted from Falser, "Krishna and the Plaster Cast," 18.
99. As noted in handwriting in the Inventory of 1868, bought for £10 each ("All subsequent copies £6 each"). Numbered '68.-10 and '68.-11. Handwritten inventory 1868, Victoria and Albert Museum Archive. The production and purchase of the portals were described the next year in *Catalogues of Reproductions of Objects of Art, in Metal, Plaster, and Fictile Ivory, Chromolithography, Etching and Photography* (London: South Kensington Museum, 1869), 36.
100. J. C. Dahl, *Denkmale einer sehr ausgebildeten Holzbaukunst aus den frühesten Jahrhunderten in den innern Landschaften Norwegens* (with drawings by Frantz Wilhelm Schiertz) (Dresden, 1837), preface. Upon its demolition in 1841, Dahl bought the Vang stave church at auction. After having lobbied unsuccessfully to have it reinstalled, whole or in parts, at several prominent venues in Norway, he persuaded Friedrich Wilhelm IV of Prussia to rebuild the church on the Pfaueninsel near Berlin. After a winter in storage in the courtyard of the "Berlin Museum," it was in the end rebuilt as Kirche Wang in Brückenberg in Silesia (today Karpacz, Poland), where it is still in use. For a discussion of Dahl, preservation, and museum critique, see Mari Lending, "Landscape versus Museum: J. C. Dahl and the Preservation of Norwegian Burial Mounds," *Future Anterior: Journal of Historic Preservation, History, Theory, and Criticism* 6, no. 1 (2009).
101. Wyatt and Waring, *A Hand Book to the Byzantine Court*, 100.
102. James Fergusson, *A History of Architecture from All Countries, from the Earliest Times to the Present Day*, vol. 2 (London: John Murray, 1874), 116–17.
103. Swenson, *The Rise of Heritage*, 149.
104. Enlart, "La sculpture étrangere," in *Le Musée de sculpture comparée au Palais du Trocadéro*, 143. With the inventory numbers 228–31, 232, and 233 they are described under the heading "Norvège" in Enlart and Roussel, *Catalogue Général du Musée de sculpture comparée au Palais du Trocadéro*, 283–84.
105. Rousseau, *Promenade méthodique*, 30 and 32. The Brussels museum also purchased the Urnes casts in 1907. The five pieces may not have been installed, however, as they never appear in the catalogues. Letters to Henry Rousseau from Haakon Shetelig, July 3, December 14 and 31, 1907. Correspondence Archives, University Museum of Bergen.
106. Henry Rousseau, *Catalogue sommaire des Moulages*, illustré de nombreuses planches en simili-gravure (2e édition) (Brussels: Musées royaux du Cinquantenaire, 1926), 141.
107. "2nd and 3rd Interim Report," signed the Chairman of Sculpture and Casts, March 8 and November 7, 1889. Met archives.
108. The Metropolitan catalogue entries refer to a sales catalogue of casts from the Guidotti brothers. There are no traces testifying to the existence of such a catalogue. Given the many misspellings of Norwegian names and institutions in the Metropolitan catalogues and correspondence, the reference to the catalogue is most probably an error.
109. Letter from John W. Beatty to Gabriel Gustafson, August 13, 1906. Carnegie archive.
110. Letter from John W. Beatty to Gabriel Gustafson, June 5, 1906. Carnegie archive.
111. Letter from Gabriel Gustafson to John W. Beatty, August 6, 1906. Carnegie archive.
112. Letter from Gabriel Gustafson to John W. Beatty, October 19, 1906. Carnegie archive.
113. Haakon Shetelig, *Norske museers historie* (Oslo: Cappelen, 1944), 42.

114. Letter from Gabriel Gustafson to John W. Beatty, August 6, 1906. Carnegie archive. A receipt from J. Carpanini for "Church portal formed and cast, 370 kroner," dated June 6, 1893, was found among unsorted letters in the archives in what is today the Museum of Cultural History in Oslo. At least one more cast from the same series has survived in the museum's repository.
115. The endeavor was also a success in economic terms. According to the 1907 annual report, the extraordinary sales revenue provided a surplus after covering the actual costs of the production of "these beautiful and scientifically valuable casts." J. Holmboe, "Beretning, 1907," *Bergen Museum Aarbog 1907* (Bergen: John Griegs Bogtrykkeri, 1908), 13. The shipping receipt documenting weight and cubic feet from the Norwegian Royal Mail Steamers is filed in V&A Archive, Victoria and Albert Museum, MA/1/B1186.
116. Letter from Haakon Shetelig to the director of the Victoria and Albert Museum, June 18, 1907. V&A Archive.
117. Board of Education, South Kensington, *List of Reproductions in Metal and Plaster Acquired by the Victoria and Albert Museum in the Years 1907 and 1908* (London: Eyre and Spottiswoode, 1908), 11. Robinson et al., *Catalogue of the Collection of Casts* (1908), entries 1596–99.
118. Letter from Shetelig to Reginald Smith, July 7, 1907. V&A Archive, MA/1/B1188.
119. Danish archaeologist Knud J. Krogh has documented the vanished eleventh-century church, and the hidden reminiscences of "a long-lost totality" conceived as "one magnificent, continuous art work," with lavishly ornamented friezes, tympanums, doorways, columns, pilasters, and other fully architecturally integrated details, before being partly clad, partly modified to the dimensions of the 1130 church. Knud J. Krogh, *Urnesstilens kirke* (Oslo: Pax, 2011), 187.
120. Letter from Francis Beckett to Haakon Shetelig, February 2, 1931. The Royal Cast Collection archives, National Gallery of Denmark.
121. Letter from Edward Robinson to the director at the Bergen Museum, July 5, 1907. Correspondence Archives, University Museum of Bergen.
122. I thank Mathilde Jonghmans, a conservation student at the École supérieure de Beaux-Arts in Tours, for bringing this French Urnes relic to my attention. In the first decades of the twentieth century, the Trocadéro increasingly encrusted the casts, not least the ones depicting wooden structures. Julie Beauzac, "L'histoire matérielle des moulages du musée de Sculpture comparée," *In Situ. Revue des patrimoines* 28 (2016): 8.
123. Letter from Haakon Shetelig to V&A, June 18, 1907, and several notes in a minute book dated 1907. V&A Archive, MA/1/B1186.
124. Letter from Haakon Shetelig to Gabriel Gustafson at the Historical Museum in Oslo, December 19, 1907. Copy book 1907–1909, Correspondence Archives, University Museum of Bergen.
125. Riegl, "The Modern Cult of Monuments," 23.
126. Ibid., 31.
127. Panayotis Tournikiotis, "The Place of the Parthenon in the History and Theory of Modern Architecture," in *The Parthenon and Its Impact on Modern Times*, ed. Panayotis Tournikiotis (Athens: Melissa Publishing House, 1994), 202.
128. Can Bilsel, *Antiquity on Display: Regimes of the Authentic in Berlin's Pergamon Museum* (Oxford: Oxford University Press, 2012), 109–10.
129. Hélène Lipstadt, "The Building and the Book in César Daly's *Revue Générale de l'Architecture*," in *ArchitectureProduction*, ed. Beatriz Colomina (Princeton, NJ: Princeton Architectural Press, 1988), 25, 55.
130. Payne, *From Ornament to Objects*, 17.
131. Arrhenius, *The Fragile Monument*, 140.
132. Ibid.
133. *Skilling-Magazin*, April 5, 1845.
134. Letter to the director at the Metropolitan Museum of Art from Haakon Shetelig, June 1, 1907. The selection of the cast parts was made in collaboration with Herman Major Schirmer, a leading figure in Norwegian preservation, and appointed director for cultural heritage when the office was established in 1912. Letter from Haakon Shetelig to H. M. Schirmer May 31, 1907. Correspondence Archives, University Museum of Bergen.
135. Smith, *Art Education, Scholastic and Industrial*, 244.
136. Bressani, *Architecture and the Historical Imagination*, 250.
137. Viollet-le-Duc, "Musée de sculpture comparée appartenant aux divers centres d'art et aux diverses époques."
138. Enlart and Roussel, *Catalogue général du Musée de sculpture comparée au Palais du Trocadéro*, 8.
139. P.-J. Angoulvent, *Catalogue des Moulages en vente au musée de sculpture comparée* (Paris: Musée de sculpture comparée, Palais du Trocadéro, 1932), vii.
140. Gilman, *Manual of Italian Renaissance Sculpture*, iv–v.
141. Guha-Thakurta, "The Production and Reproduction of a Monument," 15.
142. Ibid., 16.
143. Ibid., 29.
144. Falser, "Krishna and the Plaster Cast," 6.
145. Ibid., 20.

Chapter 4
Cablegrams and Monuments

1. "Fame won at Delphi," *New York Times*, September 21, 1890.
2. "The American School had, owing to the indefatigable extortions of Dr. Waldstein, raised a large sum of money with a view to the excavation of the site; and when the French School succeeded after all in establishing its claim to Delphi, the Americans turned their energies and their resources into another channel; their excavations at the Heraeum near Argos." E. A. G., "Archaeology in Greece, 1892," *Journal of Hellenic Studies* 13 (1882–93): 139. For the history of the excavations, see Michael Scott, "Epilog: Unearthing Delphi," in *Delphi: A History of the Center of the Ancient World* (Princeton, NJ: Princeton University Press, 2014).
3. In 1874 a treaty concerning the excavations at Olympia secured the antiquities' remaining in Greece, while the German excavators acquired the right to cast the artifacts. "Prussia alone will receive the glory," said Crown Prince Friedrich. The enterprise would confirm Germany's standing as a patron of scholarship and art, said the prince's tutor Ernst Curtius, who masterminded the dig. Marchand, *Down from Olympus*, 82–83.
4. Christiane Pinatel, "Reconstitutions des façades est et ouest du trésor du Siphnos au Musée des monuments antiques de Versailles, et provenances des moulages réutilisés," *Revue Archéologique*, n.s., 1 (1994): 39.
5. The porch disappeared from the stairway in 1934 and was reinstalled at the École des Beaux-Arts in the mid-1950s. In 1970 the porch was moved to Versailles, and restored with new, more accurate plaster reconstructions based on new knowledge about the originals. For the complex trajectory of the Delphi casts, as well as the status of the reconstructed original porch, see Pinatel, "Reconstitutions des façades."
6. The French reception of antiquity was a chronology in reverse, from Roman to Hellenistic and finally Greek architecture, according to Jean-Luc Martinez, the current director of the Louvre. A triumphant moment in the dissemination of archaeological discoveries via plaster casts occurred when the excavations at Delphi were shown in Paris in 1900. Martinez, "La gypsotèque du musée du Louvre à Versailles," 1136.
7. Pierre Le Brun, "Annual Report of the New York Chapter of the American Institute of Architects," *American Art and Building News* 18, no. 31 (October 1885): 209.
8. Perkins, "American Art Museums," 7.
9. Ibid.
10. Payne, *From Ornament to Object*, 18.
11. William St. Clair, *Lord Elgin and the Marbles* (London: Oxford University Press, 1967), 117, 136.
12. Ramses's travel from the Ramasseum to its pedestal in the British Museum and its contemporary reception is portrayed in detail in Elliott Colla, *Conflicted Antiquities: Egyptology, Eegyptomania, Egyptian Modernity* (Durham: Duke University Press, 2007), chapter 1, "The Artification of the Memnon Head."
13. Layard, *The Assyrian Court, Crystal Palace*, 17. In a letter to the keeper of antiquities at the British Museum, Layard in 1850 wrote that the trustees seemed "to think that anything can be done for nothing here, as if I were old Merlin himself who had only to wave his hand and send colossal lions flying over the four quarters of the globe." Quoted from Julian Reade, "Nineteenth-Century Nimrud: Motivation, Orientation, Conservation," in *New Light on Nimrud*, ed. J. E. Curtis et al. (London: Institute for the Study of Iraq/British Museum, 2008), 12. For cutting of architectural elements, loss, theft, and accidents en route, see 11–14.
14. Michel Goutal, chief architect of historic monuments, "Conservation Treatment of the Winged Victory of Samothrace and the Monumental Daru Staircase, September 2013–March 2015," Louvre, Press pack, 13.
15. Henry Cole initiated this operation in 1866, and it was underwritten by the expertise of James Fergusson. Flour, "'On the Formation of a National Museum of Architecture,'" 225.
16. Cole, *Catalogue of the Objects of Indian Art*, 13–14.
17. "The process of making elastic moulds with gelatin was employed both at Sanchi and in the repetition of copies in London. The painted illustrations, which are exhibited near the gateway, show the positions of the gateways around the tope—of the encampment near the tope—and of the difficulties besetting the transport of materials, &c., from Jabbalpúr to Sanchi." Ibid.
18. Falser, "Krishna and the Plaster Cast," 23.
19. Newspaper clipping, 1887, no name. Met archives. While in Berlin in 1891 Edward Robinson praised the Berlin Museum's ingenious system at Charlottenburg, located in "immediate connection with a railroad, so that cases of casts can be packed in the freight-cars upon the grounds of the foundry, and thus one danger of transhipment is avoided." Robinson, "Report of Mr. Edward Robinson," 21.
20. George B. Prescott, *History, Theory, and Practice of the Electric Telegraph* (Boston: Ticknor and Fields, 1860), 339.
21. Cablegrams from Beatty to Navez, October 2 and November 7, 1906. Carnegie archive.

22. Letter from Beatty to Brucciani and Co., May 15, 1905. Drawing, Carnegie archive.
23. Letter from Beatty to Navez, April 17, 1905. Carnegie archive.
24. Letter from Beatty to Brucciani & Co, April 19, 1905. Carnegie archive.
25. Cablegram from Brucciani to Beatty, May 4, 1905. Carnegie archive.
26. Cablegram from Beatty to de Sachy, École des Beaux-Arts, Paris, April 6, 1905. Carnegie archive.
27. On Barak, *On Time: Technology and Temporality in Modern Egypt* (Berkeley: University of California Press, 2013), 146.
28. Letter from Beatty to Lorenzo Rinaldo, June 7, 1906. Carnegie archive.
29. Letter from Lorenzo Rinaldo to Beatty, June 9, 1906. Carnegie archive.
30. Letter from Beatty to Edmond Aman-Lean, April 7, 1905. Carnegie archive.
31. Letter from Beatty to Enlart, May 8, 1905. Carnegie archive.
32. The still-intact Slater collection, for which Edward Robinson had been an adviser, was an important inspiration for other American collections. Present at the opening were Charles Eliot Norton, professor of the history of the fine arts at Harvard University, and Martin Brimmer, the first director of the Boston Museum of Fine Arts.
33. Carnegie, "Value of the World's Fair to the American People," 421.
34. A lesson learned during the making of the Metropolitan collection was that "breakage is also an important addition to the cost of importing plaster casts"; in fact the mending of casts broken "during the voyage" or "at the Custom House, etc.," "sometimes doubles the cost of the cast itself." Di Cesnola, "Plan for a Casting Department," note to the executive committee, November 27, 1893. Met archives.
35. Letter from di Cesnola to W. R. Frew, April 19, 1895. Met archives.
36. Carnegie, directive to the Board of Trustees, 1901. Quoted from Franklin Toker, *The Hall of Architecture. Museum of Art, Carnegie Institute: A Feasibility Report on the Restoration of the Room and Its Casts*, June 1983, epigraph.
37. Kent was involved in setting up the collections at the Rhode Island School of Design in Providence, the George Walter Vincent Smith Art Museum in Springfield, Massachusetts, and the Knox Gallery in Buffalo.
38. Henry Watson Kent, *The Horace Smith Collection of Casts of Greek and Renaissance Sculpture: A Brief Statement of the Cost and Manner of Its Installation* (Springfield, MA: Springfield City Library Association, 1900) and *What I Am Pleased to Call My Education* (New York: The Grolier Club, 1949).
39. Letter from Beatty to Kent, January 4, 1904. Carnegie archive.
40. Letter from Kent to Beatty, April 13, 1905. Carnegie archive.
41. Letter from Beatty to Navez, July 16, 1907. Carnegie archive.
42. Beatty in the 1910 Annual Report, quoted from Toker, *The Hall of Architecture*, 14.
43. Ibid., 7.
44. Letter from Beatty to Mr. F. Edwin Elwell, June 22, 1905. Carnegie archive.
45. Famously, the British sculptor Richard Westmacott's pediment, *The Progress of Civilization*, over the entrance to the British Museum, depicts the origin and enlightenment of man and the allegorical invention of architecture, sculpture, painting, science, geometry, drama, music, and poetry. Appropriating elements from the Elgin Marbles, it is "both a celebration of nineteenth-century pride in human achievement and an eloquent statement of belief in the idea of progress." Jenkins, *Archaeologists & Aesthetes*, 61.
46. *The Metropolitan Museum of Art: Publications on Sale* (New York, 1915).
47. Letter from Pouzadoux to Kent, September 14, 1904. Carnegie archive.
48. Letter from Ettore Malpiere to Kent, August 5, 1905. Carnegie archive.
49. Letter from Beatty to Messrs. D. Brucciani and Co., March 15, 1906. Carnegie archive.
50. Letter from Beatty to Messrs. D. Brucciani and Co., April 4, 1906. Carnegie archive.
51. Letter from Beatty to Cecil Smith, September 5, 1906. Carnegie archive.
52. Letter from Cecil Smith to Beatty, September 26, 1906. Carnegie archive.
53. Letter from Elener & Andersson to Beatty, April 19, 1905. Carnegie archive.
54. Letter from Charles McKim to Beatty, April 10, 1905. Carnegie archive.
55. Letter from Matthew Prichard to Mr. Longfellow, April 20, 1905. Carnegie archive.
56. Letter from Beatty to Knoedler, May 8, 1905. Carnegie archive.
57. Letter from E. Poulin & Cie to Kent, April 21, 1905. Carnegie archive.

58. The architect Laurance W. Hitt shared his experience of making this model in Witt, "The Parthenon," *Carnegie Magazine* 7, no. 1 (April 1933).
59. Carpo, *Architecture in the Age of Printing*, 51.
60. Camille Enlart, "The Carnegie Museum," in *Memorial of the Celebration of the Carnegie Institute at Pittsburgh, PA., April 11, 12, 13, 1907* (Pittsburgh, PA: Carnegie Institute, 1907), 451.
61. Margaret Henderson Floyd, *Architecture after Richardson: Regionalism before Modernism—Longfellow, Alden, and Harlow in Boston and Pittsburgh* (Chicago: University of Chicago Press, 1994), 204–6.
62. The moment Beatty thought the three-arched version of Saint-Gilles might be within reach, he cabled the agents in Paris that he would contact "our architects as to space and cable you if we can use the entire porch." Cablegram from Beatty to Navez and Knoedler, August 5, 1905. Carnegie archive.
63. Floyd, *Architecture after Richardson*, 230.
64. Cablegram from Navez to Beatty, April 14, 1904 (repeated in letter April 18). Carnegie archive.
65. Letter from Knoedler to Beatty, August 22, 1905. Carnegie archive.
66. Cablegram from Beatty to French, April 20, 1905. Carnegie archive.
67. Cablegram from French to Beatty, April 21, 1905. Carnegie archive.
68. Letter from French to Beatty, April 21, 1905. Carnegie archive.
69. Letter from Enlart to Beatty, May 1905. Carnegie archive.
70. Letter from the mayor in Dijon to Paul Navez, May 23, 1905. Carnegie archive.
71. Letter from Navez to Beatty, June 16, 1905. Carnegie archive.
72. Letter from Pouzadoux to Beatty, May 20, 1905 (5875). A few years later Enlart sketched the character of his chief molder Edouard Pouzadoux, the son of the first molder at the Trocadéro, making it clear that he would not easily be bullied by an American billionaire: the majority of the works and the most important ones are made by these "deux maîtres ouvrier d'art," and authorized by their skill and integrity. Enlart, *Le Musée de sculpture comparée au Palais du Trocadéro*, 10.
73. Letter from Beatty to Enlart, November 10, 1905. Carnegie archive.
74. Letter from Beatty to Enlart, January 29, 1906. Carnegie archive.
75. Letter from Enlart to Beatty, July 27, 1906. Carnegie archive.
76. Letter from Beatty to Roland F. Knoedler, July 12, 1905. Carnegie archive.
77. Letter from Beatty to Roland F. Knoedler, July 12, 1905. Carnegie archive.
78. The price for the cast alone was at least forty thousand francs. Letter from Beatty to Pouzadox, September 12, 1906. Carnegie archive.
79. Gilman, *Museum Ideals of Purpose and Method*, 235–36.
80. Ibid., 236.
81. Ingrid A. Steffensen-Bruce, *Marble Palaces, Temples of Art: Art Museums, Architecture, and American Culture, 1890–1930* (Lewisburg, PA: Bucknell University Press, 1998), 215.
82. Scharf, *The Greek Court erected in the Crystal Palace, by Owen Jones*, vi.
83. Haskell and Penny, *Taste and the Antique*, 83–84.
84. Marcus Jacob Monrad, "Om et archæologisk Museum III," *Morgenbladet*, March 7, 1860, front page.
85. Pierre Le Brun, "A Collection of Plaster Casts. Report of the Agent," August 15, 1885. Read to the trustees at the quarterly meeting held November 22, 1885. Met archives.
86. Bilbey and Trusted, "'The Question of Casts,'" 469.
87. Robinson, "Report of Mr. Edward Robinson," 19.
88. Edward Robinson, *Catalogue of Casts. Part I. Museum of Fine Arts Boston* (Cambridge, MA: The Riverside Press, 1891), 3.
89. Robinson, "Report of Mr. Edward Robinson," 16. The first casts from the Assyrian sculptures were made at the British Museum in 1847 and immediately caused debate on the molding process's destruction of the surfaces. Reade, "Nineteenth-Century Nimrud," 14.
90. For the development of European monument legislation, see Swenson, *The Rise of Heritage*.
91. Robinson, "Report of Mr. Edward Robinson," 29.
92. Letter from Beatty to Arrondelle, March 23, 1906. Carnegie archive.
93. Letter from Navez to Beatty, April 6, 1906. Carnegie archive.
94. "Will you cable me at once if it would suit you to take it this way, otherwise you will have to relinquish the plan," Navez asked Beatty. Letter from Navez to Beatty, April 6, 1906. Carnegie archive.
95. Letter from Beatty to Knoedler, May 8, 1905. Carnegie archive.
96. Letter from Beatty to Knoedler, September 7, 1905. Carnegie archive.
97. Letter from secretary at the Metropolitan to Beatty, April 25, 1905. Carnegie archive.
98. Letter from Beatty to Knoedler, June 6, 1907. Carnegie archive.

99. Cablegram from Beatty to Navez, April 19, 1905. Carnegie archive.
100. Cablegram from Beatty to Navez, April 22, 1905. Carnegie archive.
101. Letter from Navez to Beatty, April 18, 1904. Carnegie archive.
102. Cablegram from Navez to Beatty, April 26, 1905. Carnegie archive.
103. Cablegram from Navez to Beatty, April 27, 1905. Carnegie archive.
104. Letter from Navez to Beatty, April 27, 1905. Carnegie archive.
105. Cablegram from Beatty to Pouzadoux, May 4, 1905. Carnegie archive.
106. "The favor will be considered a great one, and highly esteemed by the Institute and Mr. Carnegie as well . . . The work occupies a very important place in our plan, and if it might be secured through your kind favor, we will be correspondingly grateful": "Your persistent and successful efforts in securing the privilege of reproducing this noble monument are deeply appreciated," etc. Carnegie archive.
107. Letter from Beatty to the mayor of Saint-Gilles-du-Gard, June 5, 1905. Carnegie archive.
108. Cablegram from Knoedler to Beatty, September 26, 1905. Carnegie archive.
109. Cablegram from Beatty to Navez, March 31, 1906. 5755. Letter to Beatty from Navez, April 6, 1906. Carnegie archive.
110. Letter from Beatty to Navez, June 19, 1906. Carnegie archive.
111. Letter from Beatty to Knoedler, May 8, 1905. Carnegie archive.
112. Letter from Beatty to Navez, June 7, 1905. Carnegie archive.
113. In May 1905 Knoedler was "authorized to make any reasonable offer to secure St. Gilles," and asked to send Beatty a "comprehensive but brief cable" to give him the "satisfaction of knowing that you have succeeded, as I feel sure you will." Letter from Beatty to Knoedler, May 8, 1905. Carnegie archive.
114. Letter from Beatty to Navez, June 7, 1905. Carnegie archive.
115. Cablegrams from Navez and Knoedler to Beatty, August 4, 1905. The agreement was set up by Knoedler: Pouzadoux was asked to execute "the three porches, ornamenting the western front of the church," the date of delivery is fixed to May 1, 1906. Letter from Knoedler to Pouzadoux, August 19, 1905. Carnegie archive.
116. Letter from Pouzadoux to the secretary of the Department of Fine Arts, Carnegie Institute, August 1, 1906. Carnegie archive.
117. Letter from Beatty to Knoedler, September 7, 1905. Carnegie archive.
118. Letters from Navez to Beatty, January 12 and April 21, 1906. Carnegie archive.
119. Letters from Navez to Beatty, May 4, 11, and 18, 1906. Carnegie archive.
120. To his colleague at the Art Institute in Chicago, he reported triumphantly: "I ordered the entire porch of St. Gilles, including the wall above the portals, and the steps. Do you not think it will be a noble exhibit in a hall 125–125 feet square?" Letter from Beatty to French, April 30, 1906. Carnegie archive.
121. Robinson, "Report of Mr. Edward Robinson," 11.
122. To address the absence of sculpture from antiquity by means of plaster casts, the collector Hans West recommended that either the secretary La Valle or the molder Getti at Museum Napoleon be contacted. Hans West, *Raissoneret Catalog over Consul West's Samling af Malerier med innledning samt liste over Haandtegninger, Figurer, Kobberstik og trykte Værker Samlingen tilhørende* (Copenhagen: Andreas Seidelin, 1807), xiv.
123. Robinson, "Report of Mr. Edward Robinson," 11–12.
124. Smith, *Art Education, Scholastic and Industrial*, 256.
125. *Catalogue of Plaster Reproductions from Antique, Medieval and Modern Sculpture Made and for Sale by P. P. Caproni and Brother* (Boston, 1911).
126. *Supplement for 1914 to Catalogue of Caprioni Casts: Reproductions from Antique, Medieval and Modern Sculpture* (Boston, 1914), 2.
127. *Catalogue & Price List of Plaster Re-Productions, of Antique, Grecian, Roman, Mediæval and Modern Statues, Statuettes, Busts, &c. for Sale by L. Castelvecchi, Manufacturer and Importer, 143 Grand Street, New York* (n.d.).
128. Letter from Beatty to the director, The Museum of Egyptian Antiquities, Palace of Gizeh, February 14, 1906. Carnegie archive.
129. Letter from D. F. Donovan & Co., Plain and Ornamental Plasterers, Cement Works, Boston to Beatty, July 28, 1906. Carnegie archive.
130. Confirmed in letter from P. P. Caproni to Beatty, December 4, 1905. Carnegie archive.
131. Jenkins, "Acquisition and Supply of Casts from the Parthenon Sculptures from the British Museum, 1835–1939," 108.
132. In 1919 the Brucciani stock of casts and molds were transferred to the Victoria and Albert Museum, but the casts made from worn-out molds were inferior in

133. Letter from Pietro Caproni to Beatty, December 4, 1905. Carnegie archive.
134. Letter from Navez to Beatty, June 15, 1905. Carnegie archive.
135. Letter from Navez to Beatty, April 6, 1906. Carnegie archive.
136. Letter from Navez to Beatty, May 5, 1905. Carnegie archive.
137. Letter from Navez to Beatty, June 2, 1905. Carnegie archive.
138. Letter from Navez to Beatty, September 22, 1905. Carnegie archive.
139. Letter from Navez to Beatty, August 1, 1905. Carnegie archive.
140. Letter from Navez to Beatty, August 18, 1905. Carnegie archive.
141. Letter from Navez to Beatty, August 2, 1905. Carnegie archive.
142. Letter from Navez to Beatty, June 15, 1905. Carnegie archive.
143. Letter from Beatty to Messrs. P. P. Caproni and Brother, July 3, 1905. Carnegie archive.
144. Letter from Beatty to Pouzadoux, December 26, 1906. Carnegie archive.
145. Letter from Pietro Caprioni to Beatty, June 28, 1905. Carnegie archive.
146. Letter from P. P. Caproni to Beatty, August 11, 1906. Carnegie archive.
147. Letter from Beatty to Navez, August 11, 1906. Carnegie archive.
148. Letter from D. Brucciani & Co. to Beatty, August 9, 1904. Carnegie archive.
149. Letter from D. Brucciani & Co. to Kent, August 9, 1904. Letter to Messrs. D. Brucciani and Co. from Beatty, March 15, 1906. Carnegie archive.
150. Toker, *The Hall of Architecture*, 14, 16.
151. Report of the Committee of Sculptures and Casts. October 30, 1894. Met archives.
152. Letter from Beatty to Pouzadoux, November 19, 1905. Carnegie archive.
153. Letter from Beatty to Pouzadoux, December 26, 1905. Carnegie archive.
154. Cablegrams from Beatty to Navez, June 4, 1906, and July 9, 1906. Carnegie archive.
155. Letter from Pouzadoux to Beatty, July 14, 1906. Carnegie archive.
156. Van Trump, *An American Palace of Culture*, 32.
157. Letter from French to Beatty, November 13, 1905. Carnegie archive.
158. Letters from French to Beatty, April 28, 1906, and June 22, 1906. After the opening French asked whether he might copy the doors and hinges of Saint-Gilles to display in Chicago, which would have resulted in a new unique plaster monument, the central doorway with doors, exclusive to the Chicago edition. Letter from French to Beatty, September 17, 1907. Carnegie archive.
159. Letter from Enlart to Beatty, November 24, 1906. Carnegie archive.
160. Letter from de Sachy to Beatty, April 15, 1905. Carnegie archive.

Chapter 5
The Yale Battle of the Casts: Albers vs. Rudolph

1. C. Ray Smith, "Interview no. 7 with Paul Rudolph, 1977," 7. In that he planned to write "The Biography of the Building," Smith's 1981 manuscript and many interviews with a number of people, including the architect, are important sources for Rudolph's thoughts on the casts. Smith's raw transcription is characterized by poor orthography including misspelling of well-known names and artworks, of which the most obvious errors are corrected in the following quotes. C. Ray Smith Files on the Yale Art and Architecture Building by Paul Rudolph. Box 1. Manuscripts and Archives, Yale University Library.
2. Walter Benjamin, *The Origin of the German Tragic Drama*, trans. John Osborn (London: Verso, 1963), 177–78.
3. Mark Alden Branch, "The Building That Won't Go Away," *Yale Alumni Magazine*, February 1998.
4. Robert A. M. Stern quoted from Sarah Mulrooney, "The Architecture of Influence: Paul Rudolph's Art & Architecture Building" (PhD diss., University of Cork, 2014), 136.
5. Benjamin, *The Origin of the German Tragic Drama*, 176.
6. "Death of the Gargoyle," *Time Magazine*, November 15, 1963, 53.
7. Adrian Forty, *Concrete and Culture: A Material History* (London: Reaktion Books, 2012), 52.
8. Ellen Perry Berkeley, "Architecture on the Campus: Yale, Building as a Teacher," *Architectural Forum* 127 (July–August 1967): 48.
9. Rudolph's inaugural speech appeared as "Architecture: The Unending Search," *Yale Alumni Magazine* 21, no. 8 (May 1958). Reprinted as "Alumni Day Speech: Yale School of Architecture, February 1958," *Oppositions* 4 (1974): 142.
10. John Ferguson Weir, "The Yale Collection of Casts," 1–2. Undated lecture manuscript, probably turn of the century. John Ferguson Weir Papers (MS 550), Manuscripts and Archives, Yale University Library.

11. Betsy Fahlman, *John Ferguson Weir: The Labor of Art* (Newark: University of Delaware Press, 1997), 134.
12. For the school's strong Beaux-Arts tradition, see Robert A. M. Stern and Jimmy Stamp, *Pedagogy and Place: 100 Years of Architecture and Education at Yale* (New Haven, CT: Yale University Press, 2016), particularly chapters 1 and 2, "Beginnings: Toward an American Beaux-Arts, 1869–1916" and "An American Beaux-Arts, 1916–1947."
13. "Charles H. Sawyer Discusses Josef Albers. A Conversation with Fred Horowitz February 12, 2000," 1, Box 1, Fred Horowitz papers. Archives of the Josef and Anni Albers Foundation, Bethany, Connecticut. Hereafter, Fred Horowitz papers.
14. Letter from Perkins quoted in Edward E. Salisbury, "Yale School of the Fine Arts," *The College Courant*, February 27, 1869, 129. Salisbury was appointed professor of Arabic and Sanscrit languages and literature at Yale University in 1841.
15. Salisbury, "Yale School of the Fine Arts," 129.
16. Ibid.
17. Ibid.
18. The Nike of Samothrace came from the very first series of casts made at the Louvre and before a series of restorations would change her appearance radically. "Broken and incomplete as the statue now is, it is of the sublimest art," according to Weir. Among the early casts were metope-reliefs from the Temple of Salinus at Sicily purchased from the museum in Palermo, a series of metopes from the Harpy monument at Xanthos, a large relief from the sanctuary of Eleusis, the caryatid from the Erechtheion at the British Museum, an "exceptionally fine cast" of the Venus de Milo, Praxiteles's Hermes with the infant Dionysos found at the Hera temple at Olympia in 1877, the Apollo Belvedere and the Laocoön group, taken from the originals at the Vatican, and Ghiberti's Gates of Paradise from the Baptistery in Florence—the second reproduction made from molds in the British Museum. John Ferguson Weir, "The Yale Collection of Casts."
19. *Descriptive Catalogue of the Permanent Collections of Works of Art on Exhibition in the Galleries*, 2nd ed. (Philadelphia: The Pennsylvania Academy of Fine Arts, 1904), 4.
20. For a short history of this collection, see Cheryl Leibold, "The Historic Cast Collection at the Pennsylvania Academy of the Fine Arts," *Antiques & Fine Art*, Spring 2010.
21. William C. Brownell, "The Art Schools of Philadelphia," *Scribner's Monthly, an Illustrated Magazine for the People* 18, no. 5 (September 1879): 738.
22. *Descriptive Catalogue of the Permanent Collections of Works of Art on Exhibition in the Galleries* (1904), 90. This new collection suffered a nomadic existence before the current building was completed in 1876.
23. Brownell, "The Art Schools of Philadelphia," 739.
24. The collection also depicted the history of restoration by casts, e.g., with two versions of Venus de' Medici "without arms, as the original was found," and "complete, as in the restored original in the Uffizi gallery, Florence." *Catalogue of the Permanent Collection of the Pennsylvania Academy of the Fine Arts*, 7th ed. (1882), 13.
25. Mark Wigley, "Prosthetic Theory: The Disciplining of Architecture," *Assemblage*, no. 15 (August 1991): 20.
26. "Architectural Education in the United States I: The Massachusetts Institute of Technology," *American Architect and Building News* 24, no. 658 (August 4, 1888): 44.
27. Weir, "The Yale Collection of Casts," 1.
28. Horowitz, "Notes on a Conversation with George Heard Hamilton and Polly Hamilton at Williamstown June 3, 1992," 2. Box 1, Fred Horowitz papers.
29. Jill Pearlman, *Inventing American Modernism: Joseph Hudnut, Walter Gropius, and the Bauhaus Legacy at Harvard* (Charlottesville: University of Virginia Press, 2007), 1.
30. Quoted from ibid., 55.
31. Jill Pearlman, "Joseph Hudnut's Other Modernism at the 'Harvard Bauhaus,'" *Journal of the Society of Architectural Historians* 56, no. 4 (December 1997): 4579.
32. Betsy Fahlman, "A Plaster of Paris Antiquity: Nineteenth Century Cast Collections," *Southeastern College Art Conference Review* 12, no. 1 (1991): 9.
33. Horowitz, "Charles H. Sawyer Discusses Josef Albers. A Conversation with Fred Horowitz February 12, 2000," 1. Box 1, Fred Horowitz papers.
34. Ibid., 2.
35. Ibid., 3.
36. Brenda Danilowitz, "Teaching Design: A Short History of Joseph Albers," in Frederick A. Horowitz and Brenda Danilowitz, *Josef Albers: To Open Eyes. The Bauhaus, Black Mountain College, and Yale* (London: Phaidon, 2006), 43 and 70.
37. Letter from Sawyer to Albers, confirming that he would serve on the University Council's Committee on the Divison of the Arts, and confirming the first meeting, April 24 and 25, 1948. Josef Albers Papers, MS 32, Box 2, Manuscripts and Archives, Yale University Library.
38. Danilowitz, "Teaching Design," 44. For the report: University Council Report of the Chairman of the Committee on the Division of the Arts (Architecture, Sculpture and Painting). Records of the School of Art and Architecture, Yale University (RU 189) Box

38. 4, Folder: University Committee on Architecture, Painting, and Sculpture 1948–1949. Manuscripts and Archives, Yale University Library.
39. Horowitz, "Notes on a conversation with George Heard Hamilton and Polly Hamilton at Williamstown," 1. Box 1, Fred Horowitz papers.
40. Josef Albers, *Interaction of Color* (1963) (New Haven, CT: Yale University Press, 1971), 75.
41. Ibid., 69 and 71.
42. Eeva-Liisa Pelkonen, "On the Actuality of Forms," *Materia Arquitectura*, no. 9 (2014): 40.
43. Albers, "Historical or Contemporary" (1924), trans. Russel Stockman, in *Josef Albers: Minimal Means, Maximum Effect* (Madrid: Fundación Juan March, 2014), 207–8.
44. Danilowitz, "Teaching Design," 25.
45. When Johannes Itten resigned from Bauhaus in Weimar 1923, Albers changed the subject of his course from *werklehre*, Principles of Craft, to Principles of Design. Ibid., 21.
46. Charles Sawyer to Robert Osborn, April 16, 1956. Records of the School of Art and Architecture, Yale University (RU 189) Box 3, Folder: Osborn 1957–1958, Manuscripts and Archives, Yale University Library.
47. Horowitz, "Albers the Teacher," in *To Open Eyes*, 99 and 140.
48. Ibid., 171.
49. Ibid., 177.
50. Ibid., 151.
51. Horowitz, "Conversation with Bernard Chaet, March 4, 1992," 10. Box 1, Fred Horowitz papers.
52. Ibid.
53. Nikolaus Pevsner, "Address Given by Nikolaus Pevsner at the Inauguration of the New Art and Architecture Building of Yale University 9 November 1963," *Journal of the Society of Architectural Historians* 26, no. 1 (March 1967): 5.
54. Albers's first annual report to A. Whitney Griswold, President, Yale University. June 21, 1951. Josef Albers papers. Box 2, Manuscripts and Archives, Yale University Library.
55. Horowitz, "Albers the Teacher," 140.
56. Rudolph quoted from "A & A: Yale School of Art and Architecture; Paul Rudolph, Architect," *Progressive Architecture* 45 (February 1964): 115.
57. Among them, Eero Saarinen's Morse and Stiles Colleges and Ingalls Rink, the Beinecke Library by Gordon Bunshaft (of Skidmore, Owings & Merrill), Philip Johnson's Kline Biology Tower and Kline Chemistry Laboratory, and Rudolph's Greeley Forestry Laboratory and Married Student Housing.
58. Paul Rudolph, "Regionalism in Architecture," *Perspecta* 4 (1957): 19 and 15.
59. Ibid., 19.
60. Paul Rudolph, "Paul Rudolph," *Perspecta* 1 (Summer 1952): 19.
61. Rudolph, "Alumni Day Speech," 142.
62. Paul Rudolph, "Six Determinants of Architectural Form," *Architectural Record* 120 (October 1956): 183.
63. Rudolph, "Alumni Day Speech," 142. This passage appeared almost verbatim in "Six Determinants of Architectural Form" and in "To Enrich Our Architecture," *Journal of Architectural Education* 13, no. 1 (Spring 1958).
64. Rudolph quoted in "A & A: Yale School of Art and Architecture," 115.
65. Ibid.
66. Of these panels 148 had survived and were restored and reinstalled in 2008. Robert Shure, "Yale Plaster Cast Collection. Condition & Treatment Report" (unpublished, February 2008).
67. Smith, "Interview no. 7 with Paul Rudolph, 1977," 5–6.
68. Ibid.
69. Kurt Forster, " 'Hey, Sailor . . .': A Brief Memoir of the Long Life and Short Fame of Paul Rudolph," *ANY: Architecture New York*, no. 21 (1997): 14.
70. For an explanation of the production, see Mulrooney, "The Architecture of Influence," chapter 3, "Paul Rudolph's Spatial and Material Influences."
71. Rudolph, "Alumni Day Speech," 143.
72. Charles Jencks, "Esprit Nouveau est mort à New Haven or Meaningless Architecture," *Connections* (Graduate School of Design, Harvard University, 1964), 18.
73. Salisbury, "Yale School of the Fine Arts," 129.
74. Timothy M. Rohan, "Rendering the Surface: Paul Rudolph's Art and Architecture Building at Yale," *Grey Room*, no. 1 (Autumn 2000): 93.
75. Smith, "Interview no. 7 with Paul Rudolph, 1977," 5.
76. A few Egyptian casts appeared at the Musée des monuments Français and at the Musée de sculpture comparée. The Pennsylvania Academy of Fine Arts had "Eleven casts from Egyptian monuments at Luxor and Thebes, taken by Geo. R. Gliddon for Dr. S. G. Morton, about 1847," *Catalogue of the Collection of the Pennsylvania Academy of the Fine Arts* (1882), 17. In 1841, George Gliddon had published his *Appeal to the Antiquaries of Europe on the Destruction of the Monuments of Egypt*.
77. Still, owing to diplomatic maneuvers, Robinson had received from Heinrich Karl Brugsch-Bey, the director at the museum in Cairo, a list of the Egyptian casts available, which also specified the desired objects "which cannot be cast because of the danger

78. Charles Trick Currelly, *I Brought the Ages Home* (Toronto: The Ryerson Press, 1958), 133–34, 142.
79. Walter Tyndale, *Below the Cataracts* (London: William Heinemann; Philadelphia: J. B. Lippincott Company, 1907), 156–72, and 137.
80. Only one fragment, "Portrait of the Queen of Punt," made it into the 1908 *Catalogue of Casts*, but the whole bas-relief, which was mounted in room 38, appeared in the list of accessions the same year. "Egyptian Art," inventory # 26, *Catalogue of the Collection of Casts* (1908), 5. "Complete List of Accessions," *Metropolitan Museum of Fine Arts Bulletin* 3, no. 12 (December 1908): 236.
81. Smith, "Interview no. 1 with Gibson Danes, 1978," 2. C. Ray Smith Files on the Yale Art and Architecture Building by Paul Rudolph. Manuscripts and Archives, Yale University Library. The Egyptian casts were "put in the upper room on the northeast corner, they may or may not still be there," Rudolph later recalled. Smith, "Interview no. 7 with Paul Rudolph, 1977," 6.
82. Smith, "Interview no. 7 with Paul Rudolph, 1977," 18.
83. Soane, "Crude Hints," 69.
84. Berkeley, "Yale: A Building as a Teacher," 48, 50.
85. In 1973 Charles Jencks stated that the building, "quite recently, has been burned out supposedly as a protest against Yale's restrictive admission and teaching policy." Jencks, *Modern Movements in Architecture* (London: Penguin, 1987), 191.
86. Sedlarz, "Incorporating Antiquity," 198.
87. Toker, *The Hall of Architecture*, 10, 13.
88. The Minerva surveying the drafting room was the only object of any consequence to survive the fire that destroyed the fourth and fifth levels of the building, according to Tom McDonough, "The Surface as Stake: A Postscript to Timothy M. Rohan's 'Rendering the Surface,'" *Grey Room*, no. 5 (Autumn 2001): 103.
89. Shure, "Yale Plaster Cast Collection: Condition and Treatment Report." The collection is still not properly catalogued.
90. This was written in 1991, and the building's run-down state must have affected the impression the casts produced. Fahlman, "A Plaster of Paris Antiquity," 9.
91. Smith, "Interview no. 7 with Paul Rudolph, 1977," 6.
92. Branch, "The Building That Won't Go Away."
93. Michael J. Crosbie, "Paul Rudolph on Yale's A&A Building: His First Interview on His Most Famous Work," *Architecture*, November 1988, 101.
94. Rudolph quoted from "A & A: Yale School of Art and Architecture," 126.
95. Russell M. Sanders et al., "Sustainable Restoration of Yale University's Art + Architecture Building," *APT Bulletin: Journal of Preservation Technology* 42, nos. 2/3 (2011): 32–33.
96. See Mulrooney, "The Architecture of Influence," n101.
97. Adolf Furtwängler, *Masterpieces of Greek Sculpture* (1893) (London: William Heinemann, 1895), 5.
98. Edward Robinson refers to Furtwängler's "restoration" as "a most interesting example of the discoveries which are sometimes made in museum" in entry 109, "Supposed Copy of the Lemnian Athena of Phidias. The head in Bologna, the body composed of two statues in Dresden." Robinson, *Catalogue of Casts. Part III. Greek and Roman Sculpture* (Boston: The Riverside Press, Cambridge, 1886), 86–89.
99. Ibid., 5.
100. Salvatore Settis, "Supremely Original. Classical Art as Serial, Iterative, Portable," in Settis, ed., *Serial/Portable Classic*, 57.
101. Quatremère de Quincy, "Letters to Miranda," in *Letters to Miranda and Canova on the Abduction of Antiquities from Rome and Athens*, 102.
102. See Ernst, "Not Seeing the Laocoön." Zahle has documented the fluctuations in the Laocoön as a history of its casting and has shown how the substantial changes in the original across the centuries were mediated by casts. Jan Zahle, "Laocoön in Scandinavia—Uses and Workshops 1587 Onwards," in Fredriksen and Marchand, eds., *Plaster Casts*.
103. "Mr. Di Cesnola's Statues: The Story of Their Restoration by an Eye-Witness," *New York Times*, November 2, 1883.
104. Salisbury, "Yale School of the Fine Arts."
105. J. R. Piggot, *Palace of the People: The Crystal Palace at Sydenham 1854–1936* (London: C. Hurst & Co., 2008), 118.
106. Donaldson et al., "The Architectural Collections in the Museum at Brompton," 614.
107. Vincent Scully, "Art and Architecture Building, Yale University," *Architectural Review* 135 (May 1964): 325. Rohan, "Rendering the Surface," 87. Rudolph is quoted from "Death of the Gargoyle," 52.
108. Forster, "'Hey, Sailor . . . ,'" 15.
109. Paul Rudolph, "The Essence of Architecture Is Space," (1969), reprinted in Rudolph, *Writings on Architecture* (New Haven, CT: Yale School of Architecture, 2009), 102.
110. Pevsner, "Address Given by Nikolaus Pevsner," 6.
111. Jencks, "Esprit Nouveau est mort à New Haven," 18.
112. Ibid., 16.
113. Ibid.
114. Ibid., 18–19.

115. Sibyl Moholy-Nagy, "The Future of the Past," *Perspecta* 7 (1961): 65.
116. Ibid., 66.
117. Ibid., 73.
118. Scully, "Art and Architecture Building, Yale University," 332.
119. Vincent Scully, *Modern Architecture: The Architecture of Democracy* (1961) (New York: George Braziller, 1974), 50.
120. Vincent Scully, *American Architecture and Urbanism* (London: Thames and Hudson, 1969), 204.
121. Ibid.
122. Ibid., 202.
123. Forster, "'Hey, Sailor . . . ,'" 13, 15.
124. Rohan, "Rendering the Surface," 100.
125. Ibid., 94, 93.
126. Ilse M. Reese and James T. Burns Jr., "The Opposites: Expressionism and Formalism at Yale," *Progressive Architecture*, February 1964, 128.
127. Scully, *American Architecture and Urbanism*, 257.
128. "Death of the Gargoyle," 53.
129. Paul Rudolph, "Enigmas of Architecture," *A+U* 80 (1977): 318.
130. "A & A: Yale School of Art and Architecture," 109.
131. Timothy M. Rohan, *The Architecture of Paul Rudolph* (New Haven, CT: Yale University Press, 2014), 93.
132. Scully, "Art and Architecture Building, Yale University," 325.
133. "To lessen the blow of the demolition the commission on Chicago Architectural Landmarks distributed fragments from the building to major public institutions in the Chicago area." Lauren S. Weingarden, "Adler and Sullivan," in Saliga, ed., *Fragments of Chicago's Past*, 138.
134. Rohan, "Rendering the Surface," 96.
135. Ibid.
136. Georges Didi-Huberman, *Confronting Images: Questioning the Ends of a Certain History of Art*, trans. John Goodman (University Park: Pennsylvania State University Press, 2004), 38.
137. Mikhail Bakhtin, "Forms of Time and of the Chronotope in the Novel: Notes towards a Historical Poetics" (1937–38), in *The Dialogic Imagination*, trans. Carol Emerson and Michael Holquist (Austin: University of Texas Press, 1982), 84.
138. Ibid.
139. Ibid., 250.
140. Smith, "Interview no. 7 with Paul Rudolph, 1977," 6.
141. "Death of the Gargoyle," 53.
142. Jencks, "Esprit Nouveau est mort à New Haven," 19.
143. Wagner, *Jean-Baptiste Carpeaux*, 96.
144. Ibid., 98, 96.
145. "Death of the Gargoyle," 53.
146. Ibid.
147. Reese and Burns, "The Opposites: Expressionism and Formalism at Yale," 129.
148. Whitehill, *Museum of Fine Arts Boston*, 1:199.
149. Ibid., 202.
150. Ibid., 201.
151. Smith, "Interview no. 7 with Paul Rudolph, 1977," 5.
152. Horowitz, "Notes on a conversation with George Heard Hamilton and Polly Hamilton at Williamstown," 1. Box 1, Fred Horowitz papers.
153. Albers, the eighth and last report to the president of Yale University, June 27, 1958. Josef Albers papers, Manuscripts and Archives, Yale University Library.
154. Rudolph, "Alumni Day Speech," 142–43.
155. Weir quoted from Fahlman, *John Ferguson Weir*, 142n85, and "A Plaster of Paris Antiquity," 9.
156. Smith, "Interview no. 1 with Gibson Danes, 1978," 2.
157. T. S. Eliot, "Tradition and the Individual Talent," in *The Sacred Wood: Essays on Poetry and Criticism* (1928) (New York: Barnes and Noble, 1960), 49.
158. "Vincent Scully Discusses Josef Albers. A conversation with Fred Horowitz December, 9, 1995," 10. Fred Horowitz papers.
159. Ibid., 2.
160. Ibid., 4 and 8.
161. Rudolph quoted in "A & A: Yale School of Art and Architecture," 115.
162. Paul Rudolph, "Excerpts from a Conversation," *Perspecta* 22 (1986): 105.
163. Rudolph, "To Enrich our Architecture," 10.

Coda

Lost Continents, Fluctuating Objects

1. Johann Joachim Winckelmann, *History of the Art of Antiquity*, trans. Harry Francis Mallgrave (Los Angeles: The Getty Research Institute, 2006), 351.
2. Johann Joachim Winckelmann, "Thoughts on the Imitation of Greek Works in Painting and Sculpture" (1755), in *The Art of Art History: A Critical Anthology*, ed. Donald Preziosi (Oxford: Oxford University Press, 2009), 30.
3. Hans-Georg Gadamer, *Truth and Method* (1960), trans. Joel Weinheimer and Donald G. Marshall (London: Sheed & Ward, 1989), xxxv.
4. The Pergamon Altar in Berlin, from early on proliferating in plaster pieces that were also employed in the reconstructed monument, is a chef-d'oeuvre in the history of ambiguous originals and their displacements. How "can we characterize the architectural exhibits of the Museum," asks Can

Bilsel, "as *restoration, reconstructions, or reproduction*? If the work on display should be read as a restored ancient monument—for instance the 'Great Altar of Pergamon'—where does the frame of the museum end and where does its exhibit, the work of architecture, begin?" Bilsel, *Antiquity on Display*, 17.

5. Settis, "Supremely Original," 61.
6. Ibid., 68.
7. Sally M. Foster and Neil G. W. Curtis, "The Thing about Replicas—Why Historic Replicas Matter," *European Journal of Archeology* 19, no. 1 (2016): 123.
8. The trial was mentioned in the *Times*, June 2, 1892. The offender, operating out of Manchester, pursued his dark deeds of pirating, making, selling, and disposing of copies made from copyrighted copies, thus infringing on the earlier ruling. In the new motion the defendant was ordered to file an affidavit acknowledging all the casts and models as the sole right and property of Brucciani & Co., return any casts and models to the plaintiff, and defray the full cost of the motion. *Times*, February 14, 1894.
9. See Mari Lending, "The Urgencies of Theoretical Stuff," in 2000+. *The Urgencies of Architectural Theory*, ed. James Graham (New York: GSAPP Books, 2015).
10. Nagel, *Medieval Modern*, 21.
11. "In Conversation: Philippe de Montebello with David Carrier and Joachim Pissarro," *Brooklyn Rail*, May 6, 2014.
12. Barry Bergdoll, "The Paradoxical Origins of MoMA's Model Collection," in *Modelling Time: The Permanent Collection, 1925–2014*, ed. Mari Lending and Mari Hvattum (Oslo: Torpedo Press, 2014), 160.
13. The casts that survived the 1936 fire were transferred to the Victoria and Albert Museum. Piggott, *Palace of the People*, 87.
14. Enlart, *Le Musée de sculpture comparée au Palais du Trocadéro*, 2.
15. Quoted from Flour, "'On the Formation of a National Museum of Architecture,'" 234.
16. Quoted from Bilbey and Trusted, "'The Question of Casts,'" 475.
17. *Annual Report of the Trustees of the Metropolitan Museum of Art*, no. 36 (1905): 5.
18. Henry James, *The American Scene* (New York: Harper & Brothers Publishers, 1907), 189. In the American context, "it was only through the institutionalization of the polarity between original and copy, authentic and fake, that art became irrevocably associated with notions of originality and authenticity." Alan Wallach, "The American Cast Museum: An Episode in the History of the Institutional Definition of Art," in *Exhibiting Contradiction: Essays on the Art Museum in the United States* (Amherst: University of Massachusetts Press, 1998), 39.
19. "Rare Assyrian Art Is Rockefeller Gift. Metropolitan Museum Receives Sculpture from Palace of Ancient King of Nimrud," *New York Times*, January 26, 1933. The sculptures were bought from the heirs of Sir John Guest, who had sponsored Layard's excavations in the 1840s.
20. Letter to Mr. Kent From H. E. Winlock, November 5, 1932. Met archives.
21. A visitor from Fort Knox, Kentucky, who had written to express sorrow over the missing casts, received this reply from the museum's vice director: "While your disappointment in not seeing the casts during your visit is understandable, nevertheless you must, I feel, bear in mind that we have, apart from the casts, approximately twelve acres of exhibits of actual works of great beauty and significance." Letter from Horace H. F. Jayne to George R. Allston, January 17, 1942. Met archives. When interviewed at the Metropolitan on her book *Glittering Images: A Journey through Art from Egypt to Star Wars*, Camille Paglia spoke of childhood memories of the halls filled with plaster casts. Carol Kino, "Always Ready with a Barb," *New York Times*, September 27, 2012.
22. The sculptor Antonio Salemme expressed his "shock" at the new appearance of the gallery of Greek casts, having attained "a glorified Woolworth atmosphere or, perhaps, achieving a third-rate interior decorator's idea of Greek sculpture," and he reainded the museum that a cast is at its best when not tampered with: "A plaster cast is much closer to the original sculpture than the best imaginable translation would be to a literary work. Like a good translation, it is not an imitation but a rendering in a different medium." Letter to William Church Osborn, resident of the Metropolitan Museum, from Antonio Salemme, February 25, 1943. "Patination is, of course, not imitation; one merely attempts to give the cast of a bronze a bronze-like appearance; the cast of a marble a marble-like appearance. One tries to vary the patination from one piece to another for the sake of variety, and of public interest. No attempt is made to 'jazz up' these casts; it is merely a question of making them honest and complete reflections of their originals." Letter to Francis Henry Taylor from John G. Phillips, associate curator, March 15, 1943. Met archives.
23. See Jean-Louis Cohen, "Petite histoire du Grand Paris," *Critique* 6 (2010), and "From the Ground Down."
24. Nicolas Sarkozy, "Déclaration de M. Nicolas Sarkozy, Président de la République, sur l'architecture et la politique du patrimoine" (Paris, September 17, 2007). http://discours.vie-publique.fr/notices/077002719.html.

25. For a historical contextualization of this display, see Mari Lending, "Negotiating Absence: Bernard Tschumi's New Acropolis Museum in Athens," *Journal of Architecture* 15, no. 5 (2009).
26. David Joselit, *After Art* (Princeton, NJ: Princeton University Press, 2013), 7.
27. "It's impossible to stand in the top-floor galleries, in full view of the Parthenon's ravaged, sun-bleached frame, without craving the marbles' return," exclaimed architectural critic Nicolai Ouroussoff when reviewing the new museum. Nicolai Ouroussoff, "Where Gods Yearn for Long-Lost Treasures," *New York Times*, October 28, 2007.
28. Layard, *The Assyrian Court, Crystal Palace*, 17.
29. "Ashurnasirpal II's Throne Room, Nimrud," in Adam Lowe et al., *A Selection of Stories about Cultural Preservation, Innovation, Collaboration, Technology Transfer, Digital Documentation, Digital Restoration and Re-Materialisation Carried Out by Factum Foundation* (Madrid: Factum Foundation, 2016), 39.
30. Printed note added to the British Museum's List of Casts. Enclosed in letter from Paul Ryan, managing director at Brucciani & Co., to Beatty, January 6, 1906. 6097. Carnegie archive.
31. During the recording, Factum Arte found color left on the one panel that was never cast in Dresden, while the color originally on the pieces from the throne room was mostly effaced, either "during the process of plaster casting at the British Museum or during subsequent cleaning." The planned scanning of the originals at Nimrud was canceled because of the war. New plaster casts made from the British Museum's Assyrian sculptures were sent to the University of Mosul in 2014. These too were probably destroyed by the IS, but they are readily reproducible from stored data. For the documentation of this work, see Lowe et al., *A Selection of Stories about Cultural Preservation, Innovation, Collaboration, Technology Transfer, Digital Documentation, Digital Restoration and Re-Materialisation Carried Out by Factum Foundation*, 28–39.
32. Guha-Thakurta "The Compulsion of Visual Representation in Colonial India," 110.
33. http://www.classics.cam.ac.uk/museum/collections/peplos-kore. For the history of this study collection of classical casts and its devaluation, see Mary Beard, "Casts and Cast-Offs: The Origins of the Museum of Classical Archaeology," *Cambridge Classical Journal* 39 (1994).
34. Jane Margolies, "Move Over, Marble: Plaster Gets Pride of Place," *New York Times*, September 2, 2016.
35. Henry Cole, "Memorandum on the International Exchange of Copies of Works of Fine Art," February 8, 1864. Reprinted in *Catalogues of Reproductions of Objects of Art, in Metal, Plaster, and Fictile Ivory, Chromolithography, Etching, and Photography. Selected from the South Kensington Museum, Continental Museums, and Various Other Public and Private Collections* (London: George E. Eyre and William Spottiswood, 1869), vi.
36. Nick Clark, "3D Printers Revive the Art of Casting Your Own Venus," *Independent*, December 27, 2014.
37. Charly Wilder, "Nefertiti 3-D Scanning Project in Germany Raises Doubt," *New York Times*, March 10, 2016.
38. Latour and Lowe, "The Migration of the Aura," 278.
39. Samuel L. Parrish, *Historical, Biographical, and Descriptive Catalogue of the Objects Exhibited at the Southampton Art Museum* (New York: Benjamin H. Tyrrel, 1898), IX.
40. See Mari Lending, "Reciting the Tomb of Tutankhamun," *Perspecta* 49 (2016).
41. Giovanni Belzoni, *Narrative of the Operations and Recent Discoveries in Egypt and Nubia* (London: John Murray, 1820), 231.
42. Ibid., 240.
43. Peter Aspden, "Fit for a King: Tutankhamun's Replica Burial Chamber," *FT Magazine*, April 17, 2014.
44. Enlart, *Le Musée de sculpture comparée au Palais du Trocadéro*, 1.
45. Le Corbusier, *When the Cathedrals Were White* (1947), trans. Francis E. Hyslop, Jr. (New York: McGraw-Hill Book Company, 1964), xxi.
46. Ibid., 4.
47. Ibid.
48. Ibid., 5.
49. Camille Enlart's tenure as director ran from 1903 through 1927, and in 1926 Charles-Édouard Pouzadoux, the chief molder at the Trocadéro since 1893, retired. With a new director and the renaming of the institution, the politics of surface treatment changed at the Trocadéro, and the regime of plaster white monuments was abandoned. For changing regimes of patina, see Beauzac, "L'histoire matérielle des moulages du musée de Sculpture comparée."
50. Georges Didi-Huberman, "Before the Image, before Time: The Sovereignty of Anachronism," in *Compelling Visuality: The Work of Art in and out of History*, ed. Claire Farago and Robert Zwijnenberg (Minneapolis: University of Minnesota Press, 2003), 33.
51. Ibid.
52. Alexander Nagel and Christopher S. Wood, *Anachronic Renaissance* (New York: Zone Books, 2010), 299.

Bibliography

Archival Sources

C. Ray Smith files on the Yale Art and Architecture Building by Paul Rudolph. Manuscripts and Archives, Yale University Library.

Cast Collection Files, The Metropolitan Museum of Art Archives, New York.

Correspondence Archives. University Museum of Bergen.

Fred Horowitz papers. Archives of the Josef and Anni Albers Foundation, Bethany, Connecticut.

Hall of Architecture Archive, Heinz Architectural Center Library Collection. Carnegie Museums of Pittsburgh, Pittsburgh.

Institutional Archives of the Art Institute of Chicago.

John Ferguson Weir Papers. Manuscripts and Archives, Yale University Library.

Josef Albers Papers. Manuscripts and Archives, Yale University Library.

Royal Cast Collection archives. National Gallery of Denmark, Copenhagen.

V&A Archive, Victoria and Albert Museum, London.

Viollet-le-Duc, "Musée de sculpture comparée appartenant aux divers centres d'art et aux diverses époques." The reports are dated June 11 and July 12, 1879. Gallica, BNF.

Yale School of Art & Architecture, Administrative records of the Dean, 1943–1976. Manuscripts and Archives, Yale University Library.

Published Sources

"A & A: Yale School of Art and Architecture; Paul Rudolph, Architect." *Progressive Architecture* 45 (February 1964): 108–27.

A Constant Reader. "Letter to the Editor of the Times." *Times*, July 19, 1823.

Adorno, Theodor W. "Valéry Proust Museum" (1955). In Adorno, *Prisms*, translated by Samuel and Sherry Weber. Cambridge, MA: MIT Press, 1997.

Advertisement. *Times*, June 27, 1822.

Albers, Josef. "Historical or Contemporary" (1924). Translated by Russel Stockman. In *Josef Albers: Minimal Means, Maximum Effect*. Madrid: Fundación Juan March, 2014.

———. *Interaction of Color* (1963). New Haven, CT: Yale University Press, 1971.

Allais, Lucia. "Integrities: The Salvage of Abu Simbel." *Grey Room* 50 (Winter 2013): 6–45.

Angoulvent, P.-J. *Catalogue des Moulages en vente au musée de sculpture comparée*. Paris: Musée de sculpture comparée, Palais du Trocadéro, 1932.

Annual Report of the Trustees of the Metropolitan Museum of Art, no. 36 (1905).

"The Architectural Courts, South Kensington Museum: The Trajan Column and the Portico de la Gloria, Santiago de Compostela." *The Builder*, October 4, 1873, 789–90.

"Architectural Education in the United States I: The Massachusetts Institute of Technology." *American Architect and Building News* 24, no. 658 (August 4, 1888): 47–49.

Arrhenius, Thordis. *The Fragile Monument: On Conservation and Modernity*. London: Blackdog, 2012.

Aspden, Peter. "Fit for a King: Tutankhamun's Replica Burial Chamber." *FT Magazine*, April 17, 2014.

Baker, Malcolm. "The Reproductive Continuum: Plaster Casts, Paper Mosaics and Photographs as Complementary Modes of Reproduction in the Nineteenth-Century Museum." In Fredriksen and Marchand, eds., *Plaster Casts*.

Bakhtin, Michael. "Forms of Time and of the Chronotope in the Novel: Notes towards a Historical Poetics" (1937–38). In *The Dialogic Imagination,* translated by Carol Emerson and Michael Holquist. Austin: University of Texas Press, 1982.

Bann, Stephen. *The Clothing of Clio: A Study of the Representation of History in Nineteenth-Century Britain and France*. Cambridge: Cambridge University Press, 1984.

———. *Distinguished Images: Prints in the Visual Economy of Nineteenth-Century France*. New Haven, CT: Yale University Press, 2013.

———. "Historical Text and Historical Object: Poetics of the Musée de Cluny." *Lotus International* 35 (1982): 37–43.

———. "Proust, Ruskin, Stokes, and the Topographical Project." In *Literature & Place, 1800–2000*, edited by Peter Brown and Michael Irwin, 129–46. Bern: Peter Lang, 2008.

Barak, On. *On Time. Technology and Temporality in Modern Egypt*. Berkeley: University of California Press, 2013.

Beard, Mary, "Casts and Cast-Offs: The Origins of the Museum of Classical Archaeology." *Cambridge Classical Journal* 39 (1994): 1–29.

Beauzac, Julie. "L'historie matérielle des moulages du musée de Sculpture comparée." *In Situ. Revue des patrimoines* 28 (2016): 1–17. http://insitu.revues.org/12670. DOI : 10.4000/insitu.12670.

Belzoni, Giovanni. *Narrative of the Operations and Recent Discoveries in Egypt and Nubia*. London: John Murray, 1820.

Benjamin, Walter. *The Origin of the German Tragic Drama*. Translated by John Osborn. Introduction George Steiner. London: Verso, 1963.

———. "The Work of Art in the Age of Its Technological Reproducibility." 2nd version. In *Walter Benjamin, Selected Writings*, vol. 3, *1935–1938*, translated by Edmund Jephcott et al. Cambridge, MA: The Belknap Press of Harvard University Press, 2002.

Bergdoll, Barry. "Introduction." In *Home Delivery: Fabricating the Modern Dwelling*, edited by Barry Bergdoll and Peter Christensen. New York: Museum of Modern Art, 2008.

———. "The Paradoxical Origins of MoMA's Model Collection." In *Modelling Time: The Permanent Collection, 1925–2014*, edited by Mari Lending and Mari Hvattum. Oslo: Torpedo Press, 2014.

Berkeley, Ellen Perry. "Yale: A Building as a Teacher." *Architectural Forum* 127 (July–August 1967): 47–53.

Bilbey, Diane, and Marjorie Trusted. " 'The Question of Casts': Collections and Later Reassessment of the Cast Collections at South Kensington." In Fredriksen and Marchand, eds., *Plaster Casts*.

Bilsel, Can. *Antiquity on Display: Regimes of the Authentic in Berlin's Pergamon Museum*. Oxford: Oxford University Press, 2012.

Bloch, R. Howard. "Viollet-le-Duc's 'Republic of Architectural Art': The Greco-Gothic Revival and Building in Modern France." *Perspecta* 44 (2001): 13.

Bode, Wilhelm. "Dr. Bode, German Art Expert, Criticizes Our Museums." *New York Times*, January 28, 1912.

Bordeleau, Anne. *Charles Robert Cockerell, Architect in Time: Reflections around Anachronistic Drawings*. Farnham: Ashgate, 2014.

Born, Pamela. "The Canon Is Cast: Plaster Casts in American Museum and University Collections." *Art Documentation: Journal of the Art Libraries Society of North America* 21, no. 2 (Fall 2002): 8–13.

Bottoms, Edward. "The Royal Architectural Museum in the Light of New Documentary Evidence." *Journal of the History of Collections* 19, no. 1 (2007): 115–39.

Branch, Mark Alden. "The Building That Won't Go Away." *Yale Alumni Magazine*, February 1998.

Braudel, Fernand. *The Mediterranean and the Mediterranean World in the Age of Philip II* (1949). Translated by Sian Reynolds. New York: Harper & Row, 1975.

Bressani, Martin. *Architecture and the Historical Imagination: Eugène-Emmanuel Viollet-le-Duc, 1814–1879*. Farnham: Ashgate, 2014.

Brownell, William C. "The Art Schools of Philadelphia." *Scribner's Monthly, an Illustrated Magazine for the People* 18, no. 5 (September 1879): 737–51.

Camille, Michael. "Prophets, Canons, and Promising Monsters." *Art Bulletin* 78, no. 2 (1996): 198–217.

Carnegie, Andrew. "Value of the World's Fair to the American People." *Engineering Magazine* 6, no. 4 (January 1894): 417–22.

Carpo, Mario. *Architecture in the Age of Printing: Orality, Writing, Typography, and Printed Images in the History of Architectural History*. Cambridge, MA: MIT Press, 2001.

Catalogo dei Monumenti, Statue, Bassirilievi a altre sculture de varie epoche che si trovano formate in gess nel laboratorio di Oronzio Lelli. Florence: Pei Tip di Salvadore Landi, 1894.

Catalogue & Price List of Plaster Re-Productions, of Antique, Grecian, Roman, Mediæval and Modern Statues, Statuettes, Busts, &c. for Sale by L. Castelvecchi, Manufacturer and Importer, 143 Grand Street, New York. N.d.

Catalogue of Plaster Reproductions from Antique, Medieval and Modern Sculpture Made and for Sale by P. P. Caproni and Brother. Boston, 1911.

Catalogue of the Collection of Casts. 1908.

Catalogue of the Collection of the Pennsylvania Academy of the Fine Arts. 1882.

Catalogue of the Medals, Busts, Casts, Marbles, and Stones in the Collection of the Royal Institute British Architects. London, 1874.

Catalogue of the Objects in the Museum. Part 1, Sculpture and Painting. 2nd ed. Chicago: The Art Institute, 1896.

Catalogue of the Permanent Collection of the Pennsylvania Academy of the Fine Arts, 7th ed. 1882.

Catalogues of Reproductions of Objects of Art, in Metal, Plaster, and Fictile Ivory, Chromolithography, Etching, and Photography. Selected from the South Kensington Museum, Continental Museums, and Various Other Public and Private Collections. London: George E. Eyre and William Spottiswood, 1869.

Cates, W.L.R. "The Berlin Photographs of Great Pictures." *Fine Arts Quarterly Review*, no. 1 (1866).

Choay, Françoise. *The Invention of the Historic Monument* (1992). Translated by Lauren M. O'Connell. Cambridge: Cambridge University Press, 2001.

Clark, Nick. "3D Printers Revive the Art of Casting Your Own Venus." *Independent*, December 27, 2014.

Cohen, Jean-Louis. "From the Ground Down: Architecture in the Cave, from Chaillot to Montreal." *Log*, no. 15 (Winter 2009): 24–34.

———. "Petite histoire du Grand Paris." *Critique* 6 (2010): 486–92.

Cole, H. H. *Catalogue of the Objects of Indian Art exhibited in the South Kensington Museum, Illustrated by woodcuts, and by a map of India showing the localities of various art industries.* London: George E. Eyre and William Spottiswoode, 1874.

Colla, Elliott. *Conflicted Antiquities: Egyptology, Egyptomania, Egyptian Modernity.* Durham: Duke University Press, 2007.

Commission des Monuments historiques/Ministère de l'instruction publique et des beaux-arts. *Musée de sculpture comparée (moulages), Catalogues des sculptures. Appartenant aux divers centres d'art et aux diverses époques, exposées dans les galeries du Trocadéro.* Paris: Palais du Trocadéro, 1883.

"Complete List of Accessions," *Metropolitan Museum of Fine Arts Bulletin* 3, no. 12 (December 1908).

Corbusier, Le. *When the Cathedrals Were White* (1947). Translated by Francis E. Hyslop, Jr. New York: McGraw-Hill Book Company, 1964.

Courajod, Louis, and P.-Frantz Marcou. *Musée de sculpture comparée (moulages). Palais du Trocadéro. Catalogue raisonné publié sous les auspices de la commission des Monuments historiques. XIV et XV siècles.* Paris: Imprimerie Nationale, 1892.

Crosbie, Michael J. "Paul Rudolph on Yale's A&A Building: His First Interview on His Most Famous Work." *Architecture*, November 1988, 102–5.

"The Crystal Palace Expositor." *Illustrated London News*, October 6, 1855, 419.

Currelly, Charles Trick. *I Brought the Ages Home.* Introduction by Northrop Frye. Toronto: The Ryerson Press, 1958.

Dahl, J. C. *Denkmale einer sehr ausgebildeten Holzbaukunst aus den frühesten Jahrhunderten in den innern Landschaften Norwegens.* Dresden, 1837.

Darley, Gillian. "Wonderful Things: The Experience of the Grand Tour." *Perspecta* 41 (2008): 17–24.

"Death of the Gargoyle." *Time Magazine*, November 15, 1963, 48–53.

de Sachy, Alexandre. *Catalogue des moulages provenant des musées, collections, etc.* Paris: Imprimerie National, 1881.

Descriptive Catalogue of the Permanent Collections of Works of Art on Exhibition in the Galleries. 2nd ed. Philadelphia: The Pennsylvania Academy of Fine Arts, 1904.

Didi-Huberman, Georges. "Before the Image, before Time: The Sovereignty of Anachronism." In *Compelling Visuality: The Work of Art in and out of History*, edited by Claire Farago and Robert Zwijnenberg. Minneapolis: University of Minnesota Press, 2003.

———. *Confronting Images: Questioning the Ends of a Certain History of Art.* Translated by John Goodman. University Park: Pennsylvania State University Press, 2004.

Donaldson, T. L., George Godwin, and F. C. Penrose (and Henry Cole, Esq. C.B. &c. &c. for the second report). "The Architectural Collections in the Museum at Brompton: 'A National Museum of Architecture.'" *The Builder*, September 17, 1859, 614–15.

Dorey, Helen. "Catalogues of Drawings, Models and Plaster Casts from the Temple of Castor and Pollux, Forum Romanum, in Sir John Soane's Museum, London." Appendix 3. In *The Temple of Castor and Pollux III: The Augustan Temple*, edited by Kjell Aage Nilson, Claes B. Persson, Siri Sande, and Jan Zahle. Occasional Papers of the Nordic Institutes in Rome, 4. Rome: L'Erma di Bretschneider, 2009.

———. "Sir John Soane's Model Room." *Perspecta* 41 (2008): 46, 92–93, 170–71.

Drexler, Arthur. "Engineer's Architecture; Truth and Its Consequences." In *The Architecture of the Beaux-Arts*, edited by Arthur Drexler. London: Secker & Warburg, 1977.

Dubbini, Renzo. *Geography of the Gaze: Urban and Rural Vision in Early Modern Europe*. Chicago: University of Chicago Press, 2002.

Dumont, Albert. "Les moulages de musée du Louvre." *Gazette des Beaux-Arts. Courrier Européen de l'art et de la curiosité* 11, no. 2 (1875): 415–27.

Eliot, T. S. "Tradition and the Individual Talent." In *The Sacred Wood: Essays on Poetry and Criticism* (1928). New York: Barnes and Noble, 1960.

Emerson, Alfred. *Illustrated Catalogue of the Antiquities and Casts of Ancient Sculpture in the Elbridge G. Hall and Other Collections. Part 1, Oriental and Early Greek Art*. Chicago: The Art Institute of Chicago, 1906.

Enlart, Camille. "The Carnegie Museum." In *Memorial of the Celebration of the Carnegie Institute at Pittsburgh, PA., April 11, 12, 13, 1907*. Pittsburgh, PA: Carnegie Institute, 1907.

———. *Le Musée de sculpture comparée au Palais du Trocadéro*. Paris: Librairie Renouard. 1911.

Enlart, Camille, and Jules Roussel. *Catalogue Général du Musée de sculpture comparée au Palais du Trocadéro (moulages)*. Nouvelle édition entièrement refondue. Paris: Librairie Alphonse Picard & Fils, 1910.

Ernst, Wolfgang. "Not Seeing the Laocöon? Lessing in the Archive of the Eighteenth Century." In *Regimes of Description: In the Archive of the Eighteenth Century*, ed. John Bender and Michael Marrinan. Stanford, CA: Stanford University Press, 2005.

Fahlman, Betsy. *John Ferguson Weir: The Labor of Art*. Newark: University of Delaware Press, 1997.

———. "A Plaster of Paris Antiquity: Nineteenth Century Cast Collections." *Southeastern College Art Conference Review* 12, no. 1 (1991): 1–9.

Falser, Michael. "From Gaillon to Sanchi, from Vézelay to Angkor Wat. The Musée Indo-chinois in Paris: A Transcultural Perspective on Architectural Museums." *RIHA Journal* 0071 (June 2013). http://www.riha-journal.org/articles/2013/2013-apr-jun/falser-musee-indo-chinois.

———. "Krishna and the Plaster Cast: Translating the Cambodian Temple of Angkor Wat in the French Colonial Period." *Transcultural Studies*, no. 2 (2011): 6–50.

"Fame won at Delphi." *New York Times*, September 21, 1890.

Fergusson, James. *A History of Architecture from All Countries, from the Earliest Times to the Present Day*. Vol. 2. London: John Murray, 1874.

———. *On a National Collection of Architectural Art*. Introductory Address on the Science and Art Department and the South Kensington Museum, December 21, 1857. London: Chapman and Hall, 1857.

———. *The Palaces of Nineveh and Persepolis Restored: An Essay on Ancient Assyrian and Persian Architecture*. London: John Murray, 1854.

Field, G.W.E. "Willard Architectural Commission. The Architectural Models in the Metropolitan Museum of Art, New York." In *Souvenir of the XXVIIIth Annual Convention of the American Institute of Architects to be held at the American Fine Arts Building, 215 W. 57th St., New York (October 15th, 16th, 17th 1894)*. New York: Nicoll & Roy Co., 1894.

"Fine Arts." *Illustrated London News*, July 24, 1867, 90.

Flour, Isabelle. "National Museums of Architecture: The Creation and Re-Creation of a New Type of National Museum in the 19th Century, London and Paris." In *Comparing: National Museums, Territories, Nation-Building and Change*, edited by Peter Aronsson and Andreas Nyblom. Linköping University Electronic Press, 2008.

———. "'On the Formation of a National Museum of Architecture': The Architectural Museum versus the South Kensington Museum." *Architectural History* 51 (2008): 211–38.

———. "Orientalism and the Reality Effect: Angkor at the Universal Expositions, 1867–1937." *Getty Research Journal*, no. 6 (2014): 63–82.

Floyd, Margaret Henderson. *Architecture after Richardson: Regionalism before Modernism—Longfellow, Alden, and Harlow in Boston and Pittsburgh*. Chicago: University of Chicago Press, 1994.

Forster, Kurt. "'Hey, Sailor . . .': A Brief Memoir of the Long Life and Short Fame of Paul Rudolph." *ANY: Architecture: New York*, no. 21 (1997): 13–15.

Forty, Adrian. *Concrete and Culture: A Material History*. London: Reaktion Books, 2012.

Foster, Sally M., and Neil G. W. Curtis. "The Thing about Replicas—Why Historic Replicas Matter." *European Journal of Archeology* 19, no. 1 (2016): 122–48.

Fredriksen, Rune, and Eckart Marchand, eds. *Plaster Casts: Making, Collecting and Displaying from Classical Antiquity to the Present*. Berlin: De Gruyter, 2010.

French, W.M.R. "The Permanent Collections at the Art Institute of Chicago." *Brush and Pencil* 1, no. 4 (January 1898): 79–89.

Furtwängler, Adolf. *Masterpieces of Greek Sculpture* (1893). London: William Heinemann, 1895.

G., E. A. "Archaeology in Greece, 1892." *Journal of Hellenic Studies*. 13 (1882–93).

Gadamer, Hans-Georg. *Truth and Method* (1960). Translated by Joel Weinheimer and Donald G. Marshall. London: Sheed & Ward, 1989.

Gampp, Axel. "Plaster Casts and Postcards: The Postcard Edition of the Musée de Sculpture Comparée at Paris." In Fredriksen and Marchand, eds., *Plaster Casts.*

Gilman, Benjamin Ives. *Manual of Italian Renaissance Sculpture as Illustrated in the Collection of Casts at the Museum of Fine Arts, Boston.* Boston: Museum of Fine Arts, 1904.

———. *Museum Ideals of Purpose and Method.* Cambridge, MA: The Riverside Press, 1918.

Godwin, George. No title. *The Builder*, June 10, 1854, 398.

———. No title. *The Builder*, September 16, 1854, 482.

Goethe, Johann Wolfgang von. *Italian Journey.* Translated by W. H. Auden and Elisabeth Mayer. London: Penguin Books, 1962.

Goutal, Michel. "Conservation Treatment of the Winged Victory of Samothrace and the Monumental Daru Staircase, September 2013–March 2015." Louvre, press pack.

Grant, Lindy, and Rose Walker. "Accidental Pilgrims: 19th-Century British Travellers and Photographers in Santiago de Compostela." *British Art Journal* 1, no. 2 (Spring 2000): 3–12.

Guédy, Henry. *L'Enseignement a l'école nationale et spéciale des Beaux-Arts. Section D'architecture. Admission.—2nd Classe.—1re classe.—Diplôme-prix de l'Académie et prix de Rome avec leur exposé pratique.* Paris: Libraire de la construction modern, 1899.

Guha-Thakurta, Tapati. "The Compulsion of Visual Representation in Colonial India." In *Traces of India: Photography, Architecture and the Politics of Representation, 1850–1900*, edited by Maria Antonella Pelizzari, 109–39. Montreal: Canadian Center for Architecture; New Haven, CT: Yale Center for British Art, 2003.

———. "The Production and Reproduction of a Monument: The Many Lives of the Sanchi *Stupa*." *South-Asian Studies* 29, no. 1 (2013): 15–47.

H., Th. "Norsk Arkitektur i det 19de Aarhundrede." *Norsk Folkeblad*, October 25, 1873, 262–63.

Hals, Harald. "Et norsk arkitektur- og bygningsmuseum." *St. Hallvard* (1934).

Hankins, Thomas L., and Robert J. Silverman. *Instruments and the Imagination.* Princeton, NJ: Princeton University Press, 1995, 2014.

Harris, John. "Storehouses of Knowledge: The Origins of the Contemporary Architectural Museum." In *Canadian Center for Architecture: Buildings and Gardens*, ed. Larry Richards. Montreal: CCA, 1989.

Haskell, Francis. *History and Its Images: Art and the Interpretation of the Past.* New Haven, CT: Yale University Press, 1993.

Haskell, Francis, and Nicholas Penny. *Taste and the Antique* (1981). New Haven, CT: Yale University Press, 2006.

Heckscher, Morrison H. "Metropolitan Museum of Art: An Architectural History." *Metropolitan Museum of Art Bulletin* 53, no. 1 (1995).

Historical Plaster Casts from the Metropolitan Museum of Art, New York. New York: Sotheby's, 2006.

Hitt, Laurance W. "The Parthenon." *Carnegie Magazine* 7, no. 1 (April 1933): 3–12.

Holmboe, J. "Beretning 1907." *Bergen Museum Aarbog 1907.* Bergen: John Griegs Bogtrykkeri, 1908.

Horowitz, Frederick A., and Brenda Danilowitz. *Josef Albers: To Open Eyes. The Bauhaus, Black Mountain College, and Yale.* London: Phaidon, 2006.

Howe, Winifred E. *A History of the Metropolitan Museum of Art, with a Chapter on the Early Art Institutions of New York.* Vol. 1. New York: Metropolitan Museum of Art, 1913.

Hugo, Victor. *En voyage. Alpes et Pyrénées* (1843). Paris: J. Hetzel & Cie, 1890.

———. "Sur la destruction des monuments de France" (1825). Expanded version printed as "Guerre aux Démolisseurs." *Revue des Deux Mondes* 5 (1832).

Hvattum, Mari. *Gottfried Semper and the Problem of Historicism.* Cambridge: Cambridge University Press, 2004.

"In Conversation: Philippe de Montebello with David Carrier and Joachim Pissarro." *Brooklyn Rail*, May 6, 2014.

James, Henry. *The American Scene.* New York: Harper & Brothers Publishers, 1907.

Jarrassé, Dominique, and Emmanuel Polack. "Le musée de Sculpture comparée au prisme de la collection de cartes postales éditées par frères Neurdein (1904–1915)." *Cahiers de l'Ecole du Louvre, recherches en historie de l'art, histoire des civilisations, archéologie, anthropologie et muséologie*, no. 4 (2014).

Jencks, Charles. "Esprit Nouveau est mort à New Haven or Meaningless Architecture." *Connections* (Graduate School of Design, Harvard University, 1964), 15–20.

———. *Modern Movements in Architecture.* London: Penguin, 1987.

Jenkins, Ian. "Acquisition and Supply of Casts from the Parthenon Sculptures from the British Museum, 1835–1939." *Annual of the British School at Athens* 85 (1990): 89–114.

———. *Archaeologists & Aesthetes in the Sculpture Galleries of the British Museum 1800–1939*. London: British Museum Press, 1992.

———. *Cleaning and Controversy: The Parthenon Sculptures 1811–1939*. London: The British Museum, 2001.

Jones, Owen. *An Apology for the Colouring of the Greek Court* (With Arguments by G. H. Lewes and W. Watkiss Lloyd, an Extract from the Report of the Committee Appointed to Examine the Elgin Marbles in 1836, from Transactions of the Royal Institute of British Architects, and a Fragment on the Origin of Polychromy, by Professor Semper). Crystal Palace Library. London: Bradbury & Evans, 1854.

Joselit, David. *After Art*. Princeton, NJ: Princeton University Press, 2013.

Kahn, Eve M. "Josh Sapan's 'Big Picture,' on Group Photos as Collectibles." *New York Times*, October 11, 2013.

Karpeles, Eric. *Painting in Proust*. London: Thames & Hudson, 2008.

Kaufman, Edward N. "A History of the Architectural Museum: From Napoleon through Henry Ford." In *Fragments of Chicago's Past: The Collection of Architectural Fragments at the Art Institute in Chicago*, edited by Pauline Saliga. Chicago: The Art Institute of Chicago, 1990.

Kent, Henry Watson. *The Horace Smith Collection of Casts of Greek and Renaissance Sculpture: A Brief Statement of the Cost and Manner of its Installation*. Springfield, MA: Springfield City Library Association, 1900.

———. *What I Am Pleased to Call My Education*. New York: The Grolier Club, 1949.

Kenworthy-Browne, John. "Plaster Casts for the Crystal Palace, Sydenham." *Sculpture Journal*. 15, no. 2 (2006): 173–98.

Keyser, Rudolf, Joachim Frisch, Johan Henrik Nebelong, Christian Holst, and Adolph Tidemand. "Indbydelse til en Forening for norske Fortidsmindemærkers Bevaring." *Skilling-Magazin*, April 5, 1845.

Kino, Carol. "Always Ready with a Barb." *New York Times*, September 27, 2012.

Krogh, Knud J. *Urnesstilens kirke*. Oslo: Pax, 2011.

Kubler, George. *The Shape of Time: Remarks on the History of Things* (1963). New Haven, CT: Yale University Press, 2008.

Lathrop, George Parsons. "The Progress of Art in New York." *Harper's Monthly Magazine* 86, no. 515 (April 1893).

Latour, Bruno, and Adam Lowe. "The Migration of the Aura, or How to Explore the Original through Its Facsimiles." In *Switching Codes: Thinking through Digital Technology in the Humanities and the Arts*, edited by Thomas Bartscerer and Roderick Coover. Chicago: University of Chicago Press, 2011.

Layard, Austen Henry. *The Assyrian Court, Crystal Palace* (Erected by James Fergusson). Crystal Palace Library. London: Bradbury & Evans, 1854.

———. *The Monuments of Nineveh: From Drawings Made on the Spot by Austen Henry Layard*. London: John Murray, 1849.

———. *Nineveh and Its Remains: A Narrative of an Expedition to Assyria during the Years 1845, 1846, & 1847*. London: John Murray, 1867.

Le Brun, Pierre. "Annual Report of the New York Chapter of the American Institute of Architects." *American Art and Building News* 18, no. 31 (October 1885).

Legrand, J.-G. *Collection des chefs-d'oeuvre de l'architecture des différens peuples, exécutés en modèles, sous la direction de L.-F. Cassas, auteur des voyages d'Istrie, Dalmatie, Syrie, Phœnicie, Palestine, Basse-Égypte, etc.* Paris: De l'imprimerie de Leblanc, 1806.

Leibold, Cheryl. "The Historic Cast Collection at the Pennsylvania Academy of the Fine Arts." *Antiques & Fine Art*, Spring 2010.

Lelyveld, Joseph. "After Fire, Yale Smolders." *New York Times*, June 27, 1969.

Lending, Mari. "The Art of Collecting Architecture." *Volume* 44 (2015): 16–25.

———. "Landscape versus Museum: J. C. Dahl and the Preservation of Norwegian Burial Mounds." *Future Anterior: Journal of Historic Preservation, History, Theory, and Criticism* 6, no. 1 (2009): 1–17.

———. "Negotiating Absence: Bernard Tschumi's New Acropolis Museum in Athens." *Journal of Architecture* 15, no. 5 (2009): 567–89.

———. "Reciting the Tomb of Tutankhamun." *Perspecta* 49 (2016): 77–88.

———. "The Urgencies of Theoretical Stuff." In *2000+. The Urgencies of Architectural Theory*, edited by James Graham. New York: GSAPP Books, 2015.

Lenoir, Alexandre. *Description historique et chronologique des monumens de sculpture, réunis au Musée des Monumens Français*. Paris: Gide libraire, 1800.

Leslie, Fiona. "Inside Outside: Changing Attitudes towards Models in the Museum at South Kensington." *Architectural History* 47 (2004): 159–200.

Lipstadt, Hélène. "The Building and the Book in César Daly's *Revue Générale de l'Architecture*." In *ArchitectureProduction*, edited by Beatriz Colomina. Princeton, NJ: Princeton Architectural Press, 1988.

List of Reproductions in Metal and Plaster Acquired by the Victoria and Albert Museum in the Years 1907 and 1908. London: Eyre and Spottiswoode, 1908.

Lowe, Adam, et al. *A Selection of Stories about Cultural Preservation, Innovation, Collaboration, Technology Transfer, Digital Documentation, Digital Restoration and Re-Materialisation Carried out by Factum Foundation.* Madrid: Factum Foundation, 2016.

Lyons, Claire L., John K. Papadopoulos, Lindsey S. Stewart, and Andrew Szegedy-Maszak. *Antiquity and Photography: Early Views of Ancient Mediterranean Sites.* Los Angeles: Getty Publications, 2005.

Maleuvre, Didier. *Museum Memories: History, Technology, Art.* Stanford, CA: Stanford University Press, 1999.

Malley, Shawn. *From Archaeology to Spectacle in Victorian Britain: The Case of Assyria, 1845–1854.* Farnham: Ashgate, 2012.

Malraux, André. *The Voices of Silence* (1953). Translated by Stuart Gilbert. Princeton, NJ: Princeton University Press, 1978.

Marchand, Suzanne L. *Down from Olympus: Archaeology and Philhellenism in Germany, 1750–1970.* Princeton, NJ: Princeton University Press, 1996.

Marcou, Paul Frantz Julien. *Album du Musée de sculpture comparée.* 5 vols. Paris, 1897.

Margolies Jane. "Move Over, Marble: Plaster Gets Pride of Place." *New York Times,* September 2, 2016.

Marquand, Henry G., et al. "Report to Members and Subscribers. February 1, 1892" and "Why the Metropolitan Museum Should Contain a Full Collection of Casts." In *Special Committee to Enlarge Collection of Casts. Report of Committee to Members and Subscribers, February 1, 1892.* New York: Metropolitan Museum of Art, 1892.

Martinez, Jean-Luc. "La gypsotèque du musée du Louvre à Versailles." *Comptes rendus des séances de l'académie des Inscriptions et Belles-Lettres* 154, no. 3 (2009): 1127–52.

McDonough, Tom. "The Surface as Stake: A Postscript to Timothy M. Rohan's 'Rendering the Surface.'" *Grey Room,* no. 5 (Autumn 2001): 102–11.

Metropolitan Art-Museum. Proceedings of a meeting held at the theater of the Union League club, Tuesday evening, November 23, 1869, including addresses, remarks, and letters. New York: Printed for the Committee, 1869.

The Metropolitan Museum of Art: Publications on Sale. New York, 1915.

Miller, Wallis. "Cultures of Display: Exhibiting Architecture in Berlin, 1880–1931." In *Architecture and Authorship,* ed. Tim Anstey, Katja Grillner, and Rolf Hughes, 89–107. London: Black Dog Press, 2007.

Moholy-Nagy, Sibyl. "The Future of the Past." *Perspecta* 7 (1961): 65–76.

Monrad, Marcus Jacob. "Om et archæologisk Museum, III." *Morgenbladet,* March 7, 1860.

Montens, Valérie. "La création d'une collection nationale de moulages en Belgique. Du musée des Plâtres à la section d'Art monumental des Musées royaux des arts décoratifs et industriels à Bruxelles." *In Situ. Revue des patrimoines* 28 (2016): 1–19. http://insitu.revues.org/12564. DOI: 10.4000/insitu.12564.

Moos, Stanislaus von. "'Ruins in Reverse': Notes on Photography and the Architectural 'Non-Finitio.'" In Ernst Scheidegger, *Chandigarh 1956: Le Corbusier and the Promotion of Architectural Modernity.* Zürich: Scheidegger und Spiess, 2010.

Morton, Patricia A. *Hybrid Modernities: Architecture and Representation at the 1931 Colonial Exhibition, Paris.* Cambridge, MA: MIT Press, 2000.

"Mr. Di Cesnola's Statues: The Story of Their Restoration by an Eye-Witness." *New York Times,* November 2, 1883.

Mulrooney, Sarah. "The Architecture of Influence: Paul Rudolph's Art &Architecture Building at Yale." PhD diss., University College Cork, 2014.

Murphy, Kevin D. *Memory and Modernity: Viollet-le-Duc at Vézelay.* University Park, PA: Pennsylvania State University Press, 2000.

Nagel, Alexander. *Medieval Modern: Art Out of Time.* New York: Thames and Hudson, 2012.

Nagel, Alexander, and Christopher S. Wood. *Anachronic Renaissance.* Zone Books, 2010.

"The New Casts Galleries of the Metropolitan Museum." *The Art Interchange* 37 (July 1896).

Newton, Charles. *The Antiquities of Cyprus Discovered by General Luigi Palma di Cesnola.* London: W. A. Mansell and Co., 1873.

———. "Remarks on the Collections of Ancient Art in the Museums of Italy, the Glyptothek at Munich, and the British Museum." *The Museum of Classical Antiquities: A Quarterly Journal of Architecture and the Sister Branches of Classic Art* 1, no. 3 (July 1851): 205–27.

Nichols, Kate. *Greece and Rome at the Crystal Palace: Classical Sculpture and Modern Britain, 1854–1936.* Oxford: Oxford University Press, 2015.

"Notes." *The Builder,* March 19, 1892, 292.

"Opening of the Hall of Casts," *Metropolitan Museum of Art Bulletin* 3, no. 12 (December 1908): 232.

"Opening of the Museum." *New York Times,* November 3, 1889.

Ouroussoff, Nicolai. "Where Gods Yearn for Long-Lost Treasures." *New York Times,* October 28, 2007.

Parrish, Samuel L. *Historical, Biographical, and Descriptive Catalogue of the Objects Exhibited at the Southampton Art Museum.* New York: Benjamin H. Tyrrel, 1898.

"The Parthenon Frieze: Effects of a Century of Decay." *Illustrated London News,* May 18, 1929, 839–41.

Payne, Alina. *From Ornament to Object: Genealogies of Architectural Modernism.* New Haven, CT: Yale University Press, 2012.

———. "Portable Ruins: The Pergamon Altar, Heinrich Wölfflin, and German Art History at the Fin de Siècle." *RES,* Spring/Autumn 2008, 168–89.

Pearlman, Jill. *Inventing American Modernism: Joseph Hudnut, Walter Gropius, and the Bauhaus Legacy at Harvard.* Charlottesville: University of Virginia Press, 2007.

———. "Joseph Hudnut's Other Modernism at the 'Harvard Bauhaus.'" *Journal of the Society of Architectural Historians* 56, no. 4 (December 1997): 452–77.

Pelet, Auguste. *Description des monuments grecs et romains exécutés en modèles à l'échelle d'un centimètre par mètre.* Nîmes, 1876.

Pelkonen, Eeva-Liisa. "On the Actuality of Forms." *Materia Arquitectura,* no. 9 (2014): 39–45.

Perkins, Charles Callahan. "American Art Museums." *North American Review* 111, no. 228 (July 1870): 1–29.

———. "The Pergamon Marbles. II.—The Gigantomachia and Other Sculptures Found at Pergamon." *American Art Review* 2, no. 5 (March 1881): 185–92.

Petrie, Flinders. *Racial Photographs from the Egyptian Monuments.* London: British Associations, 1887.

Pevsner, Nikolaus. "Address Given by Nikolaus Pevsner at the Inauguration of the New Art and Architecture Building of Yale University 9 November 1963." *Journal of the Society of Architectural Historians* 26, no. 1 (March 1967): 5–7.

Phillips, Samuel. *Crystal Palace: A Guide to the Palace & Park.* Illustrated by Philip H. Delamotte. Crystal Palace Library. London: Bradbury & Evans, 1854.

Piggot, J. R. *Palace of the People: The Crystal Palace at Sydenham 1854–1936.* London: C. Hurst & Co., 2008.

Pinatel, Christiane. "Reconstitutions des façades est et ouest du trésor du Siphnos au Musée des monuments antiques de Versailles, et provenances des moulages réutilisés." *Revue Archéologique,* n.s., 1 (1994): 29–52.

———. "La 'Restauration' en plâtre de deux colonnes du temple de Castor et Pollux dans la Petit écurie Royale de Versailles: Historie et archéologie." *Revue archéologique* 1, no. 35 (2003): 67–114.

Pliny, *Natural History.* Translated by H. Rackham. Cambridge, MA: Harvard University Press, 2003.

Pollen, John Hungersford. *A Description of the Architecture and Monumental Sculpture in the South-East Court of the South Kensington Museum.* London: George E. Eyre and William Spottiswoode, 1874.

———. *A Description of the Trajan Column.* London: George E. Eyre and William Spottiswoode, 1874.

P. P. Caproni & Bro. *Catalogue and Price List of Antique and Modern Sculpture.* Boston, n.d.

———. *Catalogue of Plaster Reproductions from Antique, Medieval and Modern Sculpture.* Boston, 1911.

Prescott, George B. *History, Theory, and Practice of the Electric Telegraph.* Boston: Ticknor and Fields, 1860.

President of the Society [Earl de Grey]. "The Architectural Museum, South Kensington." *Illustrated London News,* July 25, 1857, 87.

Proust, Marcel. *À la recherché du temps perdu.* Vols. 1 and 2. Paris: Gallimard, Bibliothèque de la Pléiade, 1987–88.

———. *The Way by Swann's.* Vol. 1 of *In Search of Lost Time.* Translated by Lydia Davis. London: Penguin, 2002.

———. *In the Shadow of Young Girls in Flower.* Vol. 2 of *In Search of Lost Time.* Translated by James Grieve. London: Penguin, 2005.

———. *Finding Time Again.* Vol. 6 of *In Search of Lost Time.* Translated by Ian Patterson. London: Penguin, 2003.

Quatremère de Quincy, Antoine-Chrysôstome. *Le Jupiter olympien, ou l'Art de la sculpture antique.* Paris: Firmin Didot, 1814.

———. *Letters to Miranda and Canova on the Abduction of Antiquities from Rome and Athens.* Translated by Chris Miller and David Gilks. Los Angeles: Getty Research Institute, 2012.

"Rare Assyrian Art Is Rockefeller Gift. Metropolitan Museum Receives Sculpture from Palace of Ancient King of Nimrud," *New York Times,* January 26, 1933.

Reade, Julian. "Nineteenth-Century Nimrud: Motivation, Orientation, Conservation." In *New Light on Nimrud,* edited by J. E. Curtis et al. London: British Institute for the Study of Iraq/British Museum, 2008.

Reese, Ilse M., and James T. Burns Jr. "The Opposites: Expressionism and Formalism at Yale." *Progressive Architecture,* February 1964, 128–29.

Reinach, Salomon. *The Nation,* 1885.

Ridley, Ronald T. *The Eagle and the Spade: Archeology in Rome during the Napoleonic Era.* Cambridge: Cambridge University Press, 2009.

Riegl, Alois. "The Modern Cult of Monuments: Its Character and Its Origin" (1903). Translated by Kurt Forster and Diane Ghirardo. *Oppositions* 25 (1982): 21–51.

Robinson, Edward. *Catalogue of Casts. Part I. Museum of Fine Arts Boston.* Cambridge, MA: The Riverside Press, 1891.

———. *Catalogue of Casts. Part II. Chaldæan and Assyrian Sculpture.* Boston: Houghton, Mifflin and Company, 1891.

———. *Catalogue of Casts. Part III. Greek and Roman Sculpture.* Boston: The Riverside Press, Cambridge, 1886.

———. *Descriptive Catalogue for the Casts from Greek and Roman Sculpture.* Boston: Alfred Mudge & Son, 1887.

———. "Report of Mr. Edward Robinson, Purchasing Agent." Appendix in *Special Committee to Enlarge Collection of Casts. Report of Committee to Members and Subscribers, February 1, 1892*. New York: Metropolitan Museum of Art, 1892.

———. *Tentative Lists of Objects Desirable for a Collection of Casts, Sculptural and Architectural, Intended to Illustrate the History of Plastic Art*. New York: Metropolitan Museum of Art, 1891.

Robinson, Edward, et al. *Catalogue of the Collection of Casts*. 2nd ed. with supplement. New York: Metropolitan Museum of Art, 1910.

Robinson, Lionel G. "The Berlin Museum of Casts." *Art Journal* (March 1883): 68–71.

Rohan, Timothy M. *The Architecture of Paul Rudolph*. New Haven, CT: Yale University Press, 2014.

———. "Rendering the Surface: Paul Rudolph's Art and Architecture Building at Yale." *Grey Room*, no. 1 (Autumn 2000): 84–107.

Roth, Michael S. "Irresistible Decay: Ruins Reclaimed." In *Irresistible Decay*. Santa Monica, CA: The Getty Research Institute for the History of Art and the Humanities, 1997.

Rousseau, Henry. *Catalogue sommaire des Moulages*, illustré de nombreuses planches en simili-gravure (2e édition). Brussels: Musées royaux du Cinquantenaire, 1926.

———. *Promenade méthodique dans le Musée d'Art Monumental* (avec un plan du Musée et deux illustrations). Brussels: Musées Royaux des Arts Décoratifs et Industriels, 1902.

Rudolph, Paul. "Architecture: The Unending Search." *Yale Alumni Magazine* 21, no. 8 (May 1958). Reprinted as "Alumni Day Speech: Yale School of Architecture, February 1958." *Oppositions* 4 (1974): 141–43.

———. "Enigmas of Architecture." *A+U* 80 (1977): 317–20.

———. "The Essence of Architecture Is Space" (1969). Reprinted in Rudolph, *Writings on Architecture*. New Haven, CT: Yale School of Architecture, 2009.

———. "Excerpts from a Conversation." *Perspecta* 22 (1986): 102–7.

———. "Paul Rudolph" [part of "3 New Directions: Paul Rudolph, Philip Johnson, Buckminster Fuller"]. *Perspecta* 1 (Summer 1952): 18–25.

———. "Regionalism in Architecture." *Perspecta* 4 (1957): 12–19.

———. "Six Determinants of Architectural Form." *Architectural Record* 120 (October 1956): 183–90.

———. "To Enrich Our Architecture." *Journal of Architectural Education* 13, no. 1 (Spring 1958): 9–12.

Ruskin, John. "The Deteriorative Power of Conventional Arts over Nations," delivered at the opening meeting of the Architectural Museum, South Kensington Museum, January 1858. In *The Complete Works of John Ruskin*, edited by E. T. Cook and Alexander Wedderburn, vol. 16. London: George Allen, 1905.

———. *The Seven Lamps of Architecture*. New York: J. Wiley, 1849.

Saliga, Pauline, ed. *Fragments of Chicago's Past: The Collection of Architectural Fragments at the Art Institute in Chicago*. Chicago: The Art Institute of Chicago, 1990.

Salisbury, [Edward Elbridge]. "Yale School of the Fine Arts" (printed statement read by Professor Salisbury a few days earlier). *The College Courant*, February 27, 1869.

Salmon, Frank. "'Storming the Campo Vaccino': British Architects and the Antique Buildings of Rome after Waterloo." *Architectural History* 38 (January 1995): 146–75.

Sanders, Russell M., Benjamin Sheperd, Elisabeth Skowronek, and Alison Hoffman. "Sustainable Restoration of Yale University's Art + Architecture Building." *APT Bulletin: Journal of Preservation Technology* 42, nos. 2/3 (2011): 29–35.

Sarkozy, Nicolas. "Déclaration de M. Nicolas Sarkozy, Président de la République, sur l'architecture et la politique du patrimoine." September 17, 2007. http://discours.vie-publique.fr/notices/077002719.html.

Scharf, George, Jun. *The Greek Court Erected in the Crystal Palace, by Owen Jones*. Crystal Palace Library. London: Bradbury & Evans, 1854.

Schivelbusch, Wolfgang. *The Railway Journey: The Industrialization and Perception of Time and Space in the 19th Century*. Berkeley: University of California Press, 1986.

Scott, Sir G. Gilbert. *Royal Architectural Museum: Catalogue of the Collection with a Guide to the Museum*. London, 1877.

Scott, Michael. *Delphi: A History of the Center of the Ancient World*. Princeton, NJ: Princeton University Press, 2014.

Scully, Vincent. *American Architecture and Urbanism*. London: Thames and Hudson, 1969.

———. "Art and Architecture Building, Yale University." *Architectural Review* 135 (May 1964): 325–32.

———. *Modern Architecture: The Architecture of Democracy* (1961). New York: George Braziller, 1974.

Seddon, John P. *Caskets of Jewels: A Visit to the Architectural Museum*. London: The Architectural Museum, 1884.

Sedlarz, Claudia. "Incorporating Antiquity—The Berlin Academy of Arts' Plaster Cast Collection: Acquisition, Use and Interpretation." In Fredriksen and Marchand, eds., *Plaster Casts*.

Settis, Salvatore, with Anna Anguissola and Davide Gasparotto, eds. *Serial/Portable Classic: The Greek Canon and Its Mutations*. Milan: Progretto Prada Arte, 2015.

Shetelig, Haakon. *Norske museers historie*. Oslo: Cappelen forlag, 1944.

Shure, Robert. "Yale Plaster Cast Collection: Condition and Treatment Report." Unpublished, February 2008.

Smith, Walter. *Art Education, Scholastic and Industrial*. Boston: James R. Osgood and Company, 1873.

Soane, John. "Crude Hints towards a History of My House in L[incoln's] I[nn] Fields." In *Visions of Ruin: Architectural Fantasies and Designs for Garden Follies*, edited by Helen Dorey. London: Sir John Soane's Museum, 1999.

———. *Sir John Soane: The Royal Academy Lectures*. Edited and introduced by David Watkin. Cambridge: Cambridge University Press, 2000.

Stara, Alexandra. *The Museum of French Monuments, 1795–1816: 'Killing Art to Make Art History'*. Farnham: Ashgate, 2013.

St. Clair, William. *Lord Elgin and the Marbles*. London: Oxford University Press, 1967.

Steffensen-Bruce, Ingrid A. *Marble Palaces, Temples of Art: Art Museums, Architecture, and American Culture, 1890–1930*. Lewisburg, PA: Bucknell University Press, 1998.

Stern, Robert A. M., and Jimmy Stamp. *Pedagogy and Place: 100 Years of Architecture and Education at Yale*. New Haven, CT: Yale University Press, 2016.

Supplement for 1914 to Catalogue of Caprioni Casts: Reproductions from Antique, Medieval and Modern Sculpture. Boston, 1914,

Swenson, Astrid. *The Rise of Heritage: Preserving the Past in France, Germany and England, 1789–1914*. Cambridge: Cambridge University Press, 2013.

Szambien, Werner. *Le musée d'architecture*. Paris: Picard, 1988.

The Ten Chief Courts of the Sydenham Palace. London: G. Routledge & Co., 1854.

Toker, Franklin. *The Hall of Architecture. Museum of Art, Carnegie Institute: A Feasibility Report on the Restoration of the Room and Its Casts*, June 1983. Carnegie archive.

Tomkins, Calvin. "Gods and Heroes." *New Yorker*, September 15, 1986.

Tournikiotis, Panayotis. "The Place of the Parthenon in the History and Theory of Modern Architecture." In *The Parthenon and Its Impact on Modern Times*, edited by Panayotis Tournikiotis. Athens: Melissa Publishing House, 1994.

"Treatment of Plaster Casts." *Bulletin of the Art Institute of Chicago* 6, no. 2 (October 1912): 27.

Tschudi, Victor Plahte. "Plaster Empires: Italo Gismondi's Model of Rome." *Journal of the Society of Architectural Historians* 71, no. 3 (2012): 386–403.

Tyndale, Walter. *Below the Cataracts*. London: William Heinemann; Philadelphia: J. B. Lippincott Company, 1907.

Unknown author. No title. *The Builder*, June 10, 1854, 297.

———. No title. *The Builder*, September 9, 1854, 481.

Valéry, Paul. "Le problème des musées." In *Pièces sur l'art* (1923), *Œuvres*, 2: 1290–93. Paris: Gallimard, Bibliothèque de la Pléiade, 1960.

Van Trump, James D. *An American Palace of Culture: The Carnegie Institute and Carnegie Library of Pittsburgh*. Pittsburgh: Carnegie Institute, 1970.

Van Zanten, David. "Architectural Composition at the École des Beaux-Arts from Charles Percier to Charles Garnier." In *The Architecture of the Beaux-Arts*, edited by Arthur Drexler. London: Secker & Warburg, 1977.

———. *Designing Paris: The Architecture of Duban, Labrouste, Duc, and Vaudoyer*. Cambridge, MA: MIT Press, 1987.

Vidler, Anthony. *The Writing of the Walls: Architectural Theory in the Late Enlightenment*. Princeton, NJ: Princeton Architectural Press, 1987.

Vinet, Ernest. "L'art Grec au Palais de l'Industrie." *Journal des Débats*, November 28, 1860.

Viollet-le-Duc, Eugène-Emmanuel. *The Foundations of Architecture: Selections from the Dictionnaire raisonné*. Introduction by Barry Bergdoll. Translated by Kenneth D. Whiteland. New York: George Braziller, 1990.

———. "Sculpture." In *Dictionnaire raisonné de l'architecture française du XIe au XVIe siècle*, vol. 8. Paris: Edition Bance-Morel, 1866.

Wagner, Anne Middleton. *Jean-Baptiste Carpeaux: Sculptor of the Second Empire*. New Haven, CT: Yale University Press, 1986.

Wainwright, Oliver. "V&A's Cast Courts of Beautiful Fakes Reopen after Three Years." *Guardian*, November 25, 2014.

Wallach, Alan. *Exhibiting Contradiction: Essays on the American Art Museum in the United States*. Amherst: University of Massachusetts Press, 1998.

Weber, Samuel. *Mass Mediauras: Form, Technics, Media*. Stanford, CA: Stanford University Press, 1996.

West, Hans. *Raissoneret Catalog over Consul West's Samling af Malerier med innledning samt liste over Haandtegninger, Figurer, Kobberstik og trykte Værker Samlingen tilhørende*. Copenhagen: Andreas Seidelin, 1807.

White, Trumbull, and Wm. Igleheart. *The World's Columbian Exposition, Chicago, 1893. A Complete History of the Enterprise*. Chicago: International Publishing Co., 1893.

White, William H. "M. Chipiez's Model of the Parthenon." *The Builder*, March 19, 1892, 230.

Whitehill, Walter Muir. *Museum of Fine Arts Boston: A Centennial History*. Vol. 1. Cambridge, MA: The Belknap Press of Harvard University Press, 1970.

Wigley, Mark. "Prosthetic Theory: The Disciplining of Architecture." *Assemblage*, no. 15 (August 1991): 6–29.

Wilder, Charly. "Nefertiti 3-D Scanning Project in Germany Raises Doubt." *New York Times*, March 10, 2016.

Winckelmann, Johann Joachim. *History of the Art of Antiquity*. Translated by Harry Francis Mallgrave. Los Angeles: The Getty Research Institute, 2006.

———. "Thoughts on the Imitation of Greek Works in Painting and Sculpture" (1755). In *The Art of Art History: A Critical Anthology*, edited by Donald Preziosi, 31–39. Oxford: Oxford University Press, 2009.

Wittman, Richard. *Architecture, Print Culture, and the Public Sphere*. New York: Routledge, 2007.

Wood, Christopher S. *Forgery, Replica, Fiction: Temporalities of German Renaissance Art*. Chicago: University of Chicago Press, 2008.

Wyatt, Matthew Digby, and J. B. Waring. *A Hand Book to the Byzantine Court*. Crystal Palace Library. London: Bradbury and Evans, 1854.

Wylde, Peter. "The First Exhibition: The Architectural Association and the Royal Architectural Museum." *Architectural Association Annual Review* (1981): 8–14.

Zahle, Jan. "Laocoön in Scandinavia—Uses and Workshops 1587 Onwards." In Fredriksen and Marchand, eds., *Plaster Casts*.

———. *Thorvaldsens afstøbninger efter antikken og renæssansen*. København: Thorvaldsens Museum, 2012.

Index

A

Acropolis Museum, Athens, 229
Adams, Charles F., 185
Adams, Edward D., 243 (n. 80)
Adorno, Theodor W., 101
Ai Weiwei, 177 (fig. 85)
Aix Cathedral, 50
Albers, Josef, 28, 185, 187, 188, 189, 190, 191, 192, 214, 218, 219, 220, 221
Albertinum, Dresden, 54, 85
Alden & Harlow, 162, 165
Allais, Lucia, 239
Alma-Tadema, Lawrence, 14, 15 (fig. 8)
Altes Museum, Berlin, 21, 244 (n. 104)
Angelis, Sabatino de, 55, 171
Angkor Wat, 8, 18, 114, 142, 143 (fig. 67)
Antikensaal, Mannheim, 8
Apollo Belvedere, 8, 55, 208, 258 (n. 18)
Arch of Titus, 55
Archaeological Museum, Athens, 170
Archer, Archibald, 15 (fig. 7)
Architectural Courts, South Kensington Museum, 7 (fig. 4), 24, 49, 58, 82, 109 (fig. 48), 113, 115, 120, 121 (fig. 54), 124 (fig. 56), 134, 135 (fig. 63), 151, 250 (n. 59); cast courts, Victoria and Albert Museum, 37, 183, 192, 202, 122 (fig. 55), 236 (fig. 120); Weston Cast Court, 228
Architectural Museum, London, 18, 37 (fig. 20), 49, 64, 82, 112, 115, 124; Royal Architectural Museum, 110, 227
architecture courts, Crystal Palace, Sydenham, 18, 38, 54, 82, 92, 111, 227; Alhambra Court, 94, 198; Assyrian court, 19 (fig. 10), 21, 94, 129 (fig. 59), 198, 230; Byzantine court, 111, 112, 134 (fig. 61), 198; Egyptian court, 94 (fig. 42), 128 (fig. 58); Greek court, 92 (fig. 41), 115, 165; Pompeian court, 94
Arrhenius, Thordis, 7, 141
Arrondelle, Eugène, 53, 152, 166, 167, 168
Art Academy, Berlin, 8, 11
Art and Architecture Building, Yale University, 28, 183, 185, 191, 192, 193, 194, 196, 197, 201, 208, 210, 211, 214, 215; Hastings Hall, 201; Paul Rudolph Hall, 183
Art Institute, Chicago, 113, 123, 161, 162, 164, 176 (fig. 83)
Assyrian sculptures, 1, 24, 55, 81, 82, 111, 113, 127, 148, 153, 166, 185, 193, 216, 218, 228, 230, 243 (n. 76) 247 (n. 97), 253 (n. 13) 263 (n. 31); Ashurnasirpal II panel, 216, 217 (fig. 113), 249 (n. 97); Lachish relief, Palace of Sennacherib, 216; Lamassu, 58, 148, 153, 228
Athena Lemnia, 206
Athena Velletri, 206 (fig. 106)
Athenaeum, Boston, 47

B

Baker, George F., 243 (n. 80)
Baker, Malcolm, 12, 122
Bakhtin, Mikhail, 216
Balanos, Nikolaos, 12, 14
Bann, Stephen, 11, 87, 89, 245 (n. 11)
Barry, Charles, 38, 55
Basilica di San Giovanni in Laterano, 157
Baudot, Anatole de, 81

Beatty, John W., 45, 46, 137, 152, 153, 154, 155, 156, 157, 160, 161, 162, 163, 164, 166, 167, 168, 169, 171, 172, 173, 174, 176, 178
Beckett, Francis, 138
Belzoni, Giovanni Battista, 147 (fig. 69), 232, 233
Benjamin, Walter, 28, 102, 103, 104, 143, 184, 221
Bergdoll, Barry, 17, 91, 227
Bergen Museum, 137, 139 (fig. 65), 140
Bilsel, Can, 11, 141
Blythe House, London, 109
Bode, Wilhelm von, 54, 131
Bordeaux Cathedral, 1, 161, 162, 163, 164, 167, 176 (fig. 83), 177 (figs. 84, 85), 179 (fig. 87), 180–81 (fig. 88)
Bordeleau, Anne, 11
Borges, Jorge Luis, 53
Borghese Gladiator, 187
Botta, Paul-Émile, 147
Boucholtz, M., 174
Boullée, Étienne-Louis, 37
Bourdais, Jules, 80
Braudel, Fernand, 85, 211
Bressani, Martin, 91, 142
Breuer, Marcel, 17, 192
British Museum, London, 4, 6, 7, 12, 13, 14 (fig. 7), 19, 24, 25, 27, 38, 54, 55, 58, 82, 109, 110, 111, 112, 138, 148, 153, 157, 160, 166, 170, 171, 186, 201, 230; Duveen Gallery, 14, 229, 242 (n. 43)
Brucciani, Domenico, 25, 55, 114, 115, 120, 132, 134, 137, 171
Bruce, Thomas, 7th Earl of Elgin, 147
Brugsch Bey, Heinrich, 54, 259 (n. 77)
Brunn, Heinrich, 6, 54
Bryant, William Cullen, 47
Buchanan, James, 152
Buda, Giovanni, 146
Bunshaft, Gordon, 192
Butler, Howard Crosby, 160

C
Camille, Michael, 105
Cantoria, Florence Cathedral: Luca della Robbia, 201 (fig. 99), 202 (fig. 101), 203 (fig. 102), 204 (fig. 103); Donatello, 215
Caproni, Pietro and Emilio, 170, 171, 172, 173, 174
Caproni & Bro., Boston, 97, 170, 186, 187, 200, 247 (n. 101); Caproni Gallery, 170; Giust Gallery, 200, 201 (fig. 99)
Carnegie, Andrew, 4, 5, 18, 137, 152, 154, 155, 161, 164, 167, 168, 169, 170
Carnegie Institute/Carnegie Museum of Art, Pittsburgh, 44, 46, 113, 137, 151, 152, 155, 157, 161, 163, 165, 166, 167, 168, 169, 170, 176
Carpanini, Josef (Giuseppe), 137, 252 (n. 114)

Carpo, Mario, 18
Cassas, Louis-François, 37
Castelvecchi, L., New York, 171
Cathedral of Saint-Pierre de Beauvais, 88, 160, 245 (n. 47)
Centennial Exhibition, Philadelphia 1876, 47
Certosa di Pavia, 50, 94, 174
Chaet, Bernard, 191
Champoiseau, Charles, 148
Chartres Cathedral, 76, 88, 136, 246 (n. 35)
Chipiez, Charles, 49, 50, 126, 161
Choay, Françoise, 37
Choragic Monument of Lysicrates, 2, 7, 50, 57, 60–61 (fig. 27), 153, 245 (n. 120)
Christie's: London, 25, 32, 49, 241 (n. 6); New York, 25
Clairvaux, Bernard of, 84
Clarke, Sir Purdon, 54, 167
Clermont-Ferrand Cathedral, 173, 246 (n. 35)
Clooney, Amal Alamuddin, 231 (fig. 117)
Cockerell, Charles Robert, 28, 90
Cognaux, Emile, 50
Cohen, Jean-Louis, 91
Cole, Henry, 21, 24, 38, 49, 84, 132, 134, 137, 139, 165, 172, 231
Cole, Henry Hardy, 113, 148, 149 (fig. 71), 151
Colonial Exhibition, Paris, 1931, 114
Comfort, George F., 48
Commission des monuments historiques, 65; Historic Monuments Commission, 41, 77, 80, 81, 84, 120, 134
Convers, Louis, 146
Coquart, Ernest-Georges, 41, 44, 67, 242 (n. 45)
Corcoran Gallery, Washington, DC, 47
Cottingham, Lewis Nockalls, 38
Cour vitrée, École des Beaux-Arts, Paris, 5, 11, 16 (fig. 9), 35, 41, 42–43 (figs. 21, 22) 58, 66 (fig. 30), 67, 86, 130, 185
Crystal Palace, Sydenham, 18, 21, 38, 39, 49, 54, 55, 82, 90, 92, 97, 98 (fig. 43), 109, 111, 115, 128, 129, 198, 200 (fig. 98), 207, 227
Currelly, Charles Trick, 197
Curtius, Ernst, 54, 56, 57, 253 (n. 3)
Cuvier, Georges, 103

D
D. Brucciani & Co., London, 25, 53, 56, 152, 153, 157, 160, 171, 174, 227, 230, 262 (n. 8)
Dahl, J. C., 132, 133 (fig. 60), 134, 138, 251 (n. 100)
Dance, George, 32, 40, 64
Dancing Faun, 8
Danes, Gibson, 197, 220
Danilowitz, Brenda, 189, 190
Daru stairway, Louvre Museum, 6 (fig. 3), 7, 144 (fig. 68), 146, 177 (fig. 87)

Darwin, Charles, 110
Davioud, Gabriel, 80, 161
De Forest, Robert W., 243 (n. 80)
De Sachy, Alexandre, 41, 44, 54, 168, 178, 239 (n. 21)
Debret, François, 40
Delamotte, Philip H., 19 (fig. 10), 96 (fig. 43)
Delaporte, Louis, 142, 151
Delphi Archaeological Museum, 146
Dewey, John, 190
Di Cesnola, Luigi Palma, 48, 125, 154, 207
Dicksee and Company, 160
Didi-Huberman, Georges, 216, 237
Dörpfeld, Dr., 57
Drexler, Arthur, 74
Du Sommerard, Alexandre, 36, 36, 39
Duban, Félix, 40, 41, 44, 218
Dufourny, Léon, 41, 44
Dutert, Charles-Loius-Ferdinand, 41, 44, 52, 64
Duveen, Joseph, 14
Dying Gladiator, 8, 186

E

Eastlake, Lady Elizabeth, 92
École des Beaux-Arts, Paris, 5, 35, 40, 41, 45, 49, 52, 54, 58, 76, 77, 80, 81, 112, 146, 153, 162, 168, 176, 178, 185, 186, 188, 196, 206, 227, 253 (n. 5); Palais des Études, 41
Egyptian papyrus-bud column, Eighteenth Dynasty, 153
Elener & Andersson, 160
Elgin, Lord. *See* Bruce, Thomas, 7th Elgin of Elgin
Elgin Marbles, 12, 14, 54, 55, 67, 92, 94, 98, 110, 148, 171, 229, 254 (n. 45); Temporary Elgin Room, 14, 15 (fig. 7)
Eliot, T. S., 210, 220
Enlart, Camille, 45, 46, 76, 82, 83, 92, 99 (fig. 44), 131, 154, 160, 161, 163, 164, 178
Erechtheion temple, 2, 8, 11 (fig. 5), 45 (fig. 23), 59 (fig. 26), 78–79 (fig. 37), 108, 131, 153, 160, 174, 179 (fig. 86), 231, 258 (n. 18); Caryatides, 2, 78–79 (fig. 37), 106, 143
Ernst, Wolfgang, 104, 207
Exposition internationale des Arts et des Techniques appliqués à la Vie moderne, Paris 1937, 82
Exposition universelle: Paris, 1867, 21, 24, 113, 132; Paris, 1878, 80, 142; Paris, 1889, 41, 49, 80; Paris, 1900, 7, 146

F

Factum Arte, 230, 232, 233, 234–35 (fig. 119)
Fahlman, Betsy, 201
Falser, Michael, 8, 11, 91, 142, 151
Farnese Hercules, 8, 47
Fellows, Sir Charles, 147
Fergusson, James, 17, 37, 38, 39, 40, 49, 64, 94, 109, 115, 129, 134, 147

Ferry, Jules, 80, 229
Flour, Isabelle, 11, 18, 90
Formerei der Kgl. Museen, Berlin, 21
Forster, Kurt, 194, 208, 210
Forty, Adrian, 184
Fouquet, François, 241 (n. 7)
Franchi, Giovanni, 122, 228
François I (king of France), 8, 77
Fredriksen, Rune, 11
French, William M. R., 162, 176
Frew, W. R., 154
Frick, Henry Clay, 154
Frieze of Archers, Frieze of Lions, Susa, 94, 156, 166, 172
Frothingham, Arthur L., Jr., 244 (n. 90)
Fuller, Buckminster, 189
Furtwängler, Adolf, 206

G

Gadamer, Hans-Georg, 226
Gandy, Joseph Michael, 32
Gardner, Isabella Stewart, 51
Gebrüder Micheli, 20 (fig. 11)
Gerber, August, 171
Gerchenkron, Alexander, 46
Getti, M., 170, 186
Gates of Paradise (Giberti Lorenzo), 1, 18, 25, 122 (fig. 55), 124, 165, 171, 177 (fig. 84), 186, 187 (fig. 90a), 250 (n. 63), 258 (n. 18)
Gilliéron and Son, Athens, 171
Gilman, Benjamin Ives, 89, 164
Gliddon, George, 259 (n. 76)
Glyptothek, Dresden, 206
Glyptothek, Munich, 6, 54, 90
Godwin, George, 38, 92, 94
Goethe, Johann Wolfgang von, 8, 24, 106
Great Stupa at Sanchi, 7 (fig. 4), 8, 113, 115, 142, 147, 148, 150–51 (figs. 72, 73)
Gropius, Walter, 188, 192, 210
Groswold, A. Whitney, 192
Guha-Thakurta, Tapati, 142, 230
Guidotti brothers, Christiania (Oslo), 55, 137, 171, 251 (n. 108)
Gustafson, Gabriel, 137
Gwathmey, Charles, 200

H

Hadrian, Emperor, 37
Hall of a Hundred Columns, Persepolis, 26 (fig. 13)
Hall of Architecture, Carnegie Institute, Pittsburgh, 1, 2 (fig. 1), 4, 5, 28, 45, 46, 109, 137, 146, 151, 152, 155, 156 (fig. 75), 158–59 (fig. 76), 160, 161, 162 (fig. 77), 164, 167,

Hall of Architecture (*cont.*)
 168, 170, 171, 176 (figs. 84, 85), 178, 179 (figs. 86, 87), 180–81 (fig. 88), 237
Hall of Casts, Harvard University, 168, 169 (fig. 91)
Hals, Harald, 17
Hamilton, George Heard, 187, 219
Hamilton, W. R., 7
Harlow, Alfred B., 162
Harpy Tomb, Xanthos, 216, 258 (n. 18)
Harris, John, 37
Hatshepsut's funerary temple, Theban Necropolis, 193, 194, 195 (figs. 92, 93), 196, 197, 198 (figs. 95, 96), 222–23 (fig. 114), 287
Hegel, Georg Wilhelm Friedrich, 221
Hennecke & Co., 170
Hildesheim Cathedral, 122, 171
Historical Museum, Christiania (Oslo), 137, 166; Museum of Cultural History, Oslo, 27
Homolle, Théophile, 146
Horace Smith Collection, Springfield, Mass., 21, 240 (n. 60)
Horowitz, Frederick, 191
Howe, George, 190
Hudnut, Joseph, 188
Hugo, Victor, 17, 81, 89, 132, 141
Hunt, Richard Morris, 46, 243 (n. 77)
Hvattum, Mari, 11

I
Institute of Classical Architecture and Art, New York, 231
Islamic State, 226, 230

J
James, Henry, 228
Jefferson, Thomas: Monticello, 47
Jencks, Charles, 196, 209, 214, 218
Jenkins, Ian, 11, 54, 110
Johnson, Philip, 192, 209
Jolly, Adolphe, 49
Jones, Owen, 38, 54, 55, 92, 94, 165, 231

K
Kahn, Louis, 189, 192, 209, 210
Kaupert, J. A., 57
Kennedy, John S., 243 (n. 80)
Kent, Henry Watson, 155
Klenze, Leo von, 54, 90
Knoedler, Roland F., 155, 168, 169; M. Knoedler & Company, 155
Kreittmayr, Joseph, 53, 55
Kubler, George, 27, 214
Kuntze, Edward J., 207

L
Laocoön, 8, 24, 55, 104, 187, 207, 247 (n. 101)
Latour, Bruno, 25, 104
Layard, Austen Henry, 19, 94, 129, 147, 148, 230
Le Brun, Napoleon, 49
Le Brun, Pierre, 5, 49, 50, 58, 146, 165, 174
Le Corbusier, 74, 100, 140, 192, 209, 210, 211, 214, 234, 235
Ledoux, Claude-Nicolas, 37
Legrand, Jacques-Guillaume, 37
Lelli, Giuseppe, 171, 215
Lelli, Oronzio, 55, 122, 228, 240 (n. 60), 250 (n. 63)
Lenoir, Alexandre, 35, 36 (fig. 19), 37, 41, 110, 129, 130
Leopold II (king of Belgium), 107
Lepsius, Karl Richard, 147
Lessing, Gotthold Ephraim, 104, 207
Longfellow, Alden and Harlow, 161, 162
Longfellow, Alexander, Jr., 160, 162
Louis XIV (king of France), 67
Louvre Museum, Paris, 4, 6 (fig. 3), 7, 40, 41, 48, 53, 54, 55, 94, 100, 101 (fig. 45), 110, 112, 131, 142, 143, 144 (fig. 68), 146, 152, 154, 156, 166, 167, 168, 170, 172, 186, 206, 232, 233, 240 (n. 55); Musée Napoléon, 170
Lowe, Adam, 25, 104, 233
Ludwig I (king of Bavaria), 90
Lysistratus of Sicyon, 8

M
Maclagan, Eric, 227
Madeleine de Vézelay, abbey church, 84, 85 (fig. 39), 88, 162, 167
Maleuvre, Didier, 100
Malmesbury, Lord, 54, 55
Malpiere, Ettore, 157
Malpieri, L., 55
Malraux, André, 111 (fig. 49)
Mansart, Jules Hardouin-, 67
Mansfield, Howard, 243 (n. 80)
Marchand, Eckart, 11
Marchand, Suzanne, 8
Marcou, M. Frantz, 157
Marcus Aurelius, 55
Marinetti, Filippo Tommaso, 100
Marker, Chris, 229
Marquand, Allan, 80, 243 (n. 80)
Marquand, Henry Gordon, 48, 243 (n. 80)
Martinelli, Napoleone, 55, 57, 248 (n. 26)
Massachusetts Institute of Technology, 187
Mausoleum of Halicarnassus, 3, 6, 21, 114, 142, 145, 152, 164, 205; Amazonomachy frieze, 7, 21, 205
McEnroe, John, 24

McKim, Mead & White, 160, 162, 243 (n. 77); Charles McKim, 160
Mellon, Andrew, 154
Mérimée, Prosper, 80
Merriam, Augustus C., 243 (n. 80)
Metropolitan Museum of Art, New York, 5, 17, 24, 25, 28, 44, 46, 47, 48, 49, 50, 51, 52, 56, 57, 58, 59 (fig. 26), 60–61 (fig. 27), 62–62 (fig. 28), 64, 100, 107, 109, 112, 113, 115, 116–17 (fig. 50), 118–19 (fig. 51), 124, 131, 136, 137, 138, 139, 140, 146, 154, 155, 156, 157, 160, 161, 162, 163, 166, 167, 170, 174, 197, 206, 207, 216, 227, 228, 231
Michaelis, Adolf, 54, 126
Micheli, Pierre-Laurent, 55
Mies van der Rohe, Ludwig, 75, 188, 192
Miller, Wallis, 18
Millet, Francis D., 243 (n. 80)
Minerva, New Haven, 182 (fig. 89), 183, 193, 198, 199 (fig. 97), 205 (fig. 105), 206, 207, 209
Moholy-Nagy, László, 188
Moholy-Nagy, Sibyl, 209
Moissac, church of, 81, 120 (fig. 52)
Monet, Claude, 72 (fig. 35)
Monrad, Marcus Jacob, 165
Montebello, Philippe de, 227
Monti, Raphaelle, 92
Moos, Stanislaus von, 14
Morgan, J. P., 154
Moses, Robert, 228
Mould, J. W., 48
Murphy, Kevin D., 84
Musée de Cluny, Paris, 36
Musée de sculpture comparée, Paris, 5, 28, 45, 48, 49, 51, 70, 71 (fig. 33), 72 (fig. 34), 75 (fig. 36), 77, 78–79 (fig. 37), 80, 81, 85 (fig. 39), 91 (fig. 40), 99 (fig. 44), 105, 120 (fig. 52), 121 (fig. 53), 134, 136, 142, 154, 167 (figs. 79, 80), 227; Palais du Trocadéro, 5, 80, 109, 229; Trocadéro Museum, 3, 5, 18, 24, 28, 36, 50, 52, 55, 70, 72 (fig. 34), 73, 75, 76, 80, 81, 82, 83, 84, 85, 86, 88, 89, 90, 92, 97, 98, 103, 105, 109, 121 (fig. 53), 139, 151, 154, 156, 157, 160, 161, 162, 163, 167, 169, 173, 178, 234, 235
Musée des monuments français, 1937, 82
Museum of Classical Archaeology, Cambridge University, 230
Museum of Egyptian Antiquities, Cairo, 113, 171
Museum of Fine Arts, Boston, 46, 47, 48, 74, 89, 97, 127, 155, 160, 164, 187, 219
Museum of French Monuments, Paris, 35, 36 (fig. 19), 40, 41, 110, 129; Petits-Augustins convent, 35, 40
Museum of Modern Art, New York, 17, 74
Museum of Roman Civilization, Rome, 109, 127 (fig. 57), 229

N
Nagel, Alexander, 2, 227, 237
Napoleon, 14, 17, 36 (fig. 19), 40, 206, 232
Napoleon (prince of France), 84
Napoleon III, 24, 84
National Museum, Athens, 186
Navez, Paul, 155, 168, 169, 172
Naxian Sphinx, 145 (fig. 68), 146, 177 (fig. 84), 178 (fig. 87)
Neues Museum, Berlin, 8, 11 (fig. 5), 123, 232
Neurdein brothers, 99 (fig. 44), 121 (fig. 53)
Newton, Charles, 6, 7, 54, 82, 83, 110, 111, 112, 145, 147
Nichols, Kate, 18, 129
Nike of Samothrace, 6 (fig. 3), 7, 8, 59 (fig. 26), 106, 131, 148, 187, 232, 258 (n. 18)

O
Obelisk of the Lateran, 55
Olmsted, Frederick Law, 48
Oscar II (king of Sweden and Norway), 132
Otero-Pailos, Jorge, 235, 237 (fig. 120)
Otto I (king of Greece), 156

P
Palazzo Vecchio, Florence, 174
Palladio, Andrea, 232
Pantheon, 50, 115, 116–17 (fig. 50)
Parke, Henry, 31 (fig. 14), 32, 35, 40, 64, 67
Parthenon, 2, 12 (fig. 6), 14, 15 (figs. 7, 8), 16 (fig. 9), 21, 25, 27, 41, 42 (fig. 22), 46, 49, 50, 56, 57, 58, 60–61 (fig. 27), 67 (fig. 31), 68, 86, 90, 92, 93 (fig. 41), 98, 103, 106, 112, 115, 116–17 (fig. 50), 118–19 (fig. 51), 124, 125, 126, 130, 140, 147, 153, 161, 162, 171, 178, 186, 187 (figs. 90a/b), 191, 192, 200, 204 (fig. 104), 205, 215 (figs. 111, 112), 216, 218, 226, 228, 229, 230, 231 (fig. 117), 230, 242 (nn. 43 and 44), 243 (n. 75), 248 (n. 26)
Payne, Alina, 21, 25, 147
Peale, Charles Willson, 186
Pearlman, Jill, 11, 188
Pelet, August, 122
Pelkonen, Eeva-Liisa, 190
Pennsylvania Academy of Fine Arts, 186, 187, 260 (n. 76)
Pergamon Altar, 11, 18, 20 (fig. 11), 21, 25, 114, 140, 141, 142, 156, 261 (n. 4); Gigantomachy frieze, 21, 141
Perkins, Charles Callahan, 6, 21, 46, 47, 56, 97, 112, 146, 147, 185, 186, 196
Petrie, William Matthew Flinders, 12, 197
Pevsner, Nikolaus, 191, 208, 209
Phidias, 14, 15 (fig. 8), 76, 98, 106, 111, 206
Philadelphia Museum of Art, 90
Phillips, Samuel, 92
Pierotti, Edoardo and Pietro, 55, 94, 171

Pinatel, Christiane, 11
Piranesi, Giovanni Battista, 32, 33 (fig. 15), 40, 64
Pliny the Elder, 8
Pollen, John Hungersford, 250 (n. 59)
Portico de la Gloria, Santiago de Compostela cathedral, 37, 121 (fig. 54), 168, 170, 173, 175, 226
Poulin, Abel, 50
Pouzadoux, Charles-Édouard, 98, 99 (fig. 44), 157, 163, 164, 167, 168, 169, 174, 255 (n. 72)
Prada Foundation, Venice and Milan, 231
Prescott, George B., 152
Prichard, Matthew Stewart, 74, 160, 161, 219
Proust, Antoine, 80
Proust, Marcel, 3, 4, 5, 28, 29, 70, 72, 73, 74, 75, 80, 81, 85, 86, 87, 88, 89, 90, 91, 98, 100, 101, 102, 103, 105, 122, 235
Prouvé, Jean, 17
pulpit, Pisa cathedral (Nicola Pisano), 124, 134

Q

Quatremère de Quincy, Antoine-Chrysòstome, 14, 16, 67, 68, 98, 100, 103, 129, 130, 207

R

Reims Cathedral, 27, 78–79 (fig. 37), 90, 91 (fig. 40)
Reinach, Salomon, 46, 54
Rhinelander, Frederick W., 243 (n. 80)
Richardson, Henry Hobson, 162, 164
Riegl, Alois, 7, 140, 226
Rinaldo, Lorenzo, 153, 171
Robinson, Edward, 27, 51, 52, 53, 54, 55, 56, 57, 58, 64, 85, 94, 97, 113, 127, 131, 139, 155, 157, 166, 170, 197, 219, 228, 259 (n. 77)
Robinson, John Charles, 114
Rockefeller, John D., 228
Rohan, Timothy M., 11, 208, 210, 2011, 215
Roman ruins, Baalbek, 85
Rosetta Stone, 197
Roth, Michael, 85
Rousseau, Henry, 110, 126, 127, 130, 131, 136
Royal Academy, London, 30, 32
Royal Cast Collection, Copenhagen, 138
Royal Frederik's University, Christiania (Oslo), 134, 137
Royal Museum of Art and History, Brussels, 106; Musée d'art monumental, 107 (fig. 46), 136 (fig. 64), 150 (fig. 72); Musée du Cinquantenaire, 107, 123, 142, 206, 243 (n. 75); Royal Museum of Fine Arts, 27
Royal Museums, Berlin, 48, 49
Royal Ontario Museum, Toronto, 197
Rudolph, Paul, 11, 28, 183, 184, 185, 192, 193, 194, 196, 197, 198, 201, 205, 208, 209, 210, 211, 214, 215, 216, 218, 219, 220, 221

Ruskin, John, 38, 64, 65, 73, 249 (n. 51)
Ruthwell Cross, 124

S

Sadoaune, M., 176
Saint-Gilles-du-Gard, abbey church, 2 (fig. 1), 5, 45, 123, 137, 161, 162, 163 (fig. 78), 164, 166, 167 (figs. 79, 80), 168, 170, 172, 174, 175 (fig. 82), 176, 180–81 (fig. 88), 226
Salemme, Antonio, 262 (n. 22)
San Marco Basilica, Venice, 131, 139, 153
San Petronio Basilica, Bologna, 122 (fig. 55), 228
Sansovino, Andrea, 55
Sarkozy, Nicolas, 229
Sawyer, Charles H., 185, 188, 189, 190, 191
Schiller, Friedrich, 8
Schinkel, Karl Friedrich, 21, 192, 244 (n. 104)
Schirmer, Herman Major, 263 (n. 134)
Schivelbusch, Wolfgang, 87
Scott, Sir Gilbert, 38
Scully, Vincent, 208, 210, 211, 214, 220
Semper, Gottfried, 94
Settis, Salvatore, 207, 226
Shetelig, Haakon, 137, 138, 139, 140, 141, 142
Shure, Robert, 200, 206
Siena Cathedral, 50
Sir John Soane's Museum, London, 34 (figs. 16, 17), 35 (fig. 18), 68, 69 (fig. 32), 218, 227; Lincoln's Inn Fields, 32, 46, 197, 218
Skulpturhalle Basel, 229, 232
Skylight Studios, Woburn, Mass., 200, 206 (fig. 106)
Slater Memorial Museum, Norwich, Conn., 109, 154, 155, 254 (n. 32)
Smith, Cecil, 157, 160
Smith, Reginald, 138
Soane, John, 18, 30, 32, 35, 36, 37, 38, 39, 40, 46, 64, 197, 227, 233
Society for the Preservation of Norwegian Ancient Monuments, 17, 132, 141
Sotheby's, New York, 25
South Kensington Museum, London, 8, 21, 24, 25, 37, 38, 48, 54, 81, 114, 120, 122, 124, 125, 134, 137, 156, 160, 165, 166, 170, 208; Victoria and Albert Museum, 24, 27, 126, 138, 140, 156, 228, 231, 235
Southampton Museum, New York, 232
St. Gaudens, Augustus, 243 (n. 80)
Stara, Alexandra, 37
stave churches, 28, 132, 134, 138, 141; Ål, 193, 195, 196; Flå, 134 (fig. 63), 190, 193, 194, 195; Sauland, 9, 10, 11, 136 (fig. 64), 190, 193, 194, 195, 197; Urnes, 108 (fig. 47), 133 (fig. 60), 135 (figs. 61, 62), 139 (figs. 65, 66), 192, 193, 194, 197, 198, 199, 200, 201, 202, 206; Vang, 251 (n. 100)

Stendhal, 122
Stern, Robert A. M., 184
Street Hall, Yale University, 183, 185, 187 (figs. 90 a/b), 191, 192, 196, 197, 219
Stüler, Friedrich August, 8
Sullivan, Louis, 214, 215 (figs. 111, 112)
Summerson, John, 227

T

Taliban, 226
Taylor, Baron, 81, 89, 132
Taylor, Francis Henry, 228
Temple at Karnak, Hypostyle Hall, 138, 169
Temple of Apollo, Bassae, 201, 202 (fig. 100)
Temple of Apollo, Didyma, 174
Temple of Athena, Aegina, 90
Temple of Bel, Palmyra, 225 (fig. 115), 226
Temple of Castor and Pollux, 5, 27, 30, 32, 33 (fig. 15), 34 (figs. 16, 17), 35 (fig. 18), 39, 40, 41, 42 (fig. 21), 44, 45 (fig. 23), 46 (fig. 24), 52, 56, 57, 58, 62–63 (fig. 28), 64, 65 (fig. 29), 66 (30), 67 (fig. 31), 68, 69 (fig. 32), 86, 130, 178; Temple of Jupiter Stator, 30 (fig. 14), 39, 46, 58, 65, 241 (n. 5)
Temple of Dendur, 17
Temple of Nike Apteros, 2 (fig. 1), 3 (fig. 2), 107, 156, 171, 174 (fig. 81), 180–81 (fig. 88), 188, 211
Temple of Zeus, Olympia, 50, 57, 58, 59 (fig. 26), 60–61 (fig. 27), 131, 141
Thompson, Thurston, 114, 115
Thorvaldsen, Bertel, 90
Tiffany, Louis C., 243 (n. 80)
Toker, Franklin, 155
tomb of François II, 161, 163
tomb of Seti I, 234–35 (fig. 119)
Tomkins, Calvin, 24, 25, 100, 107
Tournaire, Joseph Albert, 146
Trabacchi and Cencetti, 50
Trajan's Column, 7, 24, 58, 107, 109 (fig. 48), 120, 122, 124 (fig. 56), 125, 126, 127 (fig. 57), 136, 228, 229, 235, 250 (n. 59)
Treasury of Atreus, Mycenae, 230
Treasury of the Siphnians, 6 (fig. 3), 7, 144 (fig. 68) 146, 156 (fig. 75), 168
Treu, Georg, 54, 57, 58
Tschudi, Victor Plahte, 246 (n. 117)
Tschumi, Bernard, 229, 230
Turner, Joseph Mallord William, 30
Tyndale, Walter, 197

U

Uffizi Gallery, Florence, 171

V

Valéry, Paul, 100
Van Trump, James D., 109
Vatican Museums, Rome, 6, 8, 55, 104, 112, 134, 170, 186, 207; Belvedere court, 104
Vaux, Calvert, 48
Venus de Milo, 8, 47, 186, 191, 208, 232, 258 (n. 18)
Veronese, Paolo, 232
Vesta temple, Tivoli, 1, 46, 171, 174, 176 (fig. 84)
Victoria (queen of England), 152
Vidler, Anthony, 37
Vinet, Ernest, 122
Viollet-le-Duc, Eugène-Emmanuel, 5, 36, 76, 77, 80, 81, 82, 84, 87, 91, 103, 112, 123, 131, 134, 142, 162, 229, 235
Vitet, Ludovic, 77

W

Wagner, Anne Middelton, 11, 130, 218
Walger, Heinrich, 57
Ward, John Q. A., 243 (n. 80)
Ware, William R., 125, 187, 188, 243 (n. 76)
Weber, Samuel, 103
Wedding at Cana (Paolo Veronese), 232, 233 (fig. 118)
Weir, James Ferguson, 185, 186, 187, 220, 258 (n. 18)
Weir, Julian, 186
Well of Moses, 161, 163, 164, 172, 173, 179 (fig. 84)
Wenman, Cosmo, 232
Westmoreland, Lord, 55
Wheeler, Arthur M., 185
White, Stanford, 243 (n. 80)
Whiteread, Rachel, 162 (fig. 77)
Wight, Peter B., 191
Willard, Levi Hale, 48
Willard Collection, Metropolitan Museum of Art, 49, 56, 112, 174
Winckelmann, Johann Joachim, 8, 77, 225, 226, 235
Wittman, Richard, 8
Wood, Christopher W., 25, 237
World's Columbian Exposition, Chicago, 1893, 18, 123, 154, 162, 176
Wright, Frank Lloyd, 4, 210, 211
Wyatt, Matthew Digby, 54, 55, 134

Y

Yale School of Fine Arts, New Haven, 28, 185, 187, 220

Z

Zahle, Jan, 139, 207

Illustration Credits

Books/Catalogues

Henry Hardy Cole, *The Architecture of Ancient Delhi, especially the Buildings around the Kutb Minar* (London: The Arundel Society, 1872): Fig. 71.

J. C. Dahl, *Denkmale einer sehr ausgebildeten Holzbaukunst aus den frühesten Jahrhunderten in den inneren Landschaften Norwegens* (Dresden, 1837): Fig. 60.

Camille Enlart and Jules Roussel, *Catalogue Général du Musée de sculpture comparée au Palais du Trocadéro (moulages)*. Nouvelle edition entièrement refondue (Paris, 1910): Figs. 36, 39, 80.

James Fergusson, *A History of Architecture from All Countries, from the Earliest Times to the Present Day*, vol. 2 (London, 1874): Fig. 62.

Austen Henry Layard, *The Assyrian Court, Crystal Palace* (London, 1854): Figs. 59, 70.

Paul Frantz Julien Marcou, *Album du Musée de sculpture comparée* (Paris, 1897): Figs. 33, 37, 40, 52, 79.

MM. Ch. Nodier, J. Taylor et Alp. De Cailleux, *Voyages pittoresques et romantiques dans l'ancienne France*, vol. 2, *Ancienne Normandie* (Paris, 1824): Fig. 38.

Ludwig Ross, Eduard Schaubert, and Christian Hansen, *Die Akropolis von Athen nach den Neuesten Ausgrabungen. Erste Abtheilung: Der Temple der Nike Apteros* (Berlin, 1839): Fig. 2.

Henry Rousseau, *Catalogue sommaire des Moulages*, illustré de nombreuses planches en simili-gravure (Brussels, 1926): Figs. 64, 72.

Matthew Digby Wyatt and J. B. Waring, *A Hand Book to the Byzantine Court* (London, 1854): Fig. 61.

Journals/Newspapers

Illustrated London News, courtesy of Mary Evans Picture Library: Figs. 6, 58.

New York Times: Fig. 89.

Individuals

Roy Berkeley, courtesy of Ellen Perry Berkeley: Fig. 97.
Adrian Forty, courtesy of Reaktion Books: Fig. 110.
Mari Lending: Figs. 24, 46, 57, 66, 94, 99, 106.
Christiane Pinatel: Jacket and fig. 29.
Jan Zahle: Fig. 47.

Institutions

Albany Institute of History & Art: Fig. 69.
AW Asia/Carnegie Museum of Art, Pittsburgh: Fig. 85.
bpk/Zentralarchiv, Staatliche Museen zu Berlin: Fig. 5.
Birmingham Museum Trust: Fig. 8.
British Library Board: Fig. 10.
British Museum, courtesy of the Trustees: Fig. 7.
Bromley Local Studies and Archives, UK: Figs. 41, 42.
Carnegie Museum of Art, Pittsburgh: Figs. 1, 23, 24, 74, 75, 76, 81, 82, 83, 84, 86, 87, 88.
Factum Arte: Figs. 118, 119.
Fondation Le Corbusier/BONO: Fig. 45.
Frances Loeb Library, Graduate School of Design, Harvard University: Fig. 91.
Getty Images: Figs. 115, 117.
Kunstbibliothek, Staatliche Museen zu Berlin: Fig. 11.
Luhring Augustine, New York, Lorcan O'Neill, Rome, and Gagosian Gallery (courtesy of Rachel Whiteread)/

Carnegie Museum of Art, Pittsburgh: Fig. 77.
Manuscripts and Archives, Yale University Library: Figs. 90 (a/b).
Médiathèque de l'architecture et du patrimoine, Charenton-le-Pont/Fonds Henri Olivier: Fig. 67.
Metropolitan Museum of Art/Art Resource, NY: Figs. 26, 27, 28, 42, 43, 50, 51, 103.
Musée des Monuments français/Cité de l'architecture et du patrimoine: Figs. 44, 53.
Musée du Louvre, département des antiquités grecques, étrusques et romaines: Figs. 3, 9, 68.
Nasjonalmuseet for kunst, arkitektur og design, Oslo: Figs. 12, 29.
Paris Match Archive/Getty Images: Fig. 49.
RMN (École nationale supérieure des Beaux-Arts): Figs. 21, 22, 31.
RMN (Musée d'Orsay): Figs. 35, 98.
RMN (Musée du Louvre): Fig. 19.
Scala, Florence/Courtesy of the Ministero Beni e Att. Culturali: Fig. 15.
Sir John Soane's Museum, London: Figs. 14, 16, 17, 18, 32.
Skylight Studios: Figs. 96, 104.
Sotheby's, New York: Fig. 13.
Statens museum for kunst, København: Fig. 47.
Thomas J. Watson Library, Metropolitan Museum of Art, NY: Figs. 25, 78.
Universitetsmuseet i Bergen: Fig. 65.
Victoria and Albert Museum: Figs. 4, 20, 48, 54, 55, 56, 63, 73, and 120 (courtesy of Jorge Otero-Pailos).
Virginia Museum of Fine Arts: Fig. 95.
Yale School of Architecture: Figs. 93, 100, 102, 105, 107, 108, 109, 112, 113, 114.

Photographers
Peter Kelleher: Fig. 120.
Joseph W. Molitor, courtesy of the Joseph W. Molitor Photograph Collection, Avery Architectural and Fine Arts Library, Columbia University: Figs. 92, 101.
Ezra Stoller © Esto: Fig. 111.

Copyright © 2017 by Princeton University Press
Published by Princeton University Press, 41 William Street, Princeton, New Jersey 08540

In the United Kingdom: Princeton University Press, 6 Oxford Street, Woodstock, Oxfordshire OX20 1TR

press.princeton.edu

Cover illustration: Rebuilding the Castor and Pollux colonnade, Versailles, 1975–76. Photo by Christiane Pinatel, courtesy of Musée du Louvre, département des antiquités grecques, étrusques et romaines

All Rights Reserved

Library of Congress Cataloging-in-Publication Data
Names: Lending, Mari, 1969- author.
Title: Plaster monuments : architecture and the power of reproduction / Mari Lending.
Description: Princeton : Princeton University Press, 2017. | Includes bibliographical references and index.
Identifiers: LCCN 2016053830 | ISBN 9780691177144 (hardcover : alk. paper)
Subjects: LCSH: Architectural casts. | Art—Reproduction—Social aspects.
Classification: LCC NA2005 .L46 2017 | DDC 702.8/72—dc23 LC record available at https://lccn.loc.gov/2016053830

British Library Cataloging-in-Publication Data is available

Design: Luke Bulman—Office with Camille Sacha Salvador
This book has been composed in Cormorant Garamond and Akkurat

Printed on acid-free paper. ∞
Printed in China
10 9 8 7 6 5 4 3 2 1